UNION LEAGUE CLUB
OF CHICAGO
ART COLLECTION

UNION LEAGUE CLUB OF CHICAGO ART COLLECTION

Introduction by Neil Harris

Essays by
Marianne Richter
Wendy Greenhouse

With contributions by
Eden Juron Pearlman and
Dean A. Porter

Collection entries
and checklist. © Union League
Club of Chicago, 2003

"Art and the American Club:
Chicago's Union League Club
as Patron"
© Neil Harris, 2001

Photography by Michael Tropea,
Chicago, Illinois

Published by the
Union League Club of Chicago,
2003

Printed by
Arti Grafiche Amilcare Pizzi S.p.A.
Milan, Italy

Edited by
Claudia Lamm Wood

Designed by
Sam Silvio
Silvio Design, Inc.

The publishers are indebted
to the artists and their estates
for permission to reproduce
illustrations. Every effort has
been made to trace copyright
holders, but in a few cases
this has not been possible.

Back cover and page 63:
Roger Brown, *Chicago Taking
a Beating* © The School of
the Art Institute of Chicago
and the Brown family.

ISBN 0-9717579-2-5 (cloth)
ISBN 0-9717579-0-9 (pbk.)

Union League Club of Chicago
65 West Jackson Boulevard
Chicago, Illinois 60604

Key to abbreviations of authors

WG	Wendy Greenhouse
EJP	Eden Juron Pearlman
DP	Dean Porter
MR	Marianne Richter

Key to abbreviations of organizations

AIC	The Art Institute of Chicago
MAL	Municipal Art League
UL C&AF	Union League Civic & Arts Foundation
ULC	Union League Club of Chicago

Key to abbreviations of references

Corliss, *Catalogue*, 1899
Corliss, George. *Union League Club of Chicago: Catalogue of Paintings and Other Works of Art.* Chicago: Union League Club of Chicago, 1899.

Earle, *Biographical Sketches*.
Earle, Helen L., comp. *Biographical Sketches of American Artists*. Collingswood, NJ: A.C. Schmidt Fine Arts, 1972.

Gerdts. *Art Across America*.
Gerdts, William H. *Art Across America: Two Centuries of Regional Paintings, 1710-1920*. 3 vols. New York: Abbeville Press, 1990.

Loy and Honig. *One Hundred Years*.
Loy, Dennis and Carolyn Honig. *One Hundred Years 1887-1987: Catalog of the Collection, Union League Club of Chicago*. Chicago: Union League Club of Chicago, 1987.

Martin. *Art in the ULC*.
Martin, Edward M. *Art in the Union League Club*. Chicago: Union League Club of Chicago, 1971.

McCauley. *Catalogue*, 1907.
McCauley, L. M. *Catalogue of Paintings, Etchings, Engravings and Sculpture*. Chicago: Union League Club of Chicago, 1907.

Sparks. *American Art in the ULC*.
Sparks, Esther. *American Art in the Union League Club of Chicago: A Centennial Exhibition*. Exh. cat. (Chicago: Union League Club of Chicago, 1980).

Sparks, "Biographical Dictionary."
Sparks, Esther. "A Biographical Dictionary of Painters and Sculptors in Illinois, 1808-1945," Ph.D diss., Northwestern University, 1971.

TABLE OF CONTENTS

MISSION STATEMENT

In order to provide pleasure and enrichment to the membership, to enhance the prestige of the Union League Club of Chicago owing to its historically developed art collection, to nurture relationships with both the art community and the community at large, and to foster member and public appreciation of art and the local creation of art,

The mission of the Union League Club of Chicago's Art Committee is to improve the Club's art collection through acquisition, conservation, deaccession, and research; to publicize the collection in diverse media; to conduct art programs, events and tours; to selectively make the collection available to wider audiences; to support the Distinguished Artists Membership program and to facilitate and support both the creation and display of art by local artists.

FOREWORD

In the letter that accompanied the Union League Club of Chicago's first significant work of art, its donor, J. M. Thacher, wrote prophetic words: "I trust this gift may soon find company." Club members quickly took his wish to heart. Within a decade, the Club had established an art committee and an art acquisitions fund and had purchased a number of the works that are today considered among the most important in the collection. Dedicated from the start to collecting works of merit, the Club is today recognized as having one of the most important privately held collections in the region, with a special strength in works by midwestern artists. The Club has over 750 works of art, including paintings, sculpture, works on paper, and decorative arts.

 The Club's long history of supporting artists involves not only the acquisition of their work, but also biennial juried exhibitions, held from 1955 until 1989; these activities are chronicled in Neil Harris's essay, "Art and the American Club: Chicago's Union League Club as Patron." Today interest in art among our members has renewed strength, and the Club's current activities include recognizing the contributions of distinguished Chicago artists with honorary memberships, organizing exhibitions with other Chicago arts institutions, and producing monthly exhibitions of contemporary art. In 1997, the Club established an on-site conservation laboratory and added a paintings conservator to the staff. Our longstanding and great commitment to art and artists is reflected in the mission of the Art Committee, adopted in 2001 and published on page VI.

 Our intention in producing this catalogue, the Club's sixth, is twofold: to provide our members with in-depth information about works in the collection, and to introduce one of Chicago's "hidden treasures" to a wider audience. *Union League Club of Chicago Art Collection* includes important new information that we hope you will find both interesting and useful. One hundred twenty-five works of art are featured in entries that include, for the first time, each object's record of exhibitions and publications, as well as its provenance. More important, you will find extensive information about the artist and the work of art. A complete listing of the collection is located in the back section of the book.

 With great pride and pleasure the Union League Club of Chicago presents this new catalogue of its art collection in the 125th year of our founding. We hope you will enjoy it for many years to come.

Seymour H. Persky
Chair, Art Committee, 2000–2002

ACKNOWLEDGMENTS

A publication of this scope would not be possible without the generous assistance and support of numerous people. Foremost among them are the Club's Board of Directors and the Art Committee, led by Nina Owen. They provided both material and moral support throughout the production of *Union League Club of Chicago Art Collection*. Heartfelt thanks are reserved for Clark L. Wagner, who, as Art Committee chair from 1997 to 2000, initiated this project and for Seymour H. Persky, Art Committee chair from 2000 to 2002, who furthered it into production. The late J. Dillon Hoey, an enthusiastic advocate for the art collection, was chair during much of the production phase of the book.

Special thanks also go to Philip J. Wicklander, Wicklander Printing Corporation, for his counseling during the printing bid process. Lyn Delliquadri, Executive Director of Graphic Design and Communication Services and Amanda Freymann, Associate Director of Publications at The Art Institute of Chicago, graciously shared their expertise at several stages in the production of this catalogue. Joan G. Wagner, author of *A History of the Art Collection of the Union League Club of Chicago*, provided important information about the history of the collection. Club member Joel S. Dryer, director of the Illinois Historical Art Project, supplied primary source material about several artists in the collection.

The Club gratefully acknowledges the superb contributions of Neil Harris, who wrote the introductory essay; Dean A. Porter, who wrote the entries on Victor Higgins and Walter Ufer; and Eden J. Pearlman, who wrote the entry on Fritzi Brod. Wendy Greenhouse, author of sixty-one entries, was tireless in her dedication to the project. The catalogue would not exist without her outstanding entries and invaluable advice in matters both scholarly and practical. The manuscript became a cohesive text through Claudia Lamm Wood's excellent and judicious editing, while the reliably high quality of Michael Tropea's photography has done justice to the collection. Sam Silvio, of Silvio Design, Inc., created a beautiful graphic design that reflects the spirit of the Union League Club.

Research about artists and works in the Club's collection was greatly aided by the help of many people, including Margaret Andera, Assistant Curator, Milwaukee Art Museum; Rebecca B. Bedell, Assistant Professor, Wellesley College; Bryan Blank, Oak Park Public Library; Ralph H. Bower, Goshen, Ind.; Powell Bridges; James R. Dabbert; Paula Ellis, Milton and Estelle Horn Fine Arts Trust; Barton Faist; Sharon Flaim, Nettie J. McKinnon Art Collection, Ogden School, La Grange, Ill.; Janine Fron, (art)[n], Chicago; William H. Gerdts, Professor Emeritus, City University of New York; Michael Glenn, Springfield-Greene County Public Library; Angela Harrison, Lepore Fine Arts; Michael Hasenclever, Galerie Michael Hasenclever, Munich; Maggie Kruesi, Manuscripts Cataloguer, Philadelphia Art Alliance; Rebecca Johnson Malvin, Special Collections Librarian, University of Delaware Library; Thomas McCormick, Thomas McCormick Gallery, Chicago; David Meschutt; Maureen Murphy, Maureen Murphy Fine Art, Santa Barbara, Calif.; Lisa N. Peters, Spanierman Gallery, New York; Jan and Eva Rocek;

Bart Ryckbosch, Archivist, Ryerson and Burnham Libraries, The Art Institute of Chicago; John Sabraw, Department of Art, Ohio University, Athens, Oh.; Ellen Sandor, (art)n, Chicago; Daniel Schulman, Associate Curator, Department of Twentieth Century and Contemporary Art, The Art Institute of Chicago; the staff of the Albright-Knox Art Gallery, Buffalo, N.Y.; the staff of the Chicago Historical Society library; the staff of the Ryerson and Burnham Libraries, The Art Institute of Chicago; Patricia Trenton, former Curator, Los Angeles Athletic Club; Andrew Walker, Senior Curator, Missouri Historical Society, Saint Louis; Susan Weininger, Professor of Art History, Roosevelt University, Chicago; Thomas M. Whitehead, Special Collections, Temple University Libraries.

The completion of this book would not have been possible without the staff of the Union League Club. Jonathan F. McCabe, General Manager, was enthusiastic and supportive of the catalogue at all stages of production. Elyse L. Klein, paintings conservator, shared her extensive knowledge of artists' materials and techniques and of the condition of works on many occasions. Kristin U. Fedders, former assistant curator, and Carrie Schloss, former curatorial intern, created the checklist that appears in the back section of the catalogue, and Ms. Schloss also verified signatures and measurements and prepared works for photography. April Hann, former curatorial assistant, provided research assistance on the entries and helped with photography of the collection. The Club's engineering department, headed by Keith Poetz, gave essential assistance during the photography phase of catalogue production. Betsy Buckley, Director of Communications, was quick to respond to requests for information and to offer advice about the production of the catalogue. Jane Kenamore helped in verifying information and providing photographs from the Club's archives.

Finally, to the members of the Union League Club of Chicago past and present, thank you. Without your commitment to and interest in the collection, this book would not be possible.

Marianne Richter
Curator

ART AND THE AMERICAN CLUB: CHICAGO'S UNION LEAGUE CLUB AS PATRON

Neil Harris
Preston and Sterling Morton Professor of History,
University of Chicago

The quest to popularize the visual arts, and the institutions set up to promote public interest, have been far more inclusive and diverse than normally acknowledged. Narrators have traditionally focused upon individual collectors, galleries, and art museums, the predominant purchasers and display settings.[1] While these forces have undoubtedly shaped our national art culture, there were other active promoters of the visual arts, including department stores, art fairs, artist organizations, newspapers, business corporations, and social and civic clubs.[2]

The Union League Club of Chicago, as a patron of greater Chicago's art resources, exemplifies this lesser known story. Inextricably linked with the business and art world of Chicago, the Club's efforts constitute a characteristic pattern in American collecting. Yet it stands apart from similar institutions in its early concentration on native art and in the priority it placed upon its art collection. The history of its collecting efforts parallels that of a number of museums, yet its collecting philosophy diverged from major institutions. Thus it became, in the 1960s, a celebrated venue for traditional contemporary art.

The background to America's Union League clubs validates the insight expressed by French philosopher Alexis de Tocqueville some one hundred and seventy years ago, in *Democracy in America.* "Feelings and opinions are recruited, the heart is enlarged, and the human mind is developed only by the reciprocal influence of men upon one another." As soon "as several of the inhabitants of the United States have taken up an opinion or a feeling which they wish to promote," they seek "mutual assistance; and as soon as they have found one another, they combine." This genius for association, Tocqueville argued, constituted one of the safeguards for democracy. In "democratic countries the science of association is the mother of science; the progress of all the rest depends upon the progress it has made."[3]

Born during a moment of national peril while the Civil War raged, the original Union League sought to solidify public sentiment for the Union cause, in part by bringing together like-minded men in local associations and socially isolating those who remained sympathetic to the Confederacy.[4] With the war over, most of the smaller League units disappeared, but in eastern cities, Philadelphia and New York particularly, the Union League thrived and came to stand for the interests of the Republican party. In both those cities, the club represented wealth and privilege, and the elaborate clubhouses soon completed became widely recognized symbols of political conservatism and self-serving gentility.

Such clubs, however, could also aid the interest of artists. Political orthodoxy and artistic patronage had long enjoyed an intertwined history. In Europe, church and state patronized artists to glorify the power and status they enjoyed.[5] Some Americans in the early days of the young republic worried that many painters and sculptors would perpetuate these mercenary practices. To a modest extent, by commissioning busts or portraits of club worthies and patriotic heroes, conservative social associations spawned by the Civil War may have fulfilled these fears of improper influence. But association members were hardly thriving propagandists. They found no Titians or Van Dycks to meet their triumphalist aspirations, and the art they purchased was physically inaccessible to most of the public.

Some American clubs patronizing artists bore a considerably more bohemian tinge than the Union League. New York's Century Association, founded in 1847 to promote the interests of literature and the arts, possessed probably the most significant club art collection in America by the 1870s or 1880s.[6] Originally a sketch club for artists, the club included local painters, poets, writers, intellectually minded businessmen, and professionals among its members. In the years following the Civil War several similar organizations—the Lotos, the Salmagundi, the Tile, and the short-lived but highly ambitious Arcadian—displayed art owned by their members and happily hosted exhibitions of their latest acquisitions.[7] New York's concentration of artists, writers, galleries, and publishing houses, and the cosmopolitan ambitions associated with its economic and cultural elite, could support several prestigious clubs to represent artist interests and form settings where painters and sculptors might encounter and nurture potential clients.

In its early years, in fact, Chicago club life exhibited little variety or cultural ambition. In the middle of the nineteenth century the city was too new, too small, and too dominated by economic concerns for such development. During this period, however, wealthy urbanites on the East Coast found themselves with the time and inclination to create enclaves for their leisure time.[8] These establishments aped the prestigious London clubs of the eighteenth century and reflected members' continuing desire for status as well as growing revulsion from indiscriminate contact with the diverse society expanding around them. A whole set of luncheon and dining asylums emerged. While New Yorkers, by 1860, could boast of more than a dozen well-established clubs, Chicago could barely claim two or three. The dramatic population growth during the middle third of the nineteenth century produced a series of club foundings here as well.

The rich in Chicago were hardly immune from the needs and motives of their counterparts in the East, but like so much else in this city. intense civic loyalties and regional affiliations played a large part both in their public deliberations and private actions. Significantly, the first major social club here of any permanence (descended from the earlier Dearborn Club) decided to call itself the Chicago Club. In fairly short order the Chicago Club filled up with the economic and social leadership of the city, and, after getting a clubhouse built for them by one of their members, N. K. Fairbank, came to be one of the more popular lunching spots of the day.[9]

Chicago Club members, however, took little interest in art, unless one counts their purchase of the Art Institute building, on the corner of Michigan and Van Buren. It was vacated in 1893 when the Institute moved across the street to its new building, constructed and financed (in part) to host the many congresses and meetings that were attached to the Columbian Exposition of 1893.

The World's Fair brought businessmen and artists together. In the case of some World's Fair artists they were united in the same person. During 1892 and 1893 the Chicago Club emerged as one of the places to entertain visiting artists; they formed part of a deluge of guests who descended on Chicago clubs during that year. Many of these eminently clubable artists belonged to New York clubs already. In the fair's aftermath, expressions of hospitality to artists continued, such as the creation of Tree Studios by Judge Lambert Tree, who erected his studio building to nurture artistic life in the city. Tree Studios would indeed become a vital artist center in the next century.

The Chicago Club, however, sponsored no exhibitions and purchased no art. But Chicago's second oldest surviving club, the Standard Club, did indeed create an art gallery in its first clubhouse. Although membership in the Standard, as in the Chicago Club, was confined to men, it was far more welcoming to women guests, and the art gallery became a popular gathering place.[10] Information on the exhibitions is sparse, however, and the Standard Club did not appear to pursue any particular art program.

Art enthusiasm was left to Chicago's third oldest surviving club, the Union League, and for reasons that are not absolutely clear. Its early political associations and strong Republican party attachments never entirely deserted the Union League Club in Chicago, but by the time members had settled into their first specially built clubhouse in 1886, social, commercial, and civic interests had created a more tolerant and somewhat more varied set of affiliations.[11] The clubhouse itself became an object to be decorated and adorned, made as appealing and welcoming as possible. Clubhouses were homes away from home, for dining, relaxing, conversation, and friendly competition, as well as settings to entertain visitors and to impress them with the wealth, taste, and good feelings of their hosts. Distinguished strangers were feted at elaborate receptions. Artworks, along with the other decorations, testified to the club's distinction.

Naturally enough, loyal members seeking ways of enhancing their retreat gave the Club works of art. Other clubs also benefited from such generosity, but the Chicago Union League may have been particularly favored because of the pattern set by two sister and more senior clubs, the Union League of Philadelphia, and the Union League Club of New York. The Philadelphia organization, the original Union League, created within itself in 1882 an Art Association, formed to procure "for presentation such objects of art, decoration and adornment as good taste may suggest."[12] By its second year the group contained 359 members. The primary goal, again, was clubhouse enhancement; purchases ranged from clocks, vases, and bronzes, to portraits and European paintings with titles such as *The Barberini Palace*, *If I Were Pope*, and *Charge of the Cuirassiers*.

Such ambitious goals carried high costs. In its first twenty years the association expended at least $40,000 on art objects—more than the Boston Museum of Fine Arts spent on art for its first fifteen years of operation. The Philadelphia collection included a few American works that had special links to patriotic purposes, notably a bronze tablet by Henry Bush-Brown. But the association also sponsored a number of public art exhibitions drawn from the collections of its members, which included both Old Masters and contemporary work. Academic and conservative in its taste, the Philadelphia Union League's Art Association did little to nurture American art in particular. But some Chicago Union League Club members noticed its existence and argued for creation of their own art association.

New York's Union League Club had a more active linkage with practicing artists and a more impressive set of cultural achievements than Philadelphia's club.[13] One of its founding members, the great park designer Frederick Law Olmsted, urged the club to make itself into a center for the arts. While the club did not develop as Olmsted suggested, it did, as early as the 1870s, feature "artistic memberships." Members could pay for their dues and admission fees by contributing artworks, principally paintings. Painters like Albert Bierstadt, Jasper Cropsey, and the influential cartoonist Thomas Nast became club members, as did the painter John Kensett and the sculptor John Quincy Adams Ward. The club's art committee also worked on early proposals to create the Metropolitan Museum of Art in 1869, and they helped organize a crucial meeting of several hundred museum supporters in the club's theater. Within a year, the Metropolitan charter was granted and the premier art museum in the country was underway. No subsequent club action would have as much impact upon the arts in America, but the club supported art by commissioning war scenes and portraits and by organizing exhibitions. In the early 1870s the Union League Club began hosting exhibitions that, by the following decade, had become a significant addition to the New York scene. Art committee members over these years included significant painters, collectors, and dealers, such as Eastman Johnson, Thomas B. Clark, and Samuel Avery, and their exhibitions concentrated upon American art, with some concessions to the French academic taste then in vogue. Paintings were not only put on exhibition, they could be sold to interested visitors, the club librarian serving as a go-between. Special loan exhibitions were often built around special subjects or materials—textiles, Japanese art, Chinese art. A series of one-man shows featured contemporary artists such as Charles Rollo Peters, Francis D. Millet, and landscapist C. H. Davis. Some of the artists were so grateful for this opportunity they presented the club with paintings as a gift.

The New York club's active efforts to encourage both the creation and the appreciation of art set an example for Chicago in the 1880s as the Union League Club of Chicago was constructing its clubhouse. Although we still don't know enough about the cultural role of clubs in American cities of this era, cities

Members of the jury of the 1957 Art Show. Seated, left to right: James Murray Haddow, Francis Chapin, Frank H. Young, Constantine Paugialis, Earl C. Gross. Barbara Suster displays canvas.

such as Washington, Pittsburgh, Cincinnati, San Francisco, St. Louis, and Cleveland also contained social groups concerned with collecting and displaying works of art for their memberships. Washington's Cosmos Club, for example, had, in the 1880s, a standing advisory committee on art, helping to arrange for art exhibitions and generally encouraging club art interest. Art exhibits became an annual feature, and by 1890 attendance at these shows reached four thousand. Some years later, the Cosmos Club began appropriating money for the purchase of pictures, and some member artists donated work in lieu of dues.[14] In Boston, the Union Club was renowned for its exhibitions.[15]

Precedents and analogues aside, Chicago's large, newly arrived, and highly motivated business and professional leadership pushed the Union League Club toward a sharper definition of its responsibilities. The Club's formative years in the 1880s and 1890s coincided with the activities creating many of the city's museums, voluntary associations, universities, and libraries. Chicago is still living off that legacy. The local elite embraced the belief that Chicago cultural institutions could become assets in the struggle to burnish the city's reputation, and more than that, could redeem society itself from materialism and spiritual corruption.[16] Some among them were inspired by intellectuals and reformers such as John Ruskin and Charles Eliot Norton, others merely aroused by a general sense of uplift or sentiments of regional loyalty. But whatever the specific motives, cultural philanthropists agreed on the need to spend more time and money on their larger project for civic culture. A cluster of individuals sat on the boards of these fledgling organizations: the Art Institute, the Newberry Library, the Symphony Orchestra, the Opera Festival Association, the John Crerar Library, and the University of Chicago; subscribed to important local ventures such as the Auditorium and the Columbian Exposition of 1893; and joined downtown clubs such as the Union League. These trustees and founders included George Adams, Daniel Burnham, Edward Butler, Ferdinand Peck, Nathaniel K. Fairbank, Marshall Field, Martin A. Ryerson, and Charles L. Hutchinson, all Union League Club members.

As might be expected, membership overlapped a good deal among the clubs. At the turn of the century, half the members of the most prestigious social association in Chicago, the sixty-man Commercial Club, belonged to the Union League, and an even larger number belonged to the Chicago Club.[17] The club networks—extending to other groups like the Standard Club and several women's associations—supported a range of civic and cultural activities, from the city's capture of the Columbian Exposition to the creation of the famous Burnham plan of 1909. The Merchants and the Commercial clubs, which merged in 1907, commissioned and subsidized Burnham's Plan. It might be argued that Daniel Burnham's *Plan of Chicago*, with its celebrated illustrations by Jules Guérin and Jules Janin, its elaborate exhibitions here and

Chicago Artists in the New Millennium exhibition, January 2003

abroad, and its popularization in special textbooks constituted the single most influential art project sustained by any Chicago club in the twentieth century.[18]

Yet within what was clearly a context of activism in this period, the Union League Club's range of involvements stands out for its variety and intensity. Beautification and nurture of local artists could be said to exist within a spectrum of Club crusades that included civil service and ballot reform, anti-corruption and anti-pollution statutes, highway and harbor improvements, a new city charter, and cultivation of patriotic holidays. All of these causes represented versions of good citizenship and were clear demonstrations of local loyalty. For Chicago to achieve greatness, its government as well as its air had to be cleaner than tradition suggested, and it required as well the presence of a lively creative arts community.[19] Art had become a test to measure metropolitan greatness. Without patrons such a status seemed implausible. To achieve the goal, clubs, museums, and arts societies needed to identify and nurture both creators and clients. In this quest, redundancy and duplication mattered less than achieving results.

The redundancy of personnel worked to lessen, not increase, the competition that might occur in multiple efforts. Even though the Union League Club and The Art Institute of Chicago appeared to seek out collections simultaneously, overlapping memberships—Institute Director French, Institute President Hutchinson, and Institute Vice President Martin Ryerson were all Union League members and served on the Art Committee—suggest an absence of competition. Given the weakness of the Art Institute's holdings in the 1880s and 1890s and the challenge of fundraising to buy important artworks, the Union League Club's efforts to create its own collection might have appeared threatening or diversionary. But no evidence of this sentiment exists.

Like most other American collecting institutions of the day, the Union League Club considered Old Masters unaffordable and had little expectation of acquiring them. Instead, the acquisitions would come almost entirely from contemporary artists, European and American, with increasing emphasis upon American painters. Such a commitment to the native school as opposed to European artists differentiated the Union League Club from many other institutions. This commitment became stronger in the 1890s when the Union League Club decided to dedicate a portion of annual dues to art purchases.

These earlier years, the first period of collecting, were stimulated, then, by the motives of clubhouse decorating, patriotism, local obligation, and a search for beautiful things, no matter what their origin or subject. Prints, Civil War scenes, portraits of American presidents and Club officers, local landscapes, and an occasional Monet constituted a heterogeneous medley, but one that, by the turn of the century, actually possessed some pecuniary value and distinguished the Club from other organizations of its kind. This physical legacy pressed itself increasingly on the consciousness of the Club leadership. Its possession entailed certain kinds of responsibilities. At a certain date, the collection itself, rather than collecting as an activity, began to shape policy. In this respect the Union League Club resembled any number of newly established art museums, who were also starting to contend with the obligations of a collection, its conservation, preservation, management, and above all, its proper display.

For much of the late nineteenth and early twentieth centuries, the Union League Club retained many qualities characterizing the first generation of museums. The non-professional pattern of collecting decisions, an active interest in the local art scene, avoidance of extremely expensive purchases, and a welcoming attitude toward almost all gifts typified the early years of many American art museums as they did the Club. Like most art museum collections of its day, the Union League assortment was

eclectic and open to all sorts of donations. The level of taste was conservative, reflecting the inclinations and backgrounds of most of the membership. Over the years various Art Committees acknowledged their need to retain a high comfort level for members, rather than to outrage, shock, shake up, or provoke. Although an early Art Committee member declared that "only works of high merit and permanent value" should enter the collection, others cautioned that paintings should be purchased "with an idea of decoration and not with any notion that we are conducting a museum." Art Committee chair Percy Eckhart declared in 1928, that it "will not attempt to convert the clubhouse into an art museum nor into a store house for inartistic junk Its walls should display contemporary American paintings created during the lifetime of the Club by American artists, preferably Chicago or Mid-Western."[20] A twentieth-century commentator, William B. Mundie, noted that Club members preferred story-telling pictures, even though they may "not possess lasting merit. An Art Committee, in any club with Art pretensions, must watch its step and with breadth of view, exercise a catholicity of choice."[21]

Successive Art Committees struggled with the awareness that they were, at least potentially, capable of exerting great influence on the aesthetic judgment and knowledgeability of Club members. This sense of responsibility for broadening horizons and encouraging exploration runs through many of the Union League Club's art activities, although it was always held in check by a healthy realism about what could be tolerated by the typical member. Interest in the visual arts, outside of a small group of collectors and connoisseurs, was hardly a well-entrenched masculine pursuit in Gilded Age America. Most Club members were hard-working businessmen and professionals with little artistic experience. As normally presented, the male realm had abandoned the arts to its womenfolk.[22] "In our leisure-time efforts to improve ourselves, the female bird has worn the brighter plumage and sung the louder song," one observer commented more than sixty years ago.[23] In this sense, as in others, Club life offered a useful correction to the doctrine of "separate spheres" once favored by many historians.

By the early twentieth century, after a couple of decades of serious effort, the character and fate of the Club's collection had begun to weigh on the minds of its officers. The first catalogue of the holdings was prepared in 1899, and a second in 1907; some found them to be almost revelatory. Dominated by American paintings, a substantial portion done by Chicagoans, the collection included artists who were officially recognized members or associates of America's most prestigious art organization, the National Academy of Design in New York. Some saw the collection as an excellent investment, worth admiring on financial grounds alone. From time to time official documents tried to express the value of the paintings in dollar terms, not necessarily to divert attention from their aesthetic significance but presumably to reassure skeptics that art had an economic dimension worth respecting. Art as a sound financial as well as spiritual investment became a theme in a number of Union League pronouncements during the twentieth century, particularly when the Club became more involved with auction sales of contemporary

art. In 1909 the Art Committee Report observed that while Club purchases had been made "from the point of view of good art, it is well to know that many of the works owned by the Club are worth much more than when they were bought."[24] The following year the Art Committee, noting that the value of the collection had increased some $24,000 since the previous assessment, with a couple of canvasses quadrupling in value, justified the costs of "continual supervision and care" to insure that "their worth in the picture market may not be impaired by neglect of repairs."[25]

Maintenance, rather than expansion, would become the focus for some decades to come. After a series of purchases during the early twentieth century, some of them among the chief glories of the art collection, quieter years followed. Between about 1910 and 1950, the Union League Club failed to sustain the active, aggressive interest it had taken in representing contemporary American art on the walls of its clubhouse, although collecting continued. During this stretch of time the Club bought a number of paintings of considerable importance, work by Taos School artists Walter Ufer and Victor Higgins, an Edwin Blashfield mural commissioned especially for the new clubhouse that opened in 1926, and Thomas Hill's *Yosemite Valley*.[26] It also sold some items to individuals and sponsored, in 1928 and 1929, prize competitions among Chicago artists under the age of thirty. And in 1922 it allowed the Committee on Art and the Committee on Entertainment to host an artists' dinner and reception, "presenting to our members as guests, leading artists of our city," along with an exhibition of their works. "It brought to your committee a real thrill of pleasing surprise to find that our members were eager for truth and beauty in Art," commented the chairman, William B. Mundie.[27] But the principle of expending or annually accumulating a percentage of membership dues to be spent on the creation of a comprehensive collection no longer ruled.

Why the hiatus? The Art Committees of this period were headed, successively, by three serious, knowledgeable, and devoted figures: architect William B. Mundie, lawyer Percy B. Eckhart (a trustee of The Art Institute of Chicago and its principal legal adviser), and businessman (and art collector) Paul Schulze. Their tenure brought remarkable continuity to committee deliberations. But these were years marked by heavy Club building expenditures, as well as by war and economic crisis (two world wars and the Great Depression filled almost half the period). Finally, as Joan Wagner points out in her invaluable and very detailed account of the collection's formation, these were years of unprecedented rupture in the production of art.[28] The growth of modernism proved bitterly controversial to just about every institution involved with art sales, display, promotion, or education. In effect the American art world split into two parts during the teens, twenties, and thirties, one sector determinedly hostile to nonrepresentational art, the other championing the energetic succession of new movements as true to the spirit of the age.[29]

The 1957 Art Show

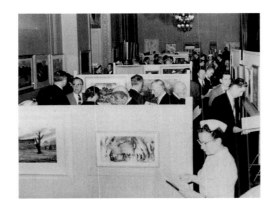

Magazines and newspapers kept scorecards of exhibition winners to chart the gains and losses of both sides, and groups of insurgents worked to contain damage or trumpet successes. In this war the sentiments of most Union League Club members clearly lay on the conservative side of the ledger. The bifurcation thrust anyone interested in contemporary art into a position of partisanship and invited labels of opprobrium. What had been, then, a relatively noncontroversial sphere before World War I—purchasing and displaying art objects—was now laden with cultural and even political overtones. This charged atmosphere may well have played a part in the Union League Club's withdrawal from active collecting during the period.

But the inaction may also have reflected changes within the Club and within Chicago, among them the Club's growing interest in social problems; it established a foundation for the Boys' Clubs in 1919. More than that, various local cultural institutions demonstrated vigorous support for contemporary artists.[30] First among them, The Art Institute of Chicago offered two shows every year to area artists and an expanding number of prestigious prizes. The Union League Club did, in these years, occasionally purchase prize-winning paintings from Art Institute exhibitions and elsewhere, but artists could choose from numerous other client and exhibition venues. The Arts Club of Chicago and the Renaissance Society, both products of the teens, provided exhibition opportunities for avant-garde artists, although most of these exhibitors came from outside Chicago and the Midwest.[31] Department stores such as Rothschild's, Carson Pirie Scott, and Marshall Field's hosted still other shows. Rothschild's, for example, exhibited a group of artists excluded by the jury from the Art Institute's American Show, while Marshall Field's featured six successive annual displays put on by the No-Jury Society, one of several organizations formed to protest the system in play at the Art Institute.[32] During the 1920s the Business Men's Art Club and the Chicago Galleries Association were also established, as well as several conservative groups including the Association of Chicago Painters and Sculptors and the South Side Art Association.

Under these circumstances the Union League Club became only one of many sites for promoting local artists, and only one of several clients for their work. The internalist emphasis of the Club during this period—recataloging its own collection, spending money on restoring and conserving individual works of art, and promoting its art in Club publications—was complemented by one important effort during the 1930s, which would lead ultimately to a significant addition. Starting in 1936, the Union League Club displayed the more than forty paintings owned by the Municipal Art League, an organization formed in 1897 to encourage local artists. In 1936, while its president, Paul Schulze, was also chairing the Club Art Committee, the League loaned its group of paintings to the Union League Club, which, through its foundation, would purchase them in 1953. The artists represented included many local notables: Pauline Palmer, Frank Dudley, Louis Betts, Oskar Gross, Walter Ufer, and Victor Higgins among them. With the sale, the Municipal Art League created a special trust fund for meritorious local art.

But these significant efforts aside, the Art Committee was fairly inactive and met only sporadically. Other interests crowded art pursuits off stage. What changed around 1949 or 1950? Certainly different Art Committee leadership helped, but more than that, during the 1950s and 1960s, Chicago's interest in the local art scene intensified, reflecting a nationwide preoccupation with cultural activity. The causes of the change are multiple: a period of extended prosperity, which encouraged discretionary expenditures; the Cold War competition with the Soviet Union, which focused attention on the spiritual and aesthetic strengths of American civilization, along with its material and military power; and a growing community of practicing artists, dealers, and galleries. In the 1960s systematic, institutional recognition of changing

priorities would come with the two national endowments and with increased levels of support given to museums, universities, the arts, and the humanities by individuals, business corporations, and foundations.[33] Art education and art appreciation gained emphasis as part of efforts to assert a new form of cultural citizenship. And while modernism seemed to have gained the upper hand, traditionalists sought their own participation.

The increased tempo of Union League Club art efforts surely owes something to this broader mood. In 1955, the Club stepped up its efforts in beginning a string of biennial exhibitions open to area artists. Sponsored jointly by the Art Committee and the Club's foundation, the exhibitions reflected discontent with Art Institute taste in contemporary art. Speaking to Club members in 1951, Director Daniel Catton Rich sought to defend Art Institute practices, insisting that art controversies were better than relegating the subject "to a little column back with the household hints and next to advice to the lovelorn." "Do you want us to keep the public uncontaminated and protected from knowing what is going on? Does Chicago want a vital, growing Art Institute or just a graceful cemetery?"[34] The response of members to these questions is unclear, but by 1955 their own biennial exhibitions had begun, sporting a set of purchase prizes that grew steadily from the $3250 initially allotted. Thirty years later prize winners competed for $18,000 in awards. More than 750 artists submitted work to the first jury, which selected approximately 10 percent of the submissions for inclusion in the show. A few years later fifteen hundred entries were considered. For conservative artists the Club exhibition quickly acquired the status of a major event. "Many artists who belong to the realistic school feel that this show is their only opportunity for recognition," *Men and Events* reported to the membership in March 1965.[35] Well-known artists, critics, and curators served as judges. In the 1950s and 1960s, they included Ivan Albright, Aaron Bohrod, and Earl Gross.

These exhibitions did not represent the diversity of the larger art world, nor reflect the rapid succession of styles and approaches of cutting edge art practices. Local critics peppered their newspaper columns with critical observations on the narrowness of vision they found in the jury selections. Edward Barry, the art critic for the *Chicago Tribune*, minced few words. "The Union League Club's biennial art shows go their own serene way," he noted in 1965, "entirely unconcerned with vogues and rages of the day." The show offered "something for everybody," so long as everybody was no "historian bent on assessing the art trends of the mid-1960s."[36] Two years later Harold Haydon, writing for the *Sun-Times*, concluded that "good paintings are outnumbered by indifferent and poor ones." Acknowledging the "splendid gesture" made by the Club, and the enormous amount of labor poured into the show, Haydon felt the "results do not equal the intention."[37]

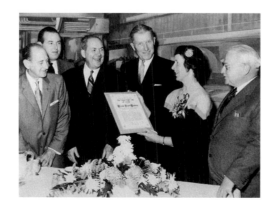

Eleanor Jewett, long-time Chicago Tribune *art critic, receiving testimonial plaque from the Union League Club's Art Committee, 1956*

Certainly the Club shows omitted significant contemporary art movements, such as Pop and Op art, and projected a nostalgic emphasis upon landscapes of fading memory and decline. But for better or worse, they more faithfully mirrored popular tastes and conceptions of art than did rival Art Institute exhibitions. And the shows nurtured the stubbornly held conviction that the Club's long-standing art interests needed expression. The social events linked to the exhibitions, from dinner dances to luncheons to artist receptions, and the publicity received, further emphasized the special relationship between the Club and the larger art community. With the impetus of these exhibitions, the Club sought professional management and conservation of the growing collection, now strengthened by active and clearly expressed acquisition and deaccessioning policies.

Special exhibitions, competitions, auctions, lectures, museum tours, prizes, scholarships, interpretive essays in Club publications, artists in residence, debates about art trends, organized visits to art centers elsewhere, conservation programs, catalogues, curatorial appointments—these activities of the Union League Club suggest without exhausting the range of art-centered activities that rested, ultimately, on the physical existence of the collection itself. In the end those hundreds of artworks received, purchased, displayed, and conserved for more than a century have reminded members and visitors of the Union League Club's special legacy. A once casual and even haphazard medley has emerged as a force that shapes decision making, an instrument of institutional identity, and an opportunity to debate the direction of American art and culture. Possession and policy have become inextricably entwined, and thus aided the Union League Club's quest to become a site for sharpening awareness of the visual arts.

Left to right: J. Dillon Hoey,
Kerry James Marshall, Philip J. Wicklander,
Ruth Duckworth, ULC Distinguished Artists
Ed Paschke and Richard Hunt, and Robert
"Jay" Pierce at the 2003 Beaux-Arts Celebration
honoring Marshall and Duckworth
as the newest Distinguished Artist members.
Photograph ©Jennifer Bisbing

ULC Distinguished Artists Vera Klement and
Don Baum, 2001 Beaux-Arts Celebration.

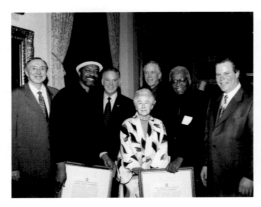

Notes

1 There is a large literature in print on this subject. For some introductory issues see W. G. Constable, *Art Collecting in the United States of America: An Outline of a History* (Toronto and New York: T. Nelson, 1964); Neil Harris, *The Artist in American Society: The Formative Years, 1790–1860* (New York: Braziller, 1966); Lillian B. Miller, *Patrons and Patriotism: The Encouragement of the Fine Arts in the United States, 1790–1860* (Chicago: University of Chicago Press, 1966); and Aline B. Saarinen, *The Proud Possessors: The Lives, Times and Tastes of Some Adventurous American Art Collectors* (New York: Random House, 1958).

2 A number of works have in fact explored these settings. See, for example, James Sloan Allen, *The Romance of Commerce and Culture: Capitalism, Modernism, and the Chicago-Aspen Crusade for Cultural Reform* (Chicago: University of Chicago Press, 1983); and Neil Harris, "Designs on Demand: Art and the Modern Corporation," in *Cultural Excursions: Marketing Appetites and Cultural Tastes in Modern America*, (Chicago: University of Chicago Press, 1990), 349–78.

3 These much quoted comments by Tocqueville appear in the second book of the second volume, chapter 4, of *Democracy in America*. See, for example, Alexis de Tocqueville, *Democracy in America* (New York: Alfred A. Knopf, 1945, 1972; Everyman's Library, 1994) 2:106–10.

4 The activities of the Union League during the Civil War are treated in Guy James Gibson, "Lincoln's League: The Union League Movement during the Civil War," a Ph.D. dissertation awarded by the University of Illinois, Urbana, and available from Ann Arbor Microfilms (1958). The conservative implications of the Union League movement were explored in George M. Fredrickson, *The Inner Civil War: Northern Intellectuals and the Crisis of the Union* (New York: Harper & Row, 1965).

5 These issues are explored in Harris, *The Artist in American Society*, chap. 2.

6 See Allan Nevins et al., *The Century, 1847–1946* (New York: Century Association, 1947), for more on this club's early history.

7 Francis Gerry Fairfield, *The Clubs of New York* (New York: Hinton, 1873), offers a fascinating commentary on clubs of this period, and is especially useful for the short-lived Arcadian, though it has descriptions of a dozen other clubs, including the Lotos. For a more recent study of one of these clubs see Ronald G. Pisano, Mary Ann Apicella, and Linda Henefield Skalet, *The Tile Club and the Aesthetic Movement in America* (New York: Abrams, 1999).

8 For general comments on the evolution of American club life see the opening pages of James H. Mayo, *The American Country Club: Its Origins and Development* (New Brunswick, N.J.: Rutgers University Press, 1999).

9 For the early history of the Chicago Club see Edward T. Blair, *A History of the Chicago Club* (Chicago, 1898). Blair argued that the slow emergence of Chicago clubs was caused also by the "rigid moralism and Puritanism" of Chicago's "best society." Few of the club's founding members had ever belonged to a club before.

10 This is briefly described in George D. Bushnell, "Chicago's Leading Men's Clubs," *Chicago History* 40 (Summer 1982): 79–88.

11 The most readable survey of the Club's history is Bruce Grant *Fight for a City: The Story of the Union League Club of Chicago and Its Times, 1880–1955* (Chicago: Rand McNally, 1955). See also the internal history presented by the Club to its members on the occasion of the dedication of its new clubhouse, *The Spirit of the Union League Club 1879–1926* (Chicago: Union League Club, 1926).

12 The club's art activities are recounted in Maxwell Whiteman, *Gentlemen in Crisis: The First Century of the Union League of Philadelphia, 1862–1962* (Philadelphia: Union League, 1975). See also *Chronicle of the Union League of Philadelphia, 1862–1902* (Philadelphia: Union League, 1902), for further details.

13 This summary of club activities is taken from Will Irwin, Earl Chapin May, and Joseph Hotchkiss, *A History of the Union League Club of New York City* (New York: Dodd, Mead, 1952).

14 See Wilcomb E. Washburn, *The Cosmos Club of Washington: A Centennial History, 1870–1970* (Washington, D. C. Cosmos Club, 1970), *passim*.

15 See Alexander W. Williams, *A Social History of the Greater Boston Clubs* (n.p.: Barre, 1978), 19.

16 The best summary for this period of activism is Helen Lefkowitz Horowitz, *Culture & the City: Cultural Philanthropy in Chicago from the 1880s to 1917* (Lexington, Ky.: University of Kentucky Press 1976).

17 These figures were arrived at by examining *The Chicago Blue Book of Selected Names of Chicago and Suburban Towns* (Chicago: Chicago Directory Company, various years).

18 The literature on the Burnham Plan is quite extensive, but for the role of the Commercial Club see Neil Harris, *The Planning of the Plan* (Chicago: Commercial Club of Chicago, 1977).

19 For other efforts at cultivating the arts, locally and regionally, see Sarah J. Moore, "On the Frontier of Culture," *Chicago History*, n. s., 16 (Summer 1987): 5–13, for an account of the Central Art Association; and Stefan Germer, "Pictures at an Exhibition," *Chicago History* n. s., 16 (Spring 1987): 5–21, for the role of the Interstate Industrial Expositions.

20 "Club Art Committee Announces Its Plans," *Union League Club Bulletin*, July 1928, 3.

21 William B. Mundie, "Art in the Union League Club," *The Spirit of the Union League Club, 1879–1926* (Chicago: Union League Club, 1926), 115.

22 For the role of women and women's clubs in visual arts culture see Karen J. Blair, *The Torchbearers: Women and their Amateur Arts Associates in America, 1890–1930* (Bloomington, Ind.: University of Indiana Press, 1994).

23 This was Frank Ernest Hill, *Man-Made Culture: The Educational Activities of Men's Clubs* (New York: American Association for Adult Education, 1938), 65. Hill surveys men's clubs and their activities, spending a good deal of time on the Chicago Business Men's Art Club, one of almost a dozen such associations scattered across the country.

24 J. S. Dickerson, Chairman, Frank G. Logan, and William B. Mundie, "Art Committee 1909," *Union League Club of Chicago Annual Report* (Chicago: Union League Club, 1909), 33.

25 J. S. Dickerson, Chairman, Frank G. Logan, and William B. Mundie, "Art Committee 1910," *Union League Club of Chicago Annual Report* (Chicago: Union League Club, 1910), 33.

26 For more on connections between the Union League Club and Taos School artists see Dean A. Porter, Teresa Hayes Ebie, and Suzan Campbell, *Taos Artists and Their Patrons 1898–1950* (South Bend, Ind.: Snite Museum of Art, University of Notre Dame, 1999), *passim*.

27 William Bryce Mundie, "The Report of the Art Committee for 1921–22," *Union League Club of Chicago Annual Report* (Chicago: Union League Club, 1922).

28 Joan G. Wagner, *A History of the Art Collection of the Union League Club of Chicago* (Chicago: Union League Club, 2000). I am indebted to this meticulous reconstruction of the Club's collecting.

29 For more on this see George H. Roeder, *Forum of Uncertainty: Confrontation with Modern Painting in Twentieth-Century American Thought* (Ann Arbor, Mich.: UMI Research Press, 1980).

30 This pattern existed elsewhere also. Wilcomb Washburn notes that while the
 Cosmos Club's promotion of art in Washington became known nationally, "with the
 development of the National Gallery of Art (now the National Collection of Fine Arts),
 the public art exhibits were discontinued." Washburn, *The Cosmos Club*. The National
 Collection of Fine Arts has been renamed the Smithsonian American Art Museum
 since Washburn wrote.

31 For the Arts Club see Sophia Shaw, ed., *The Arts Club of Chicago: The Collection
 1916–1996* (Chicago: Arts Club of Chicago, 1997); for the Renaissance Society, Joseph
 Scanlan, ed., *A History of the Renaissance Society: The First Seventy-Five Years* (Chicago:
 Renaissance Society at the University of Chicago, 1993).

32 For more on this see Paul Kruty, "Declarations of Independents: Chicago's
 Alternative Art Groups of the 1920s," in *The Old Guard and the Avant-Garde:
 Modernism in Chicago, 1910–1940*, ed. Sue Ann Prince (Chicago: University of Chicago
 Press, 1990), 77–93.

33 For more on all of this, see, among others, Margaret Lynne Ausfield and Virginia M.
 Mecklenburg, *Advancing American Art: Politics and Aesthetics in the State Department
 Exhibition* (Montgomery, Ala.: Montgomery Museum of Art, 1984), 335–64; Serge
 Guilbaut, *How New York Stole the Idea of Modern Art: Abstract Expressionism and the Cold
 War* (Chicago: University of Chicago Press, 1983); Neil Harris, "Designs on Demand:
 Art and the Modern Corporation," *Art, Design and the Modern Corporation*
 (Washington, D.C.: Smithsonian Institution Press, 1985); Richard Pells, *Not Like Us:
 How Europeans Have Loved, Hated, and Transformed American Culture since World War II*
 (New York: Basic Books, 1997); Karal Ann Marling, *As Seen on TV: The Visual Culture of
 Everyday Life in the 1950s* (Cambridge, Mass.: Harvard University Press, 1994); and
 Jane Matthews, "Art and Politics in Cold War America," *American Historical Review* 81
 (October 1976): 762–87.

34 Daniel Catton Rich, "Chicago and Modern Art," *Men and Events*
 28 (December 1951): 12, 24.

35 *Men and Events*, 41 (March 1965): 9.

36 As quoted in *Men and Events*, 41 (March 1965): 12.

37 As quoted by Edward M. Martin, "Echoes of the Art Show," *Men and Events*, 43
 (May 1967): 26.

ESSAYS ON
WORKS IN
THE COLLECTION

ADAM EMORY ALBRIGHT
(1862–1957)

Log in the River (Boy on a Log), ca. 1908

Adam Emory Albright's images of barefoot country children were very popular during the first three decades of the twentieth century. Albright was hailed for capturing "the American boy's distinction, transferring it with consummate skill to his canvases."[1] *Log in the River* exemplifies his treatment of this subject matter. Exhibited at The Art Institute of Chicago's "Twenty-first Annual Exhibition of American Paintings & Sculpture" in October 1908, it was probably painted during Albright's first and only summer in Brown County, Indiana. From 1899, when Albright first turned to depictions of country children, until his death in 1957, the artist created hundreds of paintings on this theme. He used his sons and other local children as models, supplementing sessions by taking photographs of them posing. *Log in the River* is probably based on a photograph of one of the artist's twin sons, Ivan or Malvin.[2]

Albright preferred painting out of doors, directly from nature. Concerned about reflections, he wore plain black clothing and lined his canvases temporarily with opaque fabric to keep the sun from shining through. Albright used a limited palette of cobalt blue, rose-madder, and chrome yellow, mixing the three to achieve desired shades. The figure of the boy in *Log in the River* is painted in the artist's characteristic broad strokes. Little detail is given, particularly in the facial area. The background is likewise painted in a free manner, giving only a suggestion of the trees on the far river bank and the reflections in the water.

Born in Monroe, Wisconsin, in 1862, Albright grew up in poverty on farms in Iowa. In contrast to the idyllic life of his paintings, by the time he was twelve, he worked as a laborer and as a cowherd, and he was frequently forced to miss school. Albright, who had wanted to be an artist from an early age, left home at eighteen to pursue his chosen career. In 1882, he enrolled at the Chicago Academy of Fine Arts, which was renamed The Art Institute of Chicago in his second year. He subsequently studied at the Pennsylvania Academy of the Fine Arts in Philadelphia for three years and in Paris and Munich for two years.[3] Albright lived in the Chicago area throughout his professional career, and his home was the destination of many visitors who enjoyed his practice of keeping an open studio. He took extended painting trips to diverse places such as Brown County, the Alleghenies, Colorado, Venezuela, Wales, and California.

Albright received numerous one-person exhibitions at The Art Institute of Chicago and at other institutions such as the St. Louis Art Museum, the Detroit Institute of Art, the Boston Museum of Fine Arts, and the Cincinnati Art Museum. He was an active member of the Chicago artists' community, belonging to many local art organizations and serving as president of two, the Chicago Society of Artists and the Chicago Water Color Club. With the advent of modernism in Chicago in the 1920s, Albright's work, which did not change significantly in style, received less critical attention. He was an outspoken opponent of then-contemporary art styles, stating once about modern art, "They give you boiled squash with a mule's foot on it and call that art."[4] He died on September 13, 1957 in his home in Warrenville, Illinois. MR

Oil on canvas; 48 x 36 inches
(121.92 x 91.44 cm.)
Signed lower left: Copyright
by/Adam Emory Albright
UL1976.1

Provenance:
MAL, 1916–1951; UL C&AF,
1951–1975; ULC, 1976

Exhibitions:
AIC American Art Annual, 1908, #1

Illinois Building, Panama-Pacific
International Exposition, San Francisco,
1915, #3

"Indiana Influences," Fort Wayne
Museum of Art, Fort Wayne, Ind., 1984

"Painters and Sculptors in Illinois:
1820–1945," traveling exhibition organized
by the Illinois Arts Council, 1971–72

"American Art in the Union League
Club of Chicago, A Centennial
Exhibition," traveling exhibition
organized by the ULC, 1980–81

References:
Gerdts. *Art Across America*. Vol. 2,
page 301.

*Illinois at the Panama-Pacific International
Exposition*. Exh. cat. Chicago: Campbell,
1915. Pages 48, 66.

Loy and Honig. *One Hundred Years*.
Pages 52–53.

Sparks. *American Art in the ULC*.
Page 6.

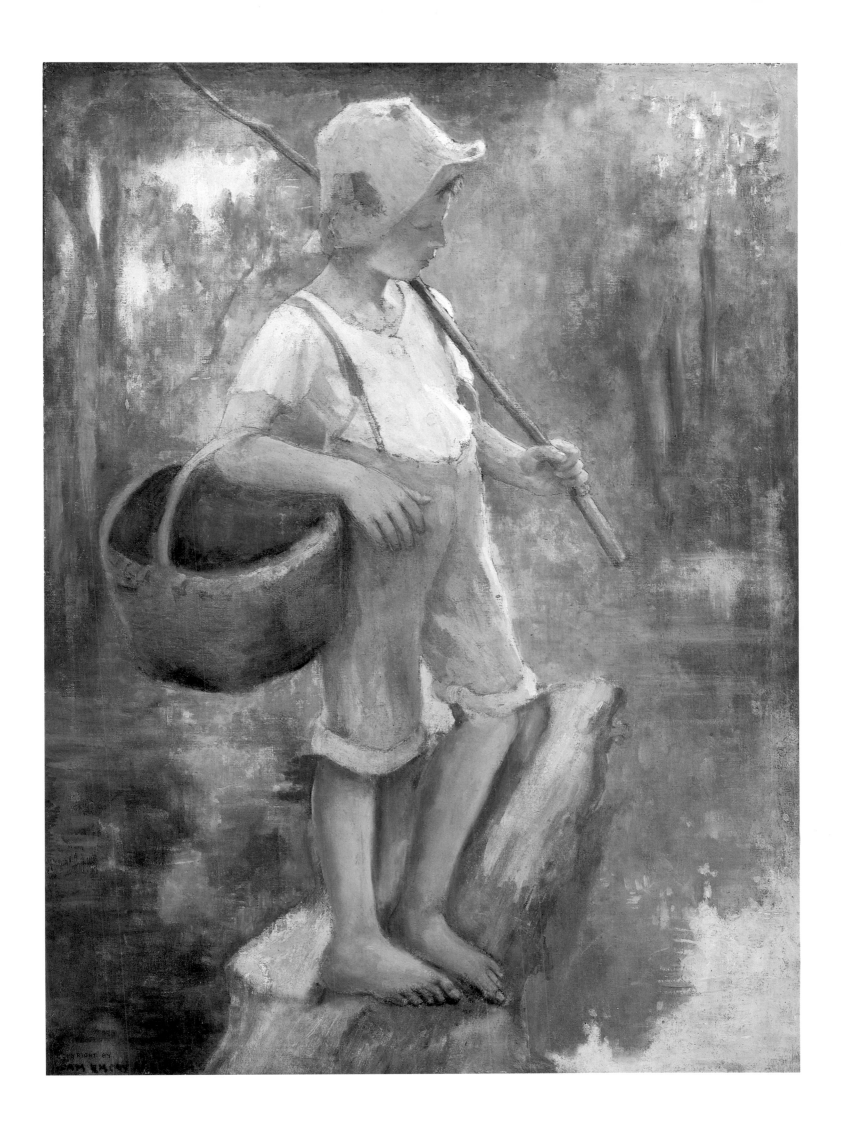

25 **Adam Emory Albright** *Log in the River (Boy on a Log)*, ca. 1908

IVAN LE LORRAINE ALBRIGHT
(1897–1983)

Knees of Cypress (Reflections of a Cypress Swamp), 1965

Ivan Albright was one of three sons born to Adam Emory Albright, a successful Chicago painter who specialized in depictions of barefoot children. Ivan and his brother Malvin, who were identical twins, received their first drawing instruction from their father at age eight. Albright studied briefly at Northwestern University and the University of Illinois at Urbana. During World War I, he was assigned to the American Expeditionary Forces Corps Base Hospital in Nantes, France, where he served as a medical artist, drawing surgical procedures and wounds. Upon his return to America, Albright studied painting at the School of the Art Institute of Chicago, graduating in 1923, and he also attended the Pennsylvania Academy of the Fine Arts and the National Academy of Design. A realist, Albright's images typically featured exaggerated forms and minute detail. In contrast to his father, who had been commercially very successful, Ivan Albright was never very interested in selling his paintings and consequently priced them very high. In 1946, Albright married Josephine Medill Patterson Reeve, the daughter of Captain Joseph Medill, the founder, editor, and publisher of the *New York News* and major stockholder of the *Chicago Tribune*. They made Chicago their base of operations until 1963, when they moved to Woodstock, Vermont, after Albright's Chicago studio was torn down to make way for a shopping mall. During the 1970s, Albright was plagued with eye problems, which were eventually resolved by a corneal transplant in his right eye. Albright continued to paint until his death in 1983.[1]

Albright, who is best known for his depictions of people and objects, occasionally painted landscapes. In the 1940s, he began spending time at the plantation home of his sister-in-law, Alicia Guggenheim, located on the Saint Mary's River in southern Georgia. Beginning with a painting created in 1948, Albright made at least six works featuring the Georgia swamp.[2] He painted *Knees of Cypress* in March and April 1965. The artist used a sketchbook as an aid; he stated in an interview that he used these books to create a master plan for each painting.[3] In the sketchbook for *Knees of Cypress*, which is also in the Union League Club's collection, Albright made careful notation of the specific times of day that the shadows were best for both the trees and the cypress "knees" (cypress roots that protrude above the earth), deciding that the hour between two and three was optimal. Albright also stated his intention to paint some of the trees and knees upside down. In this way, the tree would appear to be the mirror image, and its reflection would appear to be the actual tree. As with all of his work, Albright did not paint the scene from one point of view, but instead changed his vantage point continuously to create a feeling of movement. He wrote in the sketchbook that he wished to create a painting that would show "movement and hysteria to the knees." Albright was particularly interested in cypress trees because over time their soft wood became twisted from storms and wind; yet, paradoxically, the wood's flexibility made it tough and well-suited to the climatic conditions.

The concerns of movement and multiple vantage points seen in *Knees of Cypress* were characteristic of Albright's work. He stated, "I concentrate particularly on creating compositions that are dynamic, moving, at war, in conflict. I design with different positions in space rather than merely with related forms. Some objects are falling, others rising, others are spiraling, others moving sideways—in a kind of controlled chaos."[4] MR

Gouache on panel;
16 x 20 inches (40.64 x 50.8 cm.)
Signed lower right: Ivan Albright
UL1991.6.2

Provenance:
Senator William Benton, by 1970–1973;
Charles and Marjorie Benton, 1973–1989;
ULC, 1989

Exhibitions:
"The Benton Collection: Twentieth Century American Painting," Wadsworth Atheneum, Hartford, Conn., 1970, #10

World's Exposition, Encyclopedia Britannica Pavilion, Osaka, Japan, 1970

References:
Croydon, Michael. *Ivan Albright*. New York: Abbeville Press, 1978. Pages 252, 254, 283.

Hyman, Sidney. *The Benton Collection: 20th Century American Painting*. Exh. cat. Hartford, Conn.: Wadsworth Atheneum, 1970. Page 21.

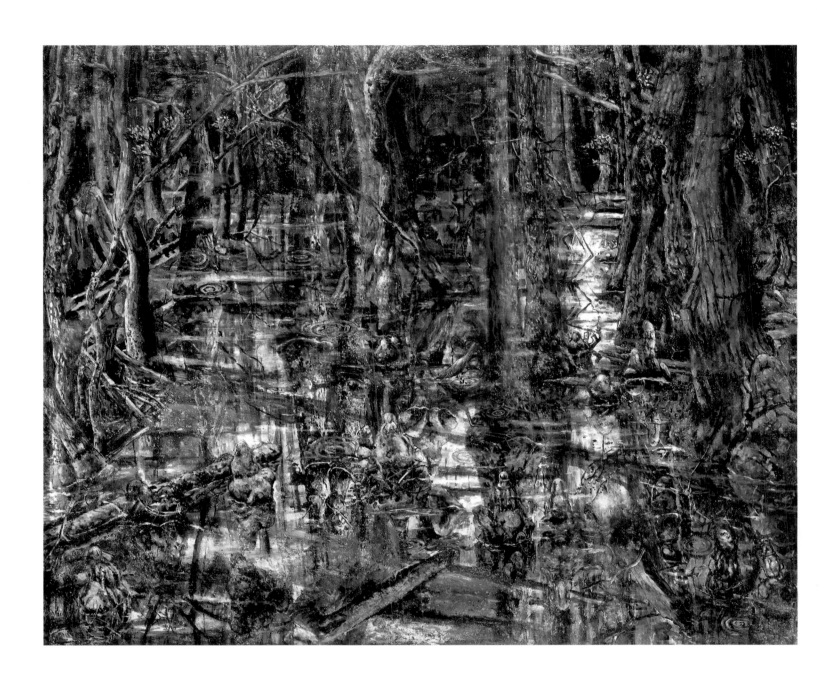

Ivan Le Lorraine Albright *Knees of Cypress (Reflections of a Cypress Swamp)*. 1965

CHARLES DUDLEY ARNOLD
(1844–1927)

*Suite of Photographs of the World's
Columbian Exposition*, 1893

Photographer Charles Dudley Arnold is best known for his photographic images of the World's Columbian Exposition.[1] Born in Canada, Arnold came to the United States at the age of twenty and settled in Buffalo, New York. In the 1880s he began to produce elegant architectural sample books, beginning with *Studies in Architecture at Home and Abroad* (1881). By 1888 Arnold had established a second studio, in New York City, but he lived in Chicago for more than three years to photograph the progress of the great fair.

The World's Columbian Exposition, a monumental celebration of western technological progress and a triumph of the classical tradition in architecture and design, opened in Chicago's Jackson Park in May of 1893. From the first, its planners consciously controlled the publicity of the fair. They chose Arnold and his partner, Harlow D. Higinbotham, son of the president of the fair's board of directors, to create its "official" image in photographs. Arnold's firm, which had documented the progress of the fair's construction, was granted an exclusive right to commercial photography on the grounds of the exposition.[2] This monopoly allowed Arnold and Higinbotham to charge comparatively high prices for their images, beginning with thirty cents for an eight-by-ten-inch picture. The firm had the franchise to supply magazines, newspapers, and guidebooks with photographic images of the fair; it filled orders for businesses with displays on the fairgrounds; and it photographed twenty thousand fair employees for their security badges. At the time, new technology was making photography accessible to average consumers, but Arnold insisted on restrictions and stiff fees to discourage amateurs as well as rival professionals from taking pictures of the wonders and beauties of the great exposition, despite vigorous protest. Arnold's control over photography at the fair was so autocratic that, in the fall of 1893, when he refused to produce a final set of negatives of his work for the fair's board, Daniel Burnham commissioned the distinguished landscape photographer William Henry Jackson to create one hundred views of the fair for an official history.

Arnold produced over one thousand photographs of the World's Columbian Exposition. He used mammoth cameras as large as twenty by forty inches and an assortment of landscape, architectural, and "super-fast" lenses. The expensive platinum print process preferred by Arnold yielded a subtle range of highlight values and elevated his photographs to the status of artworks.[3] Carefully framed and balanced compositionally, they document individual buildings and displays as well as the broad vistas and grand spaces afforded by the ambitious layout of the fair, where massive, dignified structures were set within orderly parklands. In the images people are relatively insignificant: overwhelmed by the monumental scale of the surrounding architecture, they appear as mere accessories. By photographing crowds from a distance, sometimes from the lofty perspective of a rooftop, Arnold downplayed human individuality and movement, thus aggrandizing the illusion of timelessness and permanence suggested by the classical architecture. In underscoring the aesthetic aims of the fair, Arnold's photographs present an even more perfect world than that actually experienced by the many tourists who took home these mementos of their visit to the World's Columbian Exposition. WG

37 albumen prints; sizes vary:
14 1/2–18 x 17 1/2–21 1/2 inches
(36.8–45.7 x 44.4–54.6 cm.)
Inscribed lower right (in plate):
Copyrighted 1893 by C. D. Arnold
Gift of C. W. Bergquist, 1948
UL1948.1–35

Provenance:
C. W. Bergquist, to 1948; ULC, 1948

Exhibitions:
"Display of Photographs and Mementos of the 1893 World's Columbian Exposition," Berwyn Savings and Loan Association, Berwyn, Ill., 1973

First Federal of Chicago, River Oaks Branch Office, Calumet City, Ill., 1977

Southern View of German and American Government Buildings

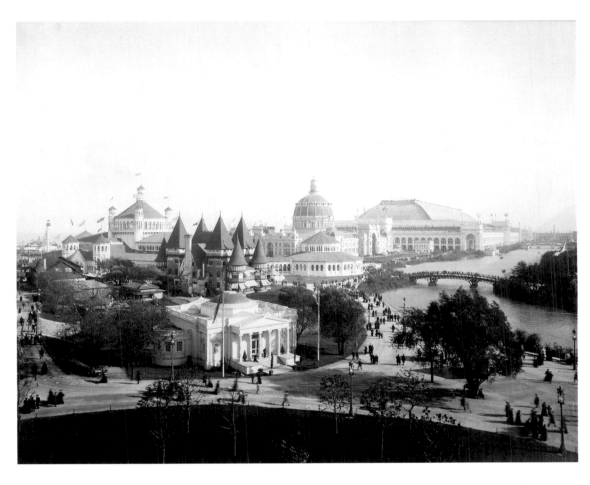

North View of the Mechanical Buildings

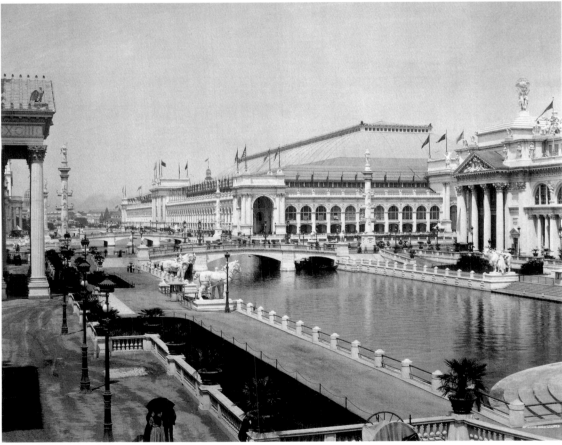

Charles Dudley Arnold *Suite of Photographs of the World's Columbian Exposition, 1893*

JOHN JAMES AUDUBON
(1785–1851)

Red-Shouldered Hawk (Falco lineatus),
published 1829

John James Audubon was born in Santo Domingo, the illegitimate son of a French sea captain and merchant and a Creole woman.[1] He was raised in France and early showed an aptitude for drawing, especially of birds. Audubon is said to have studied briefly with the great French painter Jacques-Louis David. In 1803 he left France for the United States to undertake several ultimately unsuccessful business ventures in mining and retail. An avid hunter and backwoodsman, Audubon began to study the native bird species of North America and acquired an international reputation as an ornithologist. At the same time he perfected his skills as a draftsman and painter, supporting himself partly by painting portraits. Around 1820 Audubon began to plan publication of his renderings of American birds, a project to which he devoted the next eighteen years and several long stays in Great Britain. His great *Birds of America*, engraved and published by R. Havell & Son of London, appeared serially between 1827 and 1838.

Birds of America consists of 435 plates depicting 1,065 life-sized birds. Audubon strove to include every species found in North America. His work was pioneering not only in its comprehensiveness but also in the naturalism of the illustrations. Conventional natural history illustration aimed at the minute representation of anatomy and surface markings and presented birds as lifeless products of taxidermy. But Audubon was fired with the idea that "nothing, after all, could ever answer my enthusiastic desires to represent nature, except to copy her in her own way, alive and moving!"[2] He was determined to show birds as they appeared in nature, based on his observations of their habits and habitat. For the large drawings he made for the plates of *Birds of America* Audubon worked quickly from freshly killed specimens so as to capture the living color of their plumage, and he wired them into positions that mimicked those in life. The plates were printed onto the largest sheets of paper then manufactured (giving the first edition the nickname of the "elephant folio") to allow the representation of even the largest birds in life-sized proportions. The result of Audubon's efforts was a triumph of art as well as of ornithological illustration.

The *Birds of America* included three images of the red-shouldered buzzard (*buteo linneatus*), which Audubon misidentified as the red-shouldered hawk (*falco linneatus*).[3] This view, which illustrates the characteristics of the male and female, is based on a drawing he made near St. Francisville, Louisiana, in 1825.[4] The red-shouldered buzzard is found throughout the eastern United States. In *Ornithological Biography*, which Audubon published in Philadelphia in 1838 to accompany *Birds of America*, he notes that "the mutual attachment of the male and the female continues through life . . . I knew the pair that I represented in *The Birds of America* for three years, and saw each of their nests, all within a few hundred yards of the first."[5] WG

Etching with engraving and aquatint and watercolor on paper; sheet: 37 1/2 x 25 1/2 inches (14.76 x 64.77 cm.); image: 37 x 25 inches (94 x 64 cm.) Inscribed in plate, center: Red-Shouldered Hawk./Male 1. F. 2./Falco lineatus.

Inscribed in plate, lower left: Drawn from Nature and published by John J. Audubon, F. R. S. E. F. L. S. M. W. S. Inscribed in plate, lower right: Engraved by R. Havell. Jun.' Printed & Coloured by R. Havell. Sen.' London. 1829. UL1957 A.13.4

Provenance:
W. Russell Button, Inc., ?–1957; ULC, 1957

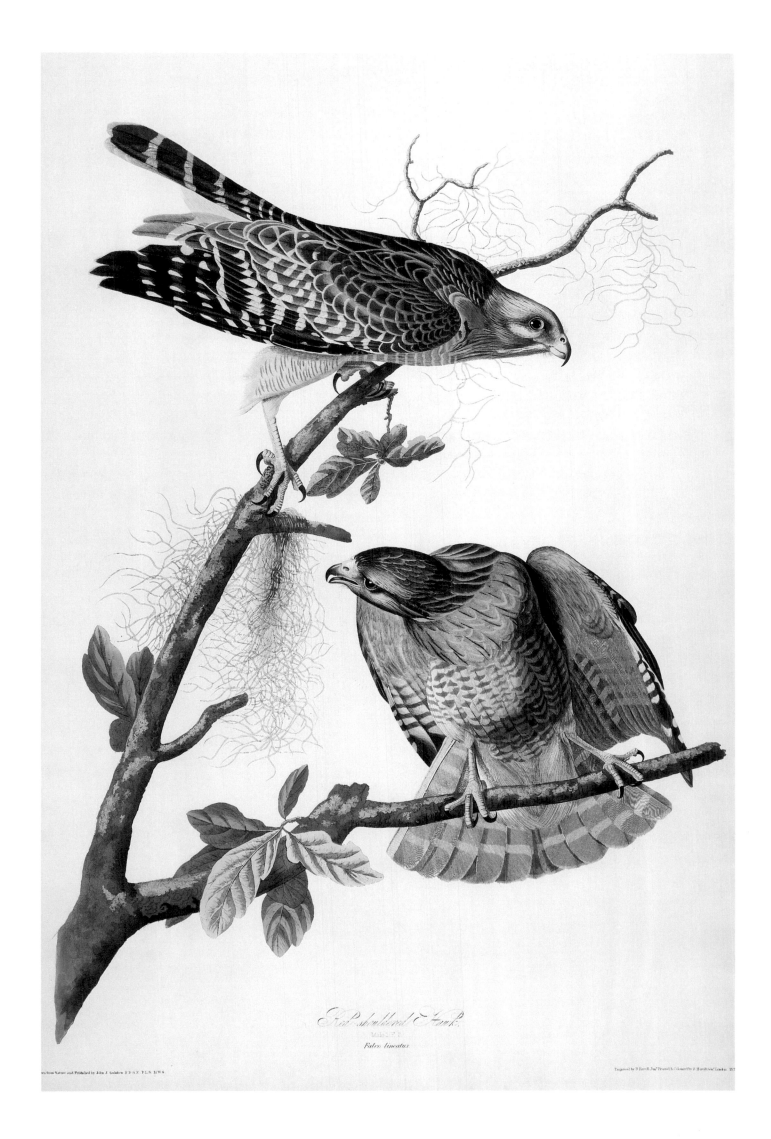

Red-Shouldered Hawk.

Falco lineatus

31 **John James Audubon** *Red-Shouldered Hawk (Falco lineatus),* published 1829

MARTHA SUSAN BAKER
(1871–1911)

In an Old Gown, 1904

Martha Susan Baker, who was born in Evansville, Indiana, on Christmas Day in 1871, studied at the School of the Art Institute of Chicago, from which she graduated with high honors in 1897. She subsequently taught there and at the Chicago Academy of Fine Arts. Although she was an accomplished oil painter, Baker was best known for her portrait miniatures, done on ivory in the watercolor medium. Demand for her miniatures became so great that in 1904 she resigned her teaching position at the School of the Art Institute of Chicago to devote more time to this medium.[1] Baker's work was regularly included in the Art Institute's annual juried exhibitions, both for Chicago artists and for works done in watercolor. She also exhibited work at the Paris Universal Exposition of 1900, the Paris Salon, and the Saint Louis World's Fair of 1904.

In an Old Gown garnered important prizes and attention for Baker. In 1904, it was included in the "International Exhibition of Paintings" at the Carnegie Institute, Pittsburgh, where it received an honorable mention prize. The next year, the Municipal Art League selected the painting as the winner of its purchase prize, given to a work from The Art Institute of Chicago's annual exhibition of paintings by Chicago-area artists; the League had established the prize as a means of creating a public gallery of the best regional work. Depicting an unknown sitter elegantly posed in profile wearing a gown that had been in style at least a generation previously, *In an Old Gown* is enlivened by Baker's fluid brushwork and subtle use of color. A critic who saw the painting at the Chicago exhibition later commented that the "figure had the appearance of a high bred guest sitting among reflections of Dutch peasantry and studio models."[2]

The subdued colors and dark tonalities of *In an Old Gown* are prime examples of Baker's early easel painting style. Shortly after this work was completed, she began using brighter, lighter colors, a change that was perhaps influenced by her growing interest in the pastel medium to which she had been introduced during a stay in Paris.[3] Baker was an artist of surprising depth: acclaimed for her facility at creating highly detailed, small work, she could not only work on easel paintings, but she also contributed a large-scale mural to the Fine Arts Building in Chicago. Greatly admired by her colleagues and considered by many contemporary critics to be one of the world's finest painters of miniature, Baker died less than one week shy of her fortieth birthday. MR

Oil on canvas; 62 x 33 1/2 inches
(157.48 x 85.09 cm.)
Signed lower right:
Martha S. Baker, 1904
UL1976.2

Provenance:
MAL, 1905–51; UL C&AF, 1951–76, ULC, 1976

Exhibitions:
"International Exhibition of Paintings at the Carnegie Institute," Carnegie Institute, Pittsburgh, 1904, #17

AIC Chicago and Vicinity Annual,1905, #8

"A Memorial Exhibition of Works of the Late Martha S. Baker at the Art Institute of Chicago," 1912, #2

References:
Bulletin of the Art Institute of Chicago 5 (April 1912): 54.

McCauley, L. M. "Chicago's Municipal Art Gallery." *Fine Arts Journal* 23 (September 1910): 140–41.

A Memorial Exhibition of Works of the Late Martha S. Baker at the Art Institute of Chicago. Exh. cat. Chicago: AIC, 1912.

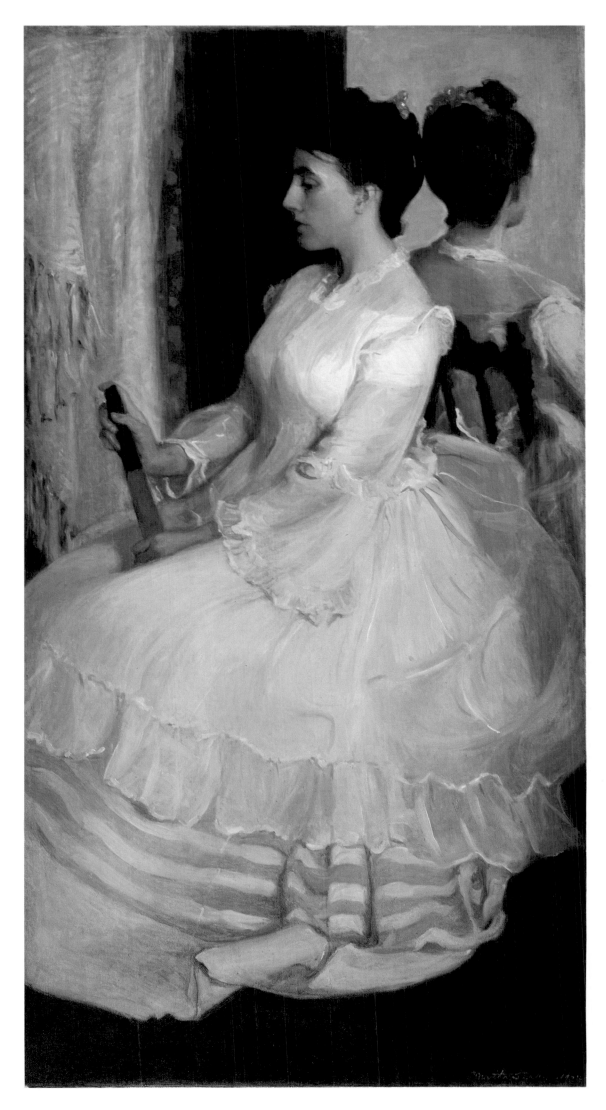

Martha Susan Baker *In an Old Gown,* 1904

ROBERT BARNES
(b. 1934)

Bocuse, 1980

Working in Bloomington, Indiana, outside the major art centers, Robert Barnes has made a name for himself as a painter of highly individualistic, expressive narrative. His interests are far reaching—subjects have included myths, poetry, writers, artists, and chefs, as in *Bocuse*—reflecting his belief that "artists should be influenced by everything around them."[1] Barnes was raised by his grandfather in his early years, since his father's diplomatic career necessitated a great deal of travel. Unhappy at his grandfather's choice of high school, Virginia Military Institute, Barnes ran away at the age of fifteen and hitchhiked his way across Texas and Arizona. Eventually he came to Wilmette, Illinois, where his parents had settled. During his senior year at New Trier High School, Barnes moved out of his parents' home to Chicago's South Side. He worked as a bartender and took up boxing, becoming the 1951 Golden Gloves champion as a flyweight in his league.[2]

By this time, Barnes was also a promising young artist, and his talent drew the attention of Alfred Barr, director of the Museum of Modern Art. Barr, the juror of "Momentum," the annual independent exhibition organized by students at the School of the Art Institute of Chicago, selected one of Barnes's paintings for the 1952 show.[3] That fall Barnes entered the freshman class at the School on a scholarship. During his college years, he forged an important relationship with the Chilean surrealist Roberto Matta, a visiting artist, who became Barnes's mentor. After graduation, Barnes and his wife moved to New York. Matta, also there, introduced them to Marcel Duchamp and Max Ernst. Barnes has noted that he was as much influenced by

the rich intellectual milieu to which he was being exposed as he was by the specific work of these artists.[4] Important critical notice came quickly when the Whitney Museum of American Art acquired Barnes's painting *Judith and Holofernes* in 1959. From 1961 until 1963, Barnes studied at the Slade School of Art at the University of London, where one of his tutors was Francis Bacon. In 1965, Barnes joined the faculty at Indiana University, a position he held until his retirement in 1999.

Bocuse is part of a series of portraits Barnes did of famous chefs. Its subject, Paul Bocuse, is a celebrated French chef whose restaurant in Lyon has earned the coveted three-star rating from Michelin for a number of years. Notably, Barnes has reversed the traditional convention of portraiture in which the sitter is framed by a setting that refers to one of his or her accomplishments or interests. In the Club's work, the chef's renowned cuisine occupies the foreground, while Bocuse himself remains a background figure, defined by his culinary artistry.

Barnes's expressive handling of paint creates a sense of the energy and movement of the kitchen preparations. Although *Bocuse* is a representational work, there is, as with all of Barnes's work, what one critic has described as "visual ambiguity."[5] Thus he presents a sense of the atmosphere in the kitchen rather than a detailed description of its appearance. In this regard, Barnes has noted that "reality is a combination of the senses. If you paint a landscape you also have to paint the sounds and the smells and the movement and the touch of it, you can't just paint with paint."[6] MR

Gouache on paper;
27 1/2 x 39 1/2 inches
(69.85 x 100.33 cm.)
Signed lower left: Bocuse/9 MA 80/1 2
Signed lower middle: I XI 80
Signed lower right: Robert Barnes
Gift of Mr. and Mrs.
Douglas Kenyon, 1985
UL1986.2

Provenance:
Mr. and Mrs. Douglas Kenyon, ?–1985,
ULC, 1985

References:
Loy and Honig. *One Hundred Years*.
Pages 116–17.

Robert Barnes *Bocuse*, 1980

FREDERIC CLAY BARTLETT
(1873–1953)

Martigues, France, 1905

The son of a prosperous hardware manufacturer, Frederic Clay Bartlett grew up in privileged surroundings on Chicago's Prairie Avenue.[1] Bartlett was inspired to become an artist after visiting the art exhibition at the World's Columbian Exposition of 1893. The following year he departed for several years of study in Munich and in Paris, where his teachers included the iconoclastic American artist James Abbott McNeill Whistler and the celebrated French mural painter Puvis de Chavannes. On his return to Chicago in 1899, Bartlett settled into a studio in the new Fine Arts Building. He exhibited at the Art Institute and also began a successful career as a muralist, creating works for such buildings as the University Club, the Second Presbyterian Church, and the Bartlett Memorial Gymnasium at the University of Chicago. Today Bartlett is best remembered as an astute collector of modern art. With his second wife, Helen Birch Bartlett, he amassed an important group of French postimpressionist and modernist paintings, including Georges Seurat's *Sunday Afternoon on the Island of La Grande Jatte*. Bartlett gave the collection to the Art Institute in 1925.

Before 1918 Bartlett painted most of his landscapes in Europe. His travels there took him to Martigues, a picturesque Provençal fishing village on an isthmus between the Mediterranean and a lagoon, the Etang de Berre. Martigues, dubbed the Venice of Provence, was already famous as an artists' haunt.[2]

Many artists portrayed the town's charming canals, quays, and old houses, but Bartlett pictured its natural surroundings. The foreground of this view, which he painted over a scene of figures on a beach, is dominated by one of the limestone hills that form an amphitheater around the Etang de Berre. At the summit stands a stubby round tower, one of the many defensive structures erected around the lagoon by the ancient Romans. On the right a body of glassy water extends into the distance, where its color shifts abruptly to a denser tone beyond a spit of pale land.[3]

With its mood of calm repose and its cool, subdued gray-greens, Bartlett's unpeopled view evokes what has been described as the "classical" nature of the region's beauty, without portraying its characteristic harsh light and the tough, sparsely vegetated character of its terrain.[4] One of three landscapes that Bartlett exhibited at the Art Institute in 1905, this work reminded a fellow artist of the lyrical landscapes of the Italian Renaissance master Giorgione.[5] The somewhat stylized trees, with their sinuously curving, gnarled trunks and dark shadows, seem part of a fantasy world of mingled antiquity and legend; the composition's flattened perspective adds to an air of unreality. Such qualities typified Bartlett's "decorative" early landscape paintings[6] and were echoed in his murals, many medieval in theme and motif. WG

Oil on canvas; 26 3/4 x 29 3/4 inches
(67.95 x 75.57 cm.)
Signed lower left: Frederic
Clay Bartlett—05
UL1905.7

Provenance:
ULC, 1905

Exhibitions:
"Tenth Annual Exhibition of the Society of Western Artists,"
AIC, 1905, #12

"Exhibition of Paintings by Frederic Clay Bartlett," AIC, 1907, #13
(as *Martique* [sic] *Bay, France*)

References:
Martin. *Art in the ULC*. Page 34.

McCauley. *Catalogue*, 1907. #19.

Payne, H. C. "The Exhibition of the Western Society of Artists [sic.],"
The Sketch Book 5 (Jan. 1906): 224.

Frederic Clay Bartlett *Martigues, France*, 1905

DON BAUM
(b. 1922)

Andromeda, 1992

Don Baum's contributions as an artist, curator, and educator were pivotal in Chicago's resurgence as an acknowledged arts center in the 1960s and 1970s. Born in Escanaba in the Upper Peninsula of Michigan, Baum did not set out to become either an artist or a curator. Instead, he studied hotel management at Michigan State University and then moved to Chicago to work at a hotel. In 1942, he enrolled at the School of the Art Institute of Chicago, and he also took classes at László Moholy-Nagy's School of Design and at the University of Chicago. In 1948, Baum joined the art department at Roosevelt University, serving as its chair from 1970 until his retirement in 1984.[1]

Baum's position as director of the Hyde Park Art Center (1956 to 1972) had great local impact. At the center, he showcased the work of Chicago-area artists, and his discerning eye for discovering new talent resulted in a series of groundbreaking exhibitions. In 1966, Baum organized a group show for Jim Nutt, Gladys Nilsson, Art Green, Suellen Rocca, Karl Wirsum, and James Falconer, entitled "The Hairy Who." The show marked the beginning of what became known as the Chicago Imagist movement. Ed Paschke, Roger Brown, Phillip Hanson, and Christina Ramberg were among the other young Imagist artists whose work was included in important group exhibitions at the Hyde Park Art Center during Baum's directorship. In 1969 Baum, who advocated institutional support and recognition for local artists, organized "Don Baum Sez: Chicago Needs Famous Artists," the first exhibition of the Chicago Imagists at the Museum of Contemporary Art, Chicago. He was appointed to make the selection of the American entry to the 1973 São Paulo Bienal,

which was entitled "Made in Chicago." Baum became a distinguished artist member of the Union League Club of Chicago in 2001.

As an artist, Baum is known for assemblages that combine found materials and hand-made elements. Some of his earliest constructions, which date to the 1960s, present corpse-like plastic dolls that are imprisoned within transparent boxes. He is perhaps best known for his *Domus* series: small houses, often placed on wooden cutting boards, which examine the social and moral significance of the concept of shelter. Baum has acknowledged the influence of Emmanuel Le Roy Ladurie on his interest in examining society's notion of the dwelling place. In *Montaillou*, an ethnological study of a medieval French village, Ladurie had defined the domus as encompassing the ideas of shelter, family, and the place where life and death meet.[2]

Baum's interest in cultural myths is at the core of *Andromeda*, an assemblage that is constructed from plywood, black velvet, a paint-by-numbers canvas, and a cutting board, elements that recur in many of his works. The profile of a woman, placed within a half-moon, is embellished with images of sailboats. These elements allude to the work's eponymous mythological character, an Ethiopian princess who was chained to a rock as a human sacrifice to save her people from a sea monster. After marrying her rescuer, the Greek hero Perseus, Andromeda became the queen of Mycenae. In this work, Baum plays with the revered and the banal, using deliberately mundane materials and imagery to create a thought-provoking and original representation of this famous mythological character. MR

Mixed media: oak plank, plywood cutouts, black velvet painting, oil on canvas;
20 x 21 x 5 1/4 inches
(50.8 x 53.34 x 13.34 cm.)
Unsigned
UL1999.2

Provenance:
ULC, 1999

Exhibitions:
"The Union League Club of Chicago Art Invitational," ULC and Prince Gallery, 1993

GEORGE WESLEY BELLOWS

(1882–1925)

Girl with Flowers, 1915

When George Bellows died of peritonitis following a ruptured appendix at the untimely age of forty-two, the art world had already recognized him as one of the most important American artists of his era. A realist, he created unromanticized depictions of urban scenes, sporting events, portraits, and landscapes. In a memorial essay that appeared in *The Arts*, the critic Forbes Watson wrote that Bellows's death "not only removes from our midst an ambitious, gifted and courageous painter, but a man who brought the weight of his reputation and the force of his personality to the support of native production in art."[1]

Bellows, a native of Columbus, Ohio, attended Ohio State University before moving to New York City.[2] There he studied with noted teachers Robert Henri and William Merritt Chase at Chase's New York School of Art in 1904. He became part of the Ashcan School, a group of artists led by Henri that was dedicated to depicting urban, industrialized life in an evocative and unsentimental manner. Bellows found his subject matter in everyday life on the Lower East Side, at sporting events such as prize fights and polo matches, in the urban landscape, and in the people of New York. Although today Bellows may be best remembered for his scenes of boxing matches, he was a prolific portraitist, and from 1915 through 1920, he exhibited with the National Association of Portrait Painters.

In *Girl with Flowers*, Bellows depicts the sitter in his customary candid style. The Club's work is not a portrait in the formal sense, but it shares stylistic characteristics with the artist's portraits, including the triangular mass of the figure, the freely applied paint, and the single strong light source.[3] The model is probably his wife, Emma, his most frequent model. Bellows preferred using Emma and other relatives as models, believing that his familiarity with them enabled him to do his best work. Family members also had a better conception of his working methods and goals than would have someone he hired to model.[4] In *Girl with Flowers*, Bellows depicts the figure as being lost in thought; her pensive expression, found in a number of his portraits, gives the viewer a sense of both the woman's psyche and the artist's sympathetic feelings towards his subject. MR

Oil on canvas;
40 1/4 x 32 1/8 inches
(102.24 x 81.60 cm.)
Signed lower left: Geo Bellows;
inscribed on reverse:
Girl With Flowers/Geo Bellows
UL1976.3

Provenance:
L. L. Valentine, 1925–?; MAL, ?–1962;
UL C&AF, 1962–1976; ULC, 1976

Exhibitions:
"Memorial Exhibition of the Work of George Bellows," Metropolitan Museum of Art, 1925

"American Art in the Union League Club of Chicago, A Centennial Exhibition," traveling exhibition organized by the ULC, 1980–81

"Faces & Figures," Nassau County Museum of Art, Roslyn Harbor, New York, 1997–1998

References:
Loy and Honig. *One Hundred Years*. Pages 80-81.

Memorial Exhibition of the Work of George Bellows. Exh. cat. New York: Metropolitan Museum of Art, 1925. Plate 54.

Schwartz, Constance and Franklin Hill Perrell. *Faces & Figures*. Exh. cat. Roslyn Harbor, NY: Nassau County Museum of Art, 1997. Page 78.

Sparks. *American Art in the ULC*. Page 7.

George Wesley Bellows *Girl with Flowers*, 1915

LOUIS BETTS
(1873–1961)

James William Pattison, 1906

James William Pattison has the distinction of being the only portrait in the collection in which both painter and sitter were Union League Club members and artists. Painted in 1906 near the beginning of Louis Betts's career, *James William Pattison* shows the artist's adherence to the portrait technique he had learned from noted artist and teacher William Merritt Chase. Like Chase, Betts worked rapidly and used long, fluid brushstrokes, seeking to capture sitters while they were "fresh." Here, Pattison's face and hands are emphasized over the dark clothing of the rest of his figure, a portrait style that was characteristic of the Chase school. Betts's technique was much admired in his time; a critic noted in 1918, for example, "His grasp of character and essentials is revealed in a broad and dashing manner. Nothing finicky and small, nothing pretty and studio-made, sullies his brush."[1]

Betts, who grew up in Michigan, was first taught painting by his father, a landscape painter who was associated with George Inness. He then studied briefly at the School of the Art Institute of Chicago in the 1890s and supported himself by illustration afterwards, first in Chicago and later in New York. While living in New York, Betts enrolled in one of Chase's summer classes on Long Island. As a result of this experience, he moved to Philadelphia so that he could enroll in Chase's class at the Pennsylvania Academy of the Fine Arts. There Betts won the Cresson traveling fellowship, enabling him to spend two years in Europe in independent study of the Old Masters.[2]

When Betts and his wife returned to Chicago in the summer of 1906, the portrait of James Pattison was one of the first works Betts completed. Pattison—artist, art critic, lecturer, and editor—was a man of progressive artistic tastes in a city known for its conservatism.[3] Active in many Chicago organizations, he was a president of the Chicago Society of Artists, served as director of the School of Fine Arts, Jacksonville, Illinois, and helped establish an artists' colony in Park Ridge, Illinois. In December 1906, shortly after the Club's portrait was completed, Pattison wrote an article about Louis Betts in which he noted that Betts's "success was so immediate because of the ability to secure not alone a likeness, but to observe keenly the fleeting and peculiar expressions of his sitters."[4] *James William Pattison* attracted much notice among local art critics, who praised it as being "a daring transcription of a unique personage, a work that has met with much interest."[5] Betts's portrait of this high-profile Chicagoan must have done much to establish him as a leading society portraitist in the city, and he subsequently received commissions to paint portraits of the Fields, the Ryersons, and the Palmers, among others. Betts moved to New York in 1915, but he continued to maintain his connections in Chicago including, from 1935 until 1944, service on the Union League Club's Art Committee. MR

Oil on canvas;
47 3/4 x 33 7/8 inches
(118.75 x 83.50 cm.)
Signed lower left: Louis Betts
UL 1976.4

Provenance:
MAL, 1909–1951; UL C&AF, 1951–1976; ULC, 1976

Exhibitions:
"102nd Annual Exhibition," Pennsylvania Academy of Art, Philadelphia, 1907, #221

AIC Chicago and Vicinity Annual, 1909, #19

"Painters and Sculptors in Illinois: 1920–1945," traveling exhibition organized by the Illinois Arts Council, 1971–72

"Currents of Expansion: Painting in the Midwest, 1820–1940," Saint Louis Art Museum, 1977, #81

"American Art in the Union League Club of Chicago, A Centennial Exhibition," traveling exhibition organized by the ULC, 1980–81

References:
Martin. *Art in the ULC.* Page 7.

Barter, Judith A. and Lynn E. Springer. *Currents of Expansion: Painting in the Midwest, 1820–1940.* Exh. cat. St. Louis: The St. Louis Art Museum, 1977. Page 128.

Gerdts. *Art Across America.* Vol. 2, page 312.

Loy and Honig. *One Hundred Years.* Pages 72–73.

McCauley, Lena M. "Chicago's Municipal Art Gallery." *Fine Arts Journal* 23 (September 1910): 141, 145–46.

McCauley, Lena M. "Promoting an Interest in Art." *Art and Progress* 5 (April 1914): 203.

Pattison, James William. "Louis Betts—Painter." *The Sketch Book* 6 (December 1906): 173.

Sparks. *American Art in the ULC.* Page 4.

43 **Louis Betts** *James William Pattison*. 1906

KATHLEEN BLACKSHEAR
(1897–1988)

Zinnias, ca. 1929–30

Born in Navasota, Texas, Kathleen Blackshear studied English literature at Baylor University, where she graduated in 1917. She then studied for one year at the Art Students League of New York before enrolling at the School of the Art Institute of Chicago in 1924. Blackshear studied with John Norton and Helen Gardner, and she developed a close relationship with Gardner, the author of *Art Through the Ages*. She graduated with a master's degree in art history, although during this period she was also painting. In 1940, she earned an M.F.A. from the Art Institute. Blackshear joined the faculty of the School of the Art Institute of Chicago in 1926. Students remembered her for helping them both personally and professionally.[1] She especially encouraged African American students, and Blackshear also concentrated on depicting African American life in many of her paintings. After her retirement from the School in 1961, Blackshear returned to her native Texas with her companion and fellow artist, Ethel Spears.

Zinnias has many of the elements that are common to Blackshear's work. A modernist, her figurative work intentionally stressed the two-dimensionality of the canvas. Thus, in the Club's work, Blackshear emphasized the painting's surface through the strong contour lines of the flowers and the flat application of color. The influence of Paul Cézanne, whom Blackshear greatly admired, is evident in the deliberately distorted space; the viewer appears to be simultaneously gazing up at the underside of the zinnias and looking down at the highly patterned floor. The inclusion of the totemic figure in the upper right reflects the artist's lifelong interest in Native American and African art. Although *Zinnias* is undated, a label on the reverse from a Houston frame shop suggests that it may have been created in 1929 or 1930, when Blackshear had a studio there.[2] MR

Oil on canvas; 12 x 18 inches;
(96.52 x 60.96 cm.)
Unsigned
UL1989.1

Provenance:
Kathleen Blackshear, ca.
1929/30–1988; Barton Faist, 1988;
ULC, 1988

45 **Kathleen Blackshear** *Zinnias*, ca. 1929–30

HARRIET BLACKSTONE
(1864–1939)

*Man with a Cane: Portrait of
James Edwin Miller*, ca. 1910–1912

Harriet Blackstone was born in New Hartford, New York, and moved to Chicago with her family in 1883, when she was in her late teens. The family settled in Galesburg, Illinois, in 1888, where Blackstone became a teacher of elocution and drama at Galesburg High School. She did not study art until 1903, when she enrolled at the Pratt Institute in Brooklyn at the age of thirty-eight. As with so many American artists in the period between the end of the Civil War and the start of World War I, she eventually decided that in order to progress, she needed to study abroad. In 1905, she went to Paris to study at the Académie Julian with Jean-Paul Laurens. Her painting entitled *A Crimean Soldier* was accepted for exhibition in the Paris Salon of 1907, an achievement that heightened interest in her work back home. In 1908, when Blackstone returned to the house she had built in Glencoe, Illinois, three years earlier, her commissions increased. Her portraits of notable Chicago people were praised for their "sympathetic true to life point of view toward the personality of [her] sitter that the average beholder agrees with and shares without pose or strain."[1]

By 1920, Blackstone decided that she wished to branch out and do work besides society portraits. Highly mystical and interested in psychic phenomena, Blackstone looked increasingly inward for inspiration. Because of her local renown as a portraitist, she believed that it would be impossible to change her focus if she remained in Glencoe, so she moved to New York in

October 1920. Although she continued to do portraits as a means of supporting herself, Blackstone devoted much time to creating paintings of faces that she saw in visions. In later years, she became friends with the donor of the Club's painting, Stell Anderson, a concert pianist who posed for the artist several times. Blackstone died on March 16, 1939, at the age of seventy-five while working on a portrait of Anderson to submit to the 1939 New York World's Fair competition.[2]

Blackstone became interested in painting James Edwin Miller after she noticed him on his daily walks past her studio in Glencoe. As with other early works by the artist, and like much conservative portraiture of the period, the painting's palette is dark, and the greatest attention is given to the sitter's face and hands. Painted circa 1911, it was awarded a one-hundred dollar prize in 1917 from The Artist's Guild, a Chicago organization Blackstone had joined that year. *Man with a Cane: Portrait of James Edwin Miller* was praised by critics of the period. One reviewer noted that "the flesh tones are remarkably true to nature and well handled, the hands beautifully drawn: the modeling in all particulars is firm and strong, and the expression one of earnest attention. Miss Blackstone has evidenced a rare ability for subtlety of treatment as the brush strokes indicate, and the reflection of light, where employed, conveys the sense of reality, notably in the hair and beard; an alertness and a vitality dominate the canvas, which is one of the best portraits by this young artist."[3] MR

Oil on canvas;
37 1/2 x 27 1/8 inches
(95.25 x 68.90 cm.)
Signed upper right:
Harriet Blackstone/—
(number indistinct)
Gift of Mrs. Stell Anderson, 1981
UL1981.5.4

Provenance:
Mrs. Stell Anderson, 1939–1981;
ULC, 1981

References:
d'Unger, Giselle. "Harriet Blackstone: Portrait Painter." *Fine Arts Journal* 26 (February 1912): 98, 100.

Higgins, Harriet Gambert. "An Afternoon with Some Well-Known Chicago Artists." *Woman's Civic Magazine*, December 1915: 15, 19.

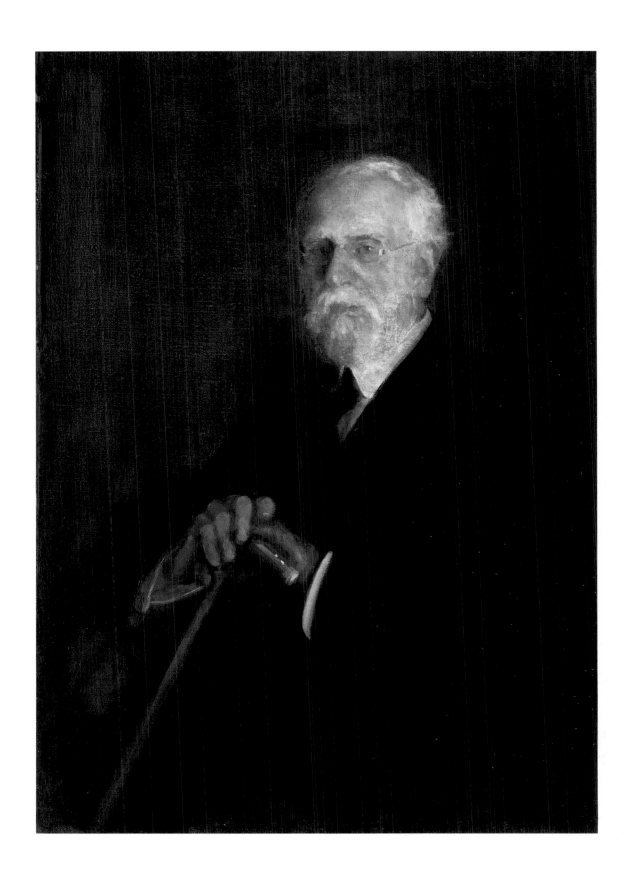

Harriet Blackstone *Man with a Cane: Portrait of James Edwin Miller*. ca. 1910-1912

MARIE ELSA BLANKE
(1879–1961)

A Bit of Beach, ca. 1899

Today a largely forgotten figure in the history of Chicago art, Marie Elsa Blanke made important contributions in the early years of the twentieth century as a painter, a popular teacher at Lewis Institute (now the Illinois Institute of Technology), and an active member of numerous arts organizations. Blanke, a Chicago native whose father was on the bench of the Superior Court of Illinois, graduated from Lake View High School and then studied at the School of the Art Institute on a scholarship from the Chicago Woman's Club. From her primary teacher at the Art Institute, Frederick Richardson, she gained a strong understanding of pattern and design, grounding that she believed later enabled her to keep an open mind toward modern art, although she herself was never a modernist.[1] She also studied in Munich and London.

Blanke began teaching art at Lewis Institute in the first decade of the twentieth century, specializing in design. There she became the leader of a group of progressive female students from affluent families who shared her interest in the arts. Blanke, known as James and Jimmy to members of her circle, organized the "Heap-Blanke Nickel Theatre" with one of her protégés and close friend, Jane Heap, who later became co-editor of the important avant-garde literary magazine

The Little Review.[2] In 1915, Blanke was one of the founding members of the Cordon Club, a Chicago women's club dedicated to the arts. In addition, she played an active role in several other arts organizations. Known for still lifes and landscapes of Galena, Illinois, and New England, Blanke worked until the end of her life, dying suddenly during a painting trip in Vermont.[3]

A Bit of Beach is an early work, which the Union League Club Art Committee purchased "in fulfillment of a promise of patronage of Chicago artists" it had made the previous year.[4] Unlike her later landscapes, which presented people within the setting of the natural environment, the subject of this work is a deserted shore. Blanke draws the eye into the composition with a strong diagonal line that runs from the lower left to the upper right section of beach. Strong horizontal elements dominate the rest of the composition, an emphasis that helps to create a tranquil atmosphere and suggests the influence of second-generation Hudson River School painters such as John Frederick Kensett and Sanford Gifford. Two thin bands of color represent the distant shoreline, while both water and sky are rendered using horizontal brushstrokes. Blanke restricted her palette to shades of blue, brown, and tan, a choice that contributes to the painting's evocation of a serene world, at peace with itself. MR

Oil on canvas laminated
to plywood; 11 1/4 x 18 1/2 inches
(28.55 x 47 cm.)
Signed lower left: Marie E. Blanke.
UL1900.2

Provenance:
ULC, 1900

Exhibitions:
AIC Chicago and Vicinity Annual,
1900, #29

References:
McCauley. *Catalogue*, 1907. #98.

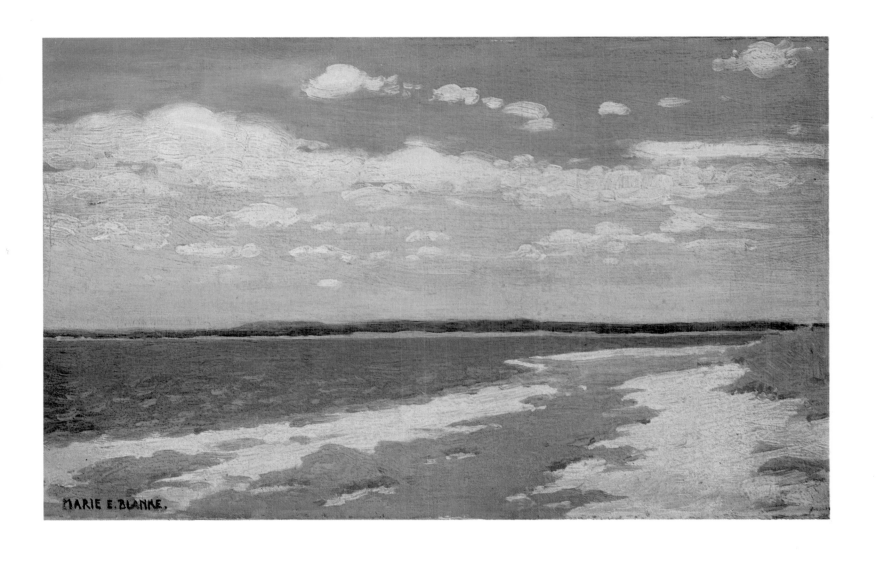

Marie Elsa Blanke *A Bit of Beach*, ca. 1899

EDWIN HOWLAND BLASHFIELD
(1848–1936)

Patria, 1926

In late 1925, during the construction of the Union League Club's present building, architect William Bryce Mundie proposed that the main lounge on the second floor should include a mural over the fireplace. He recommended that the Club commission Edwin Blashfield to do a work symbolizing the Club's motto, which was inscribed on the fireplace: "Welcome to Loyal Hearts: We join ourselves to no party that does not carry the flag and keep step to the music of the Union." Blashfield, then 77, was an ideal choice, for his conservative style perfectly matched the dignified and traditional architecture of the new clubhouse. Of especial importance for Mundie and the Club's Building Committee was Blashfield's reputation as an artist who viewed his work as a collaboration between artist and architect and his murals as part of the larger architectural vision. The artist, whose style was considered old-fashioned by some critics of the period, wrote in his official acceptance of the commission, "I am touched and pleased at receiving it at this time; the subject, size and shape of the panel also pleasing to me, urging one to his very best endeavor. I shall take personal pride in this work for the club."[1]

Blashfield had been trained in the academic tradition, studying first with Thomas Johnson and William Rimmer in Boston and then in Paris with Léon Bonnat from 1867 to 1870 and again between 1874 and 1880.[2] He rose to national prominence for his mural *Art of Metal Working*, which was created for one of the eight domes in the Manufactures and Liberal Arts Building, the largest structure at the 1893 World's Columbian Exposition. After this success, Blashfield concentrated on mural painting, and he was an eloquent spokesperson for the genre, which was experiencing a revival during the American Renaissance architectural movement of the late nineteenth century. His many public commissions included the Library of Congress, the Detroit Public Library, and the capitol buildings of Iowa, Minnesota, and Wisconsin. Blashfield was an active member of numerous artists' organizations, among them the National Academy of Design, of which

he was president from 1920 to 1926, the Architectural League of New York and the National Society of Mural Painters. He was also the author of *Mural Painting in America*, a 1913 book based on his lecture series at The Art Institute of Chicago the previous year.

Although Blashfield looked to the great masters of the Italian Renaissance for inspiration, he did not paint directly on the wall as they had. Instead, his murals were done on canvas, allowing him to create them off-site. The canvas was mounted to the wall using a coating of white lead and varnish applied to both the wall and the back of the canvas.[3] Characteristics of his style—the emphasis on contour lines, classically beautiful women, and rich color—are evident in *Patria*.[4] The standing central figure, Columbia, is depicted holding the Constitution in her left hand, while seated next to her are the allegorical figures of Fortitude and Justice; the latter's blindfold is raised so that she "may see the light." At the bottom of the composition are two "handmaidens of Loyalty" holding a shield decorated with palm and laurel leaves and the white ribbons of peace.[5]

During the installation of *Patria* in September 1926, Mundie decided that the mural needed to be set off by a framing element, and he designed flanking upright palms, which Blashfield then painted gratuitously.[6] Blashfield's generous spirit also extended to inscribing the name of his assistant, Vincent Aderente, beneath his own, a willingness to share credit that was not common in artists of his stature. *Patria* was praised at the time of its unveiling, both by Club members and the press, but only two years later, the Art Committee expressed its hope that a new mural might replace it, believing that large-scale female allegorical figures were not representative of what was then a men's Club.[7] Records do not indicate the reasons why this suggestion was not implemented, but it is likely that the financial difficulties the Club faced during the Great Depression made large-scale commissions of artwork an impossibility. MR

Oil on canvas mounted on plaster wall; 144 x 94 inches (365.76 x 238.76 cm.) Signed lower right: Edwin H. Blashfield/Vincent Aderente UL1926.1

Provenance:
Commissioned by ULC's Board of Directors in 1926 "to ideally symbolize the portent of the motto of the Club."

Exhibitions:
"American Art in the Union League Club of Chicago, A Centennial Exhibition," traveling exhibition organized by the ULC, 1980–1881

References:
Amico, Leonard N. *The Mural Decorations of Edwin Howland Blashfield (1848–1936)*. Exh. cat. Williamstown, Mass.: Sterling and Francine Clark Art Institute, 1978. Page 68.

Cortissoz, Royal. *The Works of Edwin Howland Blashfield*. New York: Charles Scribner's Sons, 1937. Plate 75.

Loy and Honig. *One Hundred Years*. Pages 24–25.

Sparks. *American Art in the ULC*. Pages 8–9.

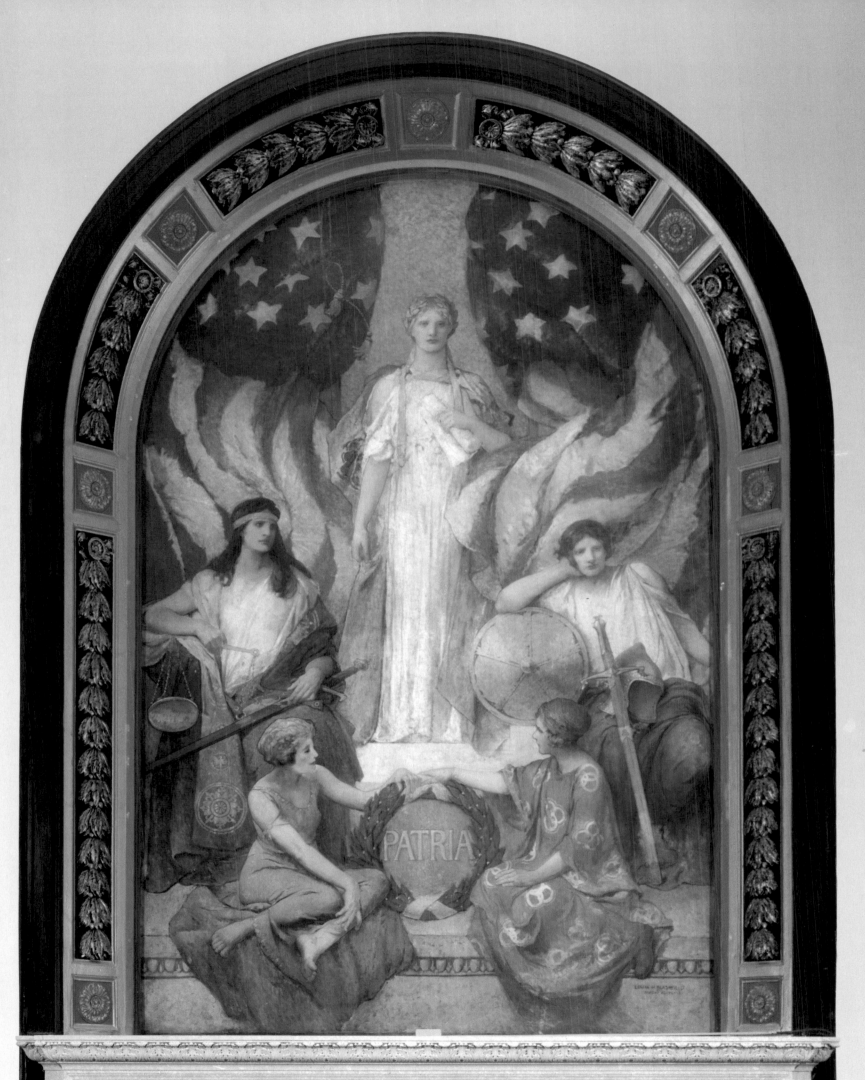

WELCOME TO LOYAL HEARTS
"WE JOIN OURSELVES TO NO PARTY WHICH DOES NOT CARRY
THE FLAG AND KEEP STEP TO THE MUSIC OF THE UNION"

ALBERT BLOCH
(1882–1961)

Dreiergruppe (Group of Three), 1921

Albert Bloch has the distinction of being the only American member of the Blue Rider, a group of German Expressionist painters that was formed in 1911 by Wassily Kandinsky and Franz Marc. Born in Saint Louis, Bloch studied art for two years at the Saint Louis School of Fine Arts (now part of Washington University) before moving to New York in 1906. In December 1908 the artist moved to Munich with the intention of studying at the Royal Academy, but instead he embarked on a program of self-instruction, which he supplemented with evening classes at private art schools. Bloch met Kandinsky in 1911, and the two artists found that they shared similar artistic goals. When the Blue Rider group's first exhibition opened on December 18, 1911, six of Bloch's paintings were included. From that point until 1921, Bloch was an active member of the German avant-garde, exhibiting at progressive galleries such as Der Sturm. He also had a one-person exhibition at The Art Institute of Chicago in 1915 at the behest of noted Chicago collector and Union League Club member Arthur Jerome Eddy, who considered him the finest American artist working abroad.[1]

Group of Three, completed immediately after Bloch's return to America, reflects the social and economic problems the artist witnessed in Germany. The Treaty of Versailles had emasculated German political and economic power, and in 1921 there were already signs of the inflation that would make German currency valueless by 1923. Bloch experienced personal loss from the war, for his friend Franz Marc had died in battle, and the destruction caused by the Great War haunted him for many years. The somber tone and sense of alienation in *Group of Three* reveal Bloch's feelings of despair. Both the intimate group and the contrast between the wintry landscape and the interior would normally signify domesticity and comfort, but here they are imbued with a sense of emotional isolation.

Group of Three also reflects the influence of Marc Chagall. Like Chagall, Bloch's forms are simply rendered, and the objects are similarly laden with a sense of symbolic content. The dog, often found in Chagall's work, began appearing in Bloch's paintings in 1916.[2] Bloch returned to the subject matter of *Group of Three* several times in the ensuing years: he made a watercolor version in 1935, a second oil version in 1942, and he wrote an unpublished poem of the same title in the early 1930s.[3]

In 1921, the artistically progressive Daniel Gallery gave Bloch a one-person exhibition, in which *Group of Three* was included. The painting was also in the artist's one-person exhibition at the Chicago Arts Club in 1927. Unhappy with the American exhibition system, the artist exhibited infrequently after returning to America. Bloch, who had taught briefly at the Chicago Academy of Fine Arts, became a professor of art at the University of Kansas, a position he held until his retirement. MR

Oil on canvas;
39 3/8 x 29 1/2 inches
(100.01 x 74.93 cm.)
Signed front center: AB; signed
verso: AB/Group of Three/
Summer 1921/St. Louis
UL1998.4

Provenance:
Collection of Anna Bloch (artist's widow), 1961–1974; private collections in Germany, 1974–1994; The Janet and Marvin Fishman collection, 1994–1998; ULC, 1998

Exhibitions:
"Exhibition of Paintings by Albert Bloch," Daniel Gallery, New York, 1921

"Exhibition of Paintings by Albert Bloch, Karl Mattern and Major Archibald Murray," The Kansas City Art Institute, 1927, #5

"Exhibition of Paintings by Albert Bloch," The Arts Club of Chicago, 1927, #25

"Albert Bloch: Watercolors, Drawings, Oils," St. John's College, Annapolis, Maryland, 1966

"Albert Bloch 1882–1961, An American Expressionist: Paintings, Drawings, Prints," Museum of Art, Munson-Williams-Proctor Institute, Utica, New York, 1974, #12

"The Janet & Marvin Fishman Collection: New Acquisitions, Recent Gifts and Old Friends," University Art Museum, University of Wisconsin-Milwaukee, 1994

"Albert Bloch: The American Blue Rider," traveling exhibition organized by The Nelson-Atkins Museum of Art, Kansas City, Missouri, 1997, #2

References:
Adams, Henry, Margaret C. Conrads, and Annegret Hoberg, eds. *Albert Bloch: The American Blue Rider.* Exh. cat. Munich and New York: Prestel-Verlag in association with the Nelson Gallery Foundation and Stadtische Galerie im Lenbachhaus, 1997. Pages 74–75, color plate 31.

The Arts Club of Chicago. *Catalogue of an Exhibition of Paintings by Albert Bloch.* Exh. pamphlet. Chicago: The Arts Club of Chicago, 1927. Page 25.

Penney, James. *Albert Bloch, 1882–1961, An American Expressionist: Paintings, Drawings, Prints.* Exh. cat. Utica, New York: Munson-Williams-Proctor Institute, 1974. Page 8.

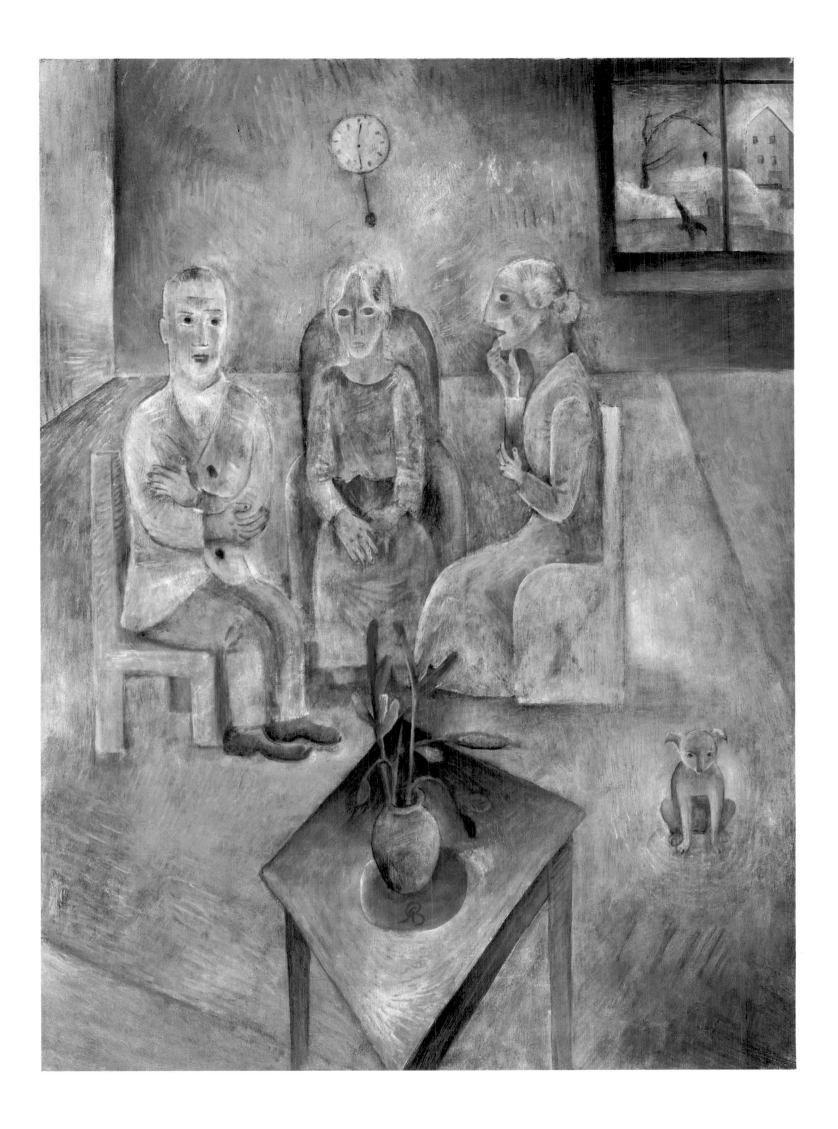

53 **Albert Bloch** *Dreiergruppe (Group of Three)*, 1921

JESSIE ARMS BOTKE
(1883–1971)

Vanity, undated

Jessie Arms Botke's paintings of birds are remarkable for their combination of detailed naturalism and highly stylized composition.[1] Often the three-dimensional appearance of the birds contrasts with a flattened, decorative background. Botke's approach to easel painting was informed by her work as a decorative painter of murals and friezes. According to the artist, she received her most important training working as a designer for the Herter Looms Company in New York City. An assignment to paint a peacock frieze introduced her to what would become her hallmark: the decorative treatment of birds, especially white birds and peacocks. Her fascination with the purely aesthetic appeal of birds, from the grace of their forms to the brilliant color and patterns of their plumage, contributed to her success as a painter of decorative easel paintings, mainly of birds. Botke studied and sketched her subjects first-hand in zoos and in nature, but then allowed her material to "cool off" in her mind so as to use it "creatively" rather than produce a merely realistic reproduction.[2] Her artistic sources ranged widely, from Japanese screen paintings to Flemish tapestries.[3]

A Chicago native, Botke studied at The Art Institute of Chicago. In 1911 she left for work in New York City. She returned to Chicago in 1915 with her husband and collaborator, Dutch-born painter Cornelis Botke, to undertake several important mural commissions, including the series *The Masque of Youth* for Ida Noyes Hall at the University of Chicago. In 1920 the Botkes joined the growing art community in California. They lived in

San Francisco, Carmel, and Los Angeles before settling in 1929 on a ranch near Santa Barbara, where they maintained a private aviary of birds of all kinds. Jessie Botke was active in the local arts scene and exhibited widely and with almost unfailing success, recognized as the premier decorative bird painter of her era.

Generously sized, *Vanity* is particularly reminiscent of Botke's mural work in its flat, hieratic, and symmetrical composition and in its rich materials. Gold is applied over a deep red ground, mingling the plane of the background with that described by the ostentatious spray of the male peacock's tail feathers, an intricate web of diaphanous tendrils punctuated by the brilliant "eyes." In a halo effect around the borders of the peacock's tail, a pattern of graceful curls suggests the formalized clouds and waves of traditional Chinese painting. The image is framed by the slender trunks of two flowering trees; at the base of each sits a Mandarin duck, a small, neat bird that, along with peacocks, became one of Botke's trademark species after she first encountered it at the Amsterdam zoo in 1924.[4] The foreground is filled with a variety of flowers and foliage rendered with a stylized simplicity recalling medieval tapestries and Islamic miniatures. *Vanity* proffers a lush abundance of beautiful objects, colors, and materials that is subtly undermined by the painting's ironic title and the accompanying dismissive gesture of the female peacock, who strolls across the foreground in defiance both of the male's vain display and of the would-be symmetry of the composition. WG

Oil on canvas;
40 1/2 x 50 1/4 inches
(102.87 x 127.64 cm.)
Unsigned
Gift of Mr. and Mrs. George B.
McKibbin in memory of
her father, Bernard Edward
Sunny, 1949
UL1949.1

Provenance:
Bernard Edward Sunny, 1930–1943; Mr. and Mrs. George B. McKibbin (Sunny's daughter), 1943–1949; ULC, 1949

Exhibitions:
"Painters and Sculptors in Illinois: 1820–1945," traveling exhibition organized by the Illinois Arts Council, 1971–72, #42

"American Art in the Union League Club of Chicago, A Centennial Exhibition," traveling exhibition organized by the ULC, 1980–81

References:
Loy and Honig. *One Hundred Years.* Page 169.

Martin. *Art in the ULC.* Pages 16, 35.

Richter, Marianne. "Curator's Corner: Vanity." *State of the Union: Official Magazine of the ULC* 74 (December 1998): 25.

Sparks. *American Art in the ULC.* Page 9.

Jessie Arms Botke *Vanity*, undated

NICHOLAS RICHARD BREWER
(1857–1949)

Motherhood, ca. 1921

At age twenty-six Nicholas Richard Brewer took his first art lessons, paying for them with money earned by hauling forty bushels of wheat by horse-drawn sled from his family's Minnesota farm to nearby Rochester.[1] Brewer later studied at the National Academy of Design in New York City and elsewhere in the United States. After receiving his first commission from the influential reformer and clergyman Henry Ward Beecher, Brewer developed a successful career as a painter and as a writer and lecturer on art. He became known for his likenesses of presidents, state governors, and other dignitaries, but he also painted landscapes and figural works.[2] Brewer exhibited and traveled throughout the United States during his career, maintaining studios in New York, in Chicago at Tree Studios, and in Saint Paul, where he died at the age of ninety-two. Three of Brewer's four surviving sons also became professional artists.

In addition to the official portraits of statesmen on which his fame rested, Brewer painted commissioned likenesses of women and of children. His *Motherhood* draws on that experience, but eschews the specificity of formal portraiture in favor of an intimate image of familial affection. Evidently unaware of the viewer, the mother and child intertwine in a seemingly spontaneous embrace. The strong contrasting colors of their clothing are relieved by the soft textures of fabric and hair.

For this painting, Brewer portrayed a woman and child who happened to come into a gallery in Evansville, Indiana, where the artist was showing his work. The woman, Brewer recalled, "was dressed plainly, evidently of the working class, an Italian type, though fair," and wore a shawl about her. "The tender manner in which she carried that child, hugging it close to her with the absorbing love of a devoted mother, suggested a splendid subject for a picture, and I painted her," titling the work *Motherhood*.[3] Brewer noted that among his works, it was the most popular one with girls.[4]

Though somewhat sentimental by comparison, Brewer's painting recalls the mother-and-child images of American impressionist artist Mary Cassatt in its emphasis on the physical and emotional bond between the figures. Indeed, *Motherhood* may have been inspired partly by a contemporary "revival of interest" in Cassatt's work.[5] As Americans turned their backs on the horrors of war during the years immediately following World War I, interest in the theme of maternity in art increased. Well-timed to take advantage of this climate, Brewer's *Motherhood* garnered for the artist a Municipal Art League purchase prize of $1,250 when displayed in the Art Institute's 1921 "Chicago and Vicinity" exhibition. One art critic lauded the work as "a sentimental subject handled without sentiment. For clear academic drawing and painting, about the best thing in the whole show."[6] Envious of Brewer's success, other Chicago artists unsuccessfully contested the award on the grounds that Brewer was not a resident of the city.[7] WG

Oil on canvas; 32 x 25 inches (81.28 x 63.5 cm.)
Signed lower left: N. R. Brewer
UL1976.5

Provenance:
MAL, 1921–1951; UL C&AF, 1951–1976; ULC, 1976

Exhibitions:
AIC Chicago and Vicinity Annual, 1921, #41

"Paintings by Chicago Artists," Garfield Park Art Galleries, Chicago, 1936, #40

References:
Reproduced in *American Art News* 19 (April 2, 1921): 10.

Brewer, Nicholas R. *Trails of a Paintbrush.* Boston: The Christopher Publishing House, 1938. Pages 216–18 (illus. opp. p. 96).

Martin. *Art in the ULC*. Page 35.

57 **Nicholas Richard Brewer** *Motherhood*, ca. 1921

FREDERICK ARTHUR BRIDGMAN
(1847–1928)

*Hot Bargain in Cairo (A Hot Bargain,
Cairo; Horse Market, Cairo)*, 1884

The people and lands of the Middle East held enormous fascination for Europeans and Americans in the nineteenth century. Westerners were intrigued by the exotic nature of Near Eastern cultures, an interest that increased after the 1869 opening of the Suez Canal made travel and commerce there easier. Artists shared this interest in the region, and their enthusiasm for depicting Near Eastern scenes led to the creation of a new topical category, "Orientalism," at the prestigious annual French Salon. The Club's painting, *Hot Bargain in Cairo*, appeared in the 1884 Salon and is a prime example of this romantic style.

Bridgman, who was born in Tuskegee, Alabama, studied at the Brooklyn Art School and the National Academy of Design. In 1866, he went to Paris, where he enrolled at the Atelier Suisse and also joined the artists' colony in Pont-Aven, Brittany. The next year, Bridgman enrolled in the atelier of Jean-Léon Gérôme, one of the foremost Orientalist painters and a teacher at the École des Beaux-Arts. In 1873, Bridgman visited Egypt for the first and only time. He also traveled in Algeria and would continue to return to that country during the 1870s and 1880s; travels there became the subject of his book, *Winters in Algeria* (1890). In addition to making numerous sketches on these journeys, Bridgman collected costumes and objects that could be used as props in his studio, which was decorated in the Egyptian style.[1]

Although Bridgman lived in Paris for the rest of his life, he made frequent trips to America, where his work was highly regarded. When *Hot Bargain in Cairo* was included in a New York exhibition of Salon paintings by American artists in 1885, critics singled it out for praise. One reviewer noted, in a discussion of the American paintings in the Paris Salon, that "glowing in color and easily the best in general execution, is 'a Hot Bargain,' by F. A. Bridgman."[2] The painting later appeared in Bridgman's 1890 solo exhibition at The Art Institute of Chicago; the Club may have purchased it from that exhibition.

Bridgman's earlier paintings were minutely detailed and had highly finished, smooth surfaces, much like the work of Gérôme. *Hot Bargain in Cairo* is characteristic of Bridgman's mature paintings, when his style developed to one of looser brushwork and more dynamic surfaces. The vivid colors of the merchants' robes are also typical of the artist's work, while the painting's subject matter, trading, was one of Bridgman's favorites. In America, Bridgman's paintings were especially popular with wealthy industrialists and financiers, the type of men who purchased *Hot Bargain in Cairo* for the Union League Club over one hundred years ago. MR

Oil on canvas; 33 x 52 1/2 inches
(83.82 x 133.35 cm.)
Signed lower right:
F. A. Bridgman 1884
UL1887.1

Provenance:
ULC, 1890

Exhibitions:
Paris Salon, 1884, #358 (as *Mon dernier prix—marchand, au Cairo*)

"Prize Fund Exhibition," The American Art Association of New York, 1885, #44

Annual Exhibition, Royal Academy, London, 1887, #172 (as *Horse Market, Cairo*)

The Glasgow International Exposition, Glasgow, 1888 (as either #887, *Horse Market* or #865, *A Hot Bargain, Cairo*)

Universal Exposition, Paris, 1889 "Pictures and Studies of F. A. Bridgman," AIC, 1890, #73

Fine Arts Department, Tennessee Centennial and International Exhibition, 1897, #686

"American Art in the Union League Club of Chicago, A Centennial Exhibition," traveling exhibition organized by the ULC, 1980–81

"Paris 1889: American Artists at the Universal Exposition," traveling exhibition organized by the Pennsylvania Academy of the Fine Arts, 1989–1990

References:
Montezuma. "My Note Book." *Art Amateur* 10 (May 1884): 122. Montezuma. "My Note Book." *Art Amateur* 12 (January 1885): 28.

M. H. S. "A Hot Bargain." *The Magazine of Art* 11 (1888): 409.

McCauley. *Catalogue*, 1907. #16.

Sparks. *American Art in the ULC.* Pages 8–9.

Loy and Honig. *One Hundred Years.* Pages 22–23.

Blaugrund, Annette, Albert Boime, D. Dodge Thompson, H. Barbara Weinberg, and Richard Guy Wilson. *Paris 1889: American Artists at the Universal Exposition.* Exh. cat. Philadelphia: Pennsylvania Academy of Fine Arts; New York: Harry N. Abrams, Inc., Publishers, 1989. Pages 122–124, 253 (Bridgman, n. 9–13).

Fink, Lois Marie. *American Art at the Nineteenth-Century Salons.* Washington, D.C.: National Museum of American Art and Cambridge University Press, 1990. Pages 193–194.

Frederick Arthur Bridgman *Hot Bargain in Cairo (A Hot Bargain, Cairo; Horse Market, Cairo),* 1884

FRITZI BROD
(1900–1952)

Katia, 1935

From the time she immigrated to Chicago in 1924 until her death in 1952, Fritzi Brod was an important member of the city's art community. She was born Fredericka Schermer in Prague, Czech Republic (Austria at the time), on June 16, 1900, to a wealthy Jewish family. Educated at private schools, she later studied art at the Lycee and the Art Institute in Prague, and in Vienna at the Kunstgewerbeschule.[1] She traveled extensively with her family, and during her travels she met her future husband, Ozwald "Ozzie" Brod, a native Austrian on a buying trip for his employer, the New York bookstore, Brentano's. When he was sent to Chicago to run the art department at Kroch's and Brentano's, Fritzi joined him in Chicago, and they married in 1924.[2]

When she arrived in Chicago, Brod initially worked as a textile designer, a trade she learned in Prague. Her patterns were immediately appreciated and recognized as "modern." She soon began to take painting lessons with A. Raymond Katz, who ran the Little Gallery, one of the few venues for exhibiting modern art in Chicago at the time. The atmosphere of the Little Gallery, Katz's progressive ideas, and his encouragement of her modernist inclinations profoundly influenced Brod. It is through Katz and the Little Gallery that Brod became active in the art community, joining the Chicago Society of Artists and exhibiting regularly at the Little Gallery and at the juried Art Institute of Chicago annual exhibitions.[3]

Katia is an excellent example of Brod's modernist work. This painting shows a woman sitting by an open window, alone in a room, probably a bedroom. There is a definite sexuality exuding from the work, but her eyes are downcast. The sitter wears a brightly colored, form-fitting garment, possibly a nightgown, that is low cut and exposes a portion of her breasts. Her arms are posed over her head, creating certain sensuality. Her fingers running through her hair are also very sensual, a provocative movement, yet her eyes are sad.

Brod's interest in textile design appears in this work. There are three different patterns. An elaborate pattern is used in the draped shawl, wrapped around the back of the sitter's head and then around her back, indicating a decorative use: it provides no warmth, nor does it preserve modesty. The artist uses a floral design on the tablecloth and a different, more subtle floral design on the curtain, directly behind the sitter.

The sitter's lips are brightly painted and her pose is seductive; however, the full meaning is unclear. The open window may reference her need to "cool her flames." Modernist style distortion, for which Brod was well known, can be seen in the sitter's left arm, which is far too large for the body and ultimately is little more than a design element. Brod's characteristic flattening of forms is evident in *Katia* and is reminiscent of Austrian Expressionism, which she would have seen before leaving Prague.

Brod's work of the 1930s had a very recognizable style, and *Katia* exemplifies this style. She used characteristic elements such as a single woman amply filling a composition or flattened shapes, an unusual style at the time. The works often carried a narrative aspect. Through repeated motifs Brod created a series of works that dealt with the themes of isolation and loneliness. Her ability to reveal a portion of a narrative, not the whole story, was a quality that ran through her work and is very evident in *Katia*, which leaves the viewer wondering what will become of the subject.

Brod's unconventional style pitted her against hostile critics and an unfriendly art public. Her modernist inclinations and her desire to defend her style brought her to the forefront of controversy.[4] Her work was appreciated by a few open-minded critics, such as C. J. Bulliet, art critic for the *Chicago Times* and *Chicago Daily News*. He praised the "emotional content" and the "explosive, exuberant, mad energy" in her work.[5] Brod is best remembered for her expressive style of depicting women in the 1930s. EJP

Oil on fiberboard;
34 x 27 1/2 inches
(86.36 x 69.85 cm.)
Signed lower left: Fritzi Brod–35;
signed on reverse in
orange-red crayon: Katia/$100-
UL1989.9

Provenance:
Brod family, 1952–1989; ULC, 1989

References:
Juron, Eden D. "Fritzi Brod: Modernism in Chicago." M.A. thesis, University of Illinois at Chicago, 1996.

61 **Fritzi Brod** *Katia*, 1935

ROGER BROWN
(1941–1997)

Chicago Taking a Beating, 1989

Roger Brown was one of the foremost artists of Chicago Imagism, a movement that developed in the 1960s and brought national and international recognition to its artists. Brown, who grew up in small towns in Alabama, became interested in art at an early age and, as a teenager, won a poster competition for a "Hire the Handicapped" campaign. From a strong religious upbringing, he considered becoming a preacher while enrolled at David Lipscomb College, a Church of Christ school in Nashville.[1] In 1962, Brown moved to Chicago, where he briefly studied at the American Academy of Art before entering the freshman class at the School of the Art Institute of Chicago that fall. Frustration with the school's lack of structure led him to return to the American Academy of Art, from which he graduated in 1964 with a degree in commercial design.[2] He eventually returned to the museum school and earned both bachelor's and master's degrees in fine arts. During this second experience there, he developed relationships that would be pivotal in his artistic development: with teacher and artist Ray Yoshida; with classmates, including Christina Ramberg and Philip Hanson; and with Joseph Yoakum, a self-taught, outsider artist. In the spring of 1968 noted curator and artist Don Baum saw the work of Brown, Ramberg, Hanson, and Eleanor Dube at the School and invited them to exhibit at the Hyde Park Art Center. The resulting exhibition, "False Image," which opened that fall, was Brown's first.

Throughout Brown's career, he remained largely skeptical of post-war high modernism, preferring instead outsider and folk art, as well as popular art forms such as comic books, and his paintings drew from these sources. Brown's goal was to create work of great complexity that viewers would nonetheless find easily readable.[3] Thus, *Chicago Taking a Beating* appears deceptively simple. The elements that are hallmarks of Brown's work are present: black contour lines, repeating forms, flat and minimally shaded color, silhouetted figures, and a flattened sense of space. At first glance, the painting appears to be a humorous representation of Chicago landmarks such as the Sears Tower, Hancock Building, and Aon Building bending under attack from the city's infamous wind. Yet a second reading points out the mastery with which Brown has, with great economy, shaded this whimsical image with a more ominous meaning.

Brown first explored the theme of natural disasters destroying skyscrapers in the 1970s, but he had been interested in both meteorology and the built environment even before he addressed the subject in his work. His curiosity about weather conditions dated to his childhood, when he made numerous studies of clouds and was fascinated by storms.[4] His love of architecture developed later, during his student days at the School of the Art Institute, and increased when he entered into a long-term relationship with the late George Veronda, a Chicago architect. In paintings such as *Chicago Taking a Beating*, Brown depicts the manmade world, as symbolized by its architecture, as something that is ultimately at the mercy of the natural one. The surreal, dream-like quality of *Chicago Taking a Beating* is thus not simply a humorous pun about the "Windy City," but also an expression of the artist's apocalyptic vision. MR

Oil on canvas; 48 x 72 inches
(121.92 x 182.88 cm.)
Unsigned
UL1997.6

Provenance:
Private collection, 1989–1997; ULC, 1997

References:
Lucie-Smith, Edward. *Art in the Eighties*. London: Phaidon Press Limited, 1990. Page 80.

Roger Brown *Chicago Taking a Beating*, 1989

CHARLES FRANCIS BROWNE
(1859–1920)

The Mill Pond, 1904

Charles Francis Browne's activities as a teacher, lecturer, writer, and editor as well as his artistic work made him one of the most influential figures on Chicago's art scene at the turn of the century. Born in Natick, Massachusetts, Browne worked in a Boston lithographic shop while studying at the Museum of Fine Arts school at night; he later trained at the Pennsylvania Academy of the Fine Arts and at the École des Beaux-Arts in Paris.[1] Browne came to Chicago in 1891 to paint murals in the Children's Building at the World's Columbian Exposition. After teaching at Beloit College, he joined the faculty of the Art Institute's school as a lecturer in art history and anatomy. Browne also served as art critic for the *Chicago Tribune* and as the first editor of the art magazine *Brush and Pencil*.

As a painter Browne focused on the rural landscape. In his writings he advocated local artistic subject matter, and he was known for his paintings of the area around Oregon, Illinois, where he was a member of the elite seasonal art colony known as Eagle's Nest.[2] Browne also painted numerous views of the French countryside in Brittany and in Giverny, where many American painters had gathered near the home of Claude Monet. Unlike the many contemporary American landscape painters who were influenced by Impressionism around the turn of the century, Browne mostly adhered to the Barbizon aesthetic of intimate naturalism and delicate tonal effects. Whether they portray France or Illinois, his landscapes capture pastoral nature in moments of quietude, often conveyed by a foreground body of still water.

The intimate scale of the rural scene in *The Mill Pond* and the close clustering of the white-plastered houses that can be glimpsed through wispy trees suggest a French setting; Browne probably executed the work during his twelve months abroad in 1904 and 1905. The painting presents a casually cropped view of a grassy path along the pond whose still surface reflects the autumnal colors of the bank above. Embedded in the scene, a horse-drawn cart, pushed from behind by the barely seen figure of a man, quietly underscores the domesticated character of Old World nature and evinces American nostalgia for passing rural traditions. WG

Oil on canvas; 20 x 28 inches
(50.8 x 71.12 cm.)
Signed lower left: C. F. Brown, 1904
UL1906.4

Provenance:
ULC, 1906

Exhibitions:
"Lewis and Clark Centennial Exposition,"
Portland, Oregon, 1905

References:
Loy and Honig. *One Hundred Years*. Page 170.

McCauley. *Catalogue*, 1907. #67.

Martin. *Art in the ULC*. Page 35.

Charles Francis Browne *The Mill Pond*, 1904

CLAUDE BUCK
(1890–1974)

Self-Portrait, 1950

Given his middle name in honor of the great French painter Claude Lorrain, Charles Claude Buck was born into poverty in Bronx, New York.[1] His father, an unsuccessful artist, recognized and cultivated his son's precocious artistic talent. At an early age Buck began to paint and to copy works in the Metropolitan Museum of Art; at fourteen he became the youngest student ever to enroll at the National Academy of Design, where his teachers included painters Kenyon Cox, Emil Carlsen, and George de Forest Brush. Buck's early allegorical and symbolist work found little support in New York City. In 1919, with the encouragement of Chicago art dealer J. W. Young, he moved to Chicago, where his career blossomed. In addition to exhibiting widely, Buck also taught at various art schools, including, briefly, the Art Institute. In 1927 and 1928 Buck spent twelve months touring Europe. In the following decade his conservative style of painting and outspoken criticism of modernism alienated him from the relatively progressive Art Institute. In 1943 Buck and his second wife, painter Leslie (Binner) Buck, moved to Santa Cruz, California, where they became prominent members of the local arts scene.

As critics noted, Buck's work spanned a remarkable range of subjects and styles.[2] During his years as a student at the National Academy and member of a small group of young symbolist artists known as The Introspectives, Buck painted small-scale religious and allegorical works in an imaginative style compared by some critics to that of Albert Pinkham Ryder and William Blake.[3] He also painted portraits on commission, and beginning in the early 1920s the need to support his young family prompted Buck to turn increasingly to portraiture, figure painting, and still life. For such works the artist developed a kind of polished academic hyper-realism that pays homage to the Old Masters he revered, notably Rembrandt, Leonardo da Vinci, and Raphael.[4] Striving for an integration of what he considered to be the four "distinct functions" of painting—realism, decoration, interpretation, and expression—Buck created exquisitely crafted images that made him a darling of the antimodernist movement.[5]

In the course of his long career Buck applied both his "ultra-mystical" and academic approaches to self-portraits that evince a self-fascination justified by his striking appearance.[6] "With the physique of an Apollo and the abundant locks of a Byron—and a ready tongue that dispenses an amiable philosophy of life—Claude Buck both looks and acts the artist," observed *Chicago Daily News* critic Marguerite B. Williams.[7] In the Club's 1950 self-portrait, the sixty-year-old artist portrayed himself holding his brushes and palette and gazing steadily at the viewer, as if arrested in the very act of painting. The dark, plain background, a favorite device of Buck in his portraiture, dramatizes the almost sculptural physical presence of the painter. WG

Oil on board; 27 x 23 inches
(68.58 x 58.42 cm.)
Signed lower right: Claude/Buck/1950
Gift of John Schiller
in memory of his wife, Juel, 1996
UL1996.3.2

Provenance:
Family of Claude Buck; John Schiller
(son-in-law of Claude Buck);
ULC, 1996

67 **Claude Buck** *Self-Portrait*, 1950

KARL ALBERT BUEHR
(1866–1954)

"If I Were Queen," ca. 1924

Karl Albert Buehr's early work was characterized by the shadowy tonalism of the Barbizon mode, but after the turn of the century he embraced the flattened forms and strong color of postimpressionism. By the early twenties, Buehr's popular paintings typified the conservative, decorative approach of a Chicago impressionist, with brilliant color and patterned brushwork used to render forms with relative naturalism. Born near Stuttgart, Germany, Buehr began his art studies at The Art Institute of Chicago in 1888 and exhibited there beginning in 1894.[1] He later studied at the Académie Julian in Paris, at the London School of Art, at the Academy of Rome, and with the influential American painter Frank Duveneck. Buehr worked in portraiture, figure painting, and etching. He became a noted teacher of nude and portrait painting at the Art Institute.

From 1910 to 1912 Buehr worked in Giverny, France, the home of Claude Monet. The locale attracted many American artists, who constituted the second generation of American impressionist painters. These artists frequently painted a figure posed on a porch or in a garden, a subject combining the brilliant color and light effects and the theme of leisure life so essential to the impressionist aesthetic. Buehr treated this theme as early as 1912 in his *Red-Headed Girl with Parasol*, and by the time he exhibited *"If I Were Queen"* at the Art Institute in 1924, critics had come to expect such a work from him "every year."[2] These paintings featured the artist's own daughter, Mary Kathleen, born in 1907, who later became a painter herself.[3]

Although she was a brunette, the artist often pictured her as a "Titian-haired type" with red hair because he felt "that it was more in harmony with his sunlit, out-of-doors picture[s]."[4] Buehr executed *"If I Were Queen"* in rural New York State, where he often worked during the summer.[5]

With titles such as *The Young Hostess*, *In a World of Her Own*, *Girlhood*, and *"If I Were Queen,"* Buehr's pictures of a young woman in a porch setting explore the threshold between childhood and womanhood.[6] *"If I Were Queen"* presents Kathleen seated in a rattan chair under the shelter of a white painted porch that lends architectural structure to the composition. Cradling a sewing basket in her lap, the girl appears about to repair a garment draped over a small table to the right. This practical feminine skill is contrasted with the mood of abstracted reverie suggested by her pose, as she sits leaning slightly forward, her face toward the viewer but her unselfconscious gaze deflected to the right. The girlish flights of fancy evoked by the work's title are echoed by her intriguingly incongruous garb: a short tiered skirt and a laced bodice topped by a blue flowered jacket, which have slipped down to reveal her right shoulder; pink ballet shoes encase her demurely crossed feet. Behind the figure stretches a landscape of sun-dappled fields rendered in broad patterned strokes of lush bluish greens, a background that sets off the rich red of her hair. *"If I Were Queen"* blends a straightforward portrait style with deliberate artifice to transcend its purely decorative appeal. WG

Oil on canvas;
43 1/4 x 39 3/4 inches
(109.85 x 100.97 cm.)
Signed lower right: K. A. Buehr
UL1976.8

Provenance:
MAL, 1924–1951; UL C&AF, 1951-1976;
ULC, 1976

Exhibitions:
AIC Chicago and Vicinity Annual,
1924, #18

"Paintings by Chicago Artists," Garfield
Park Art Galleries, Chicago, 1936, #5

"Normandy and Its Artists Remembered:
A 50th Anniversary of the Invasion,"
Nassau County Museum of Art, Roslyn
Harbor, N.Y., 1994

References:
Loy and Honig. *One Hundred Years*.
Pages 56–57.

Martin. *Art in the ULC*. Page 35.

Reproduced in Schwartz, Constance.
Normandy and Its Artists Remembered.
Exh. cat. Roslyn Harbor, NY:
Nassau County Museum of Art, 1994.
Page 63.

69 **Karl Albert Bueh** *"If I Were Queen,"* ca. 1924

EDWARD BURGESS BUTLER
(1853-1928)

Beyond the Desert, 1919

Like his fellow club member Wallace De Wolf, Edward Burgess Butler turned to art after a successful business career. The son of a grocery store owner, he was born in Lewiston, Maine, and left school at age sixteen to work as a traveling salesman for jewelry, hair ornaments, and similar "fancy goods."[1] In 1877 Butler joined his brother George in founding the Boston firm of Butler Brothers, which eventually grew into the largest wholesale business in the world.[2] Two years later, Butler opened a new store for the firm in Chicago and remained in the city to become an important civic leader and philanthropist. Butler served on the board of the World's Columbian Exposition and was instrumental in the development of Chicago's park system. He supported art in Chicago as a trustee and benefactor of the Art Institute. He endowed the Edward B. Butler Prize for the annual Chicago artists' exhibition at the Art Institute and in 1911 donated his important collection of paintings by George Inness.

A "nervous capitalist," Butler in his fifties turned to painting as therapeutic recreation.[3] In 1908 he began to study with landscape painter Frank Peyraud;[4] the following year, he contributed a painting to the Art Institute's annual "Chicago and Vicinity" exhibition under a pseudonym—a practice he sometimes used to ensure an impartial judgment of his work.[5] In 1914, Butler retired from business and devoted much of his time to painting.

In his later years Butler wintered in Pasadena, California, one important hub of the Los Angeles area art scene that developed after the turn of the century; he joined the California Art Club and other local art organizations. Butler's Pasadena studio overlooked the Arroyo Secco, a dry riverbed valley of desert plants and terrain that attracted many artists.[6] The Arroyo Secco may well be the setting pictured in *Beyond the Desert* as well as in Butler's numerous desert images that evince a midwesterner's attraction to the brilliant light, dramatic contours, and exotic vegetation of the far western landscape.

Within its vertical format *Beyond the Desert* presents a cross section of southern California topography, ranging from the sandy ground and scrubby desert plants of the foreground to the mountains rising in the hazy distance. Separating these contrasting zones are the foothills' rounded, grassy contours and broad live oaks. Butler pictured the region's tough, arid terrain at its gentlest, when the relative moisture of springtime brings forth brilliantly colored desert flowers and clothes the usually tawny hills in pale greens. WG

Oil on canvas; 30 x 25 1/4 inches
(76.20 x 64.14 cm.)
Signed lower left:
Edward B. Butler–1919
Gift of Duane L. Peterson, 1959
UL1986C.22

Provenance:
Posthumous gift of the artist to
Duane L. Peterson, ca. 1928–1959;
UL C&AF, 1959–1986; ULC, 1986

References:
Loy and Honig. *One Hundred Years.* Page 171.

Martin. *Art in the ULC.* Page 36.

71 **Edward Burgess Butler** *Beyond the Desert,* 1919

ALSON SKINNER CLARK
(1876–1949)

Saint Gervais, ca. 1909

Alson Skinner Clark was a Chicago native who began his studies at the Art Institute as a boy.[1] Clark went on to New York's Art Students League, where William Merritt Chase became his mentor, and then to Paris, where his teachers included James Abbott McNeill Whistler and Alphonse Mucha. Clark divided his time between Europe and America until the outbreak of World War I, in which he served as an aerial photographer. He exhibited frequently in Chicago, where he was honored with a solo exhibition at the Art Institute in 1906. In 1913 Clark traveled to Panama and made a series of paintings depicting the construction of the Panama Canal. In 1919 he visited California for health reasons and the following year he moved to Pasadena, where he joined an established group of impressionist painters and became director of the Stickney Memorial School of Art. Having been a photographer and etcher since early in his career, Clark expanded his work in later years to mural painting and lithography.

Clark's early urban scenes were Whistlerian in their somber tones; often they depict winter in northern urban locales such as Watertown (New York), Quebec, and Chicago. In the summer of 1907, however, a tour of the French châteaux country prompted a gradual brightening of his palette, the beginning of a conversion to impressionism that was completed by an extended trip through Spain in 1909.[2] Clark returned from that trip to his Paris studio at 39, Boulevard Saint Jacques, probably where he painted *Saint Gervais*. The work is reminiscent of his images of Madrid in its attention to the effect of bright light on the pale walls of urban buildings. Clark probably brought the painting home to Chicago in December of 1909, for it was hung in the Art Institute's annual exhibition of American art the following autumn.

Saint Gervais shows a view taken from Paris's Ile-de-la-Cité near the Pont Louis-Philippe, looking across the waters of the Seine to the picturesque houses lining the river shore of the Left Bank. Beyond them looms the dark roof of the church of Saint-Gervais-Saint-Protais, an eclectic structure built in stages between 1494 and 1620. Clark's focus is not on the historic church, however, but on the assortment of buildings that almost screen it from view. Distinctly Parisian with their Mansard roofs, projecting chimneys, and window shutters, these houses reflect the glare of bright autumn sunlight. In the foreground, barges and horse-drawn drays pulled up on the riverbank lend bright contrasts of color, human scale, and a distinct sense of place to this impression of the French capital. WG

Oil on canvas;
30 1/2 x 38 1/2 inches
(77.47 x 97.79 cm.)
Signed lower right: Alson Clark
UL1910.2

Provenance:
ULC, 1910

Exhibitions:
AIC American Art Annual, 1910, #44

"American Artists and the Paris Experience," Terra Museum of American Art, Chicago, Ill., 1997–1998

References:
Martin. *Art in the ULC.* Page 36.

Alson Skinner Clark *Saint Gervais*, ca. 1909

RALPH ELMER CLARKSON
(1861–1942)

Portrait of Lincoln, ca. 1909

Born in Amesbury, Massachusetts, Ralph Elmer Clarkson studied at Boston's Museum of Fine Arts school.[1] In 1887, while Clarkson was a student at the Académie Julian in Paris, Sara Hallowell, the organizer of the art shows at Chicago's Interstate Industrial Expositions and adviser to local art collectors, brought Clarkson's work to Chicago for exhibition. A decade later the painter moved to Chicago where, with his gentlemanly manner and facile portrait style, he soon became the city's leading portraitist and an influential member of its art scene. From the social gatherings held in Clarkson's hospitable studio in the Fine Arts Building emerged the Cliff Dwellers Club and its companion women's association, the Cordon Club. He was also a founding member of the exclusive summer art colony known as Eagle's Nest. Clarkson's talent for leadership led him to the presidency of the Chicago Society of Artists and of the Municipal Art League; he also served on the art commissions of both Chicago and Illinois. As a writer and lecturer Clarkson tirelessly championed art in his adopted city.[2]

Evidence suggests that the Union League Club commissioned Clarkson's portrait of Lincoln. It was painted from a rare photograph that was loaned to J. S. Dickerson, then chairman of the Club's Art Committee, by Charles F. Gunther, noted collector of Civil War memorabilia. The Club, founded to support preservation of the Union, no doubt sought an appropriate portrait of Lincoln. Historical portraits formed the foundation of its collection, including a life-sized portrait of Washington thought to be by Gilbert Stuart and Eastman Johnson's copy of the John Trumbull portrait of Alexander Hamilton, both acquired in 1895.[3] The Club purchased Clarkson's *Lincoln* in 1909, the centennial of Lincoln's birth; the portrait was unveiled to the membership at the Club's celebration of that event.

The original photograph on which Clarkson based his portrait of Lincoln was one of a group of five taken at one sitting by Alexander Gardner; these portraits were long thought to be among the last likenesses made before Lincoln's assassination on April 14, 1865.[4] The particular one chosen for Clarkson's model has the added distinction of showing the president with a rare, if faint, smile. Lincoln posed for the photograph with his spectacles in his left hand and what appears to be a pencil in his right. Clarkson changed the position of the hands slightly and shows Lincoln holding an undefined small object. However, the most striking change Clarkson made in transcribing the image was to set the figure against a dark background that focuses attention dramatically on Lincoln's face and frames his intense gaze. WG

Oil on canvas;
42 x 31 7/8 inches
(106.68 x 80.96 cm.)
Signed upper left: Ralph Clarkson
UL1909.3

Provenance:
ULC, 1909

Exhibitions:
"American Art in the Union
League Club of Chicago,
A Centennial Exhibition,"
traveling exhibition organized
by the ULC, 1980–1981

References:
Loy and Honig. *One Hundred Years*.
Pages 48–49.

Martin. *Art in the ULC*. Page 36.

Sparks, Esther. *American Art in the ULC*.
Page 19.

75 **Ralph Elmer Clarkson** *Portrait of Lincoln*, ca. 1909

WALTER MARSHALL CLUTE
(1870–1915)

The Child in the House—the Golden Age, ca. 1910

Walter Marshall Clute painted portraits and landscapes but was best known for his work in genre painting, which he described in 1911 as "my forte."[1] He attributed that interest both to his "severe academic training" and to his Dutch ancestry. Clute left his native Schenectady, New York, to study at the Art Students League in New York City.[2] He moved to Chicago in 1896, the year he helped to found the Society of Western Artists. Clute was hired as a staff artist by the *Chicago Daily News* during the Spanish-American War and studied in Paris around the years 1899 to 1901.[3] In 1904 he joined the faculty of The Art Institute of Chicago; he also taught in Park Ridge, Illinois, where he made his home, and in 1910 founded the Oxbow Summer School in Saugatuck, Michigan, with Frederick Fursman. Clute authored articles on fellow artists for the Chicago journal *Sketch Book*.

The Golden Age belongs to a series of three paintings known as *The Child in the House* that depict various stages in the childhood of Clute's daughter Marjorie.[4] They are set in the painter's Park Ridge home known as "The Birches"; there, "Mrs. Clute being an artist of considerable ability as well as a home woman, the conditions are arranged for tender and intimate genre painting, such as the Dutch delighted in," according to the *Chicago Evening Post*.[5]

Whatever its Dutch antecedents, Clute's *Golden Age* is in keeping with the contemporary popularity of domestic, feminine themes often expressed in the figure of a genteel woman reading, typically in a garden or, as here, in a quiet interior flooded with light.[6] This sunny nook in the painter's house boasts familiar touches of sophisticated contemporary taste: the soft cushion covered in bright oriental silk, the framed Japanese *ukiyo-e* print on the wall, and the garland of autumnal oak leaves, a favorite motif of Arts and Crafts decorating. The focus of the image, however, is on neither the graceful figure of the reading Mrs. Clute nor on her comfortable surroundings but on the little girl sitting beside her. Dressed in a frilly dress and blue hair bow, posed demurely with her feet crossed and hands clasped in her lap, she holds herself in an attitude of deliberate quietude. Although her face is turned toward her mother, her gaze seems to go beyond her to the window and the light-filled world beyond, while the reader, her face shadowed, is silently absorbed in her book. *The Golden Age* hints at the ironic contrast between conventional nostalgia for a lost age of innocence and the reality experienced by a child, for whom the pleasure of such quiet moments is tinged with boredom and anticipation. WG

Oil on canvas; 37 1/4 x 29 1/4 inches
(94.62 x 74.30 cm.)
Signed lower left: W. M. Clute
UL 1976.11

Provenance:
MAL, 1915–1951; UL C&AF, 1951–1976; ULC, 1976

Exhibitions:
AIC Chicago and Vicinity Annual, 1910, #60

"Fifth Annual Exhibition of Selected Paintings by American Artists," Buffalo Fine Arts Academy and Albright Art Gallery, 1910, #41

"Exhibition of Paintings by Walter Marshall Clute," The New Gallery, Chicago Academy of Fine Arts, 1911, #1

"An Exhibition of Paintings by Walter Marshall Clute," The Artists' Guild, Fine Arts Building, Chicago, 1915, #6

"The Municipal Art League of Chicago," AIC, 1918

"Exhibit of Recent Paintings loaned by The Municipal Art League of Chicago June 1–4, 1920 Under the auspices of Story County I. S. C. Alumni Association Complimentary to the visiting Alumni and friends," n.p., 1920, #11

"Paintings by Chicago Artists," Garfield Park Art Galleries, Chicago, 1936, #8

"American Art in the Union League Club of Chicago, A Centennial Exhibition," traveling exhibition organized by the ULC, 1980–1981

"Capturing Sunlight: The Art of Tree Studios," Chicago Department of Cultural Affairs, 1999

References:
Capturing Sunlight: The Art of Tree Studios. Exh. cat. Chicago: Chicago Department of Cultural Affairs, 1999. Page 40.

Loy, Dennis. "*The Golden Age* by Walter Marshall Clute." *State of the Union: Official Magazine of the ULC* 63 (Jan. 1988): 16.

Loy and Honig. *One Hundred Years.* Page 172.

Martin. *Art in the ULC.* Page 36.

Richter, Marianne. "Curator's Corner." *State of the Union: Official Magazine of the ULC* 76 (Aug. 2000): 10.

Sparks. *American Art in the ULC.* Page 10.

77 **Walter Marshall Clute** *The Child in the House—the Golden Age,* ca. 1910

WILLIAM COGSWELL
(1819–1903)

General U. S. Grant, 1879

Born in Sandusky, New York, William F. Cogswell taught himself to paint while working in a color factory in Buffalo.[1] In the 1840s he moved to New York City where he painted portraits and exhibited at the National Academy of Design and the American Art-Union. Cogswell also painted in Saint Louis, in Chicago (from 1860 to 1870), and in Washington, D. C., where his best-known work, a portrait of Lincoln, hangs in the White House. Having visited California briefly in 1849, Cogswell moved there permanently in 1873. He may also have worked in Hawaii, for he painted portraits of several prominent Hawaiians.

Cogswell painted five recorded likenesses of Ulysses S. Grant, including three bust portraits. Most were executed in 1867 and 1868, around the time of Grant's election to his first term as president of the United States, and show him in military dress as the victorious commander-in-chief of the Union army.[2] The Club's portrait, however, dates to the period after Grant left office and had become an international celebrity. It shows Grant in formal civilian dress. The sitter's pose, with his head turned slightly to his left, gives prominence to the large mole on his right cheek. Grant's indirect gaze lends this otherwise conventional, realistic portrayal a visionary touch that hints at his distinguished career as soldier and president. Grant's family is said to have considered this portrait the best of his many likenesses.[3] WG

Oil on canvas; 27 x 22 inches
(68.58 x 55.8 cm.)
Signed middle right side:
U.S. Grant /original/
by/W. Cogswell/1879
UL 1907C.7

Provenance:
ULC, by 1898

Exhibitions:
"American Art in the Union League Club of Chicago, A Centennial Exhibition," traveling exhibition organized by the ULC, 1980–1981

References:
Corliss. *Catalogue*, 1899. Page 6, #5.

Loy and Honig. *One Hundred Years*. Pages 172–73.

McCauley. *Catalogue*, 1907. #34.

Martin. *Art in the ULC*. Page 34.

Sparks. *American Art in the ULC*. Page 11.

Spirit of the Union League. Chicago: ULC, 1926. Pages 117–18.

79 **William Cogswell** *General U. S. Grant, 1879*

WILLIAM CONGER
(b. 1937)

Eagle City, 1972

Although art in Chicago for many people has been identified with Imagism in recent decades, in fact a number of the city's artists have continued to produce work that is non-representational. William Conger has been one of Chicago's leading abstract painters since the 1970s. Born in Dixon, Illinois, he studied at the School of the Art Institute of Chicago for two years and then transferred to the University of New Mexico, Albuquerque, where his teacher was the abstract painter Raymond Jonson. Conger has noted that the work of Jonson, as well as that of early modernist Arthur Dove, was influential in developing his interest in symbolizing nature through organic, yet abstract, form.[1] Conger received his B. F. A. in 1961. He also studied with Elaine de Kooning, the Abstract Expressionist. He earned an M.F.A. in 1966 from the University of Chicago.

Like his teachers, Conger's early work was nonobjective, but he subsequently went through a figurative period. His return to abstraction occurred in the early 1970s, the time to which the Club's painting dates. In the 1980s, Conger, along with the Chicago artists Richard Loving, Frank Piatek, and Miyoko Ito,

formed the "Allusive Abstractionists," a name that referred to the suggestion of—or allusion to—imagery in their work.[2] Most recently, Conger has created a series of collages in response to the death of his younger sister in 1997.[3] He has exhibited this new work in several subsequent one-person shows.[4] For many years a professor of art at De Paul University, Conger was appointed to a professorship at the Department of Art Theory and Practice at Northwestern University in 1985.

Eagle City is a transitional work, made at the beginning of Conger's return to abstraction. The pipelike shapes at the top of the painting herald a recurrent motif in his later work in which layers of tubular and geometric forms appear to float within a dark, three-dimensional space. Despite its abstraction, *Eagle City* nevertheless includes references to the tangible world, a central theme of Conger's work, which has sometimes been described as abstract illusionism.[5] The diagonal line transversing the lower part of the painting, for example, both creates a sense of spatial recession and symbolizes city pavement, while the rich blue tones of the upper part of the painting suggest the sky. MR

Acrylic on canvas; 66 x 67 1/4 inches
(167.74 x 170.82 cm.)
Inscribed reverse, upper left corner:
DK2002 W. Conger/W. Conger/
Eagle City/5-1972
Gift of Mr. and Mrs.
Douglas Kenyon, 1986
UL1986.5

Provenance:
Mr. and Mrs. Douglas Kenyon, to 1986;
ULC, 1986

References:
Loy and Honig. *One Hundred Years*.
Pages 120–21.

William Conger *Eagle City*, 1972

LEONARD CRUNELLE
(1872–1942)

Squirrel Boy, ca. 1908

Leonard Crunelle had taken drawing lessons in his native France when at the age of ten he moved with his family to Indiana.[1] Young Crunelle worked alongside his father, a coal miner, while modeling figures from clay he found in the mines. When the Crunelles moved to Decatur, Illinois, the young artist was "discovered" by sculptor Lorado Taft, who brought him to Chicago. Crunelle assisted Taft in making sculptural decorations for the World's Columbian Exposition of 1893 while attending night classes at the Art Institute. In 1896 Crunelle returned to Decatur for a few years but eventually settled in the Chicago suburb of Park Ridge. He continued to be associated with Taft's studio until his mentor's death in 1936.[2]

Crunelle won commissions for numerous sculptural monuments including the World War I Black Soldiers' Memorial in Chicago and the head of Lincoln at Lincoln's Tomb in Springfield. Crunelle's fame, however, rested on what Taft called his "caressing tributes to childhood."[3] His own six children often served as the models for projects such as the four youthful Fountain Figures he created for the Humboldt Park rose garden in 1905 (installed in Grant Park in 1964).[4] Crunelle's Squirrel Boy, probably his most famous work, was also intended as a garden ornament.[5]

Three copies of the bronze sculpture are known to exist: one was purchased by the Union League Club, another entered the Art Institute's collection in 1909, and a third entered the collection of the Cliff Dwellers Club.[6]

His curling locks adorned with a wreath of oak leaves and acorns, the Squirrel Boy holds a filbert in his right hand to tempt the alert small animal that perches on his extended left arm. Naked but not self-conscious, the child is likewise a creature of nature, representative of an Arcadian golden age. To continue the allusion Crunelle conceived the sculpture as a herm, a bust or half-figure "rooted" in a pedestal. A classical sculptural type associated with the ancient Greek portrayal of heroes, the herm was typically used in seventeenth-century garden sculpture to represent classical deities and mythological creatures of the forest.[7] Crunelle obscured the boundary between the figure's torso and the base by means of the draped animal skin, a further reference to the boy's primal innocence. The work's dark, glossy surface complements its evocation of naturalistic, expressive movement in a manner characteristic of the Beaux-Arts approach that defined academic sculpture at the turn of the century. WG

Bronze; 69 1/4 x 20 x 20 inches
(175.90 x 50.80 x 50.80 cm.)
Unsigned; foundry mark
on reverse of pedestal: Cast by
J. Berchem/Chicago
UL1908.3

Provenance:
ULC, 1908

Exhibitions:
AIC Chicago and Vicinity Annual, 1908,
#299 (possibly another copy)

"The Municipal Art League of Chicago,"
AIC, 1918

"Painters and Sculptors in Illinois:
1820–1945," traveling exhibition
organized by the Illinois Arts Council,
1971–1972, #32

References:
Bennett, Christine. "Leonard Crunelle, a Sculptor of Youth." Arts and Decoration 1 (Aug. 1911): 406.

Loy and Honig. One Hundred Years. Page 148, 172.

McCauley, L. M. "Chicago's Municipal Art Gallery." Fine Arts Journal 23 (Sept. 1910): 142–43.

Martin. Art in the ULC. Page 48.

CHARLES W. DAHLGREEN
(1864–1955)

Autumn in Bloom (Autumn in Brown County), ca. 1920

As Charles William Dahlgreen recorded in his autobiography, his first encounter with the landscape and atmospheric conditions of Brown County, Indiana, in 1915 was a revelation.[1] Beginning around 1908, Chicago and Indianapolis artists in search of attractive landscape subjects turned the sleepy rural region into a popular artists' colony.[2] By 1920, Dahlgreen was closely associated with Brown County; its steep hills, colorful foliage, and glowing light had become his primary subject. *Autumn in Bloom* depicts the locale at its most characteristic: when the brilliant color of early autumn glows in the hazy light of one of the season's last warm days.

Dahlgreen composed this quiet, light-filled scene using a series of receding diagonals counterbalanced by the vertical masses of the hickory tree in the foreground and the red- and gold-tinted trees in the left middle distance. Barely visible over the edge of the hill is the roof of a small white house at the end of a path that leads the eye from the lower right corner of the picture toward the center. A colorful mass of white phlox and red sumac fills the foreground. The artist recorded that he painted the work almost entirely on site in a three-day period.[3]

Dahlgreen was born in Chicago, the son of German immigrants.[4] As a young man he studied art in Düsseldorf, but he waited until the age of forty, after a successful career as a sign and banner painter, to launch a career as a fine artist. Following study at the Chicago Academy of Fine Arts and at the Art Institute, Dahlgreen toured Europe for more than a year. On his return to Chicago in 1910 he established himself as a landscape painter and etcher. After 1920 Dahlgreen lived in Oak Park, Illinois.[5] He painted most frequently in Brown County, Indiana, in the Ozark Mountains of Arkansas, and in Taos, New Mexico.wg

Oil on canvas mounted
on masonite; 32 x 39 inches
(81.28 x 99.06 cm.)
Signed lower right:
Dahlgreen; inscribed on reverse:
AUTUMN IN BLOOM/
Chas. W. Dahlgreen/Painted
at Nashville Ind./Brown Co.
UL1976.13

Provenance:
MAL, 1920–1951; UL C&AF, 1951–1976; ULC, 1976

Exhibitions:
AIC Chicago and Vicinity Annual, 1920, #85 (as *Autumn in Bloom*)

"Exhibit of Recent Paintings loaned by The Municipal Art League of Chicago June 1–24, 1920 Under the auspices of Story County I. S. C. Alumni Association Complimentary to the visiting Alumni and friends," 1920, #15

"Paintings by Chicago Artists," Garfield Park Art Galleries, Chicago, 1936, #10 (as *Autumn, Brown County, Indiana*)

References:
Dahlgreen, Charles. Autobiography, undated, MS, pages 197–98. Grant Dahlgreen Papers, Archives of American Art, microfilm reel 3954.

Loy and Honig. *One Hundred Years.* Pages 54–55.

Martin. *Art in the ULC*. Page 36.

85 **Charles W. Dahlgreen** *Autumn in Bloom (Autumn in Brown County),* ca. 1920

CHARLES HAROLD DAVIS
(1856–1933)

The Last Rays, 1887

Charles Harold Davis, a native of Amesbury, Massachusetts, began his study of art in 1877 at the Boston Museum of Fine Arts. In September 1880, he went to France for a year of further instruction, which turned into a ten-year stay. From the time he went abroad until his death, Davis devoted himself to landscape painting. During the 1880s, the period to which the Club's painting dates, the French Barbizon artists, who had pioneered *plein-air* painting, had the greatest influence on Davis's work. In addition to painting out-of-doors, Davis also shared the Barbizon School's preference for freer brushwork and simple views of nature.

Davis created *The Last Rays* in Fleury, a town near Barbizon, where he lived during the 1880s. Flat marshlands were a favorite subject of Davis's during this time.[1] The emphasis on horizontal elements in the painting creates a sense of stasis and tranquility, a characteristic of Davis's work. A regular exhibitor at the annual French Salons, Davis displayed *The Last Rays* at the Salon of 1887, where it was awarded an honorable mention, a significant achievement for an American. A smaller version of the painting, also dating to 1887, is in the collection of the Union League Club of New York.

Davis settled in Mystic, Connecticut, in 1892, two years after his return to America. Starting in 1895, Davis adopted the impressionist high-keyed palette and worked in a more painterly style.[2] Skies and clouds became the focus of many of his works, and he even authored an article, "A Study of Clouds," that gave students instructions on how to depict clouds.[3] A member of the Society of American Artists and the National Academy of Design, Davis co-founded the Mystic Art Association in Connecticut in 1913.[4] Shortly after his death, a critic noted in a memorial tribute:

No man was ever more passionately devoted to his art, more assiduous and untiring in the pursuit of it, and the harvest of work he left to succeeding generations is rich and varied. The kind of landscape for which Charles H. Davis is best known—green rolling hilltops shepherded over by clouds in illimitable blue—has made his name almost synonymous in our minds with the joy and spiritual effect of our cleared days in summer.[5] MR

Oil on canvas; 51 x 77 1/2 inches
(129.54 x 196.85 cm.)
Signed lower left: C. H. Davis 1887.
UL 1895R.16

Provenance:
ULC, 1895

Exhibitions:
Paris Salon, 1887 (as *Les Derniers Rayons*)

AIC American Art Annual, 1901, #95

References:
Martin. *Art in the ULC.* Page 45.

Corliss. *Catalogue*, 1899.
Pages 6–7, #6.

Loy and Honig. *One Hundred Years.*
Pages 32–33.

McCauley. *Catalogue*, 1907. #85.

PETER DEAN
(1934–1993)

Three Evening Pines, 1979

In 1977, when local authorities made plans to install a powerline in the land around Peter Dean's country home in Columbia County, New York, the artist responded by creating a series of landscapes capturing the beauty of the area before it was spoiled.[1] The pines in the Club's painting, which grew in front of Dean's house, were one of his favorite views. The painting's expressionistic interpretation of the subject matter and bright, fantastical colors are characteristic of the artist's work and reflect the influence of the German Expressionists, the Fauves, and James Ensor.

Dean is known for applying paint in an almost sculptural manner. In *Three Evening Pines*, the clouds in the upper left and the grass in the foreground are built out, while elsewhere the paint surface imitates the textures of pine needles, tree bark, and grass. Dean achieved this three-dimensional effect by using a combination of techniques to apply paint to the canvas, including squeezing paint directly out of the tube, most apparent in the grass in the foreground, and using his fingers, as is evident in the bushes in the middle ground.

Dean, who was born in Berlin, came to New York City with his family as a refugee in 1938. His academic training was in geology, and during the 1950s he worked as a field geologist in the western United States and in Brazil. He painted avocationally during this time, and upon his return to New York in 1959, he enrolled in graduate art classes at the City University of New York. In 1969, after painting and exhibiting in New York full time since 1961, Dean attracted critical attention when he and six other artists formed Rhino Horn, a group that focused on making social and political commentary through their art. Dean's figurative and expressionist style was not in fashion in the late 1960s and early 1970s, when Minimalism, Pop Art, and Op Art were embraced by the avant-garde, but in the late 1970s, when *Three Evening Pines* was created, Dean's work was considered an important example of the emergent neo-expressionist movement.

Throughout his career, Dean addressed social and political events in his work, including the assassinations of Bobby Kennedy and Malcolm X, the Vietnam War, and the displacement of Native Americans. He once said, "The artist has an absolute responsibility to make a statement out of his own time."[2] Although ostensibly a simple depiction of land, *Three Evening Pines*, inspired by the encroachment of civilization into the wilderness, expresses his philosophy. MR

Oil on canvas; 50 x 90 inches
(127 x 228.6 cm.)
Signed lower right: P. Dean
Signed on reverse: 3 Evening Pines/
50 x 90/1979 Oil/Peter Dean ©/NYC
UL1983.1

Provenance:
ULC, 1983

Peter Dean *Three Evening Pines*, 1979

WALLACE L. DEWOLF
(1854–1930)

California Coast, 1915

One manifestation of the close relationship between Chicago's business community and its art establishment in the first two decades of the twentieth century was the emergence of several figures who took up art seriously after making fortunes as capitalists. Among them was Wallace Leroy DeWolf, the son of one of Chicago's founding fathers.[1] DeWolf first became interested in art at the Chicago High School, where he was a classmate of Charles L. Hutchinson, later one of the founders of The Art Institute of Chicago; he was also a close friend of Edward Burgess Butler, another painter-business-man.[2] After training as a lawyer, DeWolf pursued a career in real estate and finance. He served as a trustee of the Art Institute and on the Art Committee of the Union League Club, of which he was a long-time member. Self-taught as an artist, DeWolf began painting landscapes in 1912, specializing in scenes of the desert and mountains of the American Southwest.[3]

Also an accomplished etcher, he collected prints and donated etching collections to the Art Institute and other museums.

As a painter and as an etcher, DeWolf was best known for his images of the southwestern deserts and mountains.[4] He translated something of their austerity into this view of an isolated spot along the California coast, where a steep bluff cascades down to a beach under a fair-weather sky. DeWolf built up layers of heavily textured paint to simulate the thick covering of vegetation, dotted with yellow flowers, that clings to the sandy hillside. Without the presence of animate life or a recognizable manmade structure—indeed, without any features to lend a defining sense of scale—the scene is eerily empty. *California Coast* envisions pre-Adamic nature, untouched by the processes of development that were then transforming southern California at a breathtaking rate. WG

Oil on canvas; 30 1/4 x 40 1/4 inches
(76.84 x 102.24 cm.)
Signed lower left: W. L. DeWolf '15
Gift of the artist, 1915
UL1915.1

Provenance:
ULC, 1915

Wallace L. De Wolf *California Coast,* 1915

PAUL DOUGHERTY
(1877–1947)

The Surf Ring, ca. 1908[1]

The most successful American marine painter of his generation, Paul Dougherty was born in Brooklyn, New York, and began a career as a lawyer before becoming an artist.[2] Dougherty studied briefly at the Art Students League with Robert Henri, but he mainly trained himself during a five-year study tour of Europe. On his return to America in 1905 Dougherty settled on the coast of Maine, began exhibiting widely, and was soon hailed for his technical prowess in capturing the drama of the New England seacoast.[3] "Everything came to him," observed painter John Sloan, "all his pictures sold, he won all the prizes. The rich delighted to honor him, and his wives were glamorous."[4] After 1913 Dougherty began working in watercolor and pastel as well as oils, picturing scenes from his travels in Asia and North America. In 1928, seeking a change of climate, he made the first of several visits to Arizona and New Mexico. Three years later, he moved to the Monterey area in California, where he continued to paint the sea.

As a marine painter Dougherty treated both the rolling deep sea and the interplay of surf and shore. Void of any human or constructed element, his seascapes are likewise indifferent to specifics of locale.[5] Around 1908, however, he seems to have been painting mostly at Monhegan Island in Maine and elsewhere on the Maine coast, a region already well established as the quintessential American seascape setting in the work of artists as diverse as Winslow Homer and Childe Hassam.[6] Like Homer, Dougherty focused in his shoreline scenes on the elemental conflict of restless water and rigid rock, but here he recorded it with a high degree of objectively observed detail and an element of academic finish unknown in the work of the older master.

The Surf Ring brings the viewer into disturbing proximity to a slanting cliff of solid rock pounded by the surf. The "ring" is a trough created around a flat shelf of stone as a dying wave recedes from its surface, while a succeeding crescent of wave gathers itself for a fresh onslaught on the shore. The ring is accentuated by the shadow cast by the cliff that cuts a curving horizontal line across the foreground. Dougherty's fluid brushwork depicts the mingling of deep green water and white foam and succeeds in capturing the precise moment of maximum stress between receding and incoming swells, without "freezing" the subject artificially. WG

Oil on canvas; 35 1/2 x 48 inches
(90.17 x 121.92 cm.)
Signed lower left: Paul Dougherty
UL1909.1

Provenance:
ULC, 1909

Exhibitions:
103rd Annual Exhibition, Pennsylvania Academy of the Fine Arts, Philadelphia, 1908, #736 (as *The Surf King [sic]*)

Carnegie International Exhibition, Carnegie Institute, Pittsburgh, 1908

"American Art in the Union League Club of Chicago, A Centennial Exhibition," traveling exhibition organized by the ULC, 1980–1981

References:
Loy and Honig. *One Hundred Years*. Pages 173, 175.

Martin. *Art in the ULC*. Page 14.

Rockwell, Edwin A. "Paul Dougherty— Painter of Marines: An Appreciation." *International Studio* 36 (Nov. 1908): iv–xi.

Sparks. *American Art in the ULC*. Page 12.

93 **Paul Dougherty** *The Surf Ring*, ca. 1908

RUTH DUCKWORTH

(b. 1919)

Untitled, 2003

Ruth Duckworth is widely recognized for her seminal role in the twentieth-century ceramics movement. Along with Hans Coper, Peter Voulkos, and Lucie Rie, her work expanded the definition of ceramics to encompass not only functional craft, but also sculptural work.[1] The youngest of five children, Duckworth grew up in Hamburg, Germany, immigrating to England in 1936 to escape the escalating anti-Semitic policies of the Nazis. Living first in Liverpool, where she stayed with her sister, Duckworth attended the Liverpool School of Art as a part-time student for four years. In 1940, she moved to Manchester and gave puppet shows with an assistant during the next two years. She subsequently worked in a munitions factory to support the war effort. Duckworth moved to London in 1943 and attended the Kennington School of Art two years later to study stone carving. She supported herself during this period by carving tombstones, an occupation she left when she saw that her sculptures were being adversely affected by the ornamental style of relief required for the job.

In 1956, Duckworth became interested in working in clay and, at the suggestion of Rie, enrolled at the Hammersmith School of Art to learn glazing formulas and techniques. However, the school's traditional and inflexible stance on what constituted ceramics soon caused her to leave and enroll at the Central School of Arts and Crafts. Duckworth then set up her own studio and taught part-time at the Central School until 1964, when the University of Chicago hired her for a one-year appointment. She remained in Chicago after the university commissioned her to create a mural for the Harry Hinds Laboratory in the Geophysical Science building, a work she entitled *Earth, Water, and Sky*. Duckworth has noted that she found America to be "a stimulating place for working. You have to keep on your toes—keep producing. You can work as large as you like, or small. It's a challenge, there is so much vitality here."[2] She set up her studio in a former pickle factory on Chicago's north side and continued to teach at the University of Chicago until 1977. Duckworth's oeuvre includes small biomorphic sculptures, functional vessels, and large abstract porcelain murals that include commissions for the State of Illinois Building, Springfield, the city of Rockford, Illinois, and Palm Beach Airport Terminal, Florida. She became a Distinguished Artist member of the Union League Club of Chicago in 2003.

Duckworth's work is marked by an emphasis on the inherent qualities of clay and porcelain. Stating once, "I hate giving things names, because it limits people's ideas about it,"[3] she does not give a title to any of her ceramics. Duckworth uses color sparingly and deliberately mutes her glazes to prevent reflections from interfering with the line and texture of the work. The Union League Club's mural is comprised of four contrasting elements: an angular triangle and a rounded half sphere project from an underlayer of long rectangular slabs, which is partially concealed by a white overlayer. The use of earth tones and shades of blue most likely allude to the sky and the ocean, reflecting the artist's longstanding concern with the fragility of the natural world in the modern age. MR

Porcelain wall mural;
15 3/4 x 15 3/4 x 6 1/2 inches
(40.01 x 40.01 x 16.51 cm.)
Gift of Ruth Duckworth and
Thea Burger to the ULC, 2003
UL2003.1

Provenance:
ULC, 2003

Exhibitions:
"Chicago Artists in the New Millennium,"
ULC, January 17–31, 2003.

References:
Richter, Marianne. *Beaux-Arts Celebration 2003: Chicago Artists in the New Millennium*. Chicago: ULC, 2003. Unpaginated [9].

Ruth Duckworth *Untitled,* 2003

FRANK VIRGIL DUDLEY
(1868–1957)

One Winter's Afternoon, ca. 1914

As a youth Frank Virgil Dudley worked with his father, a house painter and decorator in Delavan, Wisconsin.[1] After studying with Albert McCoy, an artist visiting from Chicago, Dudley moved there to work as a commercial engraver while attending night classes at the Art Institute. Beginning in 1916, Dudley devoted himself to painting in the Indiana dune country on the Lake Michigan shore. In 1921 the proceeds from the Art Institute's Logan Prize for his painting *Duneland*, which he sold to the museum, enabled the artist to close his small art supply business and build a cottage on a bluff overlooking the lake near Chesterton, Indiana. Working there for much of each year, Dudley became the most important of a host of painters who were attracted by the varied landscape of the Indiana shoreline. Local appreciation for the dunelands fostered by these artists' work contributed to efforts to preserve the area, and in 1923 more than two thousand acres were set aside as Indiana Dunes State Park.[2] Dudley continued to live and work on park grounds, giving one painting annually to the Indiana State Department of Conservation in lieu of rent.[3]

The movement to preserve the Indiana dunes country had begun as early as 1911, around the time that Dudley "discovered" the dunes as his artistic subject after hiking there with the Prairie Club.[4] This organization was one of numerous contemporary manifestations of a burgeoning spirit of regional identity that championed local cultural expression and the appreciation and preservation of the local landscape. In 1918, three other such organizations—the Friends of Our Native Landscape, the Dunes Pageant Association, and the Conservation Council—jointly organized an exhibition at the Art Institute that included thirty paintings by Dudley simply titled "Western scenes." Invited to guess their locales, many viewers thought they pictured the American West or the Pacific coast and were surprised to learn that such unspoiled natural beauty existed just around the bend of Lake Michigan.[5]

One Winter's Afternoon typifies Dudley's portrayal of the Indiana dunelands as an unpeopled place of understated beauty. In this early winter scene, the somewhat tumbledown barn nestled in the gentle rise of the land has a closed, forgotten appearance, despite the sweeping arc of fresh tracks that seem to approach it as they lead the eye into the scene. The high horizon fixes attention on the foreground expanse of snow, punctuated by the dried remnants of summer grasses. The glancing rays of the low winter sun create a pattern of softly tinted shadows that describe the gradual contours of the upward slope to the left. In his dune paintings Dudley often explored the subtle nuances of color in expanses of snow or sand to convey the quiet appeal of a natural landscape set apart from the ravages of a not-too-distant metropolis. WG

Oil on canvas; 38 1/4 x 60 inches
(97.16 x 152.40 cm.)
Signed lower left: Frank V. Dudley
UL1976.14

Provenance:
MAL, 1914-1951; UL C&AF,
1951-1976; ULC, 1976

Exhibitions:
AIC Chicago and Vicinity Annual,
1914, #98

"International Exhibition of Paintings,"
Carnegie Institute, Pittsburgh, 1914

"The Municipal Art League of Chicago,"
AIC, 1918

"Exhibit of Recent Paintings loaned by
The Municipal Art League of Chicago
June 1–24, 1920 Under the auspices of
Story County I.S.C. Alumni Association
Complimentary to the visiting Alumni
and friends," 1920, #5

"Paintings by Chicago Artists," Garfield
Park Art Galleries, Chicago, 1936, #11

"Dudley Dune Paintings," Sloan Gallery
of American Paintings, Valparaiso
University, Valparaiso, Ind., 1976

"American Art in the Union League Club
of Chicago, A Centennial Exhibition,"
traveling exhibition organized by the ULC,
1980–1981

"Indiana Influence," Fort Wayne Museum
of Art, Fort Wayne, Ind., 1984

"Frank Dudley," Krasl Art Center,
St. Joseph, Mich., 1984

References:
Gerdts, William H. and Peter Frank.
Indiana Influence. Exh. cat. Fort
Wayne, Ind.: Fort Wayne Museum of Art,
1984. Page 54.

Gerdts. *Art Across America*. Vol. 2, page 279.

Loy and Honig. *One Hundred Years*.
Pages 60–61.

Martin. *Art in the ULC*. Page 20.

Sparks. *American Art in the ULC*. Page 12.

Frank Virgil Dudley *One Winter's Afternoon*, ca. 1914

CHARLES WARREN EATON
(1857–1937)

On Lake Lugano, ca. 1906

Charles Warren Eaton moved to New York City from his native Albany, New York, around 1879 to study at the National Academy of Design and at the Art Students League.[1] Eaton painted landscapes in oils and also became an accomplished watercolor painter and landscape photographer. He met George Inness, who would become his mentor, after he built a studio in Bloomfield, New Jersey, not far from the great landscape painter's home. Eaton painted extensively in that area, in Maine, and in Connecticut, the setting for his many depictions of white pine forests that earned him the title of "The Pine Tree Painter." He also made numerous trips to Europe, painting particularly the rural landscape and quaint old cities of Holland and Belgium. In his later years Eaton drew material from a 1921 trip to Montana. After 1927 he ceased to paint but continued to promote his work tirelessly.

Under Inness's influence in the 1890s, Eaton created poetic landscapes in a tonalist manner. After 1900 a new sense of decorative patterning entered his work along with European subjects and, perhaps, the influence of Monet and the Belgian symbolist artist Fernand Khnopff.[2] Working with a deliberately limited range of color, Eaton favored late autumn, winter, and nighttime settings and reflections of trees and buildings in still water; his urban images, including many of the medieval town of Bruges, are suggestively empty and silent. He found the softened, blurred texture and rich but dry color of pastel an excellent medium for conveying moods of mystery or elegiac retrospection. In an article on pastel he published in 1909, Eaton enthused: "There is perhaps no medium at the command of the artist for pictorial expression that is at once so delightful and so fascinating as pastel."[3]

In the first decade of the century, Eaton's frequent trips to Europe began to include excursions to Italy, where he was drawn to the dramatic scenery around Lake Como. He also made at least two views of nearby Lake Lugano, both pastels.[4] Beginning in 1910 this region, with its colorful architecture and relatively bright light, would stimulate Eaton to experiment with a brighter palette and greater detail. His 1906 *On Lake Lugano* marks a transition from his earlier tonalism to a style infused with the formal concerns of impressionism. Brilliant light illuminates the warm, glowing tones of stucco buildings, but Eaton's image of sunset emphasizes by subtle contrast the coming twilight. In an almost perfectly square composition, gentle diagonals are balanced against vertical forms. The resulting sense of repose is underscored by Eaton's rendering of forms as soft-edged, almost shadowy masses of rich color. Seemingly unpopulated and static even at a moment of temporal transition, the alpine pleasure-ground of Lake Lugano assumes an air of ethereality and even mystery. WG

Pastel on commercially prepared
canvas; 29 3/4 x 28 inches
(75.57 x 71.12 cm.)
Signed lower left: Chas. Warren Eaton
UL1906.5

Provenance:
ULC, 1906

Exhibitions:
"Annual Exhibition of Water-Colors,
Pastels and Miniatures by American
Artists," AIC, 1906, #96

References:
Loy and Honig. *One Hundred Years*.
Page 174.

McCauley. *Catalogue*, 1907. #20.

Martin. *Art in the ULC*. Page 37.

Charles Warren Eaton *On Lake Lugano*, ca. 1906

EVE GARRISON
(1908–?)

Bride and Groom, 1959

Bride and Groom was a daring choice for the top award at the Fourth Union League Art Show in 1961. The jurors that year— Ivan Albright, James Murray Haddow, and Nicola Victor Ziroli— departed from the usual choice of a realist work to select a more avant-garde painting. The Club's award was only the second that Garrison had received for her work, and the first since she turned to abstraction in the 1940s. She wrote to Art Committee chair C. Dewey Imig, "This prize will be enough encouragement for me to keep on going for a long long time."[1]

The energetic, calligraphic style of *Bride and Groom* is characteristic of Garrison's paintings of the late 1950s. The artist intended for viewers to understand her paintings on more than one level. She noted that "Bride and Groom at first appears to be a big crushing city overtaking the spectator. Then there emerges the two forms Bride and Groom. This expresses the great human aim pushing for greater living in the merger of two souls tied together thru eternity."[2]

Garrison, who was born in Boston, studied at the School of the Art Institute of Chicago from 1926 until 1930.[3] After her change to abstraction, she became intensely dedicated to modern art. She once commented that "after 30 years of painting one either is a creative artist or an imitator of nature, and I refuse to be an imitator of nature."[4] In addition to oil paintings such as *Bride and Groom*, Garrison created works in which embedded glass, seeds, strings, boxes, branches, and other objects were incorporated into the paint surface. Continually interested in new styles, her work changed again in the mid-1960s after she became interested in the Op Art movement.

Although she was never widely known, Garrison had loyal friends. When a fixed income made it necessary for her to pare down her possessions in the 1970s, no less a figure than Joseph Shapiro, the noted Chicago collector and supporter of avant-garde artists, came to her assistance in finding public spaces for her work. Today Garrison is remembered as an important contributor to the modernist movement in Chicago and as a champion of the avant-garde. MR

Oil on masonite board;
60 x 48 inches (152.4 x 121.92 cm.)
Signed upper left: Eve Garrison 59
UL 1961.1

Provenance:
ULC, 1961

Exhibitions:
"Fourth Union League Art Show,"
ULC and the Newcomb-Macklin
Galleries, 1961 (awarded first-place
purchase prize).

101 **Eve Garrison** *Bride and Groom*, 1959

MIKLOS GASPAR
(1885–1945)

Scenes from Union League Boys Clubs, 1935

In 1935, the Union League Club commissioned Miklos Gaspar to create murals chronicling the activities enjoyed by the boys who were members of the Union League Boys Clubs (now called the Union League Boys and Girls Clubs). In 1919, concerned over illiteracy and rising crime rates in Chicago's economically disadvantaged neighborhoods, Club members had created a philanthropic organization, affiliated with the national Boys Club Federation, to help youth break free of the cycle of poverty. The first club opened in May 1920 and has provided continuous service to the community to this day. The success of "Club One," located in Chicago's Pilsen neighborhood, led to the purchase of eighty acres in Salem, Wisconsin, where the Union League Boys and Girls Clubs established a summer camp in 1924. The organization opened a second club, in the West Town area of Chicago, in 1926. Today, the Union League Boys and Girls Clubs runs four clubs that provide after-school recreational and educational programs to more than 5,600 Chicago children.[1]

The decision to use Gaspar for the project was not surprising: the artist, one of the city's best-known muralists, had recently gained even greater attention for the murals he did in the General Motors Building at the 1933–34 Century of Progress World's Fair in Chicago.[2] Gaspar had moved to Chicago in 1921. Born in Kaba, Hungary, he had studied at the Art Academy and the Industrial Art School in Budapest and later in Italy. A member of the Hungarian Art Institute, Gaspar was a successful artist in his homeland, winning awards for his work from the Gallery of Arts and the National Salon of Budapest. During World War I, the Hungarian government assigned him to the Imperial and Royal Press Headquarters as a war painter, and he traveled to Russia, Bulgaria, Romania, Serbia, and Italy to cover the conflict. After his move to Chicago, Gaspar quickly made a name for himself as the winner of the *Chicago Tribune*'s historical mural paintings competition in 1922. As a result, Gaspar received important mural commissions from the Medinah Athletic Club,

the Knights of Columbus Building in Springfield, Illinois, the Terre Haute House, in Terre Haute, Indiana, and the Century of Progress Exposition. Gaspar also made easel paintings and watercolors, and during the 1920s he exhibited regularly in the Chicago and Vicinity and American Watercolor juried exhibitions at The Art Institute of Chicago. In his later years, he created mural paintings of religious subjects for churches in Chicago and the outlying region.

Scenes from Union League Boys Clubs is comprised of twenty-eight murals that include scenes at Clubs One and Two, as well as at the camp, and show the educational and recreational programs the Union League Boys and Girls Clubs provided in a chronological narrative. Thus, the initial scenes depict boys playing on the streets in rags, the main section depicts their experience in the clubs and at camp, and the concluding scene depicts the oldest boys who are now ready to contribute to society. The room was dedicated on October 10, 1935.

Gaspar used boys from the clubs as the models for the murals, sketching their forms directly onto the canvas with brown paint. Because of his practice of outlining the figures and then filling in the forms with color, the murals have a decorative quality. Recent conservation has revealed that after making the preliminary sketches, Gaspar blocked in the scenes using light, medium, and dark tonal values. He next used thick-bodied paint, or impasto, as a means of highlighting important areas of the composition and creating a strong contrast with the more thinly applied paint used in areas of shadow. Finally, Gaspar added thin layers of opaque color over the oils in some areas to add further shading and contour to the figures and landscape.[3]

Today, these lively scenes stand not only as examples of the great interest in mural decoration during the Great Depression, but also as important documentation of the programs offered by the Union League Boys and Girls Clubs during its early years. MR

Oil on canvas; murals mounted on plaster walls; 81 inches x 93 feet, 8 1/2 inches (linear feet)
Signed in several locations:
M. Gaspar / 1935 / Chicago ILL.
UL1935.1

Provenance:
Commissioned by ULC, 1935

References:
Gray, Mary Lackritz. *A Guide to Chicago's Murals*. Chicago and London: University of Chicago Press, 2001. Pages 46–47.

FREDERIC MILTON GRANT
(1886–1959)

The Sketch Class, 1914

Born in Sibley, Iowa, Frederic Milton Grant was a talented musician who studied architecture in Fargo, North Dakota.[1] He moved to Chicago to work as a commercial artist while studying at The Art Institute of Chicago and at the Chicago Academy of Fine Arts. In 1907 Grant attended the summer class in Venice, Italy, conducted by William Merritt Chase, who awarded him the annual prize for the best summer student. Grant went on to Paris to study at the Colarossi Academy with American impressionist painter Richard Miller. In the teens he established himself in Chicago as a popular painter of brilliantly colored genre scenes; in the next decade his work tended toward exotic historical images of pageantry and architecture. After World War II Grant moved to Oakland, California, where he created abstract paintings influenced by musical compositions.

In 1914 Grant was a student of Henry Snell in Gloucester, Massachusetts, when he traveled to Carmel, California, to study again with his old master, Chase. In Carmel the class worked from a model posed on the beach. Grant remembered Chase's advice to his students in Venice to find an untried way of picturing a familiar subject or locale. Recalled Grant, "While the class was painting from the model on the beach, I chose to paint something different. I stood high on the cliff, looking down on them."[2] The result is *The Sketch Class*, a decorative, almost abstract composition that bears out Grant's own teaching that the abstract qualities of a painting determine its merit, even if it is representational.[3] The expanse of pale beach sand dotted with parasols and clusters of students with their easels can be read as a flat surface of beige painted canvas irregularly punctuated by spots of color. The colorful Japanese parasol that fills the lower left recalls contemporary Western fascination with Asian culture while it parallels and visually reinforces the picture plane. WG

Oil on canvas; 23 3/4 x 20 1/2 inches (60.33 x 52.07 cm.)
Signed lower right: Frederic M. Grant/Carmel-by-the-Sea/–14
UL1976.18

Provenance:
MAL, 1915–1951; UL C&AF, 1951–1976; ULC, 1976

Exhibitions:
"Twenty-Second Annual Exhibition of the Works of the Art Students League," AIC, 1915, #20

"The Municipal Art Gallery," AIC, 1918

"Exhibit of Recent Paintings loaned by The Municipal Art League of Chicago June 1-24, 1920 Under the auspices of Story County I. S. C. Alumni Association Complimentary to the visiting Alumni and friends," 1920, #9

"Paintings by Chicago Artists," Garfield Park Art Galleries, Chicago, 1936, #13

"American Art in the Union League Club of Chicago, A Centennial Exhibition," traveling exhibition organized by the ULC, 1980–1981

References:
Martin. *Art in the ULC*. Page 39.

Sparks. *American Art in the ULC*. Page 14.

J. JEFFREY GRANT
(1883–1960)

The Fascinating Village, 1956

The son of a painter, James Jeffrey Grant studied art in his native Aberdeen, Scotland.[1] He immigrated to North America to work as a commercial artist in Toronto and Winnipeg before settling in Chicago.[2] Grant was exhibiting professionally by 1917. In 1924 he made a painting trip to France, and during 1926 and 1927 he studied in Munich.[3] Grant realized a modest success, with three solo exhibitions at the Art Institute between 1927 and 1944. In the 1920s his work ranged from still lifes to nudes to seascapes; later he specialized in landscapes depicting Chicago, the surrounding region, and Gloucester, Massachusetts, a popular artists' haunt. In the 1950s Grant, regarded as a thorough conservative, garnered respect for his well-crafted, charming canvases.[4] He served on the jury for the Union League Club's first biennial art show in 1955.[5]

From the early 1930s to the end of his career, Grant portrayed small-town life. His images of Gloucester, of Galena and of Lemont, Illinois, and even of Chicago's South Side emphasize the slow pace of life in communities bypassed by progress. Unlike such contemporaries as Charles Burchfield and Edward Hopper, however, Grant's view of such places is emotionally muted. Thoroughly committed to representationalism in his art, Grant composed his works with particular attention to formal qualities, often applying paint in patterns of repeated strokes that emphasize the flat two-dimensionality of the painting's surface. The resulting decorative effect lends even his images of depressed rural towns a reassuring charm.

The title *The Fascinating Village* suggests a remote, even exotic, and perhaps beautiful subject, but the scene pictured here is a redundantly ordinary one: the back streets of a midwestern town in the grip of dreary winter. The setting can be identified as Lemont by the building that rises in the background: the Roman Catholic church of Saints Cyril and Methodius, completed in 1929. Rutted snow, the starkly angular branches of bare trees framed against a leaden sky, and a tumbledown fence are among the elements that lend a note of quotidian realism to the scene. Its emptiness is emphasized by the loneliness of the trudging, faceless figures of a woman and a child and the uniformly half-shaded windows of the surrounding houses. These boxy structures, crowded together in random juxtaposition, offer notes of cheerful color to contrast with the grays and whites of snow and sky. Here, as elsewhere in his work, the artist presents a town from its back side in a sympathetic revelation of the surprising romance to be found in the ordinary. WG

Oil on canvas;
25 7/8 x 29 7/8 inches
(65.7 x 75.88 cm.)
Signed lower left: J. Jeffrey Grant
UL1986C.48

Provenance:
Henry E. Cutler, to 1957;
UL C&AF, 1957–1986 (gift of Henry E. Cutler in memory of Hattie M. Cutler);
ULC 1986

Exhibitions:
Second Union League Art Show, ULC, 1957

References:
Loy and Honig. *One Hundred Years*. Page 177.

Martin. *Art in the ULC*. Page 39.

The Fascinating Village, 1956

OSKAR GROSS

(1871–1963)

Mother Earth (The Good Earth), 1937

Oskar Gross, the son of a prominent Viennese architect, first achieved success as a muralist whose work was highly regarded by American architects such as Daniel Burnham and Louis Sullivan. Gross studied at the Imperial Royal Academy of Fine Arts in Vienna, graduating with honors in 1896; he continued his artistic education in Munich and Paris. In 1898, he won his country's competition to create murals for the Austro-Hungarian State Pavilions for the Universal Exposition held in Paris in 1900. Burnham and Sullivan, who attended that world's fair, admired his depiction of Hungarian peasants and horses and suggested that he come to Chicago. After a brief period in New York, Gross and his wife arrived in Chicago in 1903. He continued to work as a muralist until 1910 when, with diminishing commissions from architects, he turned his attention to society portraiture.[1] Although his work was included in numerous group exhibitions, perhaps Gross's greatest fame came in 1942, when the *Chicago Tribune* reproduced his portrait of General Douglas MacArthur and circulated more than 144,000 buttons printed with the image.[2] After 1942, Gross was no longer as active artistically.

Although one critic believed the social conditions caused by the Great Depression prompted Gross to depict the working class, the artist's interest in this subject matter was longstanding, as evidenced in his murals for the 1900 Universal Exposition.[3] The origins of *Mother Earth* also precede the depression. In the mid-1920s, Gross had envisioned creating a painting that would embody the idea that "we have to give to the earth what we take from it. We have to till it and that is universal."[4] It would take him ten years to find a satisfactory way of representing this concept. Gross's patience paid off, for the painting met with success when it was exhibited in Chicago. In 1940, the Municipal Art League, an association of Chicago-area arts organizations, awarded *Mother Earth* its annual purchase prize, given to the work it deemed the best in The Art Institute of Chicago's annual juried exhibition of Chicago artists.

Gross made sketches of mountaineers and Cherokee plowing the slopes of the Smoky Mountains during visits to the area in 1927 and 1928, but he remained unsatisfied with these initial attempts, and he set them aside. In 1937, he was inspired to return to the subject after seeing the film adaptation of Pearl S. Buck's novel, *The Good Earth*. Later that year, during travels to the Tyrol, north of the Brenner Pass, the artist made sketches of a family plowing along a steep slope without benefit of oxen or horses. Gross then created a plasteline model of the group in his Chicago studio in order to recreate the tautness of the rope. *Mother Earth*'s low vantage point and strong diagonal, leading from lower left to upper right, create a sense of motion and labor, while the predominant earth tones symbolically join the figures to the earth they plow. The figures' struggle to till the soil and find sustenance out of rugged and inhospitable terrain personifies the triumph of the human spirit that Gross had found so compelling. MR

Oil on canvas mounted on fiberboard; 52 1/4 x 44 1/4 inches (132.72 x 112.40 cm.)
Signed lower right: Oskar Gross 37/Tyrol
UL1976.21

Provenance:
MAL, 1940–1951; UL C&AF, 1951–1976; ULC, 1976

Exhibitions:
AIC Chicago and Vicinity Annual, 1940, #81

References:
Gross, Oskar. "The Origin of a Painting." *The Union League Club Bulletin* 20 (May 1943): 18–19.

Loy and Honig. *One Hundred Years*. Page 178.

109 **Oskar Gross** *Mother Earth (The Good Earth)*, 1937

OLIVER DENNETT GROVER

(1861–1927)

Upper St. Mary's, Glacier National Park, 1923

Illinois native Oliver Dennett Grover attended law school during the day; at night and on vacations he studied art at the Chicago Academy of Design, the predecessor of The Art Institute of Chicago.[2] In 1879 a legacy enabled him to travel to Europe for study in Munich, Paris, and Italy, where he worked with Frank Duveneck. A versatile and technically accomplished artist, Grover returned to Chicago in 1884 at a moment of burgeoning opportunities for academically trained artists in the Midwest. Grover became a successful painter of murals and set designs; his portraits, figure paintings, and landscapes were also in demand. He taught at the Art Institute. Conspicuously identified with the art establishment of his day, Grover later became a target of modernist attacks on conservative institutions and methods.

In the early part of his career, portraits and figure paintings dominated Grover's easel work. In the 1910s, however, he turned increasingly to landscape painting. In the wake of the Armory Show of 1913, which introduced shocked Americans to avant-garde European art, native landscape held a new appeal for conservative artists, such as Grover, who were repelled by the foreign "insanity" of modernism. Grover made several trips to the West and California. The exact date of his visit to Montana's Glacier National Park is unknown, but in 1924 Ackermann Galleries in Chicago held an exhibition of the aging artist's recent paintings of Venice and of the park, a show that may well have included the Club's *Upper St. Mary's.*[3]

After Glacier National Park was established in 1910, the Great Northern Railway mounted a vigorous advertising campaign to stimulate tourism there.[4] Like Charles Warren Eaton, who visited in 1921, Grover was attracted by the area's spectacular mountain scenery. On 1,584 square miles along the Canadian border in northwest Montana, the park encompasses some fifty glaciers, precipitous peaks over ten thousand feet tall, and approximately 250 lakes, of which St. Mary's is considered the most beautiful.[5] Grover used a vertical format to emphasize the towering peaks that characterize the landscape, while the composition's high vantage point maximizes the visible expanse of the turquoise-tinted lake. In the foreground, a pair of mounted figures lend a sense of scale to the natural view and suggests the park's appeal for visitors from such flat, urbanized environments as Chicago.

Upper St. Mary's, Glacier National Park has been extensively repainted, especially in the foreground area of the lower left. WG

Oil on canvas lined to fiberboard;
75 x 57 inches (190.5 x 144.78 cm.)
Signed lower left:
Oliver Dennett Grover/1923
UL1930.1

Provenance:
Mrs. Oliver Dennett Grover,
to 1929; ULC, 1929

Exhibitions:
ULC, 1928[1]

References:
Loy and Honig. *One Hundred Years.*
Pages 44–45.

Martin. *Art in the ULC.*
Pages 22, 39.

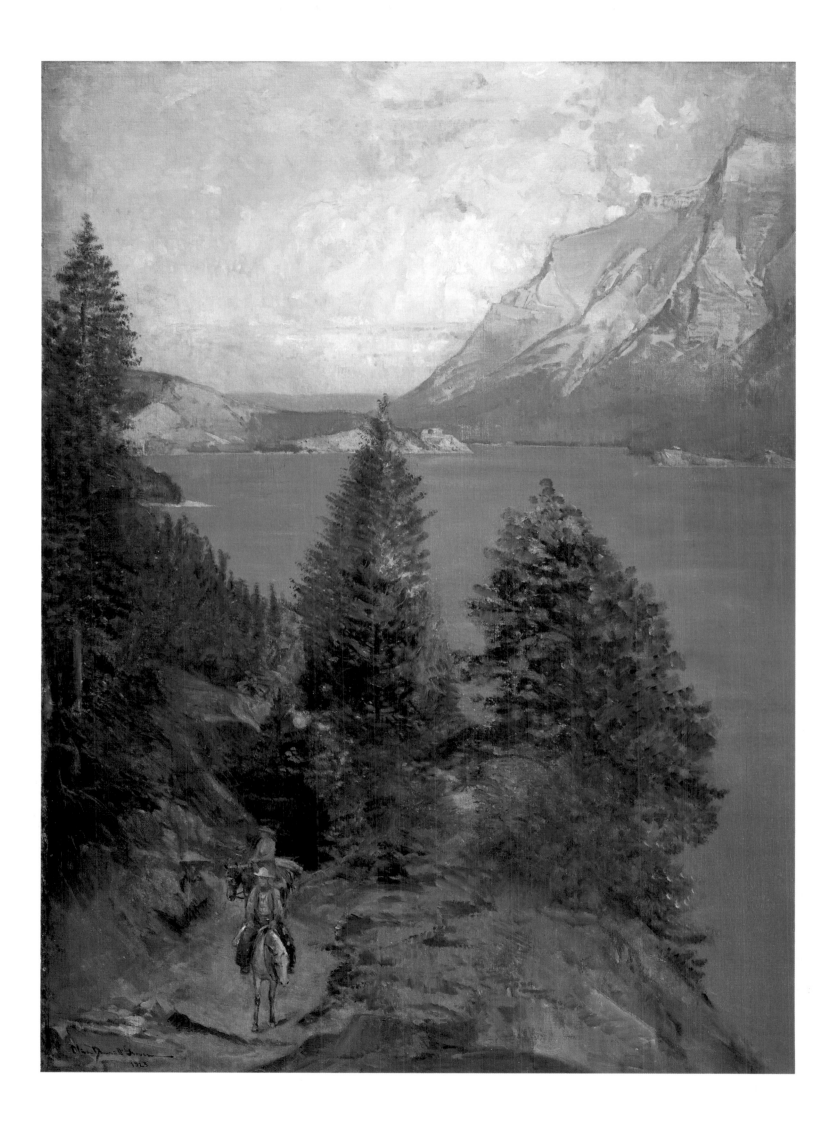

111 **Oliver Dennett Grover** *Upper St. Mary's, Glacier National Park*, 1923

LOWELL BIRGE HARRISON
(1854–1929)

Sunlight and Mist, Quebec, ca. 1910

Lowell Birge Harrison was born in Philadelphia, where he studied at the Pennsylvania Academy of the Fine Arts.[1] At the urging of painter John Singer Sargent, Harrison went to Paris in 1877 to study with Carolus-Durand and Cabanel, both successful academic portrait and figure painters. He spent his summers at popular artists' colonies in Brittany and Normandy. There he took up the current practice of *plein-air* painting, in contrast to the traditional practice of painting landscapes and other out-of-doors scenes in the studio. In 1880 Harrison's painting *Novembre* was one of the first works by an American artist purchased by the French government. Two years later, he began extensive travels to Australia, Asia, India, and Africa, during which he wrote and illustrated articles for *Harper's* and other popular American magazines. After six years in California, where he turned his attention permanently to landscape painting, Harrison returned to the Northeast, working in Massachusetts, Quebec, and New York City. In 1897 he began a lifelong association with the artists' colony of Woodstock, New York, where he directed and taught at the Art Students League summer school, founded in 1906.[2] Birge Harrison occasionally exhibited with his brother Alexander, a marine painter.

By 1910, when he was at the height of his success, Harrison had found his speciality in tonalist views of cities shrouded in wintertime mist and gloom or caught in the subdued light of twilight, moonlight, or dawn.[3] In the early 1890s, Harrison's first works in this vein were part of an exciting new trend in American painting of embracing contemporary subject matter by picturing the urban landscape and urban life. Such painters as William Merritt Chase and Childe Hassam applied an impressionist aesthetic of bright light and color to images of city parks peopled by a leisured middle class, but Harrison took a more consciously romantic approach. His broadly composed views subordinate details to unifying atmospheric effects. Inspired by the ethereal, moody late landscapes of George Inness, who had first encouraged him to paint New York City,[4] Harrison used what he termed a "lost-edge" technique to render an emotionally expressive impression "of strength and power or of poetic beauty which have come to us direct from nature." The test of the highest form of art, he wrote in his 1909 book *Landscape Painting*, is "that it should stimulate the imagination and suggest more than it expresses."[5]

For several years Harrison regularly spent part of each winter in Quebec.[6] *Sunlight and Mist* was one of a group of Quebec landscapes that created "a sensation" when they were exhibited in the artist's solo show at Thurber Art Galleries in Chicago in 1911.[7] Painted from the tower room of the fort of Frontenac overlooking the St. Lawrence River, these views embraced such "unlovely" features as the sheds and railways along the river's banks "which the modern painter in search of realism would not dare to eliminate," but treated them with " a gentleness . . . which robs the inartistic material of its crudities." *Sunlight and Mist* presents the ragged, dark forms of the sheds in the foreground as a foil for the glowing surface of the frozen waterway and the pale blue-gray banks in the distance. Steam from the buildings mingles with wraithlike clouds filtering the weak winter sunlight, which picks out a pale golden path on the river. Praised as a "feat of depicting silvery light," *Sunlight and Mist* evokes the chill of deep winter as a softening filter for the urban setting. WG

Oil on canvas lined to
fiberboard; 25 x 28 inches
(63.5 x 71.12 cm.)
Signed lower right: Birge Harrison
UL1910.4

Provenance:
ULC, 1910

Exhibitions:
"Special Exhibition of Oil Paintings
by Birge Harrison," Detroit Museum
of Art, 1910, #9

"A Collection of Paintings by
Mr. L. Birge Harrison, A.N.A.," The City
Art Museum of St. Louis, 1910, #4

Birge Harrison solo exhibition,
Thurber Art Galleries, Chicago,
Dec. 1911

"Illinois Landscape Art 1830–1975,"
Lakeview Center for the Arts
and Sciences, Peoria, Ill., 1975–1976

References:
Hoeber, Arthur. "Birge Harrison,
N. A., Landscape Painter."
International Studio 44 (July 1911): [ix]

Loy and Honig. *One Hundred Years.*
Pages 30–31.

Martin. *Art in the ULC.*
Pages 39, 45.

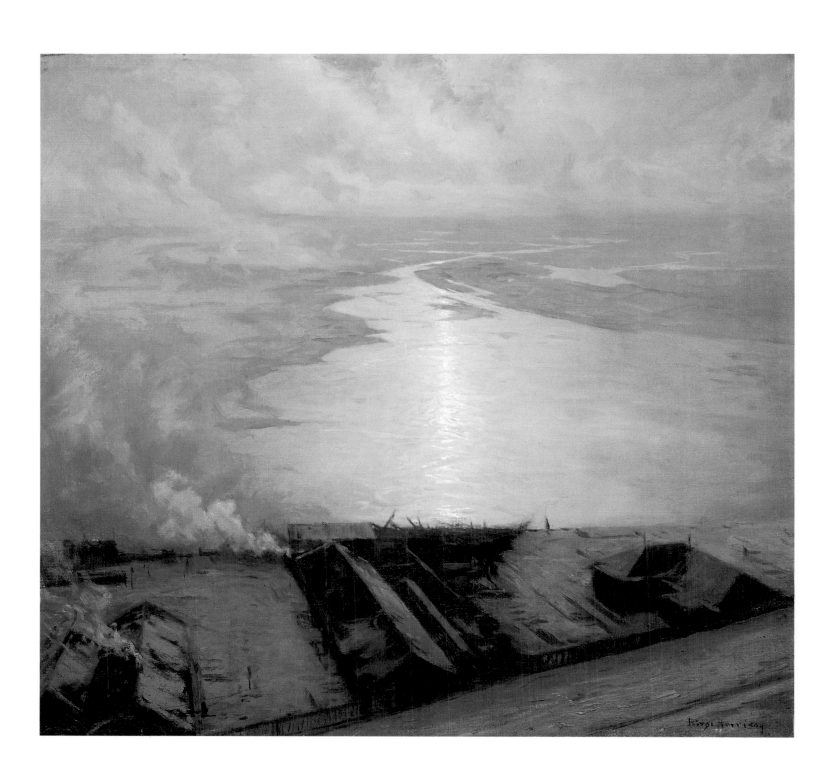

Lowell Birge Harrison *Sunlight and Mist, Quebec,* ca. 1910

LUCIE HARTRATH
(1867[1]–1962)

The Oaks (The Red Oak; Autumn Pageant), ca. 1922

Lucie Hartrath was born in Boston, grew up in Cleveland, and received her first art lessons while visiting relatives in Switzerland.[2] She later attended The Art Institute of Chicago, but after a few months Hartrath continued her studies in Paris, exhibited there at the Salon des Beaux-Arts, and worked in Brittany. On her return to the United States, Hartrath taught at Rockford College for two years ending in 1904. She established herself in Chicago, with two stays in Munich, in 1905 and 1906, where she studied and began to paint landscapes. From the 1910s through the 1930s Hartrath's light-filled impressionist renderings of the rural midwestern landscape were well received in numerous exhibitions.

In 1908 Hartrath was among the first Chicago artists to work in Brown County, Indiana, which soon became a busy seasonal artists' colony.[3] With its hilly, thickly wooded terrain and slow pace of life, the region offered a "primitive, secluded world" that appealed strongly to urban painters and to their public.[4] Hartrath likened the special quality of its light and atmosphere to that of northern France.[5] Impressionist renderings of peaceful Brown County scenery became her trademark, although she continued to produce figure paintings as well. Hartrath encouraged fellow Chicagoans, notably Charles Dahlgreen, to work in Brown County, and she used her influence among Chicago's well-to-do clubwomen to raise funds for the establishment of the region's first public library, in the county seat of Nashville.[6]

In the early 1920s, when she painted *The Oaks*, Hartrath had moved from painting mostly green-saturated canvases of midsummer scenes to more images of autumn. Compositionally reminiscent of Charles Dahlgreen's *Autumn in Bloom* of about 1920, also in the Club's collection, *The Oaks* uses the gentle diagonal of the edge of the foreground hill to suggest the steep dells characteristic of Brown County's landscape. The brilliant autumnal reds of the foreground trees and under-growth, painted with vigorous, broken brushstrokes, are seen in the brilliant light of an Indian summer afternoon. Farm buildings in the distance blend harmoniously, almost invisibly, with the land. *The Oaks* typifies Hartrath's penchant for square or nearly square compositions where horizontal and vertical elements are subtly balanced to reinforce the calmly cheerful mood of her vision of nature. WG

Oil on canvas;
42 1/8 x 42 1/8 inches
(107 x 107 cm.)
Signed lower right: L. Hartrath
UL 1976.23

Provenance:
MAL, 1922–1951; UL C&AF, 1951–1976; ULC, 1976

Exhibitions:
AIC Chicago and Vicinity Annual, 1922, #120

"Paintings by Chicago Artists," Garfield Park Art Galleries, Chicago, 1936, #17

"American Art in the Union League Club of Chicago, A Centennial Exhibition," traveling exhibition organized by the ULC, 1980–1981

"Indiana Influence," Fort Wayne Museum of Art, Fort Wayne, Ind., 1984

References:
Gerdts, William H. *American Impressionism.* New York: Abbeville Press, 1984. Page 247.

Gerdts. *Art Across America.* Vol. 2, page 309.

Gerdts, William H. and Peter Frank. *Indiana Influence.* Exh. cat. Fort Wayne, Ind.: Fort Wayne Museum of Art, 1984. Page 44.

Loy and Honig. *One Hundred Years.* Pages 62–63.

Martin. *Art in the ULC.* Pages 31, 39.

Sparks. *American Art in the ULC.* Pages 14–15.

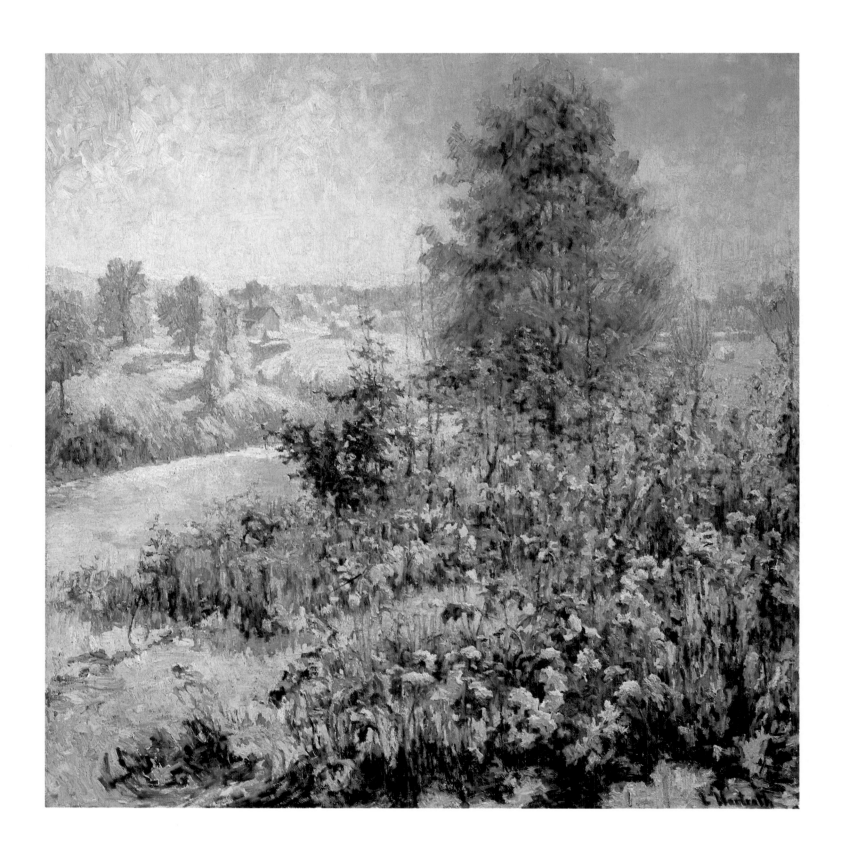

115 **Lucie Hartrath** *The Oaks (The Red Oak; Autumn Pageant)*, ca. 1922

CHARLES WEBSTER HAWTHORNE
(1872–1930)

The Shad Fisherman, ca. 1915–1916

Charles Hawthorne, who grew up in Richmond, Maine, went to New York at the age of eighteen with aspirations of becoming an artist. After saving money from his job at J. and R. Lamb Studios, a maker of stained glass, Hawthorne enrolled at the Art Students League in 1893. Completely dedicated to art, he took additional classes at the National Academy of Design at the same time.[1] In 1896, Hawthorne attended William Merritt Chase's summer school in Shinnecock, Long Island, doing so well that he became Chase's assistant the following summer. During a stay in Holland in 1898, Hawthorne became interested in the work of the seventeenth-century Dutch portraitist Frans Hals, known for his dramatic, free brushwork. Hawthorne changed his technique, painting in a looser style and often using a palette knife in place of a brush,[2] as in *The Shad Fisherman*. In 1899, Hawthorne settled in Provincetown, Massachusetts where he founded the Cape Cod School of Art that year and co-founded the Provincetown Art Association in 1914. Provincetown would remain Hawthorne's home until his death.

Hawthorne was initially interested in the landscapes and seascapes around Provincetown, but he soon turned to creating depictions of the local fishermen and their families, perhaps the subject matter for which he is best known.[3] According to the donor, Paul Schulze, Hawthorne painted *The Shad Fisherman* during the 1915–1916 season in Provincetown.[4] The anonymous fisherman is portrayed as possessing both the hardiness and the individualism that are often associated with native-bred Yankees.

Hawthorne had lectured his students to "Approach your subject in all humility and reverence—make yourself highly sensitive to its beauty."[5] The man's ruddy, weather-beaten face and work-worn hands evoke his rough life, yet his abstracted gaze—a hallmark of Hawthorne's portraits—suggests that he is lost in thoughts that are unrelated to his work. MR

Oil on fiberboard;
39 3/4 x 39 7/8 inches
(100.97 x 101.28 cm.)
Signed lower left: Chas. Hawthorne
Gift of Paul Schulze, 1926
UL1926.2

Provenance:
Paul Schulze 1918–1926; ULC, 1926

Exhibitions:
"Hawthorne Retrospective," The Chrysler Art Museum, Provincetown, Mass., 1961

"American Art in the Union League of Chicago, A Centennial Exhibition," traveling exhibition organized by the ULC, 1980–1981

References:
Richardson, E. P. *Hawthorne Retrospective*. Exh. cat. Provincetown, Mass.: The Chrysler Art Museum, 1961. Page 40.

Sparks. *American Art in the ULC.* Pages 14–15.

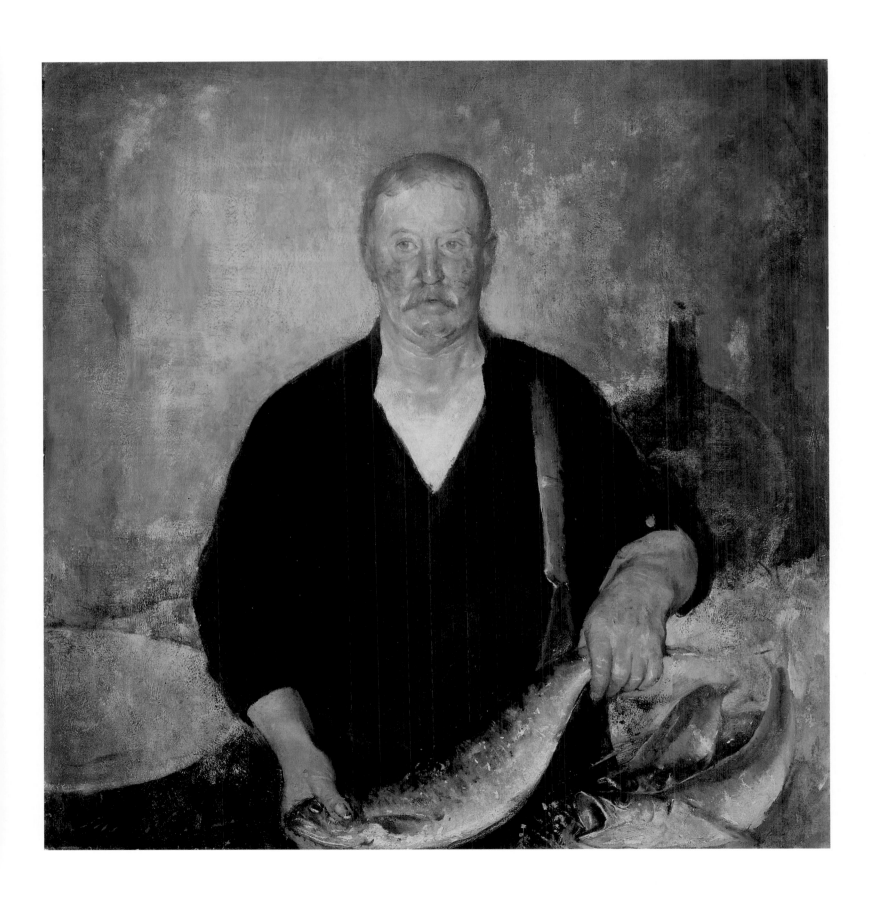

Charles Webster Hawthorne *The Shad Fisherman*, ca. 1915–1916

GEORGE PETER ALEXANDER HEALY
(1813–1894)

Daniel Webster at Marshfield, 1848

One of the most successful American portraitists of the nineteenth century, George Peter Alexander Healy was born in Boston, the son of an Irish ship captain.[1] Self-taught, he opened a studio in 1830. Four years later, with the support of a local patron, Healy went to Paris to study briefly with Baron Antoine-Jean Gros, whose romantic-realist style became the basis for his own. In Paris, Healy's work met with success, and by 1840 the French king Louis-Philippe had become his chief patron. He worked in France, England, and the United States painting portraits of statesmen and dignitaries for the king. In 1855, at the invitation of William B. Ogden, Healy established a studio in Chicago, where he was immensely popular and an encouraging influence on the city's embryonic art life. During the Civil War, Healy often worked in Washington, D. C., painting portraits of military heroes. The press of too-numerous commissions in America prompted Healy's return to Europe in 1867, according to one biographer.[2] From his studios in Rome and in Paris, he traveled throughout Europe to portray a veritable who's who of European and American notables. In 1892 Healy returned to Chicago, where he died two years later.

In 1848 Healy worked in the United States executing several commissions for his French royal patron. Among them was a large historical painting, *Webster Replying to Hayne*, which depicts the famous senatorial debate of 1830 between Robert Young Hayne of South Carolina and the brilliant New England orator Daniel Webster.[3] A New Hampshire native, Webster (1782–1852) practiced law and served as a representative in the United States Congress, as a senator, and as secretary of state. A Whig, he ran for president in 1836 and unsuccessfully sought his party's nomination in the 1848 and 1852 elections. Healy made several portraits of the then-senator from Massachusetts in preparation for *Webster Replying to Hayne*. For the last of these he traveled to Webster's country home at Marshfield, Massachusetts. There, as the artist recorded in his *Reminiscences*, "I . . . made a small picture of our great orator in his hunting gear; Mrs. Webster, his second wife, is seen in the distance in the doorway."[4]

Daniel Webster at Marshfield depicts the standing Webster as a country squire, wearing a loose coat and broad-brimmed hat at a jaunty angle; his left hand supports one end of his rifle, while dead game on a bench behind him testify to his success as a gentleman hunter. A thick-limbed tree echoes the upright stance of Webster's stocky form, while in the left distance the white-gowned figure of Mrs. Webster stands at the open door of their manor house. The painting is clearly unfinished, with the ruled pencil lines of the architecture especially visible. Nonetheless, Healy paid particular attention to Webster's head, capturing the intense gaze, set mouth, and craggy brows that distinguished the statesman's visage.

Webster acquired Marshfield in the early 1830s.[5] In the wake of his second marriage to the socially prominent Caroline LeRoy of New York and as his presidential ambitions grew, Webster pursued a lavish life style and the status of a landed gentleman. Through the political storms of the following years, he found solace in the distractions of developing Marshfield. Originally a modest family farm, it grew into a fourteen-hundred-acre estate "that became the rural showplace of New England," according to a biographer.[6] Webster saw Marshfield as an essential part in cultivating a public image that stressed agrarian roots in the manner of Washington and Jefferson. As the "Farmer of Marshfield," he entertained royally and was popularly pictured in hunting garb, as in Healy's painting.

Daniel Webster at Marshfield was bought from the artist by Thomas B. Bryan, a Chicago lawyer who ran two unsuccessful campaigns for the mayoralty. Bryan was Healy's neighbor in Elmhurst, Illinois, where the artist lived with his family during his Chicago years. An art collector, Bryan owned several portraits by Healy; he gave Healy's portraits of Stephen A. Douglas and General John C. Fremont to the Union League Club, of which he served as president in 1897.[7] Webster's championing of the ideal of federal union with which the Union League Club strongly identified made him a fitting subject for representation on the walls of the Club's quarters. WG

Oil on canvas; 46 1/4 x 35 inches
(117.48 x 88.9 cm.)
Unsigned
UL1903.1

Provenance:
Thomas B. Bryan; Jennie Bryan,
to 1903; ULC, 1903

Exhibitions:
"American Art in the Union League Club
of Chicago, A Centennial Exhibition,"
traveling exhibition organized by the
ULC, 1980–1981.

References:
De Mare, Marie. *G. P. A. Healy: American Artist*. New York: David McKay Company, Inc., 1954. Page 154.

Healy, George P. A. *Reminiscences of a Portrait Painter*. Chicago: A. C. McClurg and Company, 1894. Page 164.

McCauley. *Catalogue*, 1907. #52.

Martin. *Art in the ULC*. Page 40.

Sparks. *American Art in the ULC*. Pages 16–17.

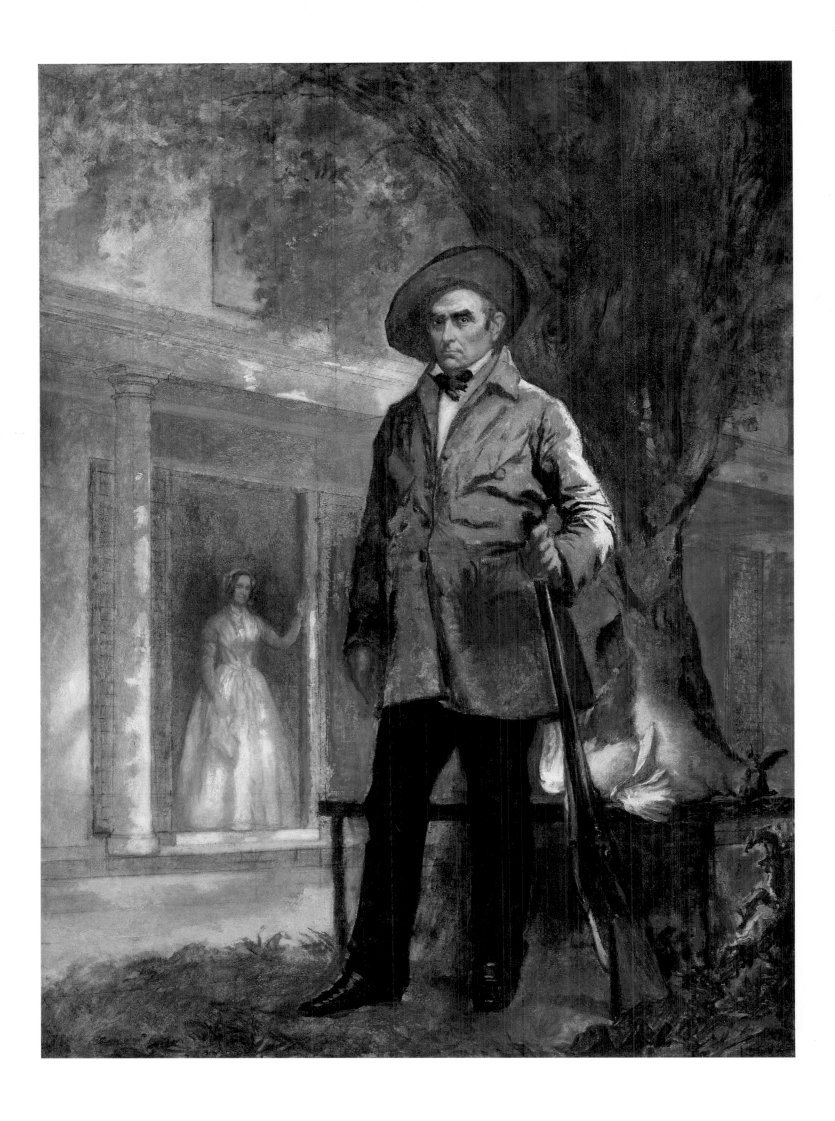

George Peter Alexander Healy *Daniel Webster at Marshfield*, 1848

VICTOR HIGGINS
(1884–1949)

Jacinto and the Suspicious Cat
(Juanito and the Suspicious Cat), 1916

When Walter Ufer and Victor Higgins, sponsored by Chicago mayor Carter Harrrison and his "syndicate," arrived in Taos, New Mexico, in 1914, they were considered young modernists from Chicago. They painted the Native American in a manner unlike the artists who preceded them. They approached their subjects with objectivity, not to romanticize or treat them as ethnographic objects as so many of their predecessors had. Their colleague Ernest Blumenschein described the "soft-spoken" Higgins as being of a "hesitating, sensitive nature," the "fire eating" Ufer of a "strong, virile character." Ufer "had an eye and a hand trained to draw with faultless precision, expressing at the same time his great vitality and, contrary to your expectations (if you knew him) with considerable refinement! Victor thought color—not construction of forms with accuracy of contour, and life in line, which were Ufer's qualities."

Blumenschein continued: "Higgins felt out his compositions with a broad sweeping style of masses of color 'en rapport.' He had a painter's style. Walter was, first of all, a draughtsman. It was Walter the realist. He must have a model before him when he painted. And Victor the dreamer. They were always in character, working or not: one frank, often to brutality; the other hesitating, uncertain."[1]

The Native American inspired Higgins to paint in a bravura style. Jacinto and the Suspicious Cat is wonderfully effective in its composition, lighting, and paint application. Higgins explored the visual possibilities of dramatic lighting, and his facility with the brush, while constraining subject matter to notions of pattern and composition. While he painted from life, the oil sketch and photograph also played a role. In the teens he frequently created an oil sketch of his model, then made a photograph to document his composition, a record that would enable him to return to his subject after his model had retired for the day.[2]

Higgins reduced subject matter to bare essentials, moved his brush across the canvas with ease, painting with broad strokes of a thick and buttery pigment. The result is a canvas that caused his colleagues to call him a "painter's painter."

In 1917, Higgins was awarded one half of the Hearst Prize ($300) from The Art Institute for seven paintings, and he was awarded the Martin C. Cahn Prize ($100), also from The Art Institute, for work by a Chicago artist without regard to subject matter. He was also awarded a Silver Medal from the Chicago Society of Artists. An article entitled "Real American Art—At Last!" containing lengthy quotes from Higgins, appeared in the Chicago Sunday Herald Magazine.[3] He had become a nationally known artist. Most important, he joined Ufer as they became the seventh and eighth members of the Taos Society of Artists. Over the next thirty-two years Higgins competed successfully in juried shows and created paintings that, like Jacinto and the Suspicious Cat, entered public collections. After a successful career, Higgins died on August 22, 1949 in Taos. DP

Oil on canvas; 39 1/8 x 43 1/4 inches (101.92 x 109.86 cm.)
Signed lower left corner: Victor Higgins
UL 1917.2

Provenance:
ULC, 1917

Exhibitions:
AIC Chicago and Vicinity Annual, 1917, #156

Corcoran Gallery, Washington, D.C., 1917

"Victor Higgins: An Indiana-Born Artist Working in Taos, New Mexico," traveling exhibition organized by the Art Gallery, University of Notre Dame, 1975–1976, #7

"American Art in the Union League of Chicago, A Centennial Exhibition," traveling exhibition organized by the ULC, 1980–1981

"Victor Higgins: An American Master," traveling exhibition organized by The Snite Museum of Art, University of Notre Dame, 1990–1991

"Taos Artists and Their Patrons: 1898–1950," traveling exhibition organized by The Snite Museum of Art, University of Notre Dame, 1999–2000

References:
Sparks. American Art in the ULC. Page 18.

Broder, Patricia Janis. Taos: A Painter's Dream. Boston: New York Graphic Society, 1980. Page 192.

"Chicago Artists' Twenty-First Annual Exhibition," Fine Arts Journal 35 (April–May 1917): 268–71.

Loy and Honig. One Hundred Years. Page 179.

Porter, Dean A. Victor Higgins: An Indiana-Born Artist Working in Taos, New Mexico. Exh. cat. Notre Dame, Ind.: Art Gallery, University of Notre Dame, 1975. Pages 10, 50, 83.

Porter, Dean A. "W. Victor Higgins." In Bickerstaff, Laura, Pioneer Artists of Taos. Revised and expanded edition. Denver: Old West Publishing Company, 1983. Page 181.

Porter, Dean A. Victor Higgins, An American Master. Exh. cat. Salt Lake City: Peregrine Smith Books, 1991. Pages 61–62.

Porter, Dean A., Suzan Campbell, and Teresa Hayes Ebie. Taos Artists and Their Patrons 1898–1950. Notre Dame, Ind.: The Snite Museum of Art, University of Notre Dame, 1999. Pages 69, 72.

Stuart, Evelyn Marie. "Taos and the Indian in Art." Fine Arts Journal 25 (April–May 1917): 349.

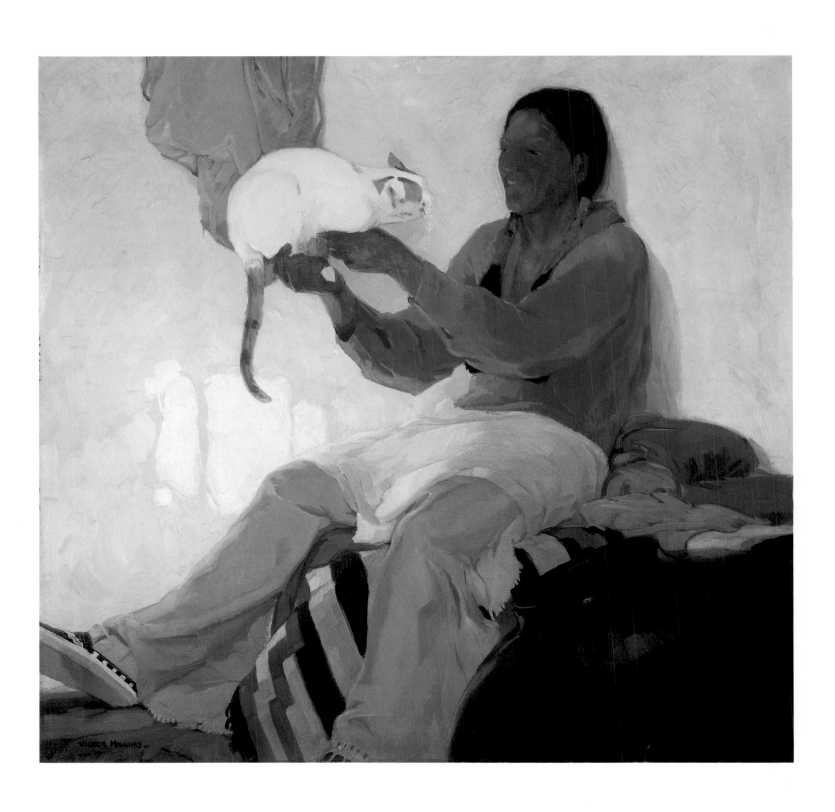

Jacinto and the Suspicious Cat (Juanito and the Suspicious Cat), 1916

THOMAS HILL
(1829–1908)

Crescent Lake (Yosemite Valley), 1892

One of the most important painters of the American West, Thomas Hill began his career as a decorative painter of coaches and signs in Massachusetts. Hill was born in Birmingham, England, and came to the United States in 1844.[1] He studied at the Pennsylvania Academy of the Fine Arts in Philadelphia. In 1861 he moved to California to open a studio in San Francisco, where he specialized in portraiture. The following year Hill made his first trip to the Yosemite valley in company with landscapists William Keith and Virgil Williams, but it was not until after further study in Paris that he turned his attention fully to landscape painting, during a three-year stay in Boston beginning in 1867. Hill returned to San Francisco around 1870,[2] became active in the local art scene, and by decade's end had succeeded Albert Bierstadt as the "artist in waiting to the Yosemite."[3] Beginning in 1882 Hill spent every summer in Yosemite, where he provided the park's numerous tourists with painted souvenirs of its spectacular scenery.[4]

The Yosemite valley region, in California's Sierra Nevada mountains about 150 miles east of San Francisco, was not extensively explored until 1851.[5] Its dramatic natural features attracted numerous landscape artists and photographers, who influenced each other in their depictions. Hill often worked there with his friend, the photographer Carleton Watkins, whose images of the valley influenced Hill's in the broad, open foregrounds and hazy backgrounds of the compositions.[6] Hill's *Crescent Lake* pictures the mountain lake near sunset as a vision of calm fulfillment. In contrast to the almost photographic perfection of Bierstadt's earlier paintings of similar subjects, Hill used richly painted surfaces and a unified color scheme that reflects the cosmopolitan taste of the day.

Hill painted roughly five thousand views of Yosemite; the largest canvas commanded over $5,000 at the height of his success in the late 1870s.[7] Not surprisingly, he frequently repeated popular views and motifs.[8] The Club's *Yosemite Valley* is a later version of a painting, titled *Crescent Lake*, reproduced in the lavish picture book *Picturesque California and the Region West of the Rockies from Alaska to Mexico*, edited by John Muir, the great naturalist and champion of Yosemite. Muir's book was issued in various formats in New York and San Francisco beginning in 1888. Crescent Lake is a small body of water near the southern edge of the national park, a "wild and desolate region" famed as the home of the grizzly bear.[9] The two mounted men are identified in Muir's book as the backwoodsmen and famed hunters Jim Duncan and Bob Whitman, seen returning at sunset from a hunt with their kill, evidently a deer, borne by one of their two pack mules. Hill invariably included the figures of Native Americans, sportsmen, or tourist-explorers in his landscapes to lend scale and human interest.[10] wg

Oil on canvas; 36 x 54 1/4 inches
(91.44 x 137.80 cm.)
Signed lower right: T. Hill/1892
UL1945.1

Provenance:
Mrs. Crocker, San Francisco;
Thomas S. Hughes Gallery, Chicago,
1930s–1945; ULC, 1945

Exhibitions:
"The American West," Continental-Illinois National Bank, Chicago, in cooperation with Mongerson Gallery, 1975

"Important Western Art from Chicago Collections," Terra Museum of American Art, Evanston, Ill., 1980

"American Art in the Union League Club of Chicago, A Centennial Exhibition," traveling exhibition organized by the ULC, 1980–1981

References:
Loy and Honig. *One Hundred Years*. Pages 8–9.

Martin. *Art in the ULC*. Page 18.

Sparks. *American Art in the ULC*. Page 18.

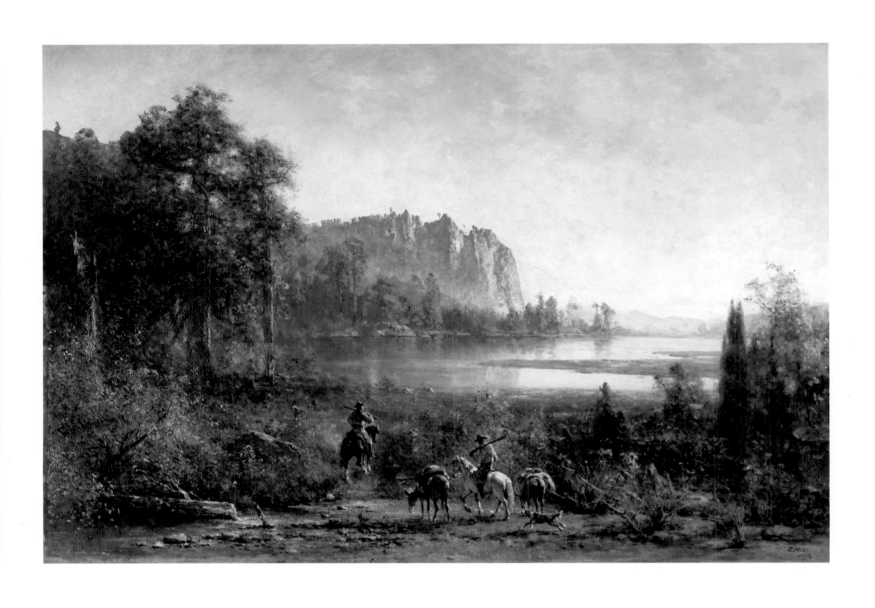

Crescent Lake (Yosemite Valley), 1892

OTHMAR HOFFLER
(1893–1954)

Babette, ca. 1933

Born in Buffalo, New York, Othmar Hoffler studied at the city's Albright Art School, the School of the Art Institute of Chicago, the Académie Grande Chaumière in Paris, and the Académie Colarossi in Rome.[1] Primarily a painter and watercolorist, he was active in numerous Chicago artists' organizations, including the Palette and Chisel Club, the Society of Chicago Painters and Sculptors, and the Chicago Galleries Association. He was also a member of the Brown County Society of Artists in Indiana. Hoffler was praised for his ability to depict children by Eleanor Jewett, the long-time art critic at the *Chicago Tribune*, who wrote, "When you consider how weak and little decorative many of the children's portraits are that have been seen recently, it is a matter of congratulation to have discovered a Chicago artist who can paint children as they should be painted."[2]

Babette won the Municipal Art League's purchase prize at the 1933 "Annual Exhibition of Works by Artists of Chicago and Vicinity" at The Art Institute of Chicago. Its inspiration was probably the well-known work by Mary Cassatt, *The Bath*, which is in the collection of The Art Institute of Chicago. Cassatt's painting depicts a woman bathing a child; the subject is presented in an unsentimental manner that nonetheless reveals the pair's closeness.[3] Like *The Bath*, the scene in *Babette* has been deliberately cropped (both the top of the woman's head and her left leg are cut off), a compositional device that reflects not only the influence of impressionism, but also of photography. Surprisingly, despite Hoffler's domestic subject, the woman appears momentarily distracted from the task at hand, lost in her thoughts rather than engaged with the child she tends. MR

Oil on canvas; 48 3/8 x 42 1/8 inches
(122.87 x 107 cm.)
Signed lower right: Othmar Hoffler
UL1976.25

Provenance:
MAL, 1933–1951; UL C&AF, 1951–1976;
ULC, 1976

Exhibitions:
AIC Chicago and Vicinity Annual,
1933, #103

References:
Loy and Honig. *One Hundred Years*.
Pages 94–95.

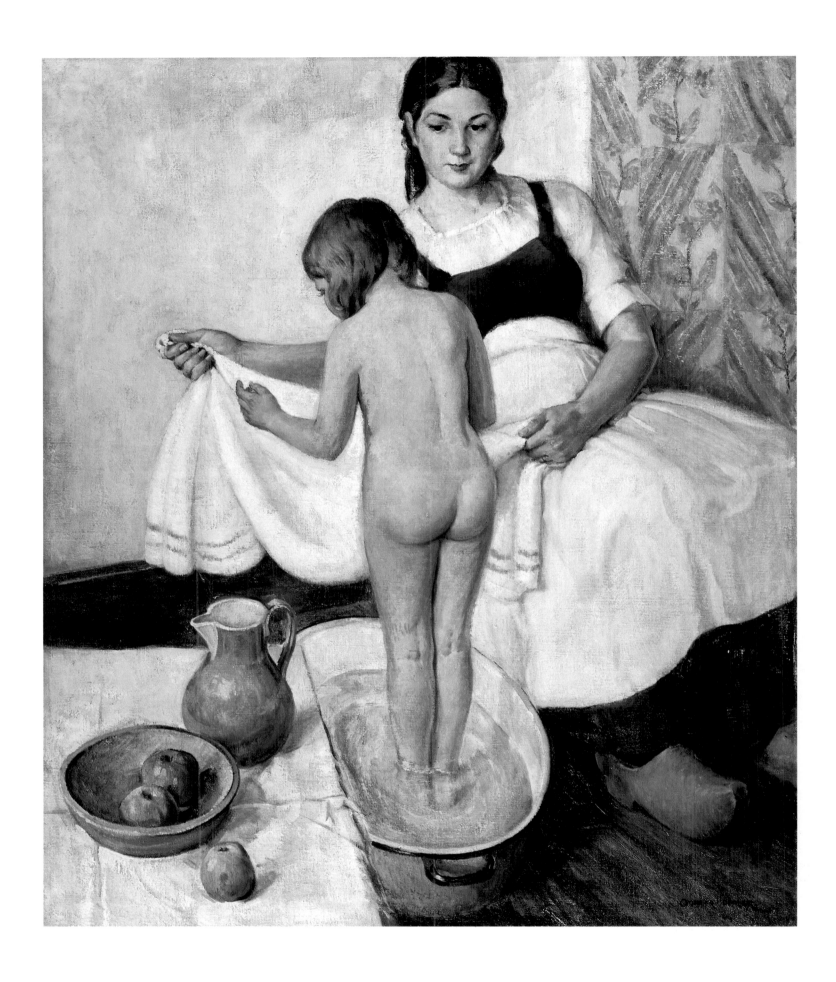

Othmar Hoffler *Babette*, ca. 1933

MILTON HORN
(1906–1995)

Maquette of Franklin Delano Roosevelt,
ca. 1950s–1995

By the 1950s, Milton Horn had gained recognition for expressive, figurative sculpture that belonged to the same movement as those by the American sculptors Chaim Gross and William Zorach. Born in Kiev, Horn immigrated to Boston as a child and began painting and drawing by the time he was eighteen.[1] He studied sculpture at the Copley Society in Boston and the Beaux-Arts Institute of Design in New York. In addition to freestanding sculpture, Horn also created sculptured elements in buildings, most notably on projects headed by Frank Lloyd Wright. From 1939 until 1949, Horn was sculptor-in-residence and later professor of art at Olivet College in Olivet, Michigan. Active in a number of artists' organizations, he was a founding member of the Sculptors Guild in 1936, honored by the National Sculpture Society in 1972, and elected an Academician by the National Academy of Design in 1976.

Horn's Jewish faith had a profound influence on his work, and he is perhaps best known for his interpretations of Old Testament stories such as Job, Bathsheba, and Jacob wrestling with the angel. He gained wide notice in 1951 when the West Suburban Temple Har Zion, in River Forest, Illinois, commissioned him to create a limestone relief for the temple exterior. Horn created a seated figure holding the tablets of the law that is believed to be the first figurative work on the exterior of a synagogue.[2] Charged with heresy because the Jewish religion bans the use of graven images in synagogues, Horn and his wife were asked to appear before a meeting of four hundred rabbis, where they successfully defended the work. Horn also received numerous public art commissions, including *Hymn to Water* for the Central Water Filtration Plant of the City of Chicago and *Chicago Rising from the Lake*, for the Chicago Department of Public Works.

Horn began working on this model for a monumental sculpture of President Franklin Delano Roosevelt in the late 1950s. Although the hoped-for large-scale bronze was never realized, the project interested him for the rest of his life, and he continued to refine the model until shortly before his death. Horn greatly admired Roosevelt. During the depression, Horn had participated in the Works Project Administration, an agency that Roosevelt established in 1935 as a means of providing jobs. Horn found the inspiration for the model from Roosevelt's assertion in his first inaugural address that "the only thing we have to fear is fear itself."[3] Horn depicts the president holding two forked-end canes, which are pinning down the double-headed serpent of fear and adversity. The strong modeling lines create a dynamic surface that suggests the energy that the monumental sculpture would have had. MR

Painted plaster; 24 x 12 x 9 inches
(60.96 x 30.48 x 22.86 cm.)
Unsigned
Gift of the Milton and Estelle Horn
Fine Arts Trust
UL1998.3.1

Provenance:
Milton and Estelle Horn Fine Arts Trust,
1995–1998; ULC, 1998

WILLIAM HENRY HOWE
(1844–1929)

Evening at Laren, the Meadows—Cattle, 1890

In the late nineteenth century no American artist was more thoroughly identified with the painting of cows than William Henry Howe.[1] Born in Ravenna, Ohio, Howe was in his mid-thirties when he abandoned a business career in Saint Louis to study art in Düsseldorf. In 1881 he moved to Paris, where he received further instruction from the animal painters Otto de Thoren and Félix Vuillefroy while exhibiting his paintings with success at the Salons, at the Paris Universal Exposition of 1889, and in exhibitions in the United States. In the 1880s Howe, along with many other artists, found picturesque agrarian subjects in his travels through rural Holland. During his time there, he began to specialize in paintings of cattle. In the course of his career Howe painted so many pictures of cattle that he was referred to as "Mr. Howe Cow." His work included illustrations of steers for Bull Durham Tobacco Company pouches and the posters that plastered American barns around the turn of the century.[2] Howe returned to the United States in 1893 and settled in Bronxville, a suburb of New York City and home to many artists. With fellow landscape painter Henry Ward Ranger, Howe founded the art colony at Old Lyme, Connecticut, in 1900, where he painted the Club's *Saybrook Point, Connecticut River*.[3]

Among the Dutch locales favored by artists in the nineteenth century, the "desolate" hamlet of Laren was the one most thoroughly colonized by Americans.[4] There they found an old-fashioned way of life and setting for images that fed American nostalgia for a rapidly fading agrarian heritage. Between 1870 and 1900 domestic animals, especially cattle, were particularly popular subjects.[5] Artists such as Howe invoked the tradition of the "cattle piece" by seventeenth-century Dutch painters so prized by American collectors of Old Masters; they were also influenced by the American popularity of such Barbizon painters as Jean François Millet and Constant Troyen, who gave prominence to domestic animals in their images of rural life.[6] For Howe's American buyers, his cows symbolized not just the timeless rhythms of agrarian life, but dependability, contentedness, and other virtues seemingly under seige in modern American culture.[7]

In *Evening at Laren* Howe joined the peaceful image of the recumbent cow to an equally peaceful setting: a tree-rimmed meadow over which a full moon has just risen. The subdued, even light suffusing the scene complements the animals' apparent mood of gentle patience. Howe's varied positioning and coloring of the animals creates an engaging composition from their potentially repetitive shapes and relieves the monotonous flatness of the Dutch landscape background. *Evening at Laren* also demonstrates his interest in infusing his bovine subjects with sympathetic individuality while rendering them realistically.[8] The foreground cow, whose white face echoes the moon above, draws the viewer into the scene, providing what art historian Lois Fink describes as "a direct confrontation with the subject, the kind of involved experience late-century Salon visitors enjoyed."[9] WG

Oil on canvas; 33 x 42 1/2 inches
(83.82 x 107.31 cm.)
Signed lower left: William H. Howe 90
[and illegible word or number]
UL1908.4

Provenance:
ULC, 1908

References:
Loy and Honig. *One Hundred Years*. Pages 18–19.

Martin. *Art in the ULC*. Page 20.

Stott, Annette. "American Painters Who Worked in the Netherlands." Ph.D. diss., Boston University, 1986. Pages 185–87.

Stott, Annette. "Dutch Utopia: Paintings by Antimodern American Artists of the Nineteenth Century." *Smithsonian Studies in American Art* 3 (Spring 1989): 49–51.

Stott, Annette. *Holland Mania: The Unknown Dutch Period in American Art & Culture*. Woodstock, N.Y.: The Overlook Press, 1998. Page 55.

129 **William Henry Howe** *Evening at Laren, the Meadows—Cattle*, 1890

RICHARD HUNT
(b. 1935)

Sidearm, 1991

Richard Howard Hunt has been described as "one of the most gifted and assured artists working in the direct-metal, open-form medium . . . not only in his own country and generation, but anywhere in the world."[1] A native of Chicago, Hunt was encouraged in his interest in art by his mother, a librarian and beautician, who enrolled him at the Junior School of The Art Institute of Chicago when he was thirteen and took him regularly to the Field Museum of Natural History, where he developed a lifelong love of African sculpture. A talented art student in high school, he was awarded a scholarship to the School of the Art Institute of Chicago by the Chicago Public School Art Society in 1953. Hunt further supported his college studies by tending the animals at the University of Chicago's zoology laboratory, an experience that increased his already strong interest in the natural world. Drawn to sculpture by the time of his matriculation, he decided to work in metal after seeing the Art Institute's exhibition "Sculpture of the 20th Century," which included three-dimensional metalwork by Julio Gonzalez, Jean Arp, and Umberto Boccioni.[2]

In 1957, the year of his graduation, the Museum of Modern Art acquired Hunt's *Arachne*, remarkable recognition for an artist at the start of his career. Hunt also was honored with the School's James Nelson Raymond Foreign Travel Fellowship, which enabled him to spend eight months traveling in England, France, and Spain following graduation. After serving in the army for two years as a medic, Hunt returned to Chicago, finding the city to be the most conducive to his work as a sculptor.

Since then, Hunt's work has been widely shown, including exhibitions at the Museum of Modern Art, the Snite Museum of Art, the Studio Museum in Harlem, The Art Institute of Chicago, and the Museum of African-American History. He is equally well known for his monumental public sculptures, which number over one hundred and are in cities throughout the country, including Chicago, Miami, Atlanta, Memphis, and Los Angeles. He became a Distinguished Artist member of the Union League Club of Chicago in 1998. That year, Hunt was inducted into the American Academy of Arts and Letters, an honorary academy with a membership limited to 250 American citizens, including fifty of the nation's leading creative talents.[3]

Hunt once stated that one of the underlying themes of his work is "the reconciliation of the organic and the industrial . . . forming a kind of bridge between what we experience in nature and what we experience from the urban industrial, technology-driven society we live in."[3] *Sidearm* embodies this concept. Made of bronze that has been cut and welded together, the sculpture's soaring form is nonetheless fundamentally organic. Hunt has described this balance in his work between the manmade and the natural as "hybridization." Although *Sidearm* is ostensibly an abstract work, it evokes numerous images, all of which have been significant in Hunt's body of work: flames, a bird in flight, branches, and the ancient Greek winged Nike of Samothrace. This suggestion of upward movement, as well as the delicately textured surface, imbues *Sidearm* with a dynamic, joyous quality that distinguishes all of Hunt's work. MR

Bronze; 49 x 38 3/4 x 8 inches
(124.46 x 98.43 x 20.32 cm.)
Signed lower right: R Hunt 91
UL1994.1

Provenance:
ULC, 1994

Exhibitions:
"The Union League Club of Chicago
Art Invitational," ULC and Prince
Gallery, 1993.

"Balancing Act: Sculpture by Richard
Hunt," Illinois State Museum and Illinois
Art Gallery, Chicago, 1998

RUDOLPH FRANK INGERLE
(1879–1950)

The Lifting Veil, 1922

Of Moravian and Bohemian ancestry, Rudolph Frank Ingerle was born in Vienna, Austria.[1] The Ingerle family immigrated to Wisconsin and then moved to Chicago when he was twelve years old. He studied at Smith's Art Academy, at The Art Institute of Chicago, and privately with painter Walter Dean Goldbeck. Ingerle was greeted as a "welcome" new exhibitor when he began showing his pastoral landscapes at the Art Institute in 1908, the year he first worked in picturesque, rural Brown County, Indiana.[2] His search for fresh subjects led him to be among the first painters to work in the Ozark Mountains of Missouri and in North Carolina's Smoky Mountains.[3] Active in many Chicago artists' organizations, Ingerle was an outspoken critic of modernism and asserted the importance of celebrating the beauties of the national landscape in art.[4]

Ingerle painted *The Lifting Veil* in 1922, the last year he visited the Ozarks before turning his attention to the Smokies. While the painting probably depicts an Ozarks scene, the artist acknowledged that his works were studio compositions that rarely presented actual locales in a recognizable form.[5] In the 1910s and 1920s Ingerle's decorative approach to landscape painting favored effects such as moonlight and mist that further obscured geographic identity in favor of moods of poetic mystery; art critic Clarence Bulliet called Ingerle "a poet of paint, living in a bluish twilight."[6]

The Lifting Veil pictures an autumn landscape pervaded by morning mist. In the middle distance trees, a building, and a rustic wood fence appear as bluish-gray silhouettes against a still-paler backdrop of wooded hills. A contrasting screen of richly tinted brush, sparkling in the brilliant light, frames the composition along the bottom and right edges. The work's layered effect and square format, typical of Ingerle's Ozark scenes, were hallmarks of a mode of decorative landscape painting also favored by his associate Carl Krafft, as well as by the Pennsylvania impressionist painter Daniel Garber.[7]

The Lifting Veil was among a group of four landscape paintings by Ingerle awarded the Chicago Society of Artists' silver medal when shown in the Art Institute's annual "Chicago and Vicinity" exhibition in the winter of 1923. wg

Oil on panel; 30 1/4 x 32 inches
(76.84 x 81.28 cm.)
Signed lower left: R. F. Ingerle 22
UL1976.27

Provenance:
MAL, 1923–1951; UL C&AF,
1951–1976; ULC, 1976

Exhibitions:
AIC Chicago and Vicinity Annual,
1923, #133

"Paintings by Chicago Artists,"
Garfield Park Art Galleries, Chicago,
1936, #20

References:
Loy and Honig. *One Hundred Years.*
Page 179.

Martin. *Art in the ULC.*
Page 40.

133 **Rudolph Frank Ingerle** *The Lifting Veil*, 1922

GEORGE INNESS
(1825–1894)

Picnic in the Woods, Montclair, New Jersey (The Picnic Party; Beech Woods; The Beeches), 1894

In 1899, when the Union League Club acquired the 1894 painting *Picnic in the Woods, Montclair, New Jersey*, George Inness's late works were hailed as the crowning achievement of American landscape art. Raised near Newark, New Jersey, Inness worked as an apprentice engraver in New York City. He studied briefly with landscape painter Régis Gignoux in the mid-1840s, when he first exhibited at the National Academy of Design.[1] In the middle decades of the century, American landscape painting was dominated by the Hudson River School, whose meticulously detailed views offered a seemingly objective celebration of the native wilderness. In his early work Inness filtered that approach through his appreciation of seventeenth-century Dutch and French landscape paintings, and he favored America's "civilized" landscape of the Northeast.[2] After a visit to France in 1853, where he came under the influence of the French Barbizon painters, Inness began to paint with freer brushwork, brighter colors, and informal compositions. Following a stay in Italy and Paris between 1870 and 1875, Inness eventually settled in Montclair, New Jersey. By the early 1880s shifts in artistic taste brought new appreciation for his romantic landscapes, and although he was temperamental and indifferent to money, the prolific Inness was the most financially successful landscape painter in America.[3]

In his art Inness sought to picture the spiritual essence inherent in the natural world. During the 1860s, while living near Perth Amboy, New Jersey, Inness met painter William Page, who introduced him to the spiritualism of the eighteenth-century mystic Emanuel Swedenborg. Swedenborg's conception of a spiritual world that was mirrored in the real deeply influenced Inness for the rest of his life. Wrote critic Charles DeKay in 1882,

"In the mind of Inness, religion, landscape, and human nature mingle so thoroughly that there is no separating the several ideas."[4] The paintings of his last decade, including *Picnic in the Woods*, subsume objective reality in a subjective emotional response to nature. Blurred outlines, rich color, a composition defined by abstract, decorative arrangement of masses and tones, and an emphasis on overall unity of effect characterize these works, which are imbued with a mood of harmonious calm tinged with mysterious longing. The techniques Inness used to achieve these visual effects have caused his late paintings to darken over time, frequently leading to overcleaning, as is the case with the Club's painting.

Picnic in the Woods is among the last canvases that Inness painted. It reflects his response to a landscape saturated with emotive memory, for the artist had called the then-rural region of northeastern New Jersey home since boyhood. The painting evokes the magical transformation of serene summer day into night: framed by tree branches, the moon rises, while the dying sun's light is reflected dramatically in the white trunk of the foremost tree. White-clad figures scatter across a distant clearing while others emerge from the shadowed foreground, including a seated couple at the right. With its hints of pastoral romance *Picnic in the Woods* subtly echoes the eighteenth-century French artist Antoine Watteau's images of aristocratic courtship in the *fête galante* tradition. At the same time, it evinces the affectionate interest with which turn-of-the-century American artists turned their attention to a familiar yet endangered landscape: lingering remnants of rural space increasingly accessible from and encroached upon by urban centers. WG

Oil on canvas mounted on fiberboard; 30 1/4 x 45 1/4 inches (76.84 x 114.94 cm.)
Signed middle left: G Inness 1894
UL1899.1

Provenance:
The artist's estate, 1895; W. Scott Thurber, Chicago, 1895–1899; ULC, 1899

Exhibitions:
"Executor's Sale. Catalogue of Paintings by the Late George Inness, N. A.," Fifth Avenue Art Gallery, New York, 1895, #177

"Exhibition of the Paintings Left by the Late George Inness," American Fine Arts Society, New York, 1894, #23
AIC American Art Annual, 1907, #192

"American Art in the Union League Club of Chicago, A Centennial Exhibition," traveling exhibition organized by the ULC, 1980–1981

References:
Corliss. *Catalogue*, 1899. #141.

Ireland, LeRoy. *The Works of George Inness: An Illustrated Catalogue Raisonné.* Austin and London: University of Texas Press, 1965. Page 405, #1535.

Loy and Honig. *One Hundred Years.* Pages 6–7.

McCauley. *Catalogue*, 1907. #15.

Martin. *Art in the ULC.* Pages 24, 40.

Sparks. *American Art in the ULC.* Page 24.

Trumble, Alfred. *George Inness, N. A., A Memorial of the Student, the Artist, and the Man.* New York: The Collector, 1895. Page 49.

Picnic in the Woods, Montclair, New Jersey (The Picnic Party) (Beech Woods) (The Beeches), 1894

WILSON HENRY IRVINE
(1869–1936)

The Road, 1910

Wilson Henry Irvine was born near the Rock River town of Byron, Illinois.[1] While attending art school in Rockford he became adept at the use of the air-brush, which had recently been invented there. In 1893 he went to Chicago to work as a finisher of portrait photographs. Between 1895 and 1903 Irvine also attended evening classes at the Art Institute, and in 1895 he joined other commercial artists in founding the Palette and Chisel Club, over which he presided in 1899. Irvine began exhibiting landscape paintings at the Art Institute in 1900. Within a decade he emerged as an influential figure on Chicago's art scene, honored with a one-man exhibition at the Art Institute in 1916. In search of subject matter Irvine traveled widely, visiting Brown County, Indiana, in 1907 and France the following year. Having made numerous trips to Old Lyme in coastal Connecticut, the site of a well-established art colony, Irvine moved there in 1918, but he returned frequently to Chicago. Toward the end of his career, Irvine painted figural and still life works as well as landscapes.

In 1910, when he executed *The Road*, Irvine was still working as a commercial artist. He was already well known as a fine artist, however, and the following year he would be elected president of the Chicago Society of Artists. *The Road* was singled out by Harriet Monroe, the *Chicago Tribune*'s art critic, as the best of a group of ten landscapes Irvine showed in the Art Institute's 1911 annual exhibition of work by Chicago artists.[2] It received the Municipal Art League's purchase prize, becoming the organization's annual acquisition for that year. The artist considered *The Road* to be among his most important works.[3]

The Road is a deceptively simple landscape image: a view of a rather barren, irregular slope of land, studded with rocky outcroppings, through which meanders a narrow, rutted dirt track. On the left, scraggly trees partly screen a whitewashed shack, from which straggles a spindly, tumble-down fence following the jagged path of the road. Void of indicators of time or place, the scene is empty of animate life and evidently silent under a soft blue sky. The only suggestion of movement is that connoted by the road itself as it travels from the central foreground (originating, by implication, in the viewer's space) through the landscape and into the undiscovered and undescribed space over the crest of the hill. Within the abandoned emptiness of this scene, the road is subtly charged with metaphorical possibility. WG

Oil on canvas;
30 1/2 x 40 1/4 inches
(77.47 x 102.24 cm.)
Signed lower left: IRVINE/10
UL1976.28

Provenance:
MAL, 1911–1951; UL C&AF, 1951–1976; ULC, 1976

Exhibitions:
AIC Chicago and Vicinity Annual, 1911, #156

"The Municipal Art League of Chicago," AIC, 1918

"Exhibit of Recent Paintings loaned by The Municipal Art League of Chicago June 1–24, 1920 Under the auspices of Story County I. S. C. Alumni Association Complimentary to the visiting Alumni and friends," 1920, #14

"Paintings by Chicago Artists," Garfield Park Art Galleries, Chicago, 1936, #21

References:
Loy and Honig. *One Hundred Years*. Page 180.

137 **Wilson Henry Irvine** *The Road*, 1910

MIYOKO ITO
(1918–1983)

Untitled, ca. 1973

Miyoko Ito's evocative abstract paintings earned her great respect among her peers. Born in Berkeley to Japanese immigrants, she became interested in art after studying calligraphy during the mid-1920s in Japan.[1] Upon graduation from high school in California, Ito enrolled at the University of California, Berkeley, and majored in art. The Berkeley art department of that era was dominated by a group of artists who specialized in watercolor, known as "The Berkeley School" or "Bay Region School of Watercolor." Not surprisingly, Ito also concentrated on this medium in her early career. In the spring of 1942, shortly before graduation, her studies were interrupted abruptly when she and her new husband were placed in an internment camp for Japanese-Americans near San Francisco. Fortunately, Ito had completed enough course work, and she graduated with the art department's highest honors. She received her diploma while detained at the camp.

In the fall of 1942, authorities permitted Ito to leave the internment camp to begin graduate study in the art department at Smith College. Frustrated by being the only graduate student in the program, Ito soon decided to seek admission to a larger art school. In the fall of 1944, she moved to Chicago to study at the School of the Art Institute of Chicago. She began working in oil in the 1950s. She worked steadily on her painting while she raised her children, and by 1956, she had developed her "essentially abstract vocabulary of form."[2] She had one-person shows at the Hyde Park Art Center in 1971 and the Renaissance Society in 1980, both in Chicago, and her work was accepted for the 1975 biennial at the Whitney Museum of American Art in New York.

The Club's untitled painting most likely dates to the early 1970s, a time when Ito's normally bright palette softened for two or three years and was dominated by shades of pink, tan, and beige. These so-called "pale pictures" frequently included images that appeared to be inspired by both landscape and architecture. In *Untitled*, the narrow rectangular elements suggest an architectural structure, while the area at the top left suggests the horizon at a beach. The diagonal lines create a sense of receding space, characteristic of the artist's work from this period. This suggestion of narrative content within Ito's paintings has led critics to identify her abstract work as metaphorical.[3]

Ito's technique was as distinctive as her style. After making a charcoal drawing on the canvas, she applied an undercoating in red or green using round-bristle brushes. Next, she applied nearly dry pigments onto the dry undercoating, building up layers using short and usually horizontal brushstrokes. The critic Dennis Adrian has observed that the ridges created by Ito's technique catch the light and throw small shadows that create a surface that is "a shimmering vibration of colored light."[4] Ito always left the tacks securing the canvas to the stretcher partially exposed, a habit many believe may have been intended to emphasize the "objectness" of the canvas.[5] MR

Oil on canvas;
47 x 44 3/4 inches
(119.38 x 113.66 cm.)
Unsigned
UL1999.3

Provenance:
ULC, 1999

BILLY MORROW JACKSON
(b. 1926)

Before My Time, ca. 1965

Kansas City native Billy Morrow Jackson took his first art classes as a child at the city's Nelson Gallery. He enlisted in the Marine Corps upon graduating from high school and was stationed in Okinawa in the First Division in the Pacific theater.[1] After receiving his honorable discharge, he studied art at Washington University in Saint Louis, where his teachers included Fred Conway and the German Expressionist Max Beckmann, who was the school's artist-in-residence. Beckmann's influence on Jackson extended not only to a series of woodcuts the young artist made in the 1950s, but also to Jackson's understanding of the importance of being able to draw the nude. Jackson subsequently enrolled at the University of Illinois at Urbana-Champaign, graduating with an M.F.A. in 1954. He joined the school's art department that fall and taught there for thirty-three years. By the early 1960s, he had made a name for himself as a promising young realist, and his work was featured in exhibitions across the country. He received a special distinction in 1967, when NASA commissioned him to record the Saturn V rocket launch. During this period, he was also an active supporter of both the civil rights movement and environmental conservation.

Since the late 1950s, Jackson has defined himself as a regionalist, finding his subject matter in the residents, prairies, and towns of central Illinois. In the early to mid-1960s he focused on compositions in which architecture and figures are set within the prairie, as seen in *Before My Time*. The Club's painting reveals Jackson's concern about racial discrimination. Hidden from the viewer in this seemingly straightforward depiction of a dilapidated building is the shadowy figure of an African American woman who stands behind the lace curtain with her eyes closed and her hands crossed. The lower portion of the house is in sunlight, but the upper portion, which includes the woman's head, is in shadow, a compositional effect that heightens the sense that the woman is both invisible and forgotten. The painting dates to the same time that Jackson created a series of prints to raise money for civil rights organizations.[2] MR

Oil on masonite;
66 x 48 inches
(167.64 x 121.92 cm.)
Signed lower left: B. M. Jackson;
reverse: Before My Time/Oil
4 ft. x 5 1/2 ft./
Billy Morrow Jackson
UL1965.2

Provenance:
ULC, 1965

Exhibitions:
"Sixth Union League Art Show,"
ULC, 1965

"Moments in Light: Paintings by Billy Morrow Jackson," traveling exhibition organized by the Wichita Art Museum, Wichita, Kan., 1980–1981

"Illinois Landscape Art 1830–1975," Lakeview Center for the Arts and Sciences, Peoria, Ill., 1975–1976

"American Art in the Union League Club of Chicago: A Centennial Exhibition," traveling exhibition organized by the ULC, 1980–1981

References:
Sparks. *American Art in the ULC*. Page 20.

Illinois Landscape Art 1830–1975. Exh. cat. Peoria, Ill.: Lakeview Center for the Arts and Sciences, 1975. Unpaginated.

141 **Billy Morrow Jackson** *Before My Time*, ca. 1965

JOHN CHRISTEN JOHANSEN
(1876–1964)

Hills of Fiesole, Springtime, 1908

John Christen Johansen was equally adept at painting land-scapes, portraits, and interior scenes. Originally from Denmark, his family came to Chicago when he was two years old.[1] Johansen studied at the School of the Art Institute of Chicago under Frank Duveneck, John Vanderpoel, and Frederick Freer around 1898.[2] He then traveled to Paris, where he enrolled at the Académie Julian, and he also briefly studied with James Abbott McNeill Whistler at the latter's Académie Carmen. In 1901, Johansen returned to Chicago and joined the faculty of the School of the Art Institute . His time there was brief, for increasing demand from patrons for his portraits caused him to resign from the faculty two years later. In 1906, he and his wife, the artist Jean McLean, went to France and Italy; it was during this trip that *Hills of Fiesole, Springtime* was painted. A contemporary critic noted in 1910 that when Johansen exhibited the landscapes in London that he had made during his travels they brought him "instant recognition."[3]

In 1910, Johansen and his wife returned to America, settling in New York, where he had a long and successful career as a portraitist and was a member of several artists' organizations, including the National Academy of Design, the National Arts Club, and the McDowell Club. A high honor came to him in 1919, when the National Art Committee asked him to make a large-scale painting of the Treaty of Versailles. Johansen died in New Canaan, Connecticut, at the age of eighty-seven.

Johansen is known to have made at least two other paintings of the Tuscan landscape at the time that he painted *Hills of Fiesole, Springtime*.[4] The influence of both the Barbizon school and impressionism on his style are evident in the composition in which the trees are cropped rather than framed, and in the emphasis given to recreating the atmospheric conditions of the day. The painting's combination of rich colors and fluid brushwork has a harmonious quality that captures the beautiful Tuscan countryside in a quiet moment. In *Hills of Fiesole, Springtime*, Johansen has effectively realized his belief that "the province of an artist is essentially that of beauty—his expression always incorporating beauty of thought into beauty of form, tone and color."[5] MR

Oil on canvas; 29 9/16 x 29 3/4 inches
(75.09 x 75.55 cm.)
Signed lower right: J. C. Johansen
1908/Florence
UL1909.2

Provenance:
ULC, 1909

References:
Loy and Honig. *One Hundred Years*.
Pages 179–80.

143 **John Christen Johansen** *Hills of Fiesole, Springtime,* 1908

EASTMAN JOHNSON
(1824–1906)

Alexander Hamilton, 1890

The son of Maine's secretary of state, Jonathan Eastman Johnson apprenticed in a Boston lithographer's shop before beginning his career as a portrait draftsman in his native state, in Washington, D. C., and in Boston.[1] Johnson departed for Europe in 1849. He studied first at the Düsseldorf Academy and then with the German-American painter Emanuel Leutze in the same city. Johnson later worked in Holland, where he studied the works of seventeenth-century masters, and he visited Paris. In 1858 he settled in New York, where he became a prominent figure in art circles. He summered in Nantucket, the setting of his famous series of paintings depicting cranberry harvesting. In the 1880s Johnson returned to portraiture after building a reputation as a painter of American genre scenes. He made three more trips to Europe before his death at the age of eighty-two.

Johnson painted his portrait of Alexander Hamilton during a period in which he was painting several portraits for the New York Chamber of Commerce.[2] The Chamber already owned a 1792 life portrait of Hamilton by the American painter John Trumbull, from which Johnson copied his image.[3] Trumbull's original, portraying Hamilton as the United States's first secretary of the treasury, is an elaborate, formal full-length portrait with a grand, imaginary architectural setting, but Johnson adapted the portrait to a bust likeness as Trumbull himself had in several replicas. Here Hamilton, wearing a light gray coat, is framed against a plain, dark background. His head and gaze are turned slightly toward his right, and a faint smile imparts an air of confidence to the subject. By scaling Trumbull's image down to a relatively informal bust portrait, Johnson focuses attention on the sitter's individuality and recaptures something of the immediacy and vitality of one of the earlier artist's finest likenesses. Although Johnson's later works often demonstrate his indebtedness to the French painter Thomas Couture in their loose brushwork and layered glazes, this work is more tightly painted, with denser application of pigment, in a manner that recalls the artist's early training in Düsseldorf.

Johnson's portrait of Hamilton was apparently his only essay in historical portraiture, and his motive in executing it is unknown. The Club did not commission the work, but its acquisition accorded with the institution's early goal of collecting the likenesses of important figures from American history. In the Club's headquarters Johnson's Hamilton would soon be joined by such works as Hiram Powers's bust of Daniel Webster, the portrait of Lincoln by Ralph Clarkson, and the grand *George Washington at Dorchester Heights* after Gilbert Stuart. (Like Johnson's portrait, the last two were copied from earlier works, a practice regarded as artistically legitimate at the turn of the century.) As an upholder of the ideals of federalism and transcendence of party divisions in the republic's infancy, Hamilton was a fitting addition to the Union League Club's pantheon of historical worthies. WG

Oil on canvas;
26 1/2 x 22 inches
(67.31 x 55.88 cm.)
Signed lower left: 1890/E. Johnson/
after/Trumbull/1792
UL1895R.1

Provenance:
ULC, 1895

Exhibitions:
"American Art in the Union League Club of Chicago, A Centennial Exhibition," traveling exhibition organized by the ULC, 1980–1981

References:
Corliss. *Catalogue*, 1899.
Pages 9–10, #17.

Loy and Honig. *One Hundred Years*.
Page 182.

McCauley. *Catalogue*, 1907. #49.

Martin. *Art in the ULC*. Page 30.

Sparks. *American Art in the ULC*.
Page 21.

145 **Eastman Johnson** *Alexander Hamilton*, 1890

FRANK TENNEY JOHNSON
(1874–1939)

Night in the Canyon, ca. 1929–1937

By the time of his death, Frank Tenney Johnson's romantic images of the Old West had brought him both commercial success and recognition. Johnson was born in Big Grove, Iowa, and lived on the family farm until he was fourteen.[1] When the family moved to Milwaukee, he dropped out of high school and supported himself while taking lessons from a local artist, Frederick William Heine. The next year, Johnson studied with Richard Lorenz, a prominent Milwaukee painter who specialized in western subjects as well as farm and other rural scenes.[2] Lorenz encouraged Johnson's interest in the West, and the young student made several sketching trips to South Dakota, where he observed the Sioux. In 1896, Johnson spent five months at the Art Students League in New York, where he took a class with the impressionist John Henry Twachtman. His final period of study came in 1902, when he returned to New York to enroll at the New York School of Art. By now married, Johnson remained in New York, finding work as a magazine and book illustrator.

A turning point in Johnson's career came in 1904, when he spent three months in Colorado, Wyoming, and New Mexico on assignment for *Field and Stream* magazine. He participated enthusiastically in cowboy life, going on cattle roundups, panning for gold, and attending a rodeo. In addition to making sketches, he also took numerous photographs, which he later used as an aid in composing work. This trip was the first of several that he made. In 1921, he purchased a home in Alhambra, California, where he and his wife first spent summers, and then, as he became financially secure enough to stop working as an illustrator, lived year-round. In 1929, Johnson realized one of his lifelong ambitions when he was elected an associate member of the National Academy of Design. He became a full Academician in 1937. He died unexpectedly of spinal meningitis on New Year's Day, 1939.

Johnson was famous for "nocturne" paintings, moonlit depictions of cowboys and Native Americans. In his idealization of the West, he followed in a long tradition that included landscape artists such as Albert Bierstadt and Frederick Church and artist-illustrators such as Frederic Remington and Charles Marion Russell. One of Johnson's favorite subjects was the solitary horseman riding into the canyon illuminated by moonlight, as in *Night in the Canyon*. His romantic view of the West and representation of its inhabitants as heroes is apparent in his depiction of the Native American, who turns resolutely to watch a potential intruder. Described once as "a poet who sings in color," Johnson primed his canvases with an underlayer of white base that also included a small amount of vermilion.[3] His richly colored and evocative paintings led one writer to call him an "expert in the depiction of atmospheric effects, the blazing heat of the day, the envelopment of the clear blue sky, the curious green-blue light bred of thunderstorm and the splendor of the moon."[4] MR

Oil on canvas; 35 x 25 inches
(88.9 x 63.5 cm.)
Signed lower left:
F. Tenney Johnson A.N.A.
UL1986C.55

Provenance:
Anna Maude Stuart, to 1975;
UL C&AF, 1975–1986; ULC, 1986

Exhibitions:
"American Art in the Union
League Club of Chicago, A Centennial
Exhibition," traveling exhibition
organized by the ULC, 1980–1981

References:
Sparks. *American Art in the ULC*.
Pages 20–21.

Loy and Honig. *One Hundred Years*.
Pages 180–81.

Richter, Marianne. "The Lure of the
American West," *State of the Union: Official
Magazine of the ULC* 75 (February 1999): 8.

147 **Frank Tenney Johnson** *Night in the Canyon*, ca. 1929–1937

ALFRED JUERGENS
(1866–1934)

Afternoon in May, ca. 1913

"You might say I was born in a paint-pot," once quipped Alfred Juergens, whose father was in the paint business.[1] The younger Juergens studied art in Chicago before he departed to attend Munich's Royal Academy and to work in Paris.[2] He returned to Chicago to work at the World's Columbian Exposition and then spent five more years in Munich. In 1899 Juergens established a studio in a house his family had purchased ten years earlier in the Chicago suburb of Oak Park. His one-man exhibition at the Art Institute that year was among the museum's first solo shows for a living local artist. Juergens made several more trips to Europe, where his work received numerous honors. He painted murals and was adept at watercolor painting. Best-known for impressionist floral and garden images, Juergens also painted city scenes, landscapes, interiors, and portraits.

At some point after the turn of the century, Juergens is said to have attended the Société Internationale des Beaux-Arts in Paris, during which he came fully under the spell of impressionism.[3] Already thoroughly grounded in academic technique, Juergens disdained "the impressionistic daub," but *Afternoon in May* demonstrates his exuberant application of impressionism's broken brushwork and happy color to a particularly apt subject: nature in flower on a bright spring day.[4] The painting won particular critical praise as "a small picture with a large expression" when it was exhibited at the Chicago artists' annual exhibition at the Art Institute in 1913.[5] A hedge of lilac at the height of its flowering dominates the scene, which suggests a suburban backyard. On the right, two figures, apparently a boy and a girl, sit in the dappled shade, surrogates for the viewer's first-hand experience of nature at its most peaceful and promising.

Afternoon in May likely pictures a scene in the artist's hometown of Oak Park. Located just beyond Chicago's western border, it was a flourishing community at the turn of the century, with a rapidly growing population and an active cultural life. One of the first artists to settle there, Juergens was soon joined by others, notably Carl Krafft, John Spelman, and Charles Dahlgreen, and in 1921 they founded the Austin, Oak Park, and River Forest Art League.[6] The village was famed for its many trees and luxuriant gardens, which provided Juergens with numerous subjects for his canvases. "In this beautiful suburb there is plenty of inspiration to lend itself to the artistic mind," the artist told a *Chicago Tribune* reporter in 1930.[7] Juergens used generic titles, but the artist named Oak Park as the setting of many of his garden pictures, including one called *Lilac Time* that may have been similar to the Club's *Afternoon in May*.[8] WG

Oil on canvas;
27 1/4 x 25 1/4 inches
(69.22 x 64.14 cm.)
Signed lower left: Alfred Juergens
UL 1976.30

Provenance:
MAL, 1913–1951; UL C&AF,
1951–1976; ULC, 1976

Exhibitions:
"The Municipal Art League of Chicago,"
AIC, 1918

AIC Chicago and Vicinity Annual,
1913, #132

"Exhibit of Recent Paintings
loaned by The Municipal Art League of
Chicago June 1–24, 1920 Under the
auspices of Story County I. S. C.
Alumni Association Complimentary to
the visiting Alumni and friends,"
1920, #21

"Paintings by Chicago Artists,"
Garfield Park Art Galleries, Chicago,
1936, #23

"Centennial Exhibition of the
Works of Alfred Juergens 1866–1934,"
Kalamazoo Institute of Arts, Kalamazoo,
Mich., 1966, #26

References:
Loy and Honig. *One Hundred Years.*
Page 181.

Martin. *Art in the ULC.* Page 41.

149 **Alfred Juergens** *Afternoon in May*, ca. 1913

WILLIAM KEITH
(1839–1911)

High Sierras, undated

Born in Scotland, William Keith was apprenticed as a boy to a wood engraver in New York City, where his family had settled.[1] In 1859 Keith moved to San Francisco and began to study watercolor painting with his first wife, artist Elizabeth Emerson, and oil painting with Samuel Marsden Brookes. Accompanied by his wife, Keith departed for Europe in 1869 to study in Düsseldorf. The following year he returned to San Francisco, where he met the visiting George Inness and was deeply impressed by his mystical approach to nature. The Keiths then briefly shared a studio in Boston with painter William Hahn, who accompanied them back to San Francisco in 1872. In 1883 Keith made a second trip abroad to study portraiture in Munich and to tour southern Europe; he made two more trips to Europe and also visited Alaska and the West. An important figure in the Bay Area artists' community, Keith lived in Berkeley, the subject of many of his late pastoral landscape paintings. Keith executed some four thousand paintings, of which half were lost when the 1906 earthquake and fire destroyed his San Francisco studio.

Keith visited the region around Yosemite Valley, in California's Sierra Nevada, as early as 1862, in company with fellow artists Virgil Williams and Thomas Hill, with whom he is often compared as a painter of Yosemite.[2] In 1872 he explored the area with naturalist John Muir. Both Keith and Hill were close friends with the photographer Carleton Watkins, whose images of Yosemite influenced theirs. Although Keith would eventually abandon grand imagery of the sublime mountain landscape in favor of more intimate subjects, the area's growing numbers of tourists were enthusiastic buyers of Yosemite images by both artists. This public demanded faithful renditions of natural detail along with compositions that dramatized the landscape's spectacular heights and seemingly untamed wildness.

Keith's *High Sierras* takes the viewer out of the familiar and much-pictured Yosemite Valley to an unspecified locale in that region. The rushing torrent and jagged peaks imply nature's forbidding inaccessibility, but a few sketchily rendered figures in the left foreground symbolize the tourism that increasingly intruded into the pristine land. Like many other late-nineteenth-century landscape artists, Keith worked in relatively broad brushstrokes, eschewing the fine detail typical of the Hudson River School, which had dominated landscape painting around mid-century. At the same time, however, *High Sierras* demonstrates the persistence of an American landscape tradition in its panoramic celebration of the distinctly native landscape of the sublime. Within its relatively small dimensions, the painting embraces the vast physical range of the landscape, from lofty peaks to the plunging depths of waterfalls. Juxtaposing those cascades and the swiftly flowing river with snow, clouds, and sunlight, Keith's image emphasizes nature's cyclical processes, envisioning the landscape as the product of continuous, inexorable change. Keith's *High Sierras* transcends mere record making of this spectacular scenery to project the excitement, optimism, and awe that the western landscape engendered in actual visitors and armchair tourists alike. wg

Oil on canvas;
17 5/8 x 35 1/2 inches
(44.77 x 90.17 cm.)
Unsigned
UL1986C.61

Provenance:
Anna Maude Stuart, to 1975;
UL C&AF, 1975–1986; ULC, 1986

References:
Loy and Honig. *One Hundred Years*.
Page 182.

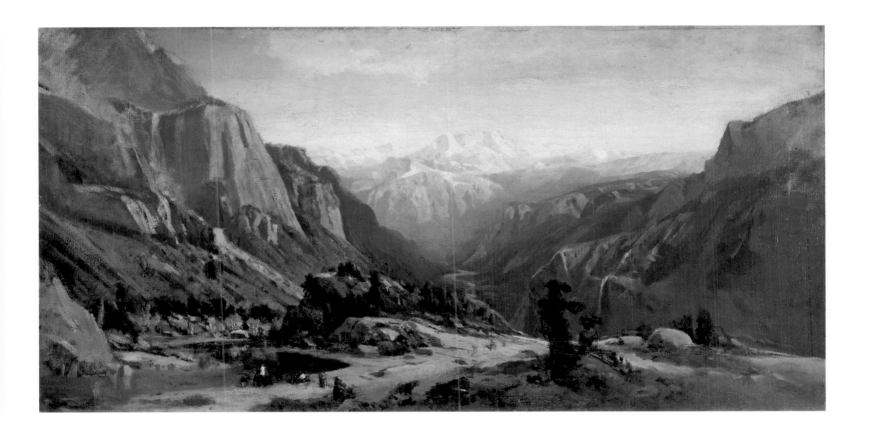

151 **William Keith** *High Sierras* undated

CHARLES PRITCHARD KILLGORE
(1889–1979)

Mexican Market, 1935

Charles Pritchard Killgore was born in Huntington, West Virginia, where he attended Marshall University. He moved to Chicago as a young man and chose a career in the visual arts. He studied at the Chicago Academy of Fine Arts for two years and at the School of the Art Institute of Chicago for two years. He participated regularly in juried exhibitions across the country, winning seventeen prizes in the annual exhibitions of The Art Institute of Chicago alone. Yet Killgore's primary career was as a staff artist and color consultant for the *Chicago Tribune*. Over the years, his responsibilities there grew to include supervising the decoration of the Tribune offices, the company apartment in New York, and the interior of the company airplane.

In spite of his busy work schedule, Killgore succeeded as a fine artist because, when originally hired by the *Tribune*, he negotiated a three-month annual hiatus. During his time off, Killgore was a dedicated world traveler. According to family members, his favorite destinations were California, which he visited forty-one times, and Mexico, which he visited twelve times.

A colorful scene that captures the energy and excitement of the market, *Mexican Market* is one of the artist's early paintings of Mexico. Included in the 1935 "Artists of Chicago and Vicinity" annual exhibition at the Art Institute, it received the Municipal Art League's purchase prize, as well as favorable notice by local art critics. In a letter to the Club written in 1966, Killgore revealed that the painting was based on sketches made in Morelia.[1] Killgore was the primary Chicago artist to make Mexico a recurring subject in this period, and his paintings were extremely popular. MR

Oil on canvas; 36 x 36 inches
(91.44 x 91.44 cm.)
Signed lower right: Charles P. Killgore
UL1976.31

Provenance:
MAL, 1935–1951; UL C&AF, 1951–1976;
ULC, 1976

Exhibitions:
AIC Chicago and Vicinity Annual,
1935, #105

"American Art in the Union League
Club of Chicago, A Centennial
Exhibition," traveling exhibition
organized by the ULC, 1980-1981

References:
Sparks. *American Art in the ULC*.
Page 22.

Loy and Honig. *One Hundred Years*.
Pages 182–83.

153 **Charles Pritchard Killgore** *Mexican Market*, 1935

VERA KLEMENT
(b. 1929)

Woman at the Window, 1965

Vera Klement was born in 1929 in the free city of Danzig (now Gdansk, Poland). In 1938 she and her family moved to New York City to escape the Nazis.[1] There she studied art at the Cooper Union School of Art and Architecture. In the 1950s, the New York art world was dominated by abstract art, most particularly by Abstract Expressionism, and Klement became interested in nonfigurative art. After moving to Chicago in 1964 with her then-husband, composer and violinist Ralph Shapey, Klement found that her commitment to abstraction was atypical in a city that had historically preferred figurative work. Compounding this situation was the rise in the late sixties of the Chicago Imagists, a group whose figurative work, influenced by surrealism and popular culture, quickly became popular with both the press and the public.

Klement's isolation from the central art scene proved to be positive, for not only was she forced to define herself artistically, but she also became active in creating her own exhibition opportunities.[2] Thus, she played an integral role in the development of the Chicago women's cooperative gallery Artemisia in the 1970s. In addition, she was a founding member of "The Five," a group of abstract artists that included Ted Argeropolis, Larry Booth, Martin Hurtig, and Larry Solomon. These artists exhibited together from 1971 to 1976. From 1969 until her retirement in 1995, Klement was an influential teacher at the University of Chicago. In 2001, the artist became Distinguished Artist member of the Union League Club in recognition of these achievements.

Painted just after Klement moved to Chicago, *Woman at the Window* is one of four images the artist created using the theme of figures at windows. The artist is known for her interest in the play between abstraction and representation within the same work. At a distance, the painting appears to be figurative, for its composition is the dominant element. At close range, the figure dissolves into the work's freely painted brushwork. A mood of yearning pervades the painting, for the woman appears to be distanced from both landscape and viewer. The colors that comprise the landscape are identical to those that comprise the figure of the woman, a subtle use of color that creates compositional unity and heightens the sense of longing for the land. MR

Oil on canvas;
58 1/4 x 70 1/2 inches
(147.96 x 179.07 cm.)
Signed bottom center: Klement
UL1999.4

Provenance:
ULC, 1999

Exhibitions:
"Vera Klement: A Retrospective
1953–1986," The Renaissance Society at
the University of Chicago, 1987

"Vera Klement: Paintings 1965–1998,"
The City of Chicago Department of
Cultural Affairs, 1999, #1

References:
Ashton, Dore and James Yood.
Vera Klement: A Retrospective, 1953–1986.
Exh. cat. Chicago: The Renaissance
Society at The University of Chicago,
1987. Pages 11, 14.

Knight, Gregory G. and Sue Taylor.
Vera Klement Paintings 1965–1998. Exh. cat.
Chicago: The City of Chicago Department
of Cultural Affairs, 1999. Pages 11, 26.

155 **Vera Klement** *Woman at the Window*, 1965

DANIEL RIDGWAY KNIGHT
(1840–1924)

Waiting for the Ferry, 1883

As a boy Daniel Ridgway Knight apprenticed in a wholesale hardware business in his native Philadelphia.[1] He studied art in secret, copying engravings from the Franklin Institute Library, for his family's strict Quaker beliefs forbade art. Knight's grandfather recognized his talent, however, and persuaded the boy's father to let him study at the Pennsylvania Academy of the Fine Arts. In 1861 Knight went to Paris and Rome for further study. He returned to the United States during the Civil War, then settled permanently in Normandy, France, in 1872. By the 1880s Knight had established a reputation for his idealized images of French peasant life and his rendering of natural light. The artist had a glasshouse built adjacent to his house so that he could work virtually outdoors year-round to capture natural light effects. Knight's paintings were so popular that he could not keep up with the demand.[2]

In the late nineteenth century peasant subjects were the rage among both European and American painters.[3] In an age of urbanization, industrialization, and social unrest, images of agrarian life in remote, traditional societies governed by timeless custom and the rhythms of nature attracted many Americans. Artists generally eschewed the bleak realities of rural poverty and back-breaking labor presented by such realists as the French artists Jean François Millet and Gustave Courbet. Thus although Knight is said to have modeled his female figures on actual residents of his French village,[4] the sturdy, well-rounded forms and smooth hands of the girls in his paintings add to his idealization of French country life. Insisted Knight,

"These peasants are as happy and contented as any similar class in the world. They work hard, to be sure, but plenty of people do that."[5] In fact, Knight portrayed his peasant subjects not at work but at moments of rest or incidental pleasure.

The anecdotal image in the Club's collection is Knight's early treatment of a theme to which he returned in later works, including his well-known *Hailing the Ferry* of 1888 (Pennsylvania Academy of the Fine Arts). At some point the Club's painting was assigned the title *Waiting for the Ferry*, but it clearly does not apply.[6] A modest rowboat, perhaps a "ferry," has already pulled up in the river's weedy shallows, possibly to receive as passengers the two young women and a boy returning from fishing with his curly haired dog; all three standing figures are laden with the spoils of nature's bounty. The girl in the boat twists around in her seat to gaze somewhat sternly at the boy, whose face is hidden from the viewer, while one of the standing girls, gesturing with an open hand, seems to appeal on his behalf. The nature of their dispute is unclear, but such anecdotal content is subordinate to the painting's technical bravura, from the balanced arrangement of the figures to the scrupulous delineation of the setting and of the figures' costumes and accoutrements, including such minutiae as the girls' patched dresses and the gaping tear near the seat of the boy's pants. Many late-nineteenth-century *plein-air* painters favored the cool gray-green tints seen in Knight's landscape, notably the French painter Jules Bastien-Lepage, with whom contemporaries frequently compared him.[7] WG

Oil on canvas; 27 1/2 x 36 1/2 inches
(69.85 x 92.71 cm.)
Signed lower left: D. Ridgway Knight
Paris 1883
UL1986C.63

Provenance:
Anna Maude Stuart,
to 1978; UL C&AF, 1978–1986;
ULC, 1986

Exhibitions:
"Lasting Impressions: American Painters in France 1865–1915," Musée d'Art Américain Giverny, 1992

References:
Gerdts, William H., et al. *Lasting Impressions: American Painters in France 1865–1915*. Exh. cat. Giverny, France: Musée d'Art Américain Giverny, 1992. Pages 226–27.

Loy and Honig. *One Hundred Years*. Pages 14–15.

157 **Daniel Ridgway Knight** *Waiting for the Ferry*, 1883

CARL RUDOLPH KRAFFT
(1884–1938)

Banks of the Gasconade, 1920

Carl Rudolph Krafft executed portraits, figure paintings, and murals but he is best known for his landscapes, painted in Brown County, Indiana, in the Ozark Mountains of Missouri, and along the Mississippi River. The son of a German Lutheran pastor on Chicago's South Side, Krafft began his career as a label designer while attending night classes at the Art Institute.[1] His Ozark landscapes established his reputation, especially when the Municipal Art League added his *Charm of the Ozarks* (now owned by the Union League Club) to its collection in 1916. After 1920 Krafft was able to devote himself to painting; he also taught widely and conducted his own summer school in Willow Springs, Illinois. In 1924 Krafft joined the growing artists' community in the Chicago suburb of Oak Park, where he had been instrumental in founding the Austin, Oak Park and River Forest Art League in 1921.[2]

In the early decades of the twentieth century, regional pride and a poetic ideal of nature prompted many Chicago landscape painters to search well beyond the metropolitan region for their subjects. Brown County, Indiana, became a popular artists' haunt; in 1912 Krafft and Rudolph Ingerle, with whom he shared a commercial art studio, deserted it for the Ozarks. The following year they founded the Society of Ozark Painters. While most landscape painters worked in the Ozarks in the summer, Krafft also visited the area to work at other seasons, including winter.[3] He called the Ozarks his "cathedral of nature."[4]

Krafft and others wrote ecstatically of the beauties of the Ozarks region, with its dramatic ridges and valleys and its hazy veils of atmosphere.[5] Krafft's studio there overlooked the Gasconade River.[6] His *Banks of the Gasconade* bears out fellow artist Otto Hake's description of the river as "flanked by huge rocky bluffs" with "wonderfully decorative, vine-hung sycamores alternating with heavily-wooded embankments."[7] October, evidently the time of year pictured by Krafft, was said to be the area's most beautiful season.[8] This almost square composition shows the sycamores as a screen through which we glimpse a riverscape of turquoise water and majestic palisades softened by a sunlit haze. Krafft's layered series of flat patches of pure color set against contrasting tones for decorative effect recall the abstracting landscape paintings of such contemporaries as Jules Guerin and Augustus Vincent Tack.

Chicago Tribune art critic Eleanor Jewett proclaimed *Banks of the Gasconade* the most beautiful painting in the Art Institute's annual exhibition by Chicago artists of 1920.[9] The work garnered for Krafft the Logan Medal and an accompanying prize of two hundred dollars. Collector L. L. Valentine, a furniture manufacturer, immediately purchased the painting, and he hung it for a time at the South Shore Country Club, of which he was a member and benefactor; Valentine later gave the painting to the Municipal Art League.[10] *Banks of the Gasconade* marked a turning point in the artist's career, for with its success Krafft could abandon commercial work entirely and move his family from Chicago's South Side to the middle-class enclave of Austin.[11] WG

Oil on canvas; 45 x 50 inches
(114.3 x 127 cm.)
Signed lower right: CARL R. KRAFFT
UL1976.33

Provenance:
L. L. Valentine, 1920–?; MAL, ?–1962; UL C&AF, 1962–1976; ULC, 1976

Exhibitions:
AIC Chicago and Vicinity Annual, 1920, #185

"Exhibition of Famous American Artists," South Shore Country Club, Chicago, 1920

"Memorial Exhibition of Paintings by Carl R. Krafft," AIC, 1939, #5

"American Art in the Union League Club of Chicago, A Centennial Exhibition," traveling exhibition organized by the ULC, 1980–1981

References:
Carr, V. E. "Carl R. Krafft." *The American Magazine of Art* 17 (Sept. 1926): 475.

Davies, Lal (Gladys Krafft). *An Artist's Life*. New York: Vantage Press, 1982. Pages 8, 11, 48.

Gerdts, William H. "Post-Impressionist Landscape Painting in America." *Art and Antiques* 6 (July–Aug. 1983): 64.

Martin. *Art in the ULC*. Page 41.

Sparks. *American Art in the ULC*. Pages 22–23.

Stuart, Evelyn Marie. "South Shore's Exhibition of Paintings." *South Shore Country Club Magazine* 4 (July 1920): 21, 24.

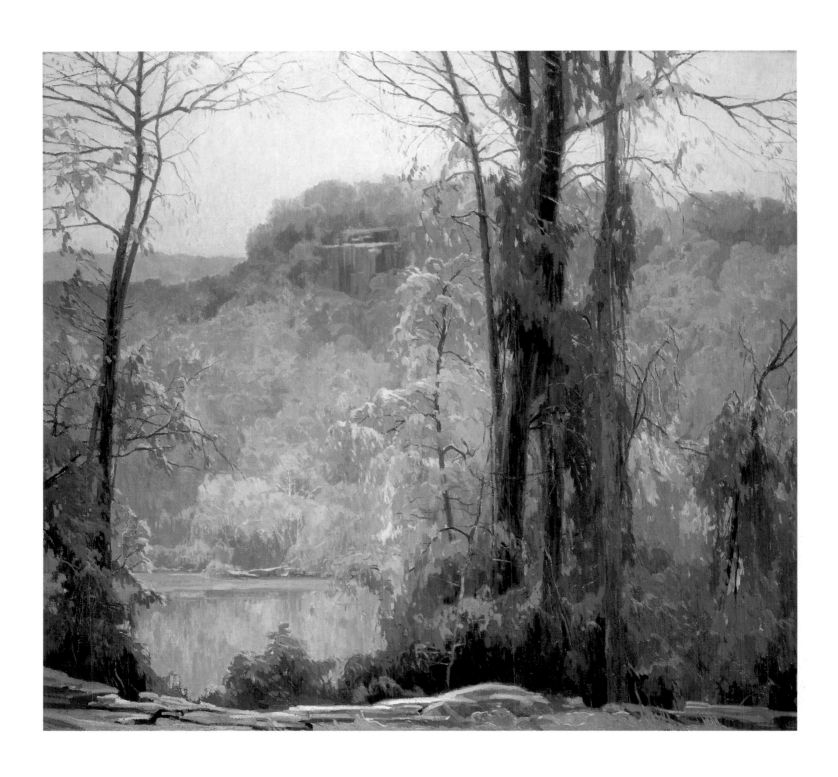

159 **Carl Rudolph Krafft** *Banks of the Gasconade,* 1920

EVELYN BEATRICE LONGMAN
(1874–1954)

Victory, ca. 1905

Among the women sculptors who gained prominence at the beginning of the twentieth century, Evelyn Longman was one of the most talented.[1] From a poor family, she rose to the heights of her profession through great determination. Longman, who was born in Ohio to English immigrants, left school at age fourteen to work at a Chicago dry goods warehouse. She became interested in studying art after seeing the fine art exhibition at the World's Columbian Exposition and taking an evening class at The Art Institute of Chicago. After several years of saving money, Longman enrolled at Olivet College in Michigan, where she remained for two years. She then studied sculpture with Lorado Taft at the School of the Art Institute of Chicago. Following her graduation, she went to New York City, where she was the only woman ever to assist the great American sculptor, Daniel Chester French. Longman set up her own studio after working with French for three years, and she received many important commissions for public sculpture. She is perhaps best known for *Electricity*, the sculpture she made for the Western Union Building in New York, which today is on view in the lobby of the American Telegram and Telegraph building in Bedminister, New Jersey. In 1919, Longman gained the distinction of being the first woman to be elected a full Academician of the National Academy of Design.

The sculpture of *Victory* in the Union League Club of Chicago's collection is a smaller version of the figure that adorned the top of the Festival Hall building at the 1904 Louisiana Purchase Exposition. *Victory*, which was awarded a silver medal, became the signal image of the fair for many visitors. Its great popularity led the Union League Club's Art Committee to commission the artist to make a smaller version in 1905. The figure gazes down at the scene below while holding a laurel wreath, the symbol of victory in ancient Greece. Although historically Victory was personified as a female, Longman chose to depart from tradition. The graceful, dance-like pose of the figure and the attention to the armor's decorative details are characteristic of Longman's work and reflect her espousal of the decorative Beaux-Arts sculptural style, then in fashion. MR

Bronze; 58 x 15 x 13 3/4 inches
(147.32 x 38.1 x 34.93 cm.)
Inscribed on back of ball:
Evelyn B. Longman Sc/1903;
on base: Roman Bronze Works,
New York
UL1905.8

Provenance:
Commissioned by the ULC, 1905

References:
McCauley. *Catalogue*, 1907, #210.

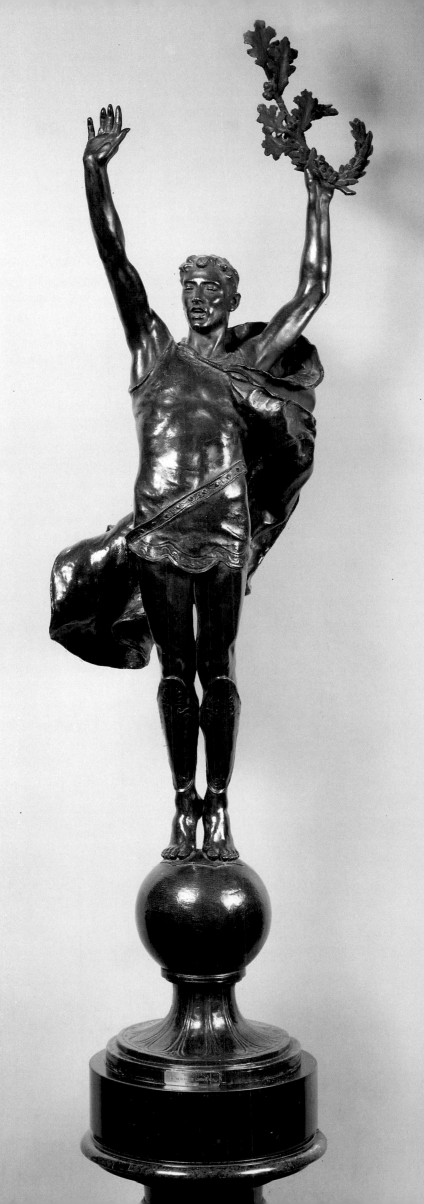

MARY FAIRCHILD MACMONNIES LOW
(1858–1946)

Blossoming Time in Normandy, 1901

Mary Fairchild MacMonnies Low was born in New Haven, Connecticut, and moved to Saint Louis with her family as a child.[1] She first learned to paint from her mother, an amateur artist. Low attended the Saint Louis School of Fine Arts, where she helped agitate for women students' right to study from the nude model. She went to Paris to study at the Académie Julian and with painters William-Adolphe Bouguereau and Carolus-Duran. In 1888, Low married fellow student Frederick MacMonnies. Her paintings won success in Paris, including a bronze medal at the Paris Universal Exposition of 1889. Low was awarded the commission to paint a mural, *Primitive Woman* (opposite Mary Cassatt's *Modern Woman*), in the Woman's Building at the World's Columbian Exposition, where she also received an award for two easel paintings. In 1894 Mary and Frederick began to summer in Giverny, site of Claude Monet's home and of an international colony of impressionist painters; they moved there permanently in 1898. While Mary's impressionist easel works continued to find critical favor, in 1904 she began to paint miniatures. Shortly after her divorce in 1909 from Frederick MacMonnies she married painter Will Hicock Low. The couple returned to the United States, where they settled in Bronxville, a suburb of New York City. Thereafter Mary Low executed commissioned portraits and painted landscapes in Gloucester, Massachusetts, and city scenes of New York.

Le Moutier, the MacMonnieses' home in Giverny, was built in the fourteenth century as a priory and included three acres of walled gardens and orchards with a small stream-fed reservoir.[2] The garden in bloom was Mary's favorite subject.[3] In early spring it "was like a great bridal bouquet, where the filmy white of cherry, pear, and plum and the modest blush of apple-bloom not only in the trees but, according to Old World usage, cunningly dwarfed to border the garden walks, filled the days with a beauty so delicate and impalpable that, knowing how soon it would vanish, brought a pleasure closely akin to pain."[4]

Thus wrote Will Hickok Low in his published account of his visit with the MacMonnieses in 1901, the year Mary painted *Blossoming Time in Normandy*. He described her, thinly disguised as "The Châtelaine," in admiring terms that hint at their embryonic romance.[5] Low dubbed himself "The Idealist" and Frederick MacMonnies "The Realist," who left the other two to admire the moonlit garden together. All three artists painted views of the garden and orchard, Mary working on "a large canvas begun the year before, as the only means of finding enough time to reproduce the evanescent beauty of the blooming garden," quite possibly the Union League Club's painting. Will Low's *Lower Garden* pictures the scene from almost the same viewpoint, suggesting that he and Mary set their easels close together and worked side by side to capture the transient beauties of springtime at Giverny.[6]

Reminiscent of similar subjects by Monet, notably the Club's *Trees in Blossom*, Mary Low's *Blossoming Time in Normandy* demonstrates her affinity with French Impressionism: its depiction of a fleeting moment in the cycle of nature; the loose dabs of bright color, particularly in the rendering of the snowy clumps of blossoms; and the cropped composition, with objects arbitrarily cut off along each edge of the canvas. Walls and buildings appear haphazardly through the screen of slender trees, and the figures in the middle distance blend almost to invisibility amidst the garden's abundance. Two brightly clothed children on the ground by the feet of the white-aproned nurse are undoubtedly the MacMonnieses' two daughters, born in 1895 and 1897.

A high-water mark in Low's already successful career, *Blossoming Time in Normandy* won the Julia A. Shaw Memorial Prize of the Society of American Artists in 1902. Exhibited that same year at the Art Institute's annual exhibition of American painting and sculpture, the painting was purchased by the Union League Club, which coincidentally added Will Low's *In the Sun, Narcissus* to its collection at the same time. wg

Oil on canvas; 38 1/2 x 63 5/8 inches
(97.79 x 161.61 cm.),
Signed lower left: MARY MACMONNIES.
GIVERNY 1901
UL1907C.18

Provenance:
ULC, 1902

Exhibitions:
"Twenty-Fourth Annual Exhibition," Society of American Artists, New York, 1902, #287

AIC American Artists Annual, 1902, #366

"American Art in the Union League Club of Chicago, A Centennial Exhibition," traveling exhibition organized by the ULC, 1980–1981

"Lasting Impressions: American Painters in France, 1865–1915," Musée d'Art Américain Giverny, 1992

"An Interlude in Giverny," Palmer Museum of Art, Pennsylvania State University, Musée d'Art Américain Giverny, and Terra Museum of American Art, 2001

References:
Buell, James Ford. "Chicago's Fifteenth Annual Art Exhibition." *Brush and Pencil* 11 (January 1903): 304.

Gerdts, William H. *Lasting Impressions: American Painters in France, 1865–1915.* Exh. cat. Giverny, France: Musée d'Art Américain Giverny. Pages 182–83, 186.

Loy and Honig. *One Hundred Years.* Pages 38–39.

McCauley. *Catalogue*, 1907. #93.

Martin. *Art in the Union League Club.* Pages 21, 42.

Robinson, Joyce Henri and Derrick Cartwright. *An Interlude in Giverny.* Exh. cat. Palmer Museum of Art, Pennsylvania State University, and Musée d'Art Américain Giverny, 2001. Pages 49, 87.

Smart, Mary. "Sunshine and Shade: Mary Fairchild MacMonnies Low." *Woman's Art Journal* 4 (fall 1983/winter 1984): 24.

Sparks. *American Art in the ULC.* Pages 22–23.

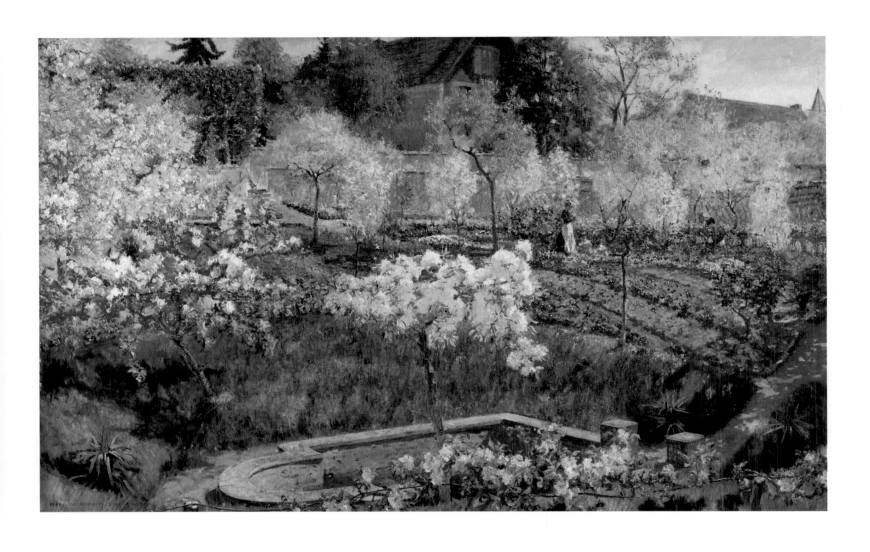

ANNA LOU MATTHEWS
(1882–1962)

Our Daily Bread (Daily Bread), ca. 1932

Relatively little is known about Anna Lou Matthews, who worked as a painter, sculptor, and teacher in Chicago and later in Wisconsin.[1] A Chicago native, she was a student of Lorado Taft and John H. Vanderpoel at the School of the Art Institute of Chicago from 1895 to 1899. In 1905 and 1906, Matthews studied at art academies in Paris and London.[2] She had a solo exhibition at The Art Institute of Chicago in 1910 and began exhibiting with some regularity at the museum's annual exhibitions. In 1940, she moved to Green Bay, Wisconsin, where she taught art at a vocational school. Little is known about her later years, but she may have retired to St. Petersburg, Florida.[3]

Our Daily Bread, shown in the Art Institute's 1932 annual exhibition of works by Chicago-area artists, offers a compelling testament to the bleak life of those hardest hit by the depression.

In this work, a young family mutely prepares to eat a meager meal of bread and soup. The brown and gray tonalities of the painting and the downcast eyes of the man and woman heighten the poignant grimness of their lives, while Matthews's empathetic treatment of the figures conveys a sense of courage and dignity. The painting's title, with its allusion to the Lord's Prayer, as well as the family itself, remind the viewer that the group has much in common with the humble circumstances of the Holy Family. While Matthews's social and political views are unknown, the painting's strong social message reveals an attitude found in Social Realism. This American movement developed during the Great Depression among artists who wished to use their work as a platform to draw attention to and express concern for the plight of common folk. MR

Oil on canvas; 48 x 38 inches
(121.92 x 96.52 cm.)
Signed lower left: Lou Matthews
UL1976.36

Provenance:
MAL, 1932–1962; UL C&AF, 1962–1976;
ULC, 1976

Exhibitions:
AIC Chicago and Vicinity Annual,
1932, #11

"Visions of a Nation: Exploring Identity
Through American Art," Terra Museum of
American Art, Chicago, 1996–1997

References:
Loy and Honig. *One Hundred Years*.
Pages 82–83.

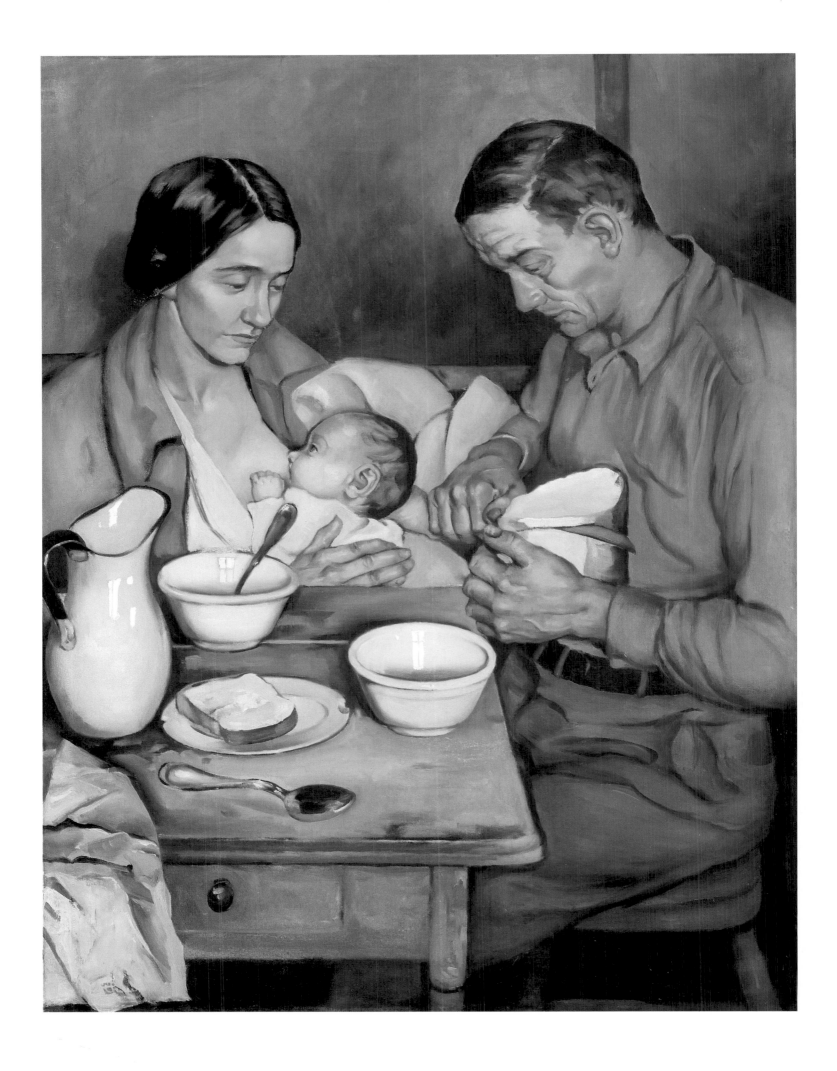

165 **Anna Lou Matthews** *Our Daily Bread (Daily Bread)*, ca. 1932

JULIUS MOESSEL
(1871–1960)

Springtime, ca. 1934

In the early twentieth century, a boom in the construction of commercial structures made possible by the expansion of Chicago business created many opportunities for mural painters. Among the last to arrive on the scene was Julius Moessel, Germany's most successful decorative painter.[1] Moessel was born in Fürth, Germany, studied at the Royal Academy in Munich, and established his own architectural decoration firm while still in his twenties. He decorated numerous theaters and civic buildings and published an important book on decorative painting, *Die Farbe im Raume* (1925). The market for such work had collapsed in Europe in the wake of World War I, however, and Moessel came to the United States in 1926. He emigrated at the invitation of Julius Rosenwald to paint murals in the proposed Museum of Science and Industry in Chicago, but the commission did not materialize. Moessel took on decorative painting projects in Saint Louis, Chicago, and possibly Detroit before settling permanently in Chicago in 1929 just as the Great Depression eliminated further opportunities. By 1932, Moessel had turned to easel painting, working prolifically in a variety of genres and styles. His paintings were well received by local critics. In the mid-1930s the artist began to lose his vision, which was restored by operations that almost ruined him financially. He welcomed the commission to paint eighteen murals at Chicago's Field Museum of Natural History illustrating the history of food plants (1937–40), a project on which his fame rests today.

Moessel first began to realize a modest critical success with his easel paintings in 1934,[2] the year in which *Springtime*, his contribution to the Art Institute's annual "Chicago and Vicinity" exhibition, was selected by popular postcard ballot to receive the Municipal Art League's purchase prize.[3] The subjects of Moessel's paintings ranged widely, from studies of birds and monkeys to surreal fantasies that included mythical themes and political satire. "Mr. Moessel paints pleasing fancies as well as ghastly ones. He is amusing and romantic, historical and decorative," wrote *Chicago Tribune* critic Eleanor Jewett.[4] The artist often repeated motifs and themes in numerous works. The landscape seen in *Springtime* appears in an almost identical work called *Spring*, which features a woman and child in the foreground.[5]

Springtime shows Moessel at his most accessible. It is a straightforward view of an unspecified midwestern landscape in the rich greens of spring, under an unclouded blue sky. A line of white paper birches set against darker evergreens separates a sloping field carpeted with wildflowers and wild grasses from the distant farmland, bisected by a curving blue river. The foreground is rendered with meticulous detail, each leaf and blade of grass delineated with almost pre-Raphaelite intensity. In the distance, neat strips of cultivated earth in contrasting tones of greens and browns blanket the smoothly rounded hills. The evident stillness and mechanical perfection of Moessel's image recalls the Iowa landscapes of his contemporary, Grant Wood. About sixty years old when he began to execute easel paintings, Moessel was self-taught in such techniques,[6] which may account for the hint of naiveté that adds to the appeal of his *Springtime*. WG

Oil on canvas; 49 7/8 x 43 7/8 inches
(126.68 x 111.44 cm.)
Signed lower right: Moessel
UL1976.37

Provenance:
MAL, 1934–1951; UL C&AF 1951–1976;
ULC, 1976

Exhibitions:
AIC Chicago and Vicinity Annual,
1934, #128 (illus.)

"Paintings by Chicago Artists," Garfield
Park Art Galleries, Chicago, 1936, #27

"Currents of Expansion Painting in
the Midwest, 1920–1940,"
The Saint Louis Art Museum, 1977

"American Art in the Union League
Club of Chicago, A Centennial
Exhibition," traveling exhibition
organized by the ULC, 1980–1981

"The American Scene: Artists from
1910–1945," Krasl Art Center, St. Joseph,
Mich., 1985

References:
Loy and Honig. *One Hundred Years*.
Pages 70–71.

McKeever-Furst, Jill Leslie. "Moessel in
America: 1929–1957" in Judith Breuer,
*Julius Moessel: Dekorations und Kunstmaler
1871–1957*. Stuttgart: Konrad Theiss
Verlag, 1995. Page 131.

Martin. *Art in the ULC*. Pages 26, 43.

Sparks. *American Art in the ULC*.
Pages 24–25.

CLAUDE MONET
(1840–1926)

Pommiers en fleurs (Apple Trees in Blossom; Le Printemps; Springtime), 1872

Pommiers en fleurs, the most noteworthy exception to the Club's longstanding focus on American art, is unquestionably the painting for which the collection is best known. It dates to the early 1870s, when Monet and his family lived in Argenteuil, a resort town on the Seine River. Argenteuil and its surrounding countryside were a source of great inspiration to Monet, who created over 170 paintings while he lived there from late 1871 until early 1878.[1] The painting's broken brushwork and pastel colors are characteristic of Monet's early Argenteuil landscapes and convey the beauty of the rural scene. As with other Barbizon and Impressionist painters, Monet frequently focused on the richness of the French countryside, extolling the nation's agricultural abundance.[2] The painting's central path may be one on the Colline d'Orgemont, a hill to the north of town.[3] Monet probably painted *Pommiers en fleurs* in the spring of 1872.

The Argenteuil period was one of greater financial stability for the artist, who had struggled both financially and professionally during the 1860s. In 1870 and 1871, while living in London, Monet met Paul Durand-Ruel, who became his principal dealer. Durand-Ruel began acquiring Monet's work for his gallery in May 1871, and his commitment increased after the artist returned to France later that year.[4] In 1873, Monet participated in the first exhibition of the "Société Anonyme des Artistes, Peintres, Sculpteurs, Graveurs." Louis Le Roy's scornful review in the journal *Le Charivari* introduced, in discussing Monet's painting *Impression, Sunrise*, the word by which the group's work became known: Impressionism. The Impressionists held their second exhibition in 1876, at which *Pommiers en fleurs* was shown under the title *Le Printemps* ("Springtime"). The title by which the painting is now known derives from critic Charles Bigot's description of *Le Printemps* as "a garden path, all grassy, that goes between apple trees in blossom and shrubs that grow their first leaves; there is much frankness, an impression of the month of May that gladdens the eyes."[5]

The story of how the painting came to the Union League Club is both fascinating and somewhat mysterious. In the Art Committee's 1896 register of the collection is a guarantee of authenticity for the Monet written by a London art dealer, Thomas Richardson, to W. C. Reynolds of New York, which is dated August 22, 1894.[6] Written in ink next to Richardson's certificate is the statement:

'Trees in Blossom' by Claude Monet. Oil. This was exhibited March 1895 in Monet exhibit Chicago Art Institute, and is a very fine example of Monet [sic] early and best work. Value $1500 Cost the Club $500 Pictures in the exhibit above mentioned of this general character and size were held at from $1800 to $2000. Purchased March 1895.

The allusion to a Monet exhibition refers to one organized by Durand-Ruel that was seen in New York and Boston before traveling to Chicago, where it was on view at the Art Institute from March 18 to 28, 1895. The only surviving exhibition checklist, from the Boston venue, does not list either *Le Printemps/Springtime* or *Pommiers en fleurs*, an omission that is at odds with the Club's records.[7] However, contemporary newspaper accounts reveal that Judge John Barton Payne, an art collector and Art Institute trustee, owned a Monet painting, called *Springtime*, in 1895, and that it was included in the Chicago exhibition as an addition to the works from Durand-Ruel.[8] If *Springtime* continued to be used as a title for *Pommiers en fleurs* during this time, it would follow that the Club purchased the work from Payne, who was chair of the Club's Art Committee in 1895. In addition, Payne's relationship with the Club makes it reasonable to assume that he would have offered the painting to the Club at a price well below those set by Durand-Ruel for the paintings in the exhibition.

Within the clubhouse, response to *Pommiers en fleurs* appears to have been mixed at the time of its acquisition. Today, members marvel at the purchase price, but according to Club lore, the president, John H. Hamline, reputedly scoffed, "Who would pay five hundred dollars for that blob of paint?"[9] The acquisition of *Pommiers en fleurs* must be credited not only to Payne, but also to the other two members of the 1895 Art Committee, artist and collector Edward Burgess Butler and Adolphus Clay Bartlett, a trustee at the Art Institute and father of artist Frederic Clay Bartlett. Significantly, the purchase made the Club—along with Mrs. Potter Palmer and Club member Martin Ryerson— one of the early Chicago collectors of Monet. MR

Pommiers en fleurs (Apple Trees in Blossom; Le Printemps; Springtime), 1872

Oil on canvas; 24 x 28 1/2 inches
(60.96 x 72.39 cm.)
Signed lower left: Claude Monet
UL1895.19

Provenance:
Durand-Ruel, May 1872 (stock #4653);
W. C. Reynolds, N.Y., 1894; Judge John
Barton Payne, 1894 or 1895; ULC, 1895

Exhibitions:
"20 Works by Claude Monet," AIC,
March 18–28, 1895

Tennessee Centennial Exposition,
Nashville, 1897

Young Men's Hebrew Charity Association,
Chicago, 1898

"Paintings by Monet," AIC, 1975, #45

"A Day in the Country: Impressionism
and the French Landscape," traveling
exhibition organized by the Los Angeles
County Museum of Art, Art Institute
of Chicago and Grand Palais, Paris,
1984–1985, #100

References:
Baignères, Arthur. "Exposition de
peinture par un group d'artistes, rue le
Peletier, 11," *L'Écho universel*,
April 18, 1876, 3.

Bigot, Charles. "Causerie artistique.
L'exposition des 'intrasigeants.'"
La Revue politique et littéraire,
April 8, 1876, 350.

Brettell, Richard, Scott Schaefer, Sylvie
Gache-Patin, Françoise Heilbrun
and Andrea P. A. Belloli, eds. *A Day in the
Country: Impressionism in the French
Landscape*. Exh. cat. Los Angeles: Los
Angeles County Museum of Art, 1984.
Pages 256–257.

Corliss. *Catalogue*, 1899. Page 10, #22.

Dax, Pierre. "Chronique." *L'Artiste*.
May 1, 1876, 348.

Geffroy, Gustave. *Claude Monet, sa vie,
son temps, son oeuvre. Cinquante-quatre
illustrations hor-texte en noir et en couleur*.
Paris: G. Crès et cie, 1922. Pages 59, 72.

Loy and Honig. *One Hundred Years*.
Pages 16–17.

Martin. *Art in the ULC*. Cover and inside
cover.

McCauley. *Catalogue*, 1907. #55.

Rivière, Georges. "Les intransigeants de
la peinture." *L'Esprit moderne*. April 13,
1876: 7–8.

Silvestre, A. *Galerie Durand-Ruel. Receuil
d'estampes*. Paris: Maisons Durand-Ruel,
1873.

Wildenstein, D. *Claude Monet*. Vol. 1:
1840–1881. Lausanne and Paris: La
Bibliothèque des Arts, 1974. Page 204,
201.

Wise, Susan ed., Andre Masson, Grace
Seiberling, J. Patrice Marandel. *Paintings
by Monet*. Chicago: The Art Institute of
Chicago, 1975. Page 99.

DANIEL MORPER
(b. 1944)

Zeus, 1983

Today based in Santa Fe, New Mexico, Daniel Morper spent his early career painting New York City street scenes such as that seen in *Zeus*. Morper, who was born in Fort Benning, Georgia, had a peripatetic childhood due to his father's career as an attorney for the Veterans Administration.[1] Although he painted and drew during his childhood, Morper did not initially envision becoming an artist, and instead, in 1969, he earned a law degree from Columbia University. In the early 1970s, on a leave from work, he studied at the Corcoran Museum School in Washington, D.C., and traveled through Europe. Morper decided to change careers. After painting New York cityscapes for several years, Morper began to make painting trips to the Southwest. He moved to Santa Fe in 1985 and since then has become known for panoramic views of canyons and, more recently, for his depictions of rail yards.

Morper's first New York cityscapes were of the sky and the tops of buildings, but the artist noted that he later "lowered [his] sights to the city streets—where the heart of New York really lay."[2] His interest in depicting New York street life shows the influence of urban realism, an artistic movement that developed in the early years of the twentieth century and that focused on scenes of urban life. The Club's painting, a depiction of Fourteenth Street and the Avenue of the Americas in Greenwich Village, is named for the coffee shop shown in the lower center. For many years, Zeus coffee shop was a famous gathering place for the city's creative community. In the lower right, Morper included an homage to a friend whose photographs served as a guide for *Zeus*. The man is shown both ascending the subway staircase and bent over taking a photograph.[3] The somewhat blurred lines of the moving cars and people in this painting contrast with the more detailed rendering of the buildings and convey the energy and activity of New York. MR

Oil on canvas; 66 x 49 inches
(167.64 x 124.46 cm.)
Signed lower right: D. M. 83
UL1984.1

Provenance:
ULC, 1984

Exhibitions:
"Daniel Morper: Class of '66," Snite Museum of Art, University of Notre Dame, Notre Dame, Ind., 1986, #7

References:
Morper, Daniel. *Daniel Morper: Class of '66*. Exh. cat. Notre Dame: Snite Museum of Art, University of Notre Dame, 1986. Unpaginated [3, 10].

Loy and Honig. *One Hundred Years*. Pages 128–29.

173 **Daniel Morper** *Zeus*, 1983

RAYMOND PERRY RODGERS NEILSON
(1881–1964)

The Mirror, 1921

Raymond Perry Rodgers Neilson, a grandson of Rear Admiral Christopher Raymond Perry Rodgers and a 1905 graduate of Annapolis, broke with the family tradition of service in the navy when he decided to become an artist. In 1908, he resigned his commission and spent the next three years in New York studying with George Bellows at the Art Students League and with William Merritt Chase at the Chase School of Art.[1] From 1911 through 1914, Neilson attended the École des Beaux-Arts in Paris. With America's entry into World War I in 1917, his career was temporarily sidelined while he returned to active duty, serving as a lieutenant and aide to Admiral William Sims. After the war, Neilson settled in New York, where he became a successful portraitist. He also taught at the Art Students League in 1926 and 1927, and at the National Academy of Design from 1928 until 1938. Members of the National Academy of Design, an organization known as a bastion of artistic conservatism, elected Neilson an associate academician in 1925 and a full academician in 1928.

In the late 1930s, Neilson's preference for traditional artistic styles led him to join the Society for Sanity in Art, a national group based in Chicago that was opposed to modernist art movements.

The sweet but somewhat bland expression of the figure in *The Mirror*, as well as the facial type itself, are characteristic of Neilson's images of women. The abundance of pattern—in the woman's dress, the chair and bowl, the pillows, and the front of the dresser—and the relatively simple modeling of the figure, create a flattened, two-dimensional space. The rich colors and finished brushwork of the bedroom setting stand in contrast to the lighter palette and more impressionistic handling of paint in the garden that is seen in the background. By using different styles to depict these spaces, Neilson heightens the contrast between the interior and exterior physical environments. Interestingly, the reflection in the mirror is not of the woman facing the viewer, a fact that adds a sense of mystery to the scene. MR

Oil on canvas; 36 3/8 x 28 5/8
(92.39 x 72.71 cm.)
Signed lower right: Raymond Neilson
UL1922.2

Provenance:
ULC, 1922

Exhibitions:
AIC Chicago and Vicinity Annual,
1921, #136

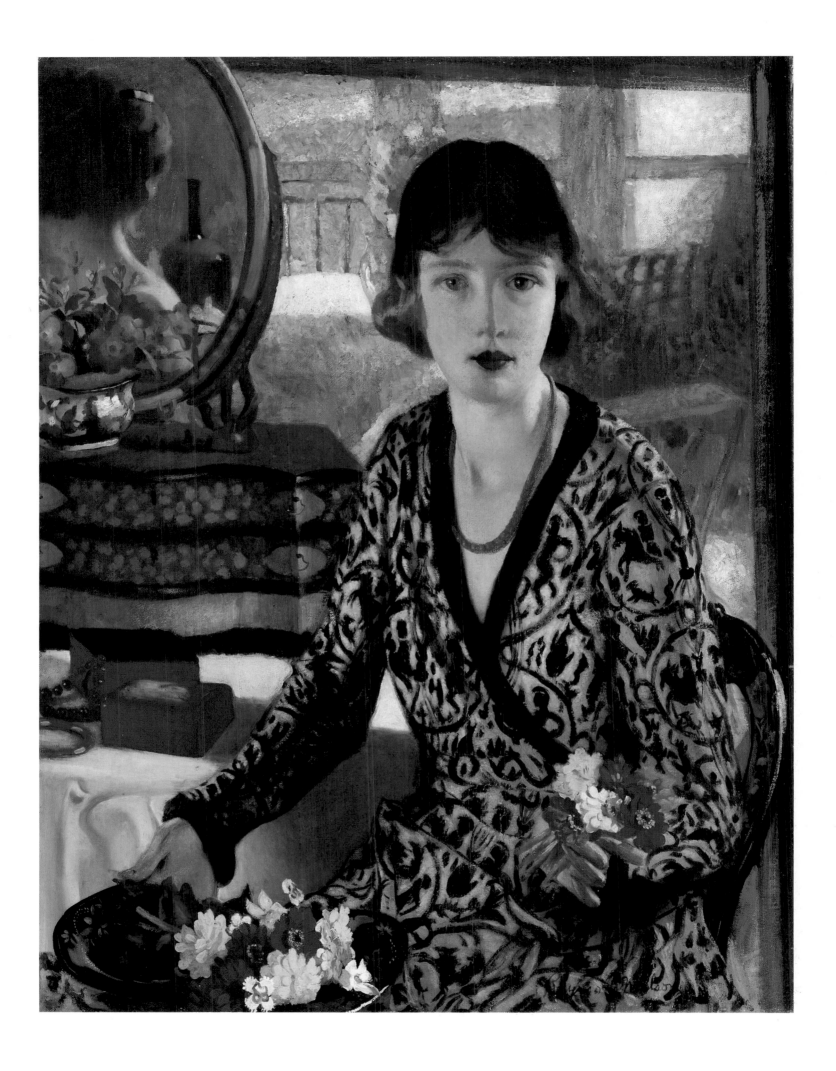

Raymond Perry Rodgers Neilson *The Mirror*, 1921

JOHN THOMAS NOLF
(1872–1950)

Boys Plowing, ca. 1928

John Nolf specialized in paintings of rural America, often using as models the residents of Grand Detour, Illinois, where he had a home for many years. He lived in Illinois for most of his adult life, but until he was in his twenties, Nolf led an itinerant life. Born in Allentown, Pennsylvania, to a father who had fought at Gettysburg, Nolf and his family had moved to Joplin, Missouri, and to Pendleton, Oregon, by the time he was in his teens.[1] Nolf apprenticed as a printing compositor and traveled widely throughout the Pacific Northwest after gaining his union card. He moved to Chicago in the 1890s after winning first-class train fare in a poker game. Nolf became interested in studying art while working at the *Chicago Tribune* and the *Inter-Ocean*, and he attended night classes at the School of the Art Institute of Chicago and the J. Francis Smith Art Academy. By 1900, he had left the printing trade to concentrate on art, working for several years at Chicago advertising agencies. He became one of the most successful artists working in Grand Detour, an artist's colony in the mid-twentieth century. A journalist once described him as being "on familiar terms with all his neighbors, witty and full

of homespun philosophy, a sort of local Will Rogers without the chewing gum or the lariat."[2] Nolf died in a nursing home in Dixon, Illinois, in 1950.

The 1920s were a particularly successful time for Nolf, for he exhibited widely and won a number of prizes, including both the Mrs. William Ormonde Thompson Prize and the Municipal Art League purchase prize for *Boys Plowing*. Although his early travels gave Nolf the opportunity to see much of the American countryside, throughout his life he remained more interested in the people he encountered than in the land, a preference that is apparent in his paintings.[3] Nolf's commitment to his adopted town and his interest in depicting its residents in paintings are characteristic of American Regionalism, an American artistic movement of the 1920s and 1930s in which artists extolled the qualities of a specific rural region. In *Boys Plowing*, the gently rolling hills in the background are typical of the landscape around Grand Detour, a town in the Rock River Valley. Nolf's presentation of the Illinois farm boys as strong, confident figures imbues them with a heroic quality and exalts the virtues of the agrarian way of life. MR

Oil on canvas;
33 3/4 x 41 7/8 inches
(85.73 x 106.36 cm.)
Signed lower right: John T. Nolf
UL1976.38

Provenance:
MAL, 1920–1951; UL C&AF, 1951–1976; ULC, 1976

Exhibitions:
AIC Chicago and Vicinity Annual, 1920, #122

References:
Martin. *Art in the ULC*. Page 38.

Bulletin of The Art Institute of Chicago 23 (March 1929): 29.

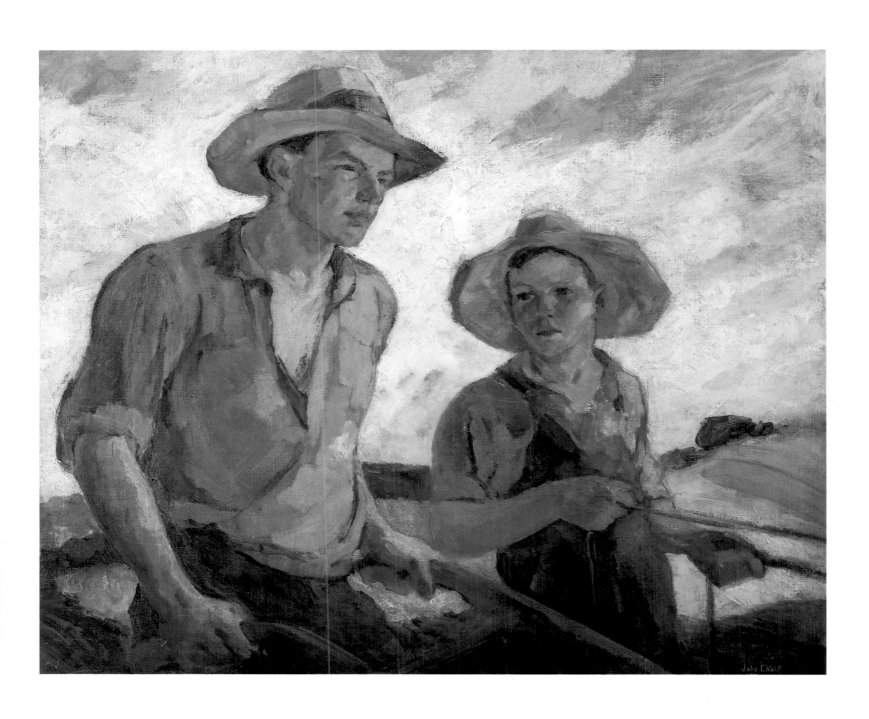

John Thomas Nolf *Boys Plowing,* ca. 1928

ELIZABETH NOURSE
(1859–1938)

Good Friday (Vendredi Saint), 1891

By the 1890s, when *Good Friday (Vendredi Saint)* was exhibited in the Palace of Fine Arts at the 1893 World's Columbian Exposition, Elizabeth Nourse had become one of the most successful women artists of her day. Born in Cincinnati, she studied at the McMicken School of Design in that city. In 1887, Nourse and her older sister traveled to Paris, where the artist was briefly enrolled in the women's classes at the Académie Julian. From 1883 until her death, she supported both herself and her sister as a full-time artist, an accomplishment made all the more impressive in light of the difficulties faced by women who pursued careers in art. Throughout her career, Nourse concentrated on depictions of rural folk, and most particularly on women and children. In her interest in peasants, Nourse was not alone, for in Europe, the laborer as subject matter was especially popular during the last quarter of the century. The artist once commented, "To me, these people are not ugly, their faces, their toil-stained hands tell the story of their lives. I cannot paint 'pretty' people; they do not appeal to me."[1]

Good Friday (Vendredi Saint) was one of three paintings that Elizabeth Nourse exhibited at the 1893 World's Fair. She was one of only 104 women—19 percent of exhibitors—whose work was selected for inclusion in the fair's juried exhibition. There, *Good Friday (Vendredi Saint)* was displayed in the first room of the exhibition; nearly half the paintings by women were placed in the less visible second-floor balcony.[2] Nourse received a medal, testimony to her high standing in the art world.

An excellent example of Nourse's sympathetic treatment of women and children, *Good Friday (Vendredi Saint)* is one of the artist's largest works, and one of a few she did of religious subject matter. The painting depicts women in Assisi kissing the crucifix as part of their Good Friday observances.[3] Preliminary sketches, made in Assisi, reveal that her original intention was to show the figures kneeling before an altar rail.[4] Nourse's sensitive and empathetic treatment of the scene may stem in part from her own piousness; she was a member of a lay group called the Third Order of Saint Francis. Completed by the artist in Rome using professional models, the painting shows the influence of Italian Baroque art in its dramatic play of light and shadow and in the monumentality of the figures.[5] In this regard, *Good Friday (Vendredi Saint)* may reflect Nourse's awareness of seventeenth-century Roman painters such as Caravaggio. MR

Oil on canvas; 61 1/2 x 55 1/2 inches (156.21 x 140.97 cm.)
Signed upper left: E. Nourse/Rome 1891
UL1901.3

Provenance:
John Irving Pearce, Jr., 1893–1901;
ULC, 1901

Exhibitions:
New Salon, Societé National des Beaux-Arts, Paris, 1891, #795

Continental Gallery, London, 1891

Munich, 1892

Palace of Fine Arts, World's Columbian Exposition, Chicago, 1893, #593

"The Work of Elizabeth Nourse," Cincinnati Art Museum, Cincinnati, Ohio, 1893, #4

Tennessee Centennial and International Exposition, Nashville, 1897, #679

"American Art in the Union League Club of Chicago, A Centennial Exhibition," traveling exhibition organized by the ULC, 1980–1981

"Elizabeth Nourse, 1859–1938: A Salon Career," traveling exhibition organized by the National Museum of American Art, 1983

References:
Martin. *Art in the ULC.* Page 19.

Arnold, C. D., and H. D. Higinbotham, *Official Views of the World's Columbian Exposition Issued by the Department of Photography.* Chicago: Press Chicago Photo-Gravure Co., 1893. Vol. 8, plate 89.

Fink, Lois Marie, and Mary Alice Heekin Burke. *Elizabeth Nourse, 1859–1938: A Salon Career.* Exh. cat. Washington, D.C.: National Museum of American Art, Smithsonian Institution, 1983. Pages 39–41, 122, 187 (cat. B-37).

Loy and Honig. *One Hundred Years.* Pages 42–43.

McCauley. *Catalogue*, 1907. #31.

Sparks. *American Art in the ULC.* Page 25.

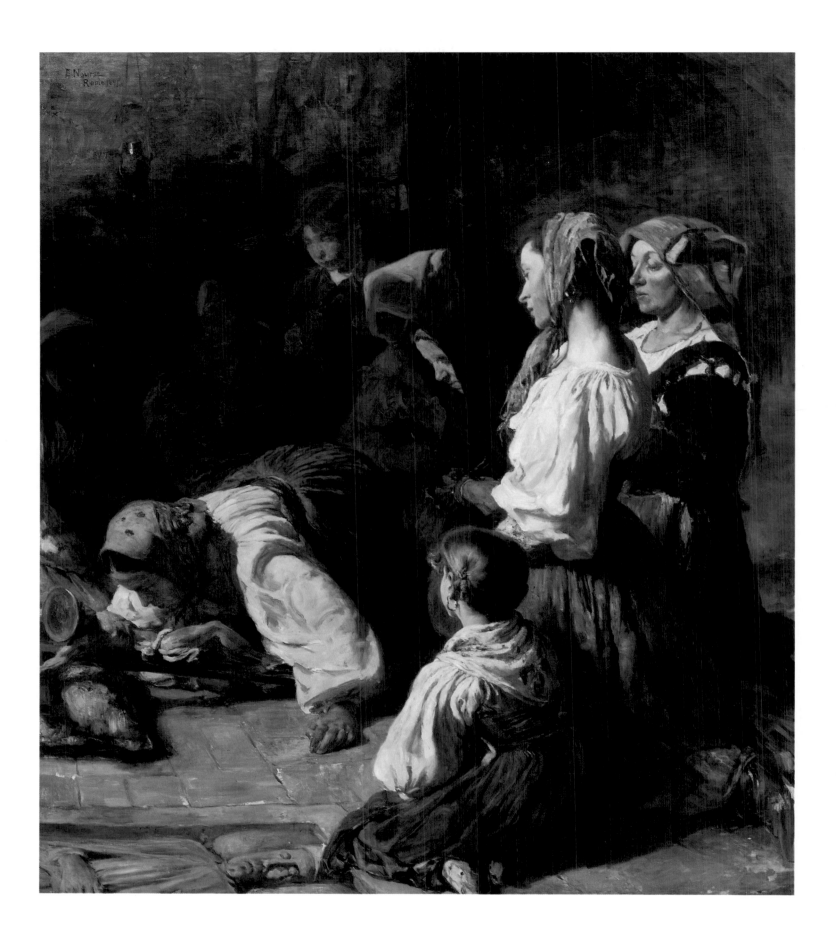

Elizabeth Nourse *Good Friday (Vendredi Saint),* 1891

LEONARD OCHTMAN
(1854–1934)

Frosty Morning, 1894

In the 1890s and early years of the twentieth century, Leonard Ochtman was acclaimed for winter landscapes such as *Frosty Morning*. Dubbed the "prince of American landscape-painters" and the "Keats of Landscape" by admirers,[1] his paintings convey a sense of stillness and quietude. In the Club's painting, created in Greenwich, Connecticut, muted colors heighten the scene's tranquil mood. Throughout his career, Ochtman omitted or minimized human figures in order to concentrate on conveying his emotional response to nature; here the lone human figure is incorporated into nature's larger scheme. The painting's high vantage point is also characteristic of Ochtman's work,[2] while the broken brushwork reveals his interest in the impressionist movement, which had advocated the technique as creating a more optically accurate representation.

Ochtman was born in Holland and immigrated to America with his family at the age of twelve.[3] Due to the family's tight financial circumstances, his formal art instruction included only a few month's study at the Art Students League in New York. He furthered his knowledge by attending exhibitions regularly and traveling through Europe. By the mid-1880s, around the same time that he began spending the summer in Connecticut, Ochtman was receiving praise for his landscapes.

Beginning in the 1890s, the area around Greenwich, Connecticut, attracted a growing number of artists. Ochtman, one of the earliest artists to work in the area, purchased a home in Greenwich in 1891. The area's grain fields greatly appealed to him and were a frequent subject of his work. While Ochtman advocated the importance of sketching from nature, he created final versions of his works in the studio from composite views.[4] By working in this fashion, he believed that the finished work would have greater emotional impact.[5] He noted that the goal of a landscape painting was to appear as if it were not composed but rather, "It should be free, fresh, and true."[6]

By all accounts, Ochtman had a retiring personality, but he was nonetheless an integral part of Greenwich's artistic community. Not only did he teach art from his home, but he was also a founding member of the Greenwich Society of Artists, serving as president from 1919 until 1933.[7] As head of the Society's exhibition committee, Ochtman was responsible for organizing exhibitions of the work of important artists such as John Henry Twachtman, Edward Potthast, Childe Hassam, and Robert Henri.

Ochtman won twenty-four major awards in exhibitions held across the nation between 1891 and 1911. He was a member of most major artists' organizations, including the National Academy of Design, the National Institute of Arts and Letters, the Lotos Club, and the National Arts Club. He died at his Connecticut home one week after his eightieth birthday. MR

Oil on canvas; 24 1/4 x 36 inches
(61.28 x 91.44 cm.)
Signed lower left:
LEONARD OCHTMAN/1894
UL1901.1

Provenance:
ULC, 1901

References:
McCauley. *Catalogue*, 1907. # 89.

181 **Leonard Ochtman** *Frosty Morning,* 1894

PAULINE PALMER
(1865[1]–1938)

Against the Light (Silhouetted against the Light;
From My Studio Window[2]), ca. 1927

Pauline Lennards Palmer received early encouragement for her artistic interests from her German immigrant parents.[3] Palmer studied drawing in McHenry, Illinois, where she was born, and in Milwaukee, where her family later moved. Following graduation from high school, Palmer taught in Chicago public schools and studied at The Art Institute of Chicago. After she married Albert Palmer, a wealthy physician, in 1891, Palmer began painting full-time. She studied with several teachers in Paris between 1900 and 1902, working especially closely with the American expatriate painter Richard E. Miller. Based in Chicago but traveling widely, Palmer built a successful career as a portrait, landscape, and still life painter, and she was active in many art organizations of the day, notably the Chicago Society of Artists, of which she was the first woman president. In the 1920s and 1930s, Palmer was an outspoken defender of artistic conservatism and a critic of modernism.

Palmer traveled as far as Europe and California to paint, but her favorite summer destination was Cape Cod on the Massachusetts coast. After her husband's death in 1920, the artist spent increasing periods of time there. In Provincetown she remodeled a large house to accommodate a studio and a steady flow of visitors, and she became an important member of the local art scene.[4] In this period Palmer's impressionist tendencies toward bright color, broken patches of paint, and cheerful, sunlit scenes developed fully, and she created works that won popular acclaim in Chicago's wintertime exhibitions. At a solo show of Palmer's works in 1927, one critic lauded *Against the Light* as "a rival for first place, owing to its exquisite effects."[5]

Against the Light is a study of Marie Lennards, the artist's sister, who is seated just inside a pair of French doors that open onto a lush garden glowing in the rich, light-saturated greens of a brilliant summer day.[6] Marie wears a black dress of fashionable cut that contrasts strongly with the bright color beyond, and a multicolored cloche hat. Unconscious of the viewer, she appears absorbed in studying a sheaf of drawings or prints, possibly Japanese *ukiyo-e*, that rest on her lap. Her face is silhouetted against the brilliant whites of the path and picket gate near the picture's center. In this casual image of summertime leisure, Palmer organizes her riot of impressionist color and lush natural elements within a structured series of rigid frames, from the garden gate to the French doors, while a subtle counterpoint is provided by such discrete forms as the lofty birdhouse, the bowl of fruit on the white-draped table, and the terra-cotta planter on the floor. Palmer's subject of a woman at leisure seated against a garden backdrop was a popular one among American painters in the late nineteenth and early twentieth centuries. The title and subject of Palmer's painting may have been inspired by American impressionist painter Childe Hassam's *Against the Light*, which was acquired by the Art Institute in 1911. Similar subjects were also the hallmark of Palmer's former teacher, Richard Miller, who worked in Provincetown during the period in which Palmer painted this work.

Shortly after Palmer's death in 1938, Marie Lennards, the executor of her sister's estate, gave *Against the Light* to the Municipal Art League, a previous owner, in exchange for her earlier *Market Day, Brittany* because she felt that this painting was more representative of Palmer's work.[7] WG

Oil on canvas mounted on fiberboard;
32 x 26 inches (81.28 x 66.04 cm.)
Signed lower left: Pauline Palmer
UL1976.40

Provenance:
Marie Lennards (the artist's sister)
to 1939; MAL, 1939–1951; UL C&AF,
1951-1976; ULC, 1976

Exhibitions:
AIC American Art Annual, 1927, #164

"Paintings by Pauline Palmer," Carson
Pirie Scott galleries, Chicago, 1927

"The Second Exhibition of the Illinois
Women Painters," Illinois Women's
Athletic Club, Chicago, 1928, #44

"Summer Exhibitions" including
"Memorial Exhibition of Paintings by
Pauline Palmer, American, 1867–1938,"
AIC, 1939, #29

Pauline Palmer memorial exhibition,
Chicago Galleries Association, 1950

"Painters and Sculptors in Illinois:
1820–1945," traveling exhibition organized
by the Illinois Arts Council, 1971–1972,
#30 "Currents of Expansion: Painting in
the Midwest, 1820–1940," Saint Louis Art
Museum, Saint Louis, 1977, #82

"American Art in the Union League
Club of Chicago, A Centennial
Exhibition," traveling exhibition
organized by the ULC, 1980–1981

"Capturing Sunlight: The Art of Tree
Studios," Chicago Department of Cultural
Affairs, Chicago Cultural Center, 1999;
Terra Museum of American Art, Chicago,
2001

References:
Barter, Judith A. and Lynn E. Springer.
*Currents of Expansion: Painting in the
Midwest, 1820–1940.* Exh. cat. Saint Louis:
The Saint Louis Art Museum, 1977. Page 129.

Capturing Sunlight: The Art of Tree Studios.
Exh. cat. Chicago: Chicago Department of
Cultural Affairs, Chicago Cultural Center,
1999. Page 42 (detail illus. front cover).

Gerdts, William H. *American Impressionism.*
New York: Abbeville Press, 1984. Page 250.

Loy and Honig. *One Hundred Years.*
Pages 58–59.

Martin. *Art in the ULC.* Page 43.

Madden, Betty I. and Esther Sparks.
Painters and Sculptors in Illinois, 1820–1945.
Exh. cat. Springfield, Ill.: Illinois State
Museum, 1971, #30 (unpaginated).

Sparks. *American Art in the ULC.* Page 26.

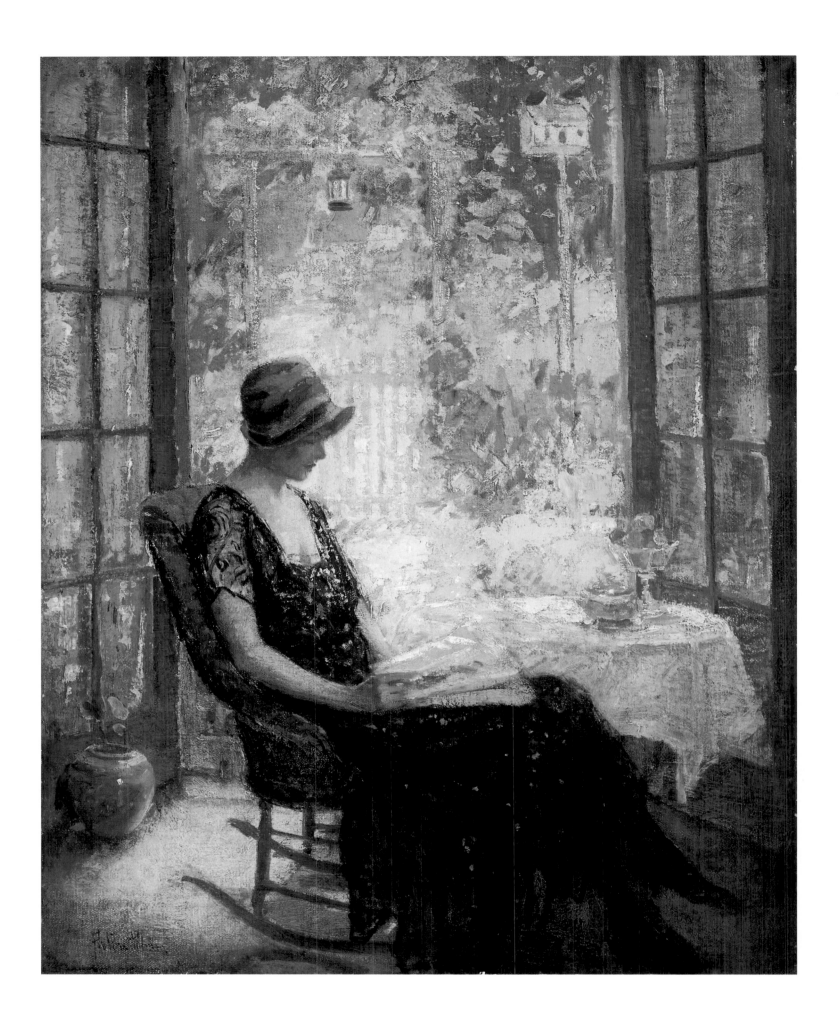

Against the Light (Silhouetted against the Light; From My Studio Window), ca. 1927

WILLIAM ORDWAY PARTRIDGE
(1861–1930)

Edward Everett Hale, 1891

Born to American parents in Paris, William Ordway Partridge was educated in New York City, studying sculpture with F. Edwin Elwell, and in Rome with Pio Welonski.[1] Partridge created numerous public monuments, including the seated bronze image of William Shakespeare in Chicago's Lincoln Park, the marble *Pietà* in St. Patrick's Cathedral, New York City, and an equestrian statue of General Ulysses S. Grant in Brooklyn. Based in Milton, Massachusetts, and later in New York City, Partridge exhibited in London and Paris as well as at home; fifteen of his works were included in the art exhibition at the World's Columbian Exposition in 1893, when the artist was only thirty-two years old. Also gifted with dramatic talent, Partridge as a youth gave much-acclaimed public readings of Shakespeare and romantic poetry, and throughout his career he lectured in the cause of a national art. In addition, he wrote art criticism and several books, including novels and works on art.

In his bust of Edward Everett Hale, one of Partridge's earliest and finest works, the sculptor portrayed from life his early supporter and longtime friend.[2] Hale was a Unitarian minister, a journalist and writer of short stories, and an abolitionist and reformer.[3] His notion of "athletic morality," by which he charged America's elite to reinvigorate itself through social action, drew many supporters, including Theodore Roosevelt. In Partridge's sculpture Hale's vigor and idealism are aptly portrayed in the lively, impressionistic modeling of his balding head, heavily bearded face, and rumpled clothing. Reflected light is concentrated on the sitter's lined forehead and in the folds of skin under his deep-set eyes to enhance the image of Hale as a seer or visionary. To capture the play of the subject's features while his mind was engaged, Partridge modeled the bust in the study of Hale's Roxbury, Massachusetts, home as Hale worked.[4]

Partridge executed his portrait of Hale only two years after finishing his studies in Rome. It was one of his most successful bust portraits, and he exhibited it widely and made several replicas.[5] The work's vigorous textures and dramatic play of light identify Partridge with the second generation of American Beaux-Arts sculptors. These artists, who include Augustus Saint-Gaudens and Daniel Chester French, strove for an invigorated naturalism that was contemporary in spirit but evocative of the dignity of Renaissance sculpture. Bronze was their favored medium for its rich color, dramatically reflective surfaces, strength and durability, and capacity to mimic the directness and spontaneity of modeled clay.

A group of Union League Club members, led by Franklin H. Head, a businessman, author, and Shakespearean scholar who served twice as Club president, purchased the bust of Hale for the Club.[6] Although Partridge was a rising star of the American art world of the 1890s, the Club's acquisition of his sculpture was probably mostly motivated by admiration for Hale as the elder statesman of American reform. In the 1890s the Club amassed portraits of Americans, such as Washington and Lincoln, who represented its founding ideals. To emphasize the timeless importance and dignity of the subject, the bust of Hale was originally displayed on a Corinthian column, as recorded in an early photograph.[7] WG

Bronze; 28 1/4 x 22 1/2 x 15 inches
(71.75 x 57.15 x 38.1 cm.)
Unsigned; foundry mark on verso:
F. Rudier fondeur
Gift of Franklin H. Head and other
Club members, 1895
UL1895.32

Provenance:
ULC, 1895

Exhibitions:
International Art Exposition, Berlin, 1891, #2175a (as *Männliche Büste [bronce]*)

Palace of Fine Arts, World's Columbian Exposition, Chicago, 1893, #101

References:
Balge, Marjorie Pingel. "William Ordway Partridge (1861–1930): American Art Critic and Sculptor." Ph.D. diss., University of Delaware, 1982. Page 231, #61.

Carr, Carolyn Kinder, et al. *Revisiting the White City: American Art at the 1893 World's Fair.* Exh. cat. Washington, D.C.: National Museum of American Art and National Portrait Gallery, 1993. Page 373.

Corliss. *Catalogue*, 1899. Page 36, #126.

Langdon, William C. "William Ordway Partridge, Sculptor." *New England Magazine*, n. s. 22 (June 1900): 384–85.

McCauley. *Catalogue*, 1907. #211.

Martin. *Art in the ULC.* Page 44.

Partridge, William Ordway. *The Works in Sculpture of William Ordway Partridge, M.A.* New York: John Lane Company, 1914. Pages viii, 54.

ED PASCHKE AND (ART)N (ELLEN SANDOR, STEPHAN MEYERS, JANINE FRON)

Primondo, 1997

The result of a collaboration between the Chicago Imagist Ed Paschke and the art group/media laboratory (art)n, *Primondo*'s vivid and literally electric image unites art and technology. In this work, a representation of George Washington derived from Paschke's 1986 painting *Prima Vere* merges with that of a pharaoh. *Primondo* is a PHSCologram, an acronym for photography, holography, sculpture, and computer imaging; these four media converge in the PHSCologram, which (art)n developed in the 1980s.[1] Using a virtual painting software program invented by (art)n member Stephan Meyers, Paschke applied a copy of *Prima Vere*, color elements, and texture to the virtual three-dimensional bust of the pharoah. (art)n then interleaved sixty-five different digital photographs of the image to create a single work that was printed and adhered to Plexiglas. A line screen—black film with clear vertical lines that correspond to the image—was next placed on top.[2] *Primondo*, which becomes visible only when electrically backlit in a light box, appears to be three-dimensional as a result of the line screen, while the interleaved photographs cause the image seemingly to move with the viewer's eye.

Paschke, a native of Chicago's Northwest Side, holds a B.F.A. and an M.F.A. from the School of the Art Institute of Chicago. His studies at the School were interrupted for a term of service in the army and for travel. In 1968, his work was included in "Nonplussed Some," one of the important exhibitions of the Chicago Imagists that Don Baum organized for the Hyde Park Art Center in the 1960s and 1970s. Paschke gained national and international recognition in 1973, when his work was included in the Whitney Biennial and in "Made in Chicago," the American entry for the São Paulo Bienal in Brazil. After teaching at the School of the Art Institute of Chicago and Columbia College, Paschke joined the faculty of Northwestern University in 1977, where he is a professor in the Department of Art Theory and Practice. His work was the subject of a major traveling exhibition seen at The Art Institute of Chicago, the Musée d'Art Moderne-Centre George Pompidou, and the Dallas Museum of Art in 1989 and

1990. He is a Distinguished Alumnus of the School of the Art Institute of Chicago, which also awarded him an honorary doctorate in 1992, and he received a Guggenheim grant in 2000. He was elected a Distinguished Artist member of the Club in 1998.

(art)n was founded in 1983 by Ellen Sandor, a sculptor and installation artist who holds an M.F.A. from the School of the Art Institute of Chicago. Sandor is director of the group, which has included a number of artists and software designers since its inception. (art)n's first large-scale work, *PHSCologram 1983*, addressed the effects of technology on society, a theme found in many of their subsequent pieces, including *Primondo*.[3] The group's pioneering work in digital imaging has made them a leader in the field. Their work is in public collections such as the Santa Barbara Museum of Art, the International Center of Photography in New York, and the Museum of Contemporary Art, Chicago. (art)n has also created PHSCologrames for numerous government organizations and corporations, including NASA, Silicon Graphics, and Nintendo. Among the artists with whom the group has collaborated are Karl Wirsum, Mr. Imagination, and Miroslaw Rogala.

Paschke's experimentation with (art)n's digital technology was a logical progression in his career, for he has long explored issues of how the mass media culture of the late twentieth century has altered human perception. In the late 1970s and early 1980s, the garish colors and patterns of horizontal lines that appeared in his paintings evoked a television screen, a style reprised and augmented by the inherent properties of the PHSCologram. *Primondo* is also related to a series of paintings from the mid-1980s (including *Prima Vere*), in which Paschke deconstructed the iconic quality of renowned figures by altering their appearance.[4] In the Club's work, Paschke and (art)n present Washington and the pharaoh, historical personages similarly esteemed by their admirers, in a deliberately artificial format that further examines the effects that mechanical and digital reproduction processes have had on our conception of cultural icons. MR

Post-canvas vintage PHSCologram®-rotated computer interleaved Duratrans and Kodalith transparent films mounted on Plexiglas®, framed in a metal lightbox; 40 x 30 inches (101.60 x 76.20 cm.) Signed lower right: E.Paschke '97 (art)n ;

inscribed lower left: 2/6; inscribed lower center: "Primondo" Gift of (art)n Laboratory and Ed Paschke on the occasion of the Beaux-Arts Celebration, January 23, 1998 UL 1998.2

Provenance:
(art)n Laboratory and Ed Paschke, 1998; ULC, 1998

JAMES WILLIAM PATTISON
(1844–1915)

Tranquility, ca. 1906

The Chicago art world's most prominent critic, writer, and lecturer at the turn of the century, James William Pattison had a long and varied career before settling in the Midwest.[1] Raised in Worcester, Massachusetts, Pattison served in the Civil War, drawing illustrations for *Harper's Weekly*. He studied landscape painting with Sanford Gifford, the brothers James and William Hart, and George Inness in New York.[2] After five years as an art instructor at Washington University in Saint Louis, Pattison went to Düsseldorf for further study and then lived in Paris, where he and his second wife, artist Helen Searle, exhibited at the Paris Salon. In 1882 the couple moved to New York for two years, then to Jacksonville, Illinois, where Pattison directed the School of Fine Arts. Pattison had already made a name for himself in Chicago as the author of "Pattison's Art Talks," a regular Sunday column in the *Chicago Journal*, when in 1897 he was appointed lecturer at The Art Institute of Chicago's school.[3] A prominent artist-resident of the Chicago suburb of Park Ridge, Pattison also taught at Rockford College from 1904 to 1909 and served as editor of *The Fine Arts Journal*.[4] His books, articles, and lectures on art and art history made him a fixture on the art scene. A Union League Club member, he was especially active in the Municipal Art League, founded in 1899, and he served as president of the Chicago Society of Artists.

Pattison's art has long been eclipsed by his work as a critic and writer, and little is known of his early paintings. During the latter part of his career in Chicago, Pattison painted mysterious nighttime scenes of yachts and fishing boats and evening views of the lights of Manhattan, usually seen from a distance across the water.[5] Pattison also portrayed animals, especially sheep, of which he had made a special study while in France during his student days.[6] *Tranquility*, a study of sheep in a grove, is his best-known work.[7]

As its title suggests, *Tranquility* presents its subject as the vehicle for a subtle mood. This scene of sheep wandering among the slender, upright trunks of young oaks in early springtime evokes not only tranquility but a hint of mystery. Snow recedes from the foreground, revealing bright green ground. The subdued light that pervades the image gives little indication of a specific time of day; equally ambiguous is the locale, which might be Europe or America.[8] The meticulously drawn animals, ranging from broad-backed ewes to gangly lambs, cluster in the foreground, pressing up against the lower edge of the picture where some are arbitrarily cropped. Near the center of the composition but almost blended into invisibility is the figure of the shepherd, seated with his back against a tree trunk, next to a small campfire from which a thin plume of smoke rises straight up in the still air, a pale echo of the surrounding trunks. *Tranquility* is innocent of any reference either to the bucolic tradition of the idealized shepherd as the embodiment of carefree idleness and rustic love or to nineteenth-century realist images of rural laborers as oppressed and brutalized by their dreary existence. Instead, docile animals, resting man, and quiet surroundings are of a piece with the painting's unity of tone and its composition of balanced verticals and horizontals of upright trees set against receding bands of ground.

Pattison's technique is clearly revealed on the painting's surface. The slightly ghostly effect of the otherwise realistically depicted sheep results from the painter's use of thin, transparent glazes over the reddish brown ground with which he prepared his canvas and the visibility of his underlying drawing in thin lines of dark paint. In places, Pattison scraped through the thickly applied paint, "drawing" in paler lines of revealed ground. His essentially graphic approach recalls the artist's early work as an illustrator, but it is applied here as a textural accessory to the coloristic and compositional effects that contributed to Pattison's reputation as a "decorative" painter.[9] wc

Oil on canvas; 29 x 36 inches
(73.66 x 91.44 cm.)
Signed lower left: Pattison
UL 1976.41

Provenance:
MAL, 1907–1951; UL C&AF, 1951–1976; ULC, 1976

Exhibitions:
AIC Chicago and Vicinity Annual, 1906, #182

"The Municipal Art Gallery," AIC, 1918

"Exhibit of Recent Paintings loaned by The Municipal Art League of Chicago June 1–24, 1920 Under the auspices of Story County I. S. C. Alumni Association Complimentary to the visiting Alumni and friends," 1920, #12

"Paintings by Chicago Artists," Garfield Park Art Galleries, Chicago, 1936, #30

References:
Clute, Walter Marshall. "James William Pattison: Author, Critic and Painter." *The Sketch Book* 5 (May 1906): 312, 314.

Martin. *Art in the ULC.* Page 44.

189 **James William Pattison** *Tranquility*, ca. 1906

FRANK CHARLES PEYRAUD
(1858–1948)

The Sunlit Valley (Sunset), 1899

Born in Bulle, Switzerland, Frank Charles Peyraud trained as an architect in Paris.[1] Peyraud arrived in Chicago in 1881, at the age of twenty-two, and soon found employment as a painter of cycloramas, enormous panoramic or in-the-round pictures that were the nineteenth-century forerunner of the wide-screen motion picture. Peyraud studied painting at the Art Institute; he began exhibiting his landscapes there in 1889. Cycloramas continued to be an important part of his work, and he also painted murals. Beginning in 1895, Peyraud spent summers in the small art colony in Peoria, Illinois. He and painter Hardesty Maratta executed an ambitious series of allegorical murals in the new Peoria Public Library, and Peyraud taught and lectured in Peoria while maintaining a presence in Chicago. In 1906 Peyraud married Elizabeth Krysher, a portrait painter and illustrator. Except for a trip to Switzerland and Italy from 1921 to 1923, he remained in Illinois for the rest of his long and successful career. In 1922 G. E. Kaltenbach, the Art Institute's registrar, dubbed Peyraud the "dean of Chicago landscape artists."[2]

In the mid-1890s, when impressionism was stirring up excitement in Chicago's art community, Peyraud was hailed as one of its most important local practitioners.[3] He was also one of the first Chicago-area artists to focus on the midwestern landscape. Peyraud's portrayals of farmlands, rivers, and dunes are generalized, composed idealizations, as his often generic titles suggest. The artist drew on his training as an architect to structure his compositions with the object of creating "something monumental."[4] Characterized by careful arrangements of heavily outlined light and dark masses, contrasting verticals and horizontals, and thick, textured paint, Peyraud's landscape paintings are decorative interpretations. They present the local landscape as a lyrical, slightly enchanted world into which quotidian human elements rarely intrude.

The Union League Club's *Sunlit Valley* is typical of Peyraud's work in the dramatic backlighting of the dominant tall trees that rise majestically in the center of the almost square composition. A faint path that straggles across the foreground hints at the domesticated nature of this quiet, deserted spot. The path also draws attention to the deep shadows of the foreground, already out of reach of the sun's rays that tint the grassy hills a warm gold. Crossing diagonals add a sense of movement that is countermanded by the anchoring effect of the four slender trunks. Foliage and clouds are unified by similar impressionist brushwork that does little to disturb the mood of repose. Peyraud painted several works on the theme of sunset. In *The Sunlit Valley*, he portrays the moment of transition from day into night as a scene of timeless tranquility. WG

Oil on canvas; 28 1/4 x 26 1/8 inches
(71.76 x 66.36 cm.)
Signed lower left: F. C. Peyraud 99
UL1901.6

Provenance:
ULC, 1901

Exhibitions:
AIC Chicago and Vicinity Annual,
1901, #126

"Paintings by Chicago Artists," Garfield
Park Art Galleries, Chicago, 1936, #31

"Frank C. Peyraud: Dean of Chicago
Landscape Artists," traveling exhibition
organized by the Lakeview Museum of
Arts and Sciences, 1984–1987, #5

References:
Loy and Honig. *One Hundred Years.*
Pages 40–41.

McCauley. *Catalogue*, 1907. #90.

Martin. *Art in the ULC.* Page 44.

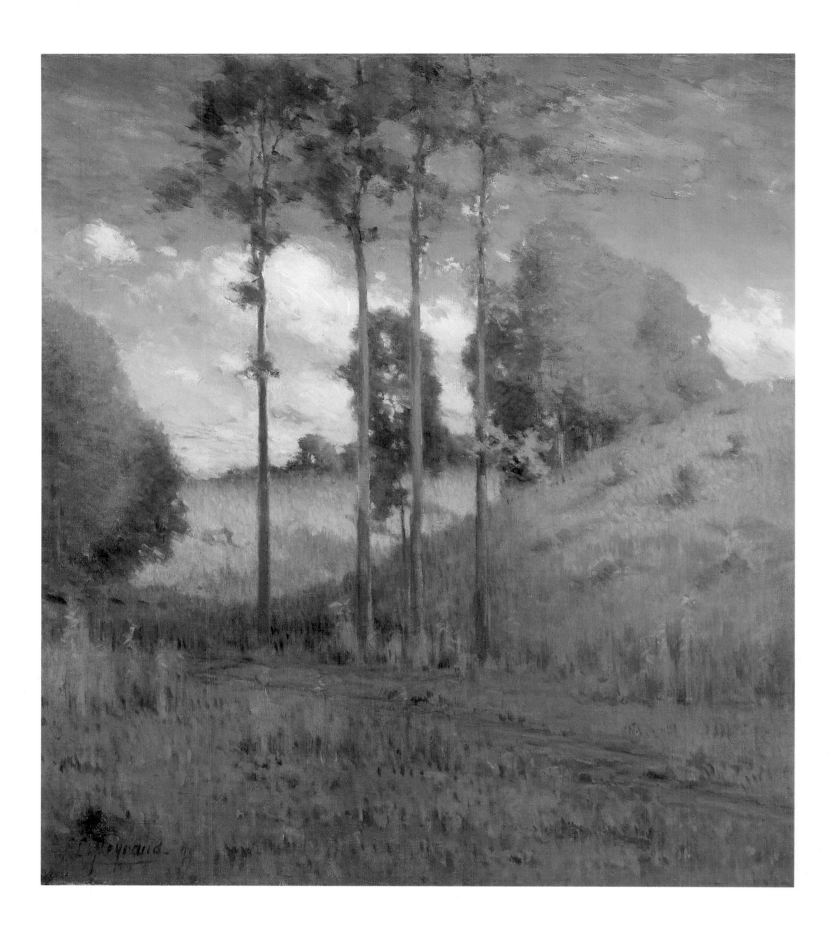

191 **Frank Charles Peyraud** *The Sunlit Valley (Sunset)*, 1899

BERT GEER PHILLIPS
(1868–1958)

The Chief (Captain of the Firelight Dance), ca. 1935

Bert Geer Phillips was the first Anglo-American artist to make Taos, New Mexico, his home.[1] Born in Hudson, New York, his interest in Native American cultures was fostered in boyhood by the close proximity of a Mohican battlefield. Although his father hoped that he would become an architect, Phillips chose instead to pursue a career in art. Phillips studied in New York at the Art Students League and the National Academy of Design, and later at the Académie Julian in Paris. During his stay in Paris, he and his friend and fellow painter, Ernest Blumenschein, learned about Taos from the artist Joseph Henry Sharp. Sharp, who had visited New Mexico in the early 1890s, recognized its potential for new subject matter, and he recommended the area to the younger artists. In 1898, when Phillips and Blumenschein made the trek to New Mexico, a broken wagon wheel left them temporarily stranded near Taos; Phillips found the area ideally suited to his goals as an artist. He later recalled:

In a few weeks I had found more inspiration and material for creative work than I could use in a lifetime; more than that, I had found the ideal climate for outdoor work; also a realization that one artist, alone, could do no more than scratch the surface in this locality, while the Great Southwest, an artistic empire, was practically undiscovered country to the art world.[2]

Phillips was one of the founding members of the Taos Society of Artists, a group formed in 1915 to create opportunities to exhibit its members' paintings nationally. Their circuit exhibitions, which traveled across the country, were extremely successful in bringing attention to the group.[3] By 1925, Taos attracted modernists such as Georgia O'Keeffe and John Marin, and the town had developed into an important artists' colony.

Because of his great respect for and interest in Native American civilization and traditions, Phillips became a trusted friend to the Pueblo community. He specialized in portraits of the Native Americans of the Taos Pueblo, many of which featured interior settings lit by firelight, as in *The Chief*. The painting's rich, golden colors and attention to the details of the figure's elegant headdress and clothing create a romantic portrait of the Native American chief. Although Phillips believed that his paintings were realistic depictions of the Pueblo culture, to modern viewers their appeal lies in their romantic style. MR

Oil on canvas; 19 1/2 x 14 1/2 inches
(49.53 x 36.83 cm.)
Signed lower left: Phillips.
Signed on reverse: "The Chief"/ By Bert
G Phillips/Taos N.M.; and inscribed
on reverse:
Frame 13 3/4 x 19 1/4– Sight/Please keep
sight measurement/as large as
possible and/not less than the above/
Bert G. Phillips
UL1936.1

Provenance:
ULC, 1936

Exhibitions:
"The American West," Continental Bank, Chicago, in cooperation with Mongerson Gallery, 1975

References:
Loy and Honig. *One Hundred Years.* Pages 184, 187.

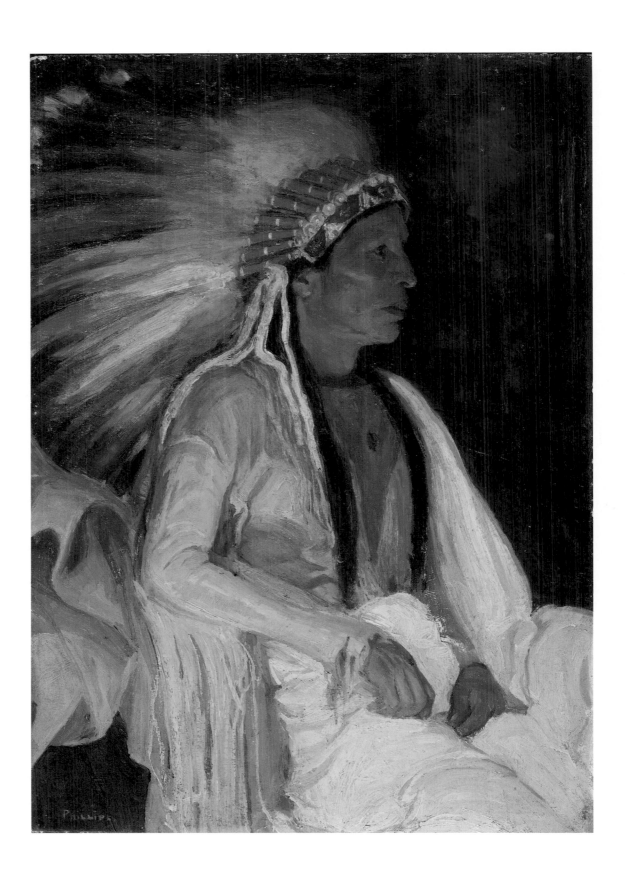

Bert Geer Phillips *The Chief (Captain of the Firelight Dance)*, ca. 1935

WILLIAM LAMB PICKNELL
(1854–1897)

In France (Sunday Morning, Moret), 1894

William Lamb Picknell gained international recognition when his painting *The Road to Concarneau* won an honorable mention at the Paris Salon of 1880, for he was the first American to receive so high an award in the landscape category.[1] Picknell had studied landscape painting with George Inness in Rome from 1872 until 1874. After spending time at Pont-Aven, a popular artists' colony in Brittany, he briefly studied with Jean-Léon Gérôme, one of the leading artists and teachers of the École des Beaux-Arts in Paris. In the 1880s, Picknell returned to his native New England, staying mainly at the artists' colony in Annisquam, Massachusetts. He returned to France in 1889, but Picknell and his wife left for America in 1897 after the unexpected death of their two-year-old son. The artist died six months later in Marblehead, Massachusetts.

In France (Sunday Morning, Moret) was probably painted in the final year of Picknell's life. The Union League Club acquired the work after members of the Art Committee saw it at The Art Institute of Chicago in 1897 as part of a special memorial tribute to the artist in the American annual exhibition that year.[2] Picknell painted *In France (Sunday Morning, Moret)* in Moret-sur-Loing, a picturesque town near the junction of the Seine and Loing rivers, which was the home of several artists, including Alfred Sisley. While he was not an impressionist, Picknell shared their interest in depicting atmospheric conditions and in working outdoors. Throughout his career, he depicted the effects of sunlight on both water and terrain. In the Club's painting, brilliant light accentuates the river path in the foreground, while the mirror-like reflections in the Loing River convey a sense of tranquility. Picknell applied paint in the foreground area using a palette knife, a technique he began using in the 1870s under the influence of the American artist Robert Wylie.[3] The painting is characteristic of an artist known for serene, peaceful landscapes. MR

Oil on canvas;
29 1/2 x 35 1/2 inches;
(78.74 x 93.98 cm.)
Signed lower left: Wm. L. Picknell
UL1897.1

Provenance:
ULC, 1897

Exhibitions:
AIC American Art Annual,
1897, #303

"Lasting Impressions: American Painters in France, 1865–1915,"
Musée d'Art Américain Giverny, 1992

References:
Gerdts, William H. *Lasting Impressions: American Painters in France, 1865–1915.* Exh. cat. Chicago.: Terra Foundation for the Arts, 1992. Page 225.

Loy and Honig. *One Hundred Years.* Pages 28–29.

McCauley. *Catalogue,* 1907. #6.

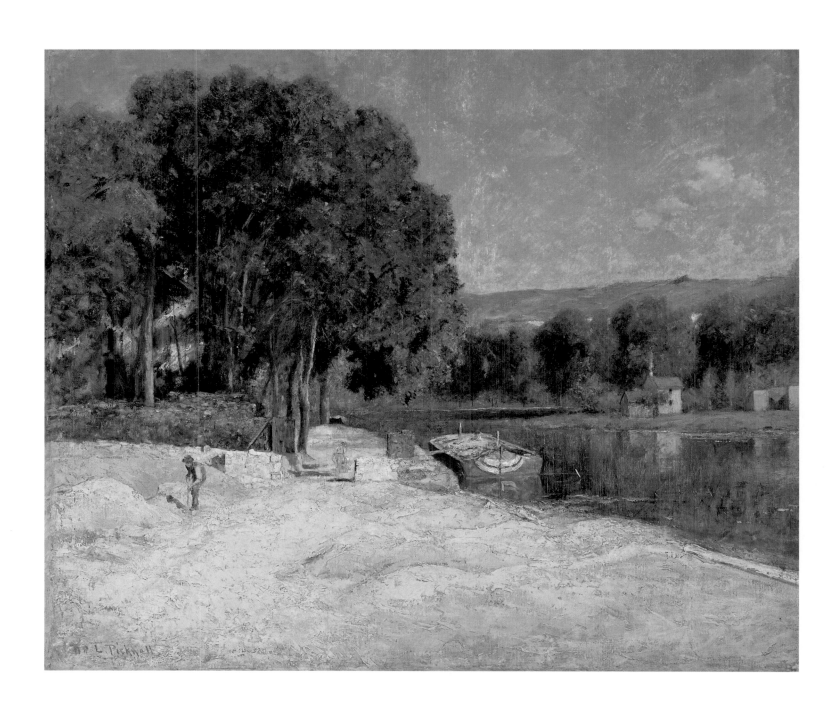

195 **William Lamb Picknell** *In France (Sunday Morning, Moret)*, 1894

ALBÍN POLÁŠEK
(1879–1965)

Man Carving His Own Destiny, 1926

Albín Polášek's interest in sculpting began as a child in his native Moravia, with modeling clay. After family hardship caused him to immigrate to America in October 1901, he found factory work producing altars in La Crosse, Wisconsin, and carving sculptures for St. Michel's Church in Chicago.[1] In 1907, he enrolled at the Pennsylvania Academy of the Fine Arts in Philadelphia, where he studied with Charles Grafly. That year, Polášek completed his first version of *Man Carving His Own Destiny*, which won for him the first of the four awards he would receive while a student at the Academy. His most significant award was the Prix de Rome prize in sculpture, which enabled him to study in Rome for three years beginning in September 1910.[2] Upon his return to America, he settled in New York City. In 1916, Polášek moved to Chicago to assume the position of chair of the sculpture department of the School of the Art Institute of Chicago, where he continued to teach until his retirement in 1949.

Following the success of the 1907 sculpture, Polášek created a second version of *Man Carving His Own Destiny* in 1915 and exhibited a terra-cotta version at The Art Institute of Chicago in 1922, where it won the Logan Medal. In later years, the popularity of this piece sometimes seemed a burden, for Polášek grew tired of the numerous requests he received for copies.[3] Yet no other piece reflected so well the artist's beliefs regarding the purpose of art, which he viewed as "not only important . . . but actually necessary as a stepping-stone to civilization."[4]

The Club's version of *Man Carving His Own Destiny*, believed to be the fourth version he made, is characteristic of Polášek's style, which was influenced by the classical sculpture tradition. Percy Eckhart, Art Committee chair at the time the sculpture was purchased and a friend of Polášek, noted that the figure proclaimed "not alone man's physical power, but his mental potentialities, and the optimism, courage, self-confidence, and determination employed in his evolution."[5] The attention given to the figure's musculature connotes a sense of strength, while the contrast between the more smoothly modeled body and the rough stone heightens the effect of the figure emerging from nothingness. *Man Carving His Own Destiny* unquestionably reflects the optimism and self-confidence that characterized America in the 1920s. MR

Bronze; 45 1/2 x 21 3/4 x 15 inches
(115.57 x 55.25 x 38.10 cm.)
Signed lower left: Runst—Foundry, N.Y.
UL1929.1

Provenance:
ULC, 1928

Exhibitions:
"Capturing Sunlight: The Art of Tree Studios," Chicago Department of Cultural Affairs, 1999

References:
Loy and Honig. *One Hundred Years*. Pages 158–59.

Capturing Sunlight: The Art of Tree Studios. Exh. cat. Chicago: Chicago Department of Cultural Affairs, 1999. Pages 18, 29, 42.

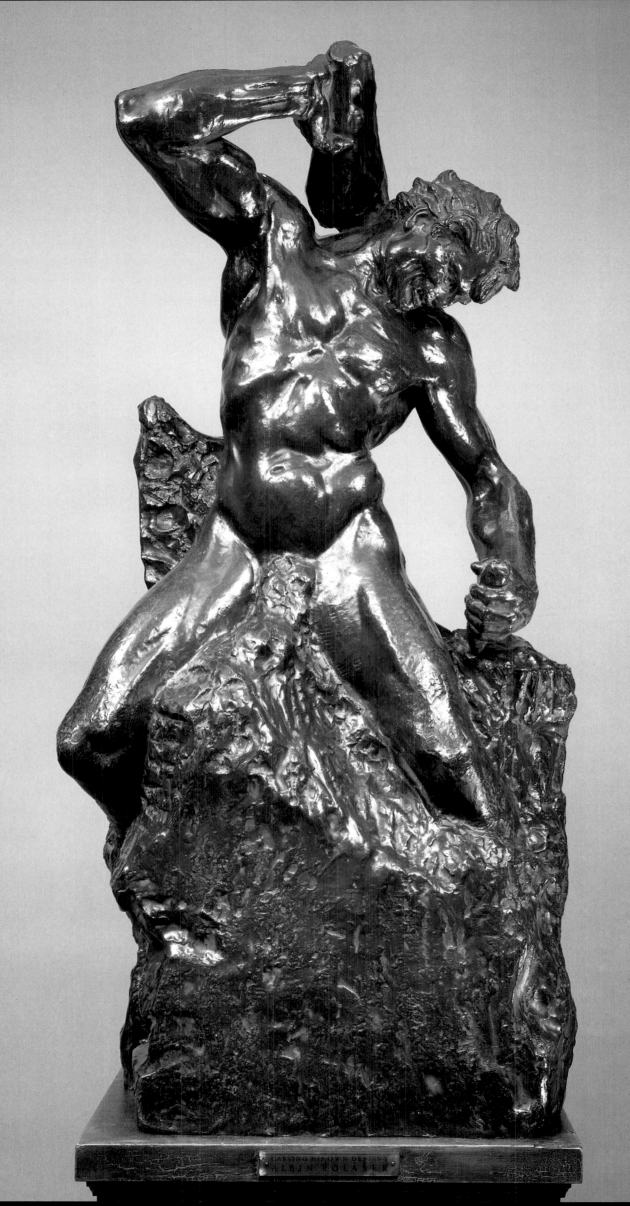

TUNIS PONSEN
(1891–1968)

Untitled (Century of Progress, World's Fair), ca. 1933–34

Tunis Ponsen was perhaps best known as a painter of landscapes and cityscapes of overcast days. The middle of three children, he experienced early tragedy, for his parents both died by the time he was eighteen. Ponsen began studying art in 1911 in his native Holland, and he became certified to teach drawing to elementary school students in 1912.[1] He came to America in 1913 in search of better employment opportunities. Settling in Muskegon, Michigan, near his older sister, Arnolda, he found work as a house painter. Engaged when he emigrated from Holland, Ponsen saved his earnings to pay for his fiancée's passage to America, only to lose her to a shipboard romance. Never married, he appears to have been a private and somewhat solitary figure for the rest of his life, perhaps because of this early heartbreak, although he had a circle of friends and was active in artists' organizations.[2]

In 1924, when Ponsen enrolled at the School of the Art Institute of Chicago, his work had already been featured twice in one-person exhibitions at the Hackley Art Gallery in Muskegon.[3] Remaining in Chicago after his graduation in 1926, he exhibited work at local organizations and galleries, such as the South Side Art Association and the Chicago Galleries Association, and in The Art Institute of Chicago's annual juried shows. Ponsen's career peaked in the 1930s, a time when his paintings of cityscapes and landscapes fit within the regionalist movement then prevalent.[4] From 1945 until 1967 he taught at the Chicago Academy of Fine Arts and in his studio.

Untitled (Century of Progress, World's Fair) is one of several paintings the artist made of the 1933–34 Chicago World's Fair. Local artists found the Century of Progress Exposition prime subject matter, and their depictions of the fair were very popular. A Century of Progress celebrated the one hundredth anniversary of the founding of Chicago and the advances made in science and industry. Its architecture emphasized bright colors and the streamlined Art Deco style. Located along Lake Michigan between Twelfth and Thirty-ninth streets, the fair was so popular that its organizers extended it for a second year.[5] In addition to depicting scenes of the fair, Ponsen also participated in The Art Institute of Chicago's official "Century of Progress" exhibitions of painting and sculpture and of prints with a painting, *Rock Quarry*, and a lithograph, *The Village Church*.[6]

In *Untitled (Century of Progress, World's Fair)*, the Avenue of the Flags, the fair's central avenue, dominates the composition. At right is the Sears Roebuck exhibition hall, while in the distance the tower of the Hall of Science is visible. An artist who incorporated elements of modernism such as simplified forms and broad strokes of color into a generally conservative style, Ponsen captured the fair's colorful architecture and festive atmosphere. An interesting detail is the preponderance of walking sticks; fairgoers purchased these canes, which were sold at each exhibit hall and featured a medallion of the building, as souvenirs. MR

Oil on canvas; 24 x 30 inches
(60.96 x 76.20 cm.)
Signed lower right: TUNIS PONSEN;
Signed on reverse, upper left:
TUNIS PONSEN/1030 E. 45th St/ Chicago,
Price 200.00
UL2000.3

Provenance:
George G. Thiel, ca. 1950–1983
(gift of the artist); William A. Thiel,
1983–2000; ULC, 2000

Tunis Ponsen *Untitled (Century of Progress, World's Fair)*, ca. 1933-34

EDWARD HENRY POTTHAST
(1857–1927)

In the Surf, ca. 1914

Edward Henry Potthast studied drawing and design at the McMicken School of Design in his native Cincinnati and worked in that city as a lithographic artist.[1] During two long stays in Europe in the 1880s, Potthast studied in Antwerp, Munich, and Paris. In 1896 he settled in New York City, where he continued to work as a graphic artist while exhibiting his paintings at the National Academy of Design and the American Watercolor Society. His work was awarded prizes there and at expositions in Saint Louis and San Francisco in 1904 and 1915. In 1910 he was among five artists selected by the Santa Fe Railroad to paint promotional views of the Grand Canyon. From his New York studio Potthast traveled on the East Coast and to Europe to paint. Noted for his extreme modesty and neat appearance, he resembled a bank clerk more than an artist.[2] His nephew recalled that Potthast amazed fellow artists by his ability to paint with both hands at once.[3]

Because Potthast's heirs destroyed much of the contents of his studio after his death, little is known of the variety of his work. Today Potthast is associated almost exclusively with the impressionist beach and bathing scenes he executed only in the last third of his life.[4] But early in his career he painted Breton peasant subjects, and during his years in New York his work included city views and scenes of families at leisure in Central Park. His famous bathing scenes were simply a further manifestation of the interest in modern urban life that he shared with many contemporary artists. As recreation became more available in the late nineteenth century, the beach became an increasingly popular artistic subject.[5]

Potthast's bathing paintings were drawn from scenes of Coney Island, Rockaway Beach, and Brighton Beach. At these easily accessible recreational spots ordinary city dwellers could temporarily escape the heat and congestion of summertime streets and tenements. Potthast's images focus not on the natural setting but on the reactions of bathers unaccustomed to the sea, sand, and vast horizon. *In the Surf* eliminates the horizon altogether to concentrate attention on three figures and their varying responses as they enter the surf: the palpable physical excitement of the girl splashing into the waves, the trepidation of a younger child perhaps on his first visit to the seashore, and the reassuring encouragement of the mother. Their faces are virtually featureless; Potthast relies on expressive pose and gesture to communicate their experience.

Potthast's impressionist technique lent itself naturally to his portrayals of beach scenes, with their brilliant light and restless waves. *In the Surf* demonstrates the range of his facile, rapid technique. For the figures he worked in broad strokes of pure color, reducing his forms to bold contrasts of light and shadow. Dashed strokes in thick paint and liquid washes combine to describe the complexities of rippled water, with its mingled tones of reddish brown, blue-gray, and deep green. White pigment scraped over the canvas from an almost dry brush conveys the confusion of foam and spray on the water's surface. Potthast's attention to impressionist technique does not detract, however, from his object of capturing the cheerful excitement of a first plunge into the surf. Enthused Chicago dealer J. W. Young: "Potthast does not paint *individuals* on the sands. He interprets the joy of *folks* on a care-free day."[6] WG

Oil on canvas later mounted on board; 24 x 30 inches (60.96 x 76.2 cm.)
Signed left of center at bottom edge: E. Potthast
UL1976.44

Provenance:
L. L. Valentine, 1920–?; MAL, 1920s?–1951; UL C&AF, 1951–1976; ULC, 1976

Exhibitions:
"Fifth Exhibition: Oil Paintings by Contemporary American Artists," Corcoran Gallery of Art, Washington, D.C., 1914, #219

"Edward Henry Potthast," J. W. Young Gallery, Chicago, 1920, #18

"Exhibition of Famous American Artists," South Shore Country Club, Chicago, 1920

"American Art in the Union League Club of Chicago, A Centennial Exhibition," traveling exhibition organized by the ULC, 1980–1981

References:
"Edward Henry Potthast." Exh. cat. Chicago: J. W. Young Gallery, 1920. Page 10.

Loy and Honig. *One Hundred Years.* Pages 34–35.

Martin. *Art in the ULC.* Page 44.

Sparks. *American Art in the ULC.* Page 26 (illus. front cover).

Stuart, Evelyn Marie. "South Shore's Exhibition of Paintings." *South Shore Country Club Magazine* 4 (July 1920): 23.

Valentine, L. L. "What I Have Learned from Pictures: Comments on the Pleasure and Culture to Be Gained in the Quest of the Best in Art." *South Shore Country Club Magazine* 12 (July 1920): 18.

201 **Edward Henry Potthast** *In the Surf*, ca. 1914

HIRAM POWERS
(1805–1873)

Daniel Webster, 1854

Daniel Webster sat for Hiram Powers during the summer of 1836, when the Massachusetts senator was preparing for his first unsuccessful presidential bid.[1] Both men were known for their charismatic, but difficult, personalities. Powers, then at the start of his career, pursued Webster for more than a year before the statesman finally agreed to a sitting. Waiting exasperated the young and ambitious artist, who wrote to a friend, "Mr. Webster's likeness would be of immense service to me in Boston, his head is so remarkable, and did he know what a fine bust it would make, I think he would be induced to condescend a little The time may come, when he will perhaps be willing to admit that the honor would have been as much received as conferred."[2]

Powers made a plaster model of Webster, from which he could then make replicas in marble on order. He completed the Club's marble bust in 1854 on commission for Duncan Hennan of New Orleans; it is one of only two made.[3] The highly finished, skin-like surface of *Daniel Webster* is a hallmark of Powers's portraits, which were naturalistic in style. The Club's version of *Daniel Webster* is distinguished by its extended torso, a device Powers used to increase the resemblance to the ancient Roman format of portrait busts. Powers was influenced by antique portrait sculpture in an even more important way, for busts made during the Roman republic were known for their frankness of representation. It is thus possible that Powers wished to draw parallels not only between his work and that of the ancients, but also between American statesmen and those of the republic that had been so influential in the founding of the United States government.[4]

Webster's famous oratorial powers and commanding physical presence were made more remarkable by his large brows and intense eyes. Powers's likeness records these features, and thus conveys a sense of the senator's overwhelming and magnetic presence. The sculptor noted that "it was not the mere pounds of human flesh that made Mr. Webster appear so very large—it was the great soul which we saw, looking out from eyes one third larger than I ever saw in any human head, and from under brows which, had I not seen them, I should have denied impossible [sic]."[5]

Powers was born in Woodstock, Vermont, and grew up in Cincinnati, where he took private instruction in sculpture from Frederick Eckstein in 1828, his only formal training. In 1834, Powers set up a studio in Washington, D. C. His rise was swift: by 1837, he had been elected an honorary member of the prestigious National Academy of Design, an unusual tribute from that organization, which did not admit sculptors to its membership at the time. That year Powers moved to Florence, where he would remain for the rest of his life. He became famous for allegorical and mythological pieces, most notably *The Greek Slave*, a work that was internationally exhibited in the 1840s to great acclaim. At the peak of his career in the mid-nineteenth century Powers was extremely successful, but his work was out of style by the end of his life, a development that caused him much bitterness.[6] In the early twentieth century, Lorado Taft, the great Chicago sculptor, expressed a more positive opinion in a discussion that concluded with praise for the Club's bust: "With the female countenance he always seemed to lose himself in a vague ideal, but with men he was unerring and unflinching. He characterized with a firm, direct stroke. He even suggested planes, and his finish, if not varied, was agreeable in flow of surface. A good example is his bust of Webster, now in Chicago."[7] Today, Powers's position as one of America's most important sculptors is once again secure. MR

White marble; 23 x 17 x 12 inches
(58.42 x 43.18 x 30.48 cm.)
Signed on lower right side:
H. POWERS. Sculp.
UL1899.3

Provenance:
Duncan Hennen, 1854–?;
descended through family of Duncan
Hennen, ?–1899; ULC, 1899

References:
Corliss. *Catalogue*, 1899.
Page 38, #137.

Loy and Honig. *One Hundred Years*.
Pages 159–60.

McCauley. *Catalogue*, 1907. #212.

Taft, Lorado. *The History of American Sculpture*. New York: The MacMillan Company, 1924. Pages 66, 68.

Wunder, Richard P. *Hiram Powers: Vermont Sculptor, 1805–1873*. Vol. 2, *Catalogue of Works*. Newark: University of Delaware Press; London and Toronto: Associated University Press, 1991. Pages 104–6.

HOVSEP PUSHMAN
(1877–1966)

The Golden Grace, undated

Hovsep Pushman was born in Armenia to a family that dealt in rugs and oriental art objects.[1] At age eleven he was the youngest student ever admitted to the Royal Academy of Arts in Constantinople, and at fourteen he was awarded top prizes in both painting and sculpture. Pushman's family immigrated to Chicago in 1896 to escape persecution of Armenian citizens by the Turkish sultan. Pushman won further honors as a student at John Francis Smith's School of Art in Chicago and at the Académie Julian in Paris. He exhibited at the Société des Artistes Français and at the Paris Salon. Pushman's work was first shown in the United States in Milwaukee in 1915, followed by a solo exhibition at The Art Institute of Chicago the next year. Between 1916 and 1919, Pushman worked in Riverside, California; he was among the founders of the Laguna Beach Art Association. Pushman returned to Paris, and then moved to New York City in 1921. His works were consistently lauded by artistic conservatives for their suggestive beauty and meticulous finish, and they commanded high prices.[2]

Although Pushman first made a name for himself for his portraits and his often exotic figure paintings, his fame rests on his still lifes.[3] Pushman specialized in groupings of decorative and religious objects representing an eclectic mixture of exotic, mostly Asian, cultures. His studio, likened by a visitor to a museum "or perhaps the sanctum sanctorum of a fastidious antiquarian," was filled with a collection of objet d'arts that imparted "an atmosphere of legendary remoteness."[4] Medieval European, Indian, Persian, and Far Eastern sculpture, vessels, and textiles provided the artist with not only specific models for his compositions but the inspiration for his "unique oriental legends in paint."[5] Lest their meaning be lost on the typical American viewer, Pushman sometimes composed short poems to append to his works.[6]

Pushman frequently resorted to dark, featureless backdrops to set off the objects he depicted. In *The Golden Grace* the background's luminous depth is the result of extensive glazing, or the mixing of resin into the oil paint.[7] It lends an air of further mystery to the artist's enigmatic selection of objects arrayed on a polished table top in a balanced yet slightly off-center arrangement. A carved wooden image of the seated Buddha, glowing golden in the raking light of an unseen source from the right, dominates the group and shadows a ceramic bowl tilted upright to show its brightly colored floral designs. At the left, a small figurine of a seated woman faces the deity, as if in prayer. The deep shadows dramatizing the contours of these objects contrast with the glowing luster of a small ancient glass vessel that bears a few small, straggling flowers. A scarf of sheer, slightly iridescent material casually draped over the table's edge emphasizes the picture's illusion of depth. The strong light on the objects and dark background create a sense of drama that contrasts arrestingly with the quiet naturalism of Pushman's exacting technique. While *The Golden Grace* hints at an underlying narrative or precept, the artist suggests that the aura of mystery that surrounds such objects originates in the viewer's contemplative gaze. WG

Oil on panel mounted on linen;
26 x 28 inches (66.04 x 71.12 cm.)
Signed lower right: Pushman
UL1986C.83

Provenance:
UL C&AF, 1959–1986; ULC, 1986

Exhibitions:
"An Exhibition of Paintings by Hovsep Pushman," International Galleries, Chicago, 1959, #10

References:
Loy and Honig. *One Hundred Years*. Pages 76–77.

Martin. *Art in the ULC*. Pages 8, 44.

Sparks. *American Art in the ULC*. Page 27.

Hovsep Pushman *The Golden Grace*, undated

HENRY WARD RANGER
(1858–1916)

The Pool at Hawk's Nest, 1901

Landscapist Henry Ward Ranger was the son of a commercial photographer in Syracuse, New York.[1] While a student at Syracuse University, Ranger took up watercolor painting, in which he was self-taught. He opened a studio in New York City in 1885 and worked as a music critic, but was soon exhibiting and selling his watercolors. Ranger spent much of the following decade in Europe and England, studying works in museums and painting in oils in several locations, especially in Holland. After his return to New York, Ranger worked in a variety of painted and graphic media and traveled extensively in search of subjects. In 1898 he began painting in Old Lyme, Connecticut, where he soon presided over a seasonal art colony that nurtured the development of American impressionism.[2] He spent several winters in Puerto Rico and Jamaica. Ranger was an astute businessman as well as a successful artist. He left a large portion of his considerable estate to the National Academy of Design to purchase works by American artists for distribution to numerous museums, libraries, and art galleries throughout the United States.

Ranger's early watercolors were meticulous and highly detailed, but his oils display a painterly naturalism that emphasizes atmosphere and mood rather than the literal reality of tangible objects. While working in Europe, Ranger absorbed these techniques from the work of the French Barbizon school and contemporary Dutch painters. Back in the United States,

Ranger joined the elderly George Inness as a leading proponent of tonalism, a style of poetic landscape in which contrasts of light and dark, rather than color and line, describe the forms that compose quiet scenes in familiar, "domesticated" locales. He once described painting as "a medium through which emotion finds the comfort of expression, and the intellect a kind of loafing ease."[3]

Poetic woodland scenes like *The Pool at Hawk's Nest* typify Ranger's work around the turn of the century.[4] This autumnal landscape with its low, flat distant horizon depicts the artist's favorite painting ground: the marshy coast of Connecticut near Lyme.[5] The deserted nest is perched high above the ground near the top of the bare, dead tree at the far left; the pool in the center of the middle ground is merely suggested by glimmers of reflected blue sky on the still water's surface. Near the picture's center the minuscule form of a building on the far edge of the horizon is visible, and two figures appear on the right, almost hidden beyond the angular boughs of a tree. Such hints of ambulant life are thoroughly overshadowed by the commanding presence of the gnarled oaks, dappled in the benevolent glow of the afternoon sunlight. The picture's unified mood of languorous contentment owes much to Ranger's technique of scumbling his paint for a softening, almost blurring effect, to his deliberately reduced range of colors, and to his extensive use of glazes and varnishes.[6] WG

Oil on canvas;
28 1/8 x 36 inches
(71.44 x 91.44 cm.)
Signed lower right: H W Ranger 1901
UL1901.7

Provenance:
ULC, 1901

Exhibitions:
"American Art in the Union League Club of Chicago, A Centennial Exhibition," traveling exhibition organized by the ULC, 1980–1981

References:
Loy and Honig. *One Hundred Years.* Pages 36–37.

McCauley. *Catalogue,* 1907. #13.

Martin. *Art in the ULC.* Pages 33, 44.

Sparks. *American Art in the ULC.* Page 27.

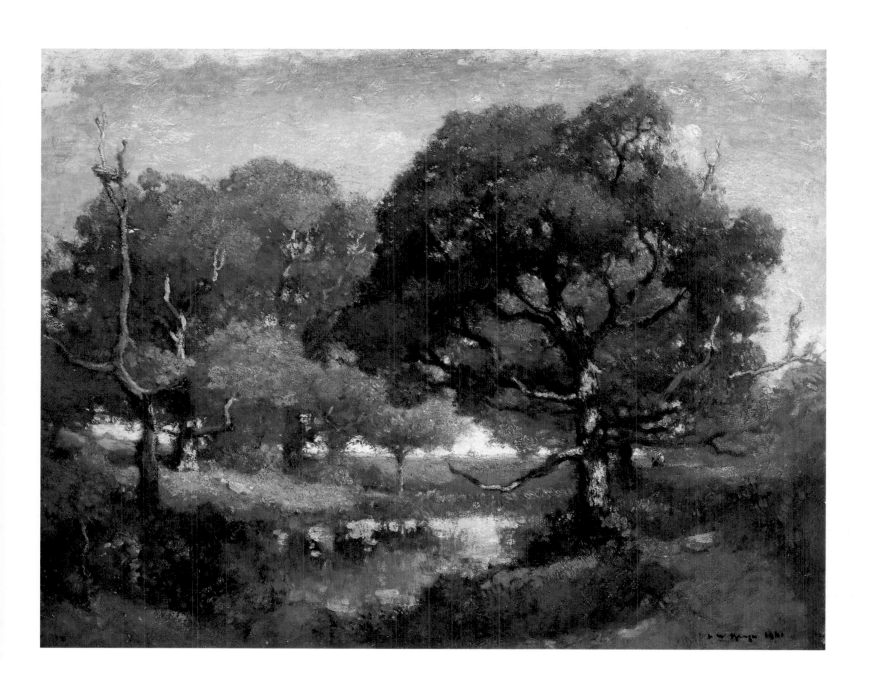

Henry Ward Ranger　　　*The Pool at Hawk's Nest*, 1901

THOMAS BUCHANAN READ
(1822–1872)

Sheridan's Ride, 1871

Thomas Buchanan Read was born in Chester County, Pennsylvania, and worked as a ship and sign painter in Cincinnati.[1] After spending a short time as an assistant to a portrait sculptor, by 1840 Read established himself as a portrait painter. He moved to Boston and then to Philadelphia, painting portraits while also gaining a reputation as a poet. In 1850 Read made the first of several visits to Europe. During the Civil War he served as a lecturer and propagandist for the Union cause. Read traveled back to Italy in 1865. At the time of his death, shortly after a return voyage to America, Read was admired as a poet on both sides of the Atlantic.

Sheridan's Ride was one of Read's most famous works of poetry. In seven verses of rhyme it recounts the breakneck journey made by General Philip Henry Sheridan on the morning of October 19, 1864, from Winchester, Virginia, to Cedar Creek: there, Sheridan rallied his Union troops to an upset victory after their near-defeat at dawn of that day.[2] Inspired by the event, Read composed the poem only days after the battle, on October 31; it was read publicly that very night by the tragedian Edward Murdock and published within a few months. The public excitement the poem aroused is said to have contributed to Lincoln's electoral victory on November 8 of that year,[3] and it secured lasting fame for the poet. The Union League Club's collection includes a later copy of the poem in Read's hand.[4]

Apart from portraiture, Read's painting, like his poetry, was devoted mainly to idealized allegorical and religious, rather than strictly historical, themes. The notion of translating his poem *Sheridan's Ride* into paint apparently originated with members of the Union League of Philadelphia, an organization with which the artist had a close political and artistic association.[5] Read visited New Orleans to make sketches of General Sheridan and of his now-famous black Morgan horse, Rienzi, renamed Winchester after the event.[6] Between 1865 and 1871, in Rome,

Read executed numerous versions of *Sheridan's Ride* in various dimensions.[7] The largest, painted in 1869, was purchased by the Union League of Philadelphia. Some years later, shared political ideals motivated Chicago's Union League Club to acquire its own copy of *Sheridan's Ride*. As interpreted by Read in both the poem and the painting, Sheridan's impetuous dash for the battlefield symbolized the heroic rescue of an embattled but righteous cause. It was a fitting addition to the collection of the Club, which at that time focused mainly on portraits of historical figures, such as George Washington, Alexander Hamilton, and Edward Everett Hale, who were identified with the organization's ideals. For Chicagoans, Sheridan's appeal went beyond his national image as the Union's greatest cavalry commander: while in charge of army headquarters in Chicago in 1871, he took swift action (including bombing buildings) to stop the spread of the Great Fire, and he restored law and order in the chaotic aftermath of the cataclysm.[8] Chicago's Sheridan Road was named in his honor, and in 1880 the Union League Club made him one of its first honorary members, shortly after the Club was founded.[9]

For his painting *Sheridan's Ride*, Read drew on a long iconographic tradition of the heroic equestrian portrait, in which he found sanction for the graceful if anatomically impossible arrangement of the horse's legs in mid-stride. Sheridan, his face as composed as the sitter for any formal portrait, is seen dashing into battle, his sword aloft, to inspire his beleaguered troops to fresh effort. The dust and artillery smoke cloud a confusion of mounted soldiers and fallen bodies, throwing the general and his powerful steed into dramatic relief. As a contemporary observer of the painting noted, the unconvincingly fresh and calm appearance of both rider and horse was consistent with the expectations of a public that had been conditioned to regard Sheridan as the epitome of heroic valor.[10] WG

Oil on canvas;
54 1/2 x 39 3/8 inches
(138.43 x 100.01 cm.)
Signed lower left:
T. Buchanan Read/Rome, 1871
UL1896.1

Provenance:
ULC, 1896

References:
Corliss. *Catalogue*, 1899. Page 12, #28.

Loy and Honig. *One Hundred Years*. Page 189.

McCauley. *Catalogue*, 1907. #44.

Martin. *Art in the ULC*. Page 44.

Mundie, William B. "Art in the Union League Club" in *Spirit of the Union League Club*. Chicago: ULC, 1926. Pages 116–17.

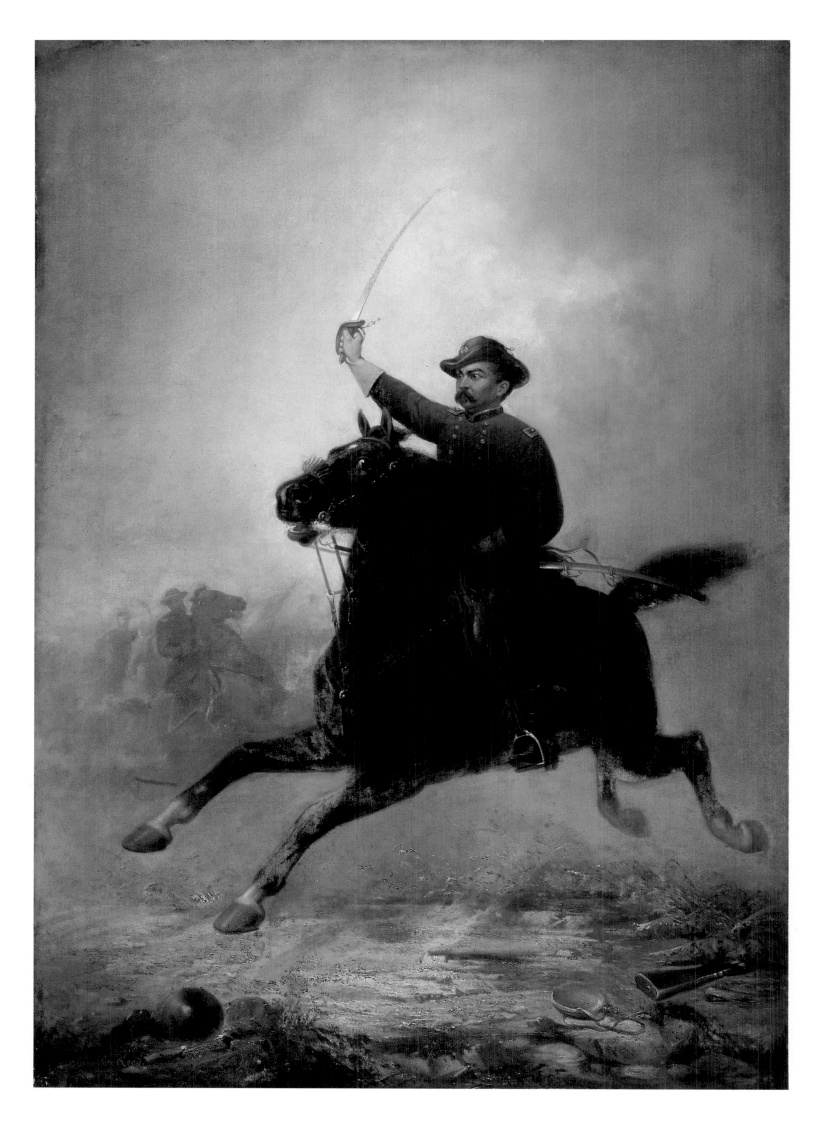

209 **Thomas Buchanan Read** *Sheridan's Ride*, 1871

ROBERT REID
(1862–1929)

Blessing the Boats, ca. 1887–1889

Robert Reid is best known as a member of the group of American impressionist painters who exhibited together beginning in 1898 as "The Ten American Painters."[1] Like other members of the first generation of American impressionists, Reid had a conventional, academic art education. Born in Stockbridge, Massachusetts, he studied at Boston's Museum of Fine Arts, where he rose to the rank of assistant instructor. After further studies at the Art Students League in New York, in 1885 Reid joined a host of American students at the Académie Julian in Paris. He exhibited successfully at the Salon and in New York at the Society of American Artists and the National Academy of Design. Reid returned to New York in 1889, and during the following decade he specialized in mural painting, including work for the World's Columbian Exposition in Chicago and the new Library of Congress. After the turn of the century, Reid executed gorgeously colored easel paintings of beautiful young women in settings filled with flowers and sunlight, in a decorative impressionist style.

Reid's work during his formative years in France gave little hint of his later turn toward impressionism. Influenced by the current interests of both his French academic mentors and fellow American expatriate artists, he painted European peasant subjects in a highly finished manner. Many images were inspired by his stay in Etaples, a fishing village on the Normandy coast and a popular haunt of artists in search of picturesque subjects.

Reid painted scenes with both interior and exterior settings showing daily life among the fishermen. While they delineate their subjects' material surroundings with faithful detail and suggest the rigor of their lives, these works are sentimental rather than realistic in approach, glorifying the charm of traditional life and settings.

Blessing the Boats was the most ambitious of these early works: a large, multi-figural composition that includes houses, beach, sea, and boats in deeply receding perspective under a changeable dawn sky. The painting was begun as a scene of a fisherman greeting his family,[2] but Reid changed it to picture the morning ritual that symbolizes the villagers' intimate relationship with the sea, at once the source of their livelihood and a hazard to their existence. In the distance a priest robed in white and gold leads the community in prayer before a towering crucifix. But both the ceremony and the boats themselves, almost lost in the distant gray haze, are secondary to the onlookers, a variety of types and ages scattered across the water-soaked sand yet united in their supplication. Dominating the composition is the trio of figures in the foreground. The sturdy mother, with her unseen face and billowing apron, is reminiscent of the heroic fishermen's wives from England's northeastern coast depicted by Winslow Homer in the early 1880s. *Blessing the Boats* successfully tapped current trends in art and was admitted into the prestigious juried Paris Salon exhibition of 1889. WG

Oil on canvas; 72 x 96 inches
(182.88 x 243.84 cm.)
Signed lower right: Robert Reid
UL1901.2

Provenance:
Mr. Pierce, to 1901; ULC, 1901

Exhibitions:
Paris Salon, 1889, #2255, (as *Avant le depart des bateaux*)

Tennessee Centennial and International Exhibition, Nashville, 1897, #678

"Normandy and Its Artists Remembered: A 50th Anniversary of the Invasion," Nassau County Museum of Art, Roslyn Harbor, N.Y., 1994

References:
Loy and Honig. *One Hundred Years.* Pages 50–51.

McCauley. *Catalogue,* 1907. #40.

Martin. *Art in the ULC.* Pages 13, 44.

Normandy and Its Artists Remembered: A 50th Anniversary of the Invasion. Exh. cat. Roslyn Harbor, N.Y.: Nassau County Museum of Art, 1994. Pages 65, 83.

Weinberg, H. Barbara. *The Lure of Paris: Nineteenth-Century American Painters and Their French Teachers.* New York: Abbeville Press, 1991. Pages 247–248.

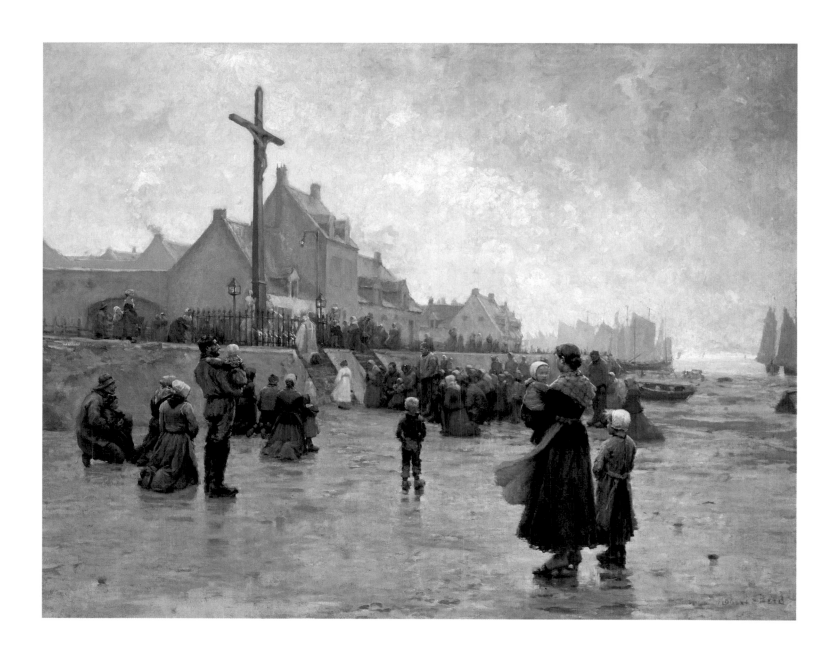

Robert Reid *Blessing the Boats*, ca. 1887–1889

JULIUS ROLSHOVEN
(1858–1930)

The Cloister, Church of St. Francis at Assisi (The Cloister), ca. 1905

The son of a German immigrant, Detroit native Julius Rolshoven was known both for his paintings of Italian and New Mexican subjects and for his cosmopolitan manner of living. Rolshoven, who was from a line of goldsmiths whose origins extended more than six hundred years, was apprenticed in his father's jewelry shop at the age of fourteen. His artistic talent soon became apparent, however, and his father agreed to let him go to New York to study art at the Cooper Union Art School. After one year, he traveled to Düsseldorf, Germany, for study at the city's art academy. In 1878, Rolshoven enrolled at the Royal Academy in Munich, a city that at the time rivaled Paris in popularity among young American artists. There he became one of the "Duveneck Boys," a group of American artists who took informal lessons from Cincinnati artist Frank Duveneck. Duveneck's depiction of the effects of outdoor light, his juxtaposition between the mass of buildings and open space, and his fluid brushwork influenced Rolshoven's style, as it did the others in the group.[1] In addition, Rolshoven's introduction to Italy came through Duveneck in 1879 during classes Duveneck taught in Venice and Florence; the Americans became famous among the locals as much for their high spirits as for their art.[2] While in Venice, Rolshoven became acquainted with James MacNeill Whistler. Rolshoven later studied with Tony Robert-Fleury and William Bouguereau at the Académie Julian in Paris. In 1889, he received a second class silver medal at the Paris Universal Exposition for a pastel self-portrait, a high honor for an American. During the 1890s, Rolshoven and his first wife settled in London, where he made a name for himself as a portraitist, and they summered in Italy.[3]

In 1902, Rolshoven, by then a widower, moved to Florence. Three years later, he purchased and restored Il Castello del Diavalo—the Devil's Tower—a thirteenth-century castle near Florence that was later declared a national monument by the Italian government. His strong emotional connection to the region was evident in his paintings, prompting one writer to comment, "Beautiful interiors of the medieval churches and palaces shared his enthusiasm with Tuscan landscapes and beautiful figures; and in portraying these subjects, which he knew so intimately, he did a more profound work, perhaps, than anywhere else."[4]

When the onset of World War I necessitated his return to America, Rolshoven settled in Taos, New Mexico, with his new wife. There he found the Hispanic and Pueblo peoples' religious rituals and beliefs to have a devotion and intensity that reminded him of the Italians.[5] He undertook a series of portraits in New Mexico, the work for which he is perhaps best known today, and he joined the Taos Society of Artists. Despite his enjoyment of this new region, however, he returned to his beloved Italy at war's end. Rolshoven, who returned regularly to America to visit relatives, died suddenly, after a transatlantic crossing, just four hours before the death of his mother.

The thirteenth-century cloister at the Church of St. Francis of Assisi was the subject of more than one painting for Rolshoven. When *The Cloister* was included in the Society of Western Artists annual exhibition at The Art Institute of Chicago in 1905, one reviewer praised it for "the gladness of this Italian sunlight on marble floor and arches and flowering garden."[6] In its attention to architecture, earth-toned palette, and deft play of light and shadow, the painting reflects the continuing influence of Frank Duveneck. Beyond its depiction of a beautiful and historic monument, however, *The Cloister* subtly alludes to the religious mysticism that Rolshoven found so fascinating, in both its radiant light and in the inclusion of a small cross in the garden, at right. MR

Oil on canvas; 28 x 36 inches
(71.12 x 91.44 cm.)
Signed lower left: Julius Rolshoven
UL1905.6

Provenance:
ULC, 1905

Exhibitions:
"Society of Western Artists Exhibition,"
AIC, 1905, #144

References:
Earle. *Biographical Sketches.* Page 270.

Loy and Honig. *One Hundred Years.*
Page 184–85.

McCauley. *Catalogue,* 1907. #17.

Payne, H. C., "The Exhibition of the Western Society of Artists," *The Sketch Book* 5 (January 1906): 221–22.

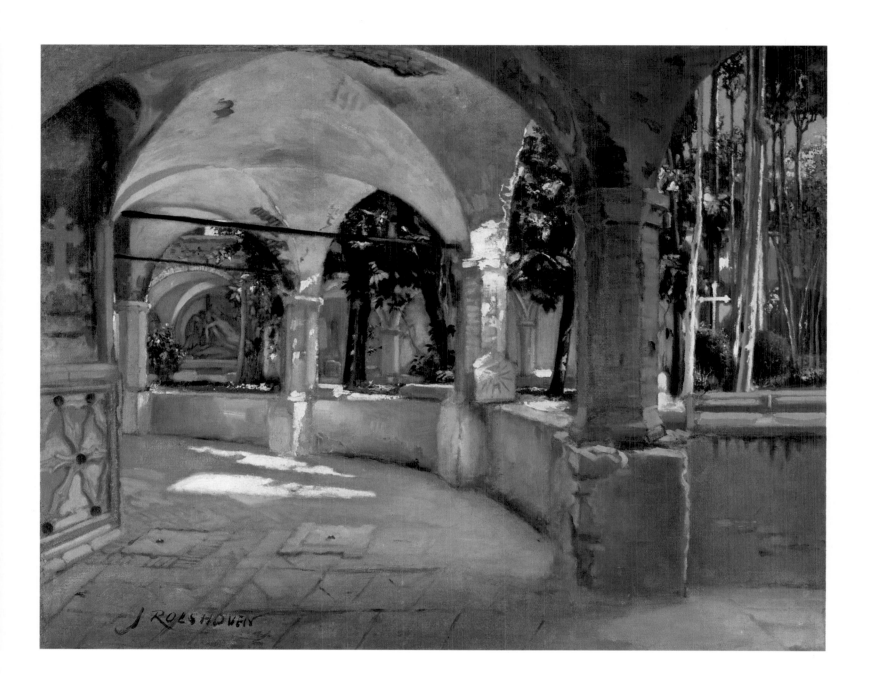

SEYMOUR ROSOFSKY
(1924–1981)

Bather's Monument, ca. 1967

Seymour Rosofsky came to critical notice in the 1950s for figurative, emotionally charged paintings with rich, textural brushwork. The youngest of three children, he was born in Chicago to Jewish immigrants from Russia and Poland. Rosofsky's college studies at the School of the Art Institute of Chicago were interrupted by three years' service in the United States Army, from 1943 until 1946. He completed his B.F.A. in 1949 and his M.F.A. in 1951, both from the Art Institute. From 1951 until his death, he taught at the city colleges of Chicago, first at Chicago Teachers College, then at Wright Junior College, and finally at Loop College (now Harold Washington Community College). During these years, Rosofsky also received grants for extended study abroad and in New York.[1]

In the late 1950s, along with artists such as Leon Golub, June Leaf, and Cosmo Campoli, Rosofsky was part of what one contemporary critic dubbed the "Monster Roster."[2] Although these artists were never formally organized, they worked in similar styles and shared an interest in depicting the grotesque and "monstrous." Rosofsky and the others found inspiration in a variety of sources: Goya, German Expressionism, non-Western art, Surrealism, and Jean Dubuffet's influential 1951 exhibition and lecture at Chicago's Arts Club.[3]

Rosofsky's work was distinguished by his strong draftsmanship and painting technique, which he used to create a highly individualized, modern mode of expression.[4] At times, his work became a platform for addressing social and political issues such as the 1960s thalidomide scandal and the Vietnam War. In other works, the autobiographical aspect dominated, as in a series of paintings he created in the 1970s as a catharsis for his marital problems. Chicago peers and critics recognized Rosofsky as one of the city's most original artistic voices, but the New York art world ignored him for many years, since his work did not fit into the prevailing artistic movements.[5] The late 1970s saw the emergence of Neo-Expressionism, a style marked by renewed interest in the figure, expressive painterly brushwork, and subjectivism. In the context of this new movement, Rosofsky's work became more widely appreciated. His health was failing by this time, however, and he died of complications from heart disease in 1981, three months after his first New York one-person show.

Bather's Monument is undated—a frustrating habit of the artist, who remarked that determining the dates for his work would give art historians something to do—but its style indicates that Rosofsky most likely painted it in the mid-1960s. The painting's surreal subject matter is combined with a naturalistic representation of space, a characteristic of a number of paintings from this period.[6] Thus, there is some sense of spatial recession in the Club's painting, and the male figure does not have the anatomical distortion found in his earlier work. As with many of Rosofsky's paintings, *Bather's Monument* has an enigmatic narrative. In a secluded landscape, a stocky man stands on a pentagonal pedestal watching three female bathers who are joined together as if they are paper-doll cutouts. Both the pedestal and the cutout figures are recurrent images in the artist's work of the period. Two interpretations suggest themselves: the artist's view that women are two-dimensional beings who preen themselves as a means of enticing men, a theme found in other works beginning in the late 1960s; and the alienation of the sexes, which Rosofsky felt keenly as the women's movement unsettled his traditional notions of gender roles.[7] MR

Oil on linen; 32 x 36 inches
(81.28 x 91.44 cm.)
Signed lower right: ROSOFSKY
UL1991.4

Provenance:
Borg-Warner Collection, ?–1991;
ULC, 1991

References:
Selections from the Borg-Warner Corporate Collection of Art. Chicago: Borg-Warner Corporation, ca. 1985–86. Page 28.

Seymour Rosofsky *Bather's Monument*, ca. 1967

EDGAR A. RUPPRECHT
(1889–1954)

The Summer Visitor and *Untitled*
(Woman at Writing Desk), ca. 1924

The two paintings by Edgar Rupprecht reproduced on the facing page have an unusual history. *The Summer Visitor*, shown at the upper right, came to the Union League Club in the late 1930s, when its owner, the Municipal Art League, placed its collection of regional paintings at the Club on long-term loan. The painting was later sold to the Club. In 1987, when *The Summer Visitor* was conserved, another painting was discovered hidden beneath it on the same stretcher. Dennis Loy, the Club's curator at the time, contacted the artist's daughter, a teacher at the School of the Art Institute of Chicago, and learned that Rupprecht had reused stretchers when he lacked the money to purchase new ones.[1] In the case of the pairing of *The Summer Visitor* and *Untitled (Woman at Writing Desk)*, the artist simply forgot to remove the bottom canvas.

Rupprecht, born in Zanesville, Ohio, was a pupil of Harry Wolcott, John Norton, and Karl Buehr at the School of the Art Institute of Chicago. In 1925, Rupprecht and his wife, Isabel, who was also an artist, went to Munich to study with Hans Hofmann. Rupprecht also assisted Hofmann at the summer art school sessions he held in Capri and Saint Tropez. A teacher at the School of the Art Institute for many years, Rupprecht was part of the faculty that established the summer program, Oxbow, in Saugatuck, Michigan, in 1926.[2]

Rupprecht's sister Edith was one of the two models for *The Summer Visitor*, which was painted at Oxbow.[3] *Untitled (Woman at Writing Desk)* depicts the artist's wife and cat, Ghosty, at the couple's apartment-studio at the Tree Studios building in Chicago. An artist whose work reflects his more conservative stylistic approach, Rupprecht also had very solid technique, which is perhaps most evident in the delicate rendering of the shadows of the figures and the reflections in the water in *The Summer Visitor* and in the ethereal quality of the light in *Untitled (Woman at Writing Desk)*. MR

The Summer Visitor, ca. 1924
Oil on canvas; 39 x 47 inches
(99.06 x 119.38 cm.)
Signed lower right: Edgar A. Rupprecht
UL1976.45A

Untitled (Woman at Writing Desk), ca. 1924
Oil on canvas; 39 x 47 1/8 inches
(99.06 x 119.38 cm.)
Signed lower right: Edgar A. Rupprecht
UL1976.45B

Provenance:
MAL, 1925–1951; UL C&AF, 1951–1976;
ULC, 1976

Exhibitions:
AIC Chicago and Vicinity Annual,
1925, #169

"American Art in the Union League
Club of Chicago, A Centennial Exhibition,"
traveling exhibition organized by the
ULC, 1980–1981

References:
Loy and Honig. *One Hundred Years*.
Page 187.

Loy, Dennis J. "Conservator Discovers
a Hidden Treasure." *State of the Union:
Official Magazine of the ULC* 62
(September 1987): Inside front cover.

The Summer Visitor, ca. 1924

Untitled (Woman at Writing Desk), ca. 1924

JOHN COLLIER SABRAW
(b. 1968)

Closet Formalism, 1998

The objects in John Sabraw's paintings have a hyper-meticulous clarity that abstracts them from their normal context. Sabraw, an assistant professor in the art department at Ohio University, began his career as an illustrator. In 1988, after earning an associate degree in illustration from Pratt Institute in New York City, he wrote and illustrated a children's book entitled *I Wouldn't Be Scared*, which was published to good reviews.[1] Sabraw left New York City to major in painting at the University of Kansas, graduating with highest honors in 1994. He earned an M.F.A. in painting from Northwestern University in 1997, where his closest faculty advisor was James Valerio. In 1996 and 1997, Sabraw received scholarships from the Union League Civic & Arts Foundation's Visual Scholarship Competition that supported him during his course of graduate study.

The vertical format of *Closet Formalism*, in which the painting's surface parallels the picture plane, is one that the artist favors in many works. The resulting shallow space, combined with the minutely detailed objects and the invisible brushstrokes, creates an illusion of reality or *trompe l'oeil* ("trick of the eye"). In America, trompe l'oeil painting became popular in the last quarter of the nineteenth century with a group of artists who created still lifes featuring inanimate objects such as pipes, currency, and wild game. As with many of these nineteenth-century works, Sabraw's paintings, which continue this tradition of illusionism, have a surreal quality.

Sabraw's trompe l'oeil effects are aided by his technique. He primes his canvases with several coats of gesso, sands the surface, and then repeats the procedure as many as thirty times until he achieves a glass-smooth surface. He builds up color and form by alternating layers of paint with layers of resin; there may be as many as three hundred layers of paint in *Closet Formalism*. Finally, after letting the surface dry, he sands and varnishes it.[2] The result is a painting surface of complete smoothness.

In *Closet Formalism*, a pane of glass marked with the remains of masking tape is visible through a torn section of the velvet cloth that has been pinned to a board. The pins appear to project into the viewer's space, heightening the sense of illusion. The pane is part of Sabraw's collection of found objects; for many years the artist has accumulated "objects that hold their own promise of becoming or acquiring my history."[3] Sabraw may own something for years before deciding to paint it. In paintings such as *Closet Formalism*, his goal is not so much to depict the object as to recreate it by imparting to its representation the new character that he has discovered in the object itself. The black void behind the glass stands for the fact that no matter how detailed or illusionist it may be, painting is ultimately comprised of abstract marks, an idea that Sabraw finds compelling: hence the title, *Closet Formalism*.[4] MR

Oil on panel, 49 x 37 inches
(124.46 x 93.98 cm.)
Signed reverse, top right: Closet
Formalism / John Collier Sabraw 1998 /
To the Union League Club, Supporters,
Influences, Friends, Thanks To All
UL2000.1

Provenance:
ULC, 2000

219 **John Collier Sabraw** *Closet Formalism*, 1998

WILLIAM SAMUEL SCHWARTZ
(1896–1977)

*Earn Your Bread by the Sweat
of Your Brow*, 1935

By 1935, the year that *Earn Your Bread by the Sweat of Your Brow* was painted, William Schwartz was widely regarded as one of Chicago's major painters. Born in Russia, the artist immigrated to America in 1913 and enrolled at the School of the Art Institute of Chicago in 1916, where he graduated with honors. Although his work was modernist, frequently showing the influence of artists such as Wassily Kandinsky and Paul Cézanne, Schwartz's paintings were typically grounded in the figurative tradition, as is the case with the Club's work.[1]

Many American artists used their paintings to address the social and economic problems caused by the Great Depression, and Schwartz focused on depictions of the common worker during the 1930s. In *Earn Your Bread by the Sweat of Your Brow*, the figures' careworn faces testify to lifes of hard work and privation, yet at the same time, their resolute expressions and solid forms indicate both courage and lack of self-pity. Their headgear indicates that both man and boy are coal miners. A village, dominated by smokestacks, is visible in the background. The geometric quality of the forms and the application of color in large block-like areas reveal the influence of Cézanne, whom Schwartz admired.

Earn Your Bread by the Sweat of Your Brow is related to *Mining in Illinois*, a 1937 mural in the El Dorado, Illinois, post office, one of three post office murals the artist did for the United States Treasury Department's Section of Painting and Sculpture.

In addition, he made a black-and-white lithograph in 1938, *The Miner*, which is a detail of the figure in the Club's work. Like many artists in the depression, Schwartz depended on government commissions as an important source of income. He participated in "The Chicago Artists' Committee for W.P.A. Jobs" and, between 1935 and 1940, made paintings and lithographs under the Works Progress Administration's Federal Art Project.

In 1970, Schwartz described his experiences as an émigré in an article for the *Chicago Tribune Magazine*, noting that

Nothing in Europe had prepared me for the wealth of interest and material abounding in American faces. People are people, of course, the world over. But Americans are a special kind of people, similar to and yet how different from the European pattern. The thoughts behind American faces, the characters I have tried to transfer from life to canvas, the men and women of many callings and many regions who have sat for me, all bear the unmistakable New World stamp. I have tried to paint this human essence of America in the major media just as I have tried to recapture the atmosphere of her woods and waters, her cities and towns, her plains and hills.[2]

Earn Your Bread by the Sweat of Your Brow exemplifies Schwartz's love for his countrymen. MR

Oil on canvas; 36 x 30 inches
(91.44 x 76.2 cm.)
Signed lower center: William S. Schwartz;
reverse: "Earn Your Bread by the Sweat
of Your Brow"/By/William S. Schwartz/
Painting #329/Chicago
UL1996.2

Provenance:
Dr. Joseph S. Kaufman, Niles,
ca. 1940–1996; ULC, 1996

Exhibitions:
"Exhibition of Paintings and Lithographs
by William S. Schwartz," AIC, 1935, #36

"Annual Exhibition of the Circulating
Picture Club," Philadelphia Art Alliance,
1939

References:
Donnell, Courtney, Susan Weininger,
and Robert Cozzolino. *Ivan Albright*.
Exh. cat. Chicago: AIC, 1997. Page 77.

*Exhibition of Paintings and Lithographs
by William S. Schwartz*. Exh. pamphlet.
Chicago: AIC, 1935. Unpaginated.

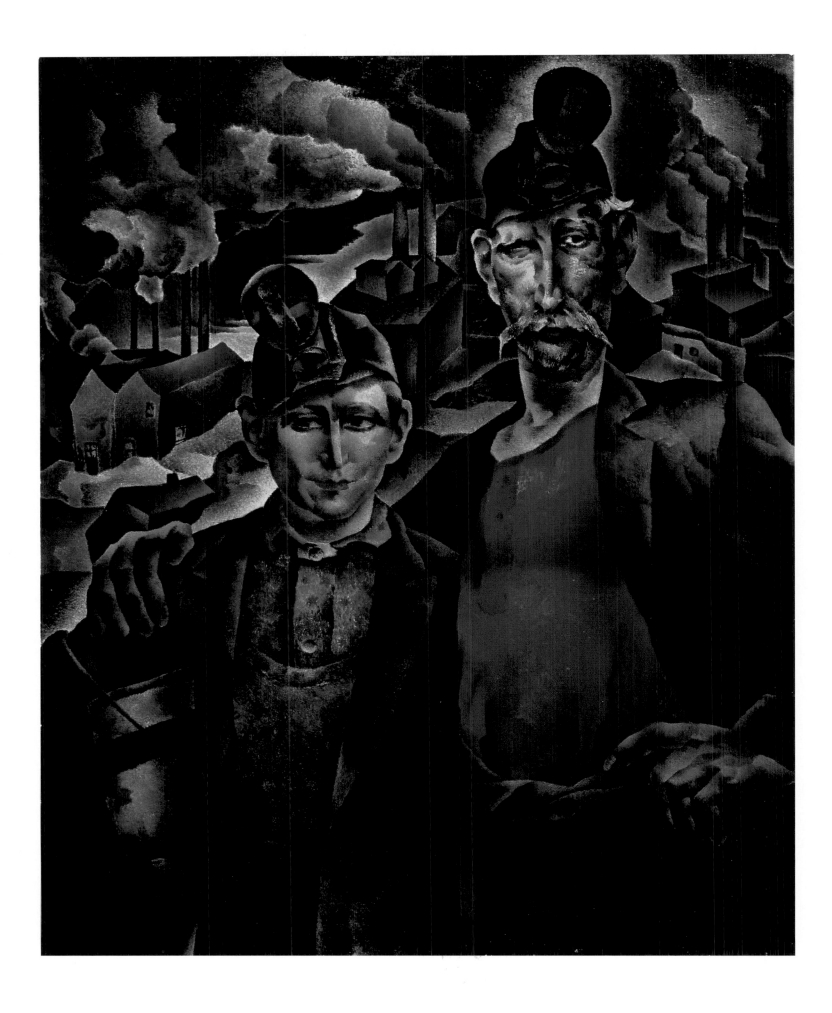

221 **William Samuel Schwartz** *Earn Your Bread by the Sweat of Your Brow*, 1935

HOLLIS SIGLER
(1948–2001)

White Bathing Suit, ca. 1973–1975

In the 1990s, Hollis Sigler became nationally known as a breast cancer awareness activist whose art addressed her own struggle with the disease as well as the silence that continues to surround the second leading cause of death for women. Sigler, who was born in Gary, Indiana, grew up in New Jersey and earned a B.F.A. from Moore College of Art in Philadelphia in 1970. In 1971, she moved to Chicago to enroll in graduate school at the School of the Art Institute of Chicago. Her style changed dramatically during these years from a nonfigurative painterly style inspired by Abstract Expressionism to a photorealist style of effaced brushwork. By the time Sigler graduated from the Art Institute in 1973, she was concentrating on large-scale realist work and underwater scenes of swimmers.[1] Seeking a way to infuse her work with greater emotional content, she began a period of stylistic experimentation. Her new work, which she exhibited for the first time in 1977, moved away from realism to a style that combined two-dimensional space, simplified and unmodeled forms, and intense colors with dreamlike narrative. Sigler focused on using pencils and oil pastels for these drawings.[2]

In 1985, Sigler was diagnosed with breast cancer. In the years immediately following this news, the artist was optimistic about her chances for complete remission, and her work only occasionally dealt with her illness, usually indirectly. In 1991, after learning that her cancer had metastasized into her bones, Sigler began a visual diary, *Breast Cancer Journal*, that dealt directly with her cancer. By the time of her death, the series encompassed over one hundred works.[3]

White Bathing Suit, which dates to the artist's initial period in Chicago, attests to her strong technique. The realist watercolor has a strongly impersonal mood. Positioning herself in the role of camera lens, Sigler dispassionately recorded the figure of the underwater swimmer. The figure is cropped, as if moving outside of the viewfinder. Interestingly, the artist's later, emotionally charged works are marked by the physical absence of people, a complete reversal of the quality of detachment that characterizes early figurative works such as *White Bathing Suit*. MR

Watercolor on paper;
19 1/2 x 28 1/2 inches
(49.53 x 72.39 cm.)
Unsigned
UL1988.17

Provenance:
UL C&AF, 1976–1988; ULC, 1988

Exhibitions:
"Eleventh Union League Art Show,"
ULC, 1976, #47 (awarded first prize for watercolor).

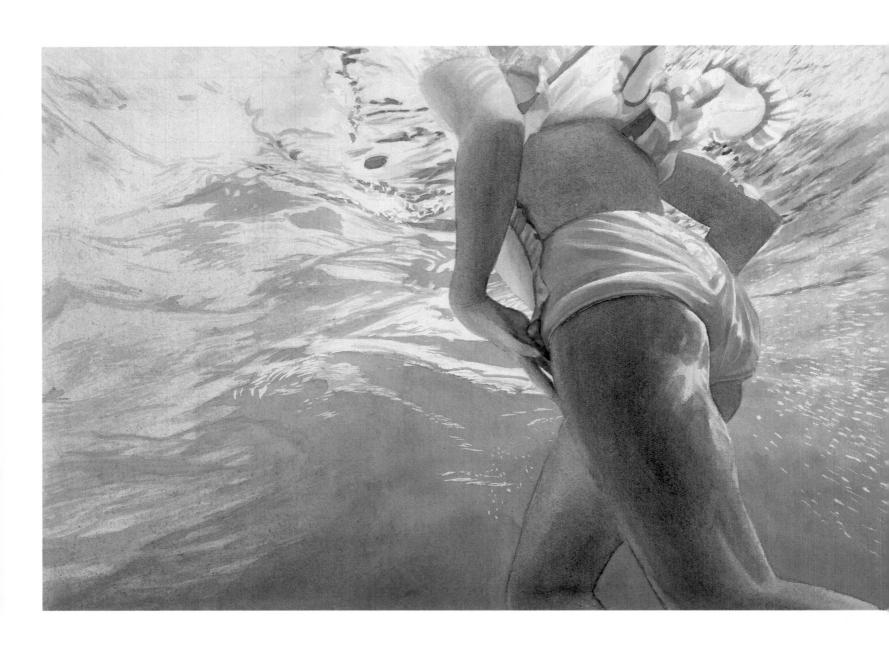

223 **Hollis Sigler** *White Bathing Suit,* ca. 1973–1975

JEANETTE PASIN SLOAN
(b. 1946)

Valle de Colore, 1994

Still lifes with an almost photorealist degree of finish and detail have been the forte of Jeanette Pasin Sloan, an artist who came to the medium of painting relatively late in her career. A first-generation Italian American whose father created the popular children's wagon, the Radio Flyer, Sloan drew constantly during her childhood in Oak Park, Illinois. Although she won a scholarship to the School of the Art Institute of Chicago, she instead enrolled at Marymount College, a Catholic women's school in Tarrytown, New York. After graduating with a major in art history, Sloan attended the University of Chicago, initially studying art history but soon switching to studio art. She graduated with a masters of fine arts degree in 1969, specializing in graphic arts. Married to the writer James Sloan by this time, for several years she ceased making art as she devoted her energies to raising her family.

In the early 1970s, Sloan began teaching herself how to paint at night, when her children were asleep, by painting all of the objects in her kitchen over a period of two years. Of this time, she once commented that she "struggled to compose, to arrange, to create order and beauty."[1] An important development came in 1975, with *Toaster*, in which she depicted the reflections created by the chrome appliance.[2] Since then, the distortions and patterns caused by the reflections of chrome, silver, and mirrors have been a hallmark of her work.

By the mid-1970s, Sloan had gallery representation in both Chicago and New York. Despite her growing reputation, however, she felt that her still lifes could not have value since they were based in her domestic life.[3] In the 1980s, she reevaluated her attitude as she saw the rise of a number of women artists who made feminist statements by celebrating those things associated with being female. After going through a divorce in the late 1980s and coping with the deaths of her father and sister, Sloan briefly included nude self-portraits in a series of watercolors as an exploration of both her identity and her experience of aging. In the past decade, she has taught as a visiting professor and as an artist-in-residence at numerous colleges and universities.

In the early 1990s, Sloan began including Native American and Hispanic textiles in her work, the result of her decision to spend part of the year in Santa Fe, New Mexico. In *Valle de Colore*, a striped Mexican cloth is the colorful backdrop for an arrangement of a zebra-striped cup and saucer, Revere Ware bowls and tumbler, and a martini glass. These objects reappear in her paintings, watercolors, and lithographs. The painting's highly polished surfaces reflect distorted views of the cup and saucer and the cloth, creating a highly energized composition. Although her very modern still lifes appear to be about her ability to control both technique and composition, Sloan notes that works such as *Valle de Colore* are "right on the edge of disorder. I think it's as much about disorder as it is about harmony and balance."[4] MR

Oil on linen canvas;
32 x 32 inches (81.28 x 81.28 cm.)
Signed recto, lower right: J. P. Sloan 96';
signed verso: J. P. Sloan 1994
UL1996.1

Provenance:
ULC, 1996

Exhibitions:
"Jeanette Pasin Sloan," ULC, 1996, #8

References:
Henry, Gerrit. *Jeanette Pasin Sloan*. New York: Hudson Hills Press, 2000. Page 104.

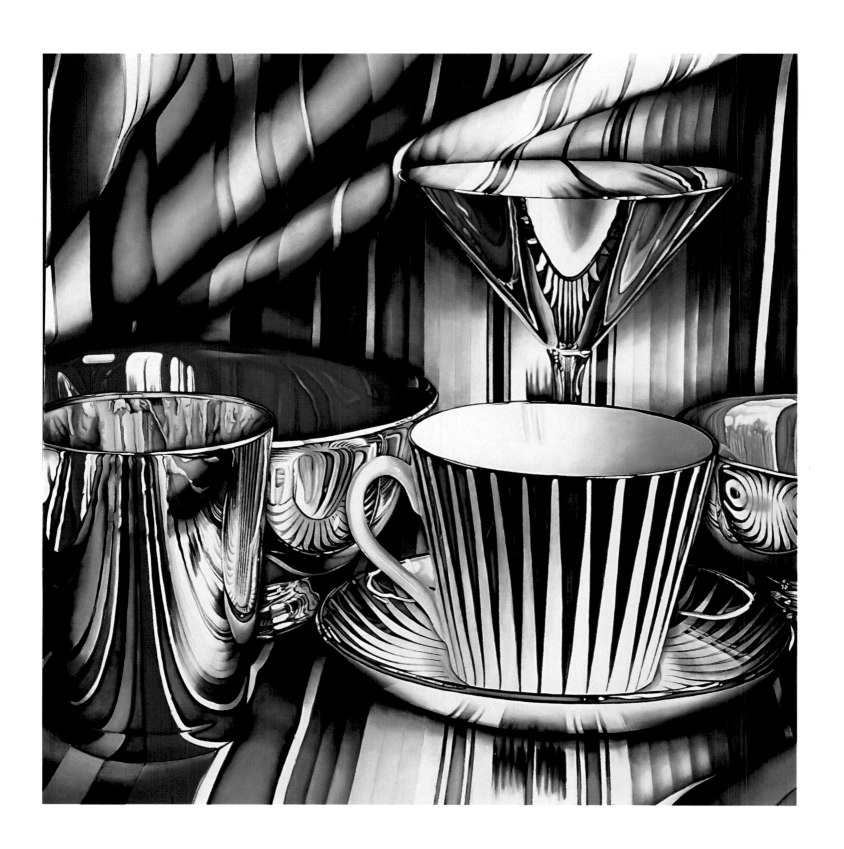

Valle de Colore, 1994

ETHEL SPEARS
(1902–1974)

Oak Street Beach, undated

Chicago native Ethel Spears's diverse career began with studies in textile design at the Art Institute.[1] She also took classes in painting from John Warner Norton and Laura van Pappelendam, and while still a student she executed murals for the museum's tearoom. Spears went on to study with the modernist sculptor Alexander Archipenko in Woodstock, New York, and in New York City at the Art Students League and New York University, specializing in lithography and design. She began exhibiting in Chicago in 1926 and returned to the Midwest in 1930. The federal work projects of the depression era provided Spears with opportunities to paint murals in area schools and hospitals; her tempera and watercolor paintings were similarly distributed. Spears was also a talented illustrator, printmaker, and craftsperson. From 1944 to 1952 she taught silk screen printing and enameling as well as painting and drawing at the Art Institute's school. In 1961 Spears left Chicago for Navasota, Texas, when her companion and fellow painter and teacher Kathleen Blackshear retired there.

Spears's art matured in an era of progressive, populist politics that drew in many artists through federally funded relief work. These projects encouraged artists to create images of ordinary Americans in everyday surroundings, using an accessible, realistic style of presentation. Easel paintings as well as murals in post offices and other public spaces were expected to be democratic in spirit, an art for and about the people, even if created by professional artists. While many artists responded with images that heroize ordinary citizens or deal with compelling social issues such as poverty or injustice, Spears tended toward an intimate, playful approach. Her work often features a multitude of small figures, neatly detailed and characterized as "typical" types, distributed over a space in slightly flattened perspective, in a deliberately naive manner recalling children's artwork. Fellow artist Frances Badger described Spears as childlike in her enjoyment of artmaking.[2]

Spears's view of Chicago's Oak Street beach looks north to take in the swooping curve of the lakeshore just off the shopping and hotel district of upper Michigan Avenue. In the left distance stand some of Chicago's earliest residential skyscrapers, which line Lake Shore Drive on the Gold Coast, long one of the city's premier neighborhoods. But Spears focuses attention on a cross section of citizens scattered across the beach on a summer's evening. Mothers and children mingle with flirtatious teenagers, servicemen on leave, and frolicking dogs; in the distant water, swimmers wade, dive, splash, and float in carefree relief from the heat of urban summertime. The brilliant stars pricking the velvety black of the slightly fantastic sky are echoed by the brightly lighted windows of the buildings and the streetlights that stretch northwards along the drive like a string of pearls. Probably executed in the 1940s, *Oak Street Beach* evokes the determined pursuit of pleasure by ordinary Chicagoans in an era overshadowed by war. WG

**Watercolor and gouache
on paper; 25 x 33 1/8 inches
(63.5 x 84.14 cm.)
Signed lower right: Ethel Spears
UL1989.5**

Provenance:
Estate of Ethel Spears; ULC, 1988

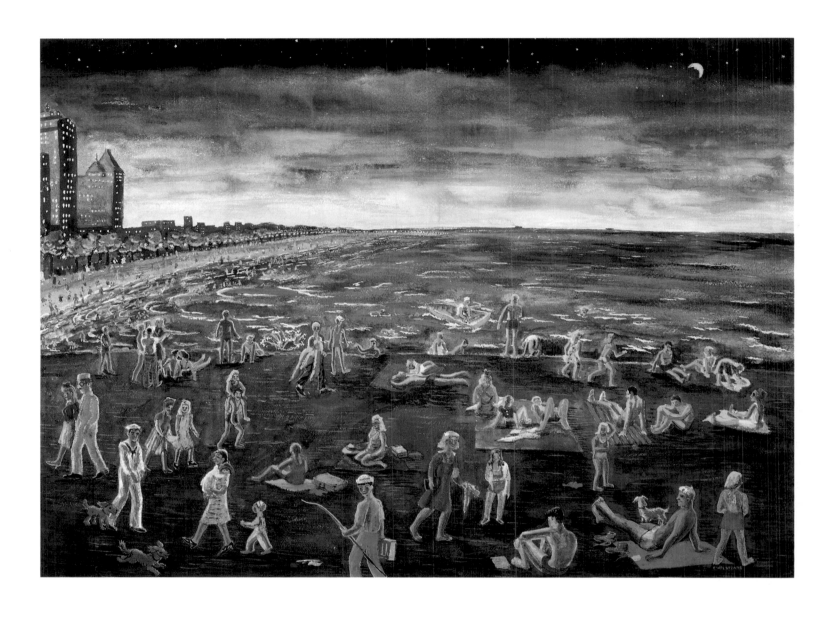

Oak Street Beach, undated

ROBERT SPENCER
(1879–1931)

The Rag Pickers (Red Shale Road), ca. 1921

In search of suitable subjects and congenial environments beyond the urban studio, American artists established numerous art colonies around the turn of the century. Around 1899 several artists began working around the Delaware River town of New Hope, Pennsylvania, north of Philadelphia. Among the second generation of what came to be called the New Hope school was Robert Spencer. He was born in Harvard, Nebraska, and studied at the National Academy of Design and at the New York School of Art, where his teachers included William Merritt Chase and Robert Henri.[1] Spencer moved to New Hope and in 1909 lived and studied with one of the group's most important painters, Daniel Garber. His works won numerous prizes in exhibitions in New York, Boston, and Philadelphia between 1913 and the mid-1920s. Thereafter, the popularity of the New Hope school's realist-impressionist paintings was overshadowed by the work of modernist artists. Beset by a troubled marriage and a series of nervous breakdowns, Spencer committed suicide at the age of fifty-one.

Landscape painting dominated the work of the New Hope school artists. Spencer, in contrast, found his signature subject in crowds of working-class men and women set among factories, mills, and tenements. His interest in urban life may reflect the influence of his teacher Robert Henri, a pioneer in the realist depiction of the modern city, and the inspiration of the Delaware Valley itself, where small industry had historically flourished thanks to the power and transportation afforded by the river.[2]

But Spencer did not embrace his "dreary" subjects as a true realist and he emphatically denied having a "Socialistic" agenda in painting them.[3] Rather, his interpretation mingles realism and romanticism. His scenes are peopled by contemporary types, the men in bowler hats and the sturdy women with bare forearms and aprons over their long skirts. The old and often dilapidated industrial structures that loom behind them are picturesque remnants of a still vital past, consciously selected and arranged for decorative effect. "People ask me what is made in my mills," remarked Spencer, "damned if I know, and if I care." It was only the "romantic mass" of a building and its placement in the landscape that counted, he declared.[4]

The Rag Pickers was one of Spencer's most important works, winning several exhibition prizes. Its ostensible subject is the crowd of women in the picture's lower left who wait to receive payment from two white-shirted men (somewhat elevated above them) for the bundles of old clothes and other discarded fabric heaped untidily on the right. The miserable poverty implied by this theme is however only a minor incident in a composition dominated by an almost symmetrical hierarchy of massive masonry structures rising majestically against a fair-weather sky. The piled buildings' drab mottled walls and blank windows strike a romantic note, suggesting a fantastic ruin of some European city.[5] However, the setting of *The Rag Pickers* has been identified as Pittsburgh, the epitome of industrial urbanism at the time.[6] WG

Oil on canvas; 30 x 36 inches
(76.2 x 91.44 cm.)
Signed lower right: Robert Spencer
UL1922.1

Provenance:
ULC, 1921

Exhibitions:
AIC American Art Annual, 1921, #188

"96th Annual Exhibition," National Academy of Design, N.Y., 1921, #202

Carnegie International, Carnegie Institute, Pittsburgh, 1921

"Robert Spencer: Impressionist of Working Class Life," New Jersey State Museum, Newark, N.J., 1983

"The Pennsylvania School of Landscape Painting: An Original American Impressionism," traveling exhibition organized by the Allentown Art Museum, Allentown, Pa., 1985, #59

"Visions of a Nation: Exploring Identity Through American Art," Terra Museum of American Art, Chicago, 1997

References:
Folk, Thomas. *The Pennsylvania School of Landscape Painting: An Original American Impressionism.* Exh. cat. Allentown, Pa.: Allentown Art Museum, 1984. Pages 72–73.

Loy and Honig. *One Hundred Years.* Pages 78–79.

Martin. *Art in the ULC.* Pages 21, 46.

S[now], R[ichard] F. "The American City: A Gathering of Turn-of-the-Century Paintings." *American Heritage* 27 (April 1976): 36.

229 **Robert Spencer** *The Rag Pickers (Red Shale Road)*, ca. 1921

HENRY FENTON SPREAD
(1844–1890)

Rufus Choate, 1890

Henry Fenton Spread was one of the founding fathers of Chicago's art community in the late nineteenth century.[1] A native of Kinsale, Ireland, Spread studied at London's South Kensington Museum and in Brussels. After five years in Australia, New Zealand, and Tasmania, he immigrated to the United States in 1870. Spread settled in Chicago around 1874, the year he was elected to the National Academy of Design. He established his own art academy, which was absorbed in 1879 by the newly founded Chicago Academy of Fine Arts, renamed The Art Institute of Chicago three years later. As the school's leading instructor of portrait painting, Spread was one of its most influential teachers. The informal gatherings of local artists that took place in his studio evolved into the Chicago Society of Artists in 1888, with Spread as its first president.

Rufus Choate was a Massachusetts lawyer famous for his oratorical ability. He served in the United States House of Representatives from 1831 to 1834, and in 1841 was elected to complete Daniel Webster's unexpired term in the Senate when the latter was appointed secretary of state. Among Choate's noted utterances was his assertion in his letter to the

Whig Convention of 1855: "We join ourselves to no party that does not carry the flag and keep step to the music of the Union." This declaration became the motto of the Union League Club of Chicago when it was selected for inscription on the mantlepiece of the main lounge of the 1885 clubhouse.[2] It was natural, then, for the Club to commission a portrait of Choate.[3] By 1895 it had joined the collection along with portraits of James Madison by Richard N. Brooke, Eastman Johnson's *Alexander Hamilton*, and the portrait of George Washington after Gilbert Stuart, according to an official register of the collection.

Rufus Choate was the subject of a number of commemorative posthumous portraits, such as Daniel Chester French's full-length bronze statue of Choate as orator.[4] Spread's bust likeness, in contrast, might pass for a life portrait painted in the last years of the sitter's life. It conforms to the conventions of mid-century portraiture in its composition and in its detailed realism in the rendering of Choate's face, with its aging, worn folds of flesh, compressed lips, and intense, visionary gaze. The immediacy of Spread's image suggests that the artist based it on a photograph, though none has been identified as a source. WG

Oil on canvas; 27 x 22 inches
(68.58 x 56.88 cm.)
Signed lower left: H. F. Spread, 1890
UL1895R.6

Provenance:
ULC, 1890

Exhibitions:
"American Art in the Union League Club of Chicago, A Centennial Exhibition," traveling exhibition organized by the ULC, 1980–1981

References:
Corliss. *Catalogue*, 1899. #36.

Gerdts. *Art Across America*. Vol. 2, page 292.

McCauley. *Catalogue*, 1907. #50.

Martin. *Art in the ULC*. Page 46.

231 **Henry Fenton Spread** *Rufus Choate*, 1890

ANNA LEE STACEY
(1871–1943)

Trophies of the Field, 1902

Anna Lee Dey was born in Glasgow, Missouri, and began her art studies at the Kansas City Art Association's School of Design.[1] There she met John Stacey, its director, whom she married in 1891. Anna Stacey attended the Art Institute of Chicago's school between 1893 and 1899; she began exhibiting there in 1896. With her husband she then traveled and painted in France, where she studied at Paris's Académie Delacluse; she later made three more trips to Europe. Figure paintings and marines in oil and in watercolor dominated her early work; around 1911 she began to concentrate on portraiture. The Staceys lived and worked in the Tree Studios building on Chicago's Near North side until 1937, when they moved to Pasadena, California.

Stacey painted *Trophies of the Field* during one of the most successful years of her career. Not only was this work quickly acquired by the Union League Club, but her *Village at Twilight* won the Art Institute's Martin B. Cahn Prize that year. "Mrs. Stacey certainly has before her a brilliant career in her chosen profession," noted the author of a contemporary survey of Illinois art.[2] Her marines and out-of-door figure paintings found considerable favor among the women's clubs that served as important art patrons in turn-of-the-century Chicago.

The floral theme of *Trophies of the Field* echoed a prevailing taste, for in addition to Stacey's painting the Union League Club in 1902 added to its collection Will H. Low's *In the Sun, Narcissus*, and *Blossoming Time in Normandy* by Mary Fairchild MacMonnies Low.

Trophies of the Field presents a pretty pubescent girl in a simple striped dress, holding an armful of lacy white flowers. Gazing directly at the viewer, she stands before a backdrop of a pleasant rural landscape of fields, houses, and trees, and a river on which a boat sails. The double-entendre of Stacey's title, which refers both to the girl and to the bouquet she has gathered, stresses the traditional symbolic associations between women and flowers. Here, the blossoms appear to be Queen Anne's Lace. While not commonly assigned a symbolic meaning, this wild species is both delicate in appearance and a vigorous denizen of uncultivated or abandoned land—an echo of the natural beauty and promising vitality of a wholesome rural child on the threshold of womanhood. The girl's thick braided hair, low forehead, and intense gaze, the somewhat artificial relationship between figure and setting, and the relatively narrow format of the composition in which the figure is confined all evoke the iconic, highly symbolic female imagery of the English Pre-Raphaelite painters of the mid-nineteenth century. WG

Oil on canvas; 24 x 16 inches
(60.96 x 40.64 cm.)
Signed lower left: Anna L. Stacey, 1902
UL1907C.12

Provenance:
ULC, 1902

Exhibitions:
AIC American Art Annual, 1902, #473

References:
McCauley. *Catalogue*, 1907. #63.

Martin. *Art in the ULC*. Page 46.

233 **Anna Lee Stacey** *Trophies of the Field*, 1902

JOHN FRANKLIN STACEY
(1859–1941)

The Valley of the Mystic (Across the Valley of the Mystic), ca. 1902

Born in Biddeford, Maine, landscape painter John Franklin Stacey studied art at the State Normal School in Boston, then taught art in Massachusetts public schools before furthering his studies at the Académie Julian in Paris between 1883 and 1886.[1] He moved to Kansas City and directed the Kansas City Art Association's newly established School of Design,[2] where he met his future wife, painter Anna Lee Dey. Around 1890 Stacey moved to Chicago to teach at the R. T. Crane Manual Training School. He began exhibiting at the Art Institute in 1897; his works were also seen in national and international exhibitions and brought him several important honors. A popular exhibitor in Chicago's conservative art venues through the 1920s, Stacey was an outspoken opponent of modernism.[3] In 1937, he and his wife left Chicago to live in the art community of Pasadena, California.

Stacey spent the summer of 1900 painting in the French art colony of Auvers-sur-Oise, an experience that probably confirmed his conversion to impressionism; defined by bright, pure color, rapid, open brushwork, and execution *en plein air*, impressionism was the dominant aesthetic by 1900.[4] The following summer Stacey worked in the area around Mystic, on the Connecticut coast, a region where artists' colonies had begun sprouting a decade earlier. The colony at Mystic, begun by Charles Harold Davis, was flourishing in 1902, when John Stacey spent the summer.[5] "In fact," wrote a contemporary observer, "some of his very best pictures have their origin in the 'hilly highways, stone fences, Yankee farmhouses and neglected meadows of New England.'"[6] These works include *The Valley of the Mystic*, "recognized as one of the very best of his pictures."

Stacey's sweeping view across the gentle slope of the Mystic River valley in southeastern Connecticut takes in the stone-fenced farmlands bordering the river not far from where it meets the Long Island Sound.[7] A sunny, seemingly timeless scene, it evokes contemporary nostalgia for "Old New England" as a peaceful, domesticated, gracious landscape mirroring generations of accumulated civilization and historical associations. Nostalgic ideas of New England had gained in appeal after the Civil War, particularly as American landscape painters returned to the Northeast to paint calm, contemplative images of familiar places conspicuously unscathed by urbanism and social strife.[8] Nothing in Stacey's view hints at the close proximity of the vast ship building facilities of nearby New London, at the river's mouth. WG

Oil on canvas;
22 1/8 x 36 inches
(56.20 x 91.44 cm.)
Signed lower left: John F. Stacey
UL1907C.17

Provenance:
ULC, 1902

Exhibitions:
AIC Chicago and Vicinity Annual,
1902, #216

AIC American Art Annual,
1902, #475

References:
Bennett, Frances Cheney, ed. *History of Music and Art in Illinois.* Philadelphia: Historical Publishing Co., 1904. Page 512.

McCauley. *Catalogue*, 1907. #91.

Martin. *Art in the ULC.* Page 46.

235 **John Franklin Stacey** *The Valley of the Mystic (Across the Valley of the Mystic)*, ca. 1902

ANTONIN STERBA
(1875–1963)

Chris Marie (Girl in a Golden Shawl), ca. 1927

Antonin Sterba was five years old when his parents brought him from his native Harmanec, in Czechoslovakia, to Chicago.[2] At fifteen he began attending night classes at The Art Institute of Chicago, and he also studied at John Francis Smith's Art Academy. Sterba then spent two years in Paris studying with portraitists Jean Paul Laurens and Benjamin Constant. On his return to Chicago he became an instructor at Smith's academy, joined the faculty of the Art Institute when its school absorbed Smith's,[3] and later taught at the American Academy of Art. A successful portraitist in Chicago, Sterba painted official likenesses commissioned by institutions, portraits of society women, and images of important figures in the arts, whom he met through his wife, the poet and musician Mabel Messenger; he also painted landscapes and still lifes. In 1928 he spent a year in Pasadena, California, and in the following years he traveled from his Evanston studio to Mexico, Florida, and New Orleans.[4]

Like many dedicated portrait painters, Sterba varied his work on commissions with figure paintings that combined the technique and composition of conventional portraiture with more imaginative themes. The titles of many of his exhibited works suggest that frequently, as in *Chris Marie*, he posed models to create interesting images of women with an appeal detached from the specific identity of the individual subject.

Chris Marie invokes the long tradition of picturing women with flowers and glamorous or exotic articles of apparel, only to subvert such associations' implications of modesty, natural purity, and delicacy. Chris Marie is evidently nude beneath her fringed silk drapery, the demureness of her sideways pose and wrapped arms belied by her frank, unashamed gaze. Fashionably modern with her bobbed coiffure and clunky jewelry, she embodies the daring allure of an era intoxicated with liberty and pleasure. The drama of the image is heightened further by the deep contrasts between the firmly modeled, brightly lit figure and the dark background. The immediacy of her presence is accentuated by the broad brushstrokes and flattened planes that describe the subject's face. Both the technique and the deliberately modern air of Sterba's *Chris Marie* suggest the influence of such contemporary painters as George Bellows and Robert Henri, who were regarded as heroes of artistic sanity by many conservative Chicago artists in the 1920s. WG

Oil on canvas;
50 x 32 inches
(127 x 81.28 cm.)
Signed lower left: Antonin Sterba
[above what appears to be an
original signature painted over]
UL1997.7

Provenance:
Antonin Messenger Sterba and
Josephine S. Sterba (the artist's son
and daughter-in-law), to 1997:
ULC, 1997

Exhibitions:
"An Exhibition of Paintings by Antonin
Sterba," Chicago Galleries Association,
1927, #4

"Antonin Sterba," Jules Kievits Galleries,
Pasadena, California, [1928], #12

Chicago artists' exhibition, Jubilee
Week, Palmer House, Chicago, 1931, #734
(as *La Paloma*, illus.)[1]

"An Exhibition of the Works of Antonin
Sterba (1875–1963)," ULC, 1994, #1
(where date of painting is given as 1928)

"Antonin Sterba: An Exhibition of
Paintings, Prints, and Drawings," The
Miller Art Center, Sturgeon Bay, Wis., 1996

References:
Weininger, Susan S. "Ivan Albright in
Context," in Courtney Graham Donnell,
et al. *Ivan Albright*. Exh. cat. Chicago: AIC,
1997. Page 56.

Antonin Sterba *Chris Marie (Girl in a Golden Shawl)*, ca. 1927

SVEND SVENDSEN
(1864–1930)

Winter Sunset in Norway, 1897

Svend Rasmussen Svendsen was born in Nittedal, Norway, and grew up in Christiana, the site of a flourishing artists' colony.[1] There he was deeply influenced by the work of painter Fritz Thaulow, the leader of the impressionist movement in Norway, who was known for his winter landscapes. Svendsen immigrated to the United States in 1881 and settled in Chicago two years later to work as a lithography artist.[2] His fame as a painter was launched when one of his snow scenes won a prize at the 1895 Young Fortnightly competitive exhibition at the Art Institute.[3] Over the next dozen years Svendsen's works were exhibited widely, received much critical praise, and won several honors. Between 1895 and 1906 the artist made three trips to Europe, including stays in Norway.[4] After 1908, however, he dropped out of sight, a victim of alcoholism. In the 1920s a Chicago businessman who admired Svendsen's work lent him space in his office where he painted occasionally,[5] but his career never revived. In the winter of 1930, Svendsen collapsed on a Chicago street and died of exposure.[6]

At the height of his career Svendsen received praise for the variety of his subjects, which included marines, moonlit landscapes, and village scenes as well as figural works.[7] But he was especially celebrated for his snow pictures. Inspired by his memories of winter in his native Norway, often refreshed by visits to suburban Palos Park, Svendsen's winter images were painted in Chicago.[8] Often they feature sunset glow on snow, the trees casting long purple shadows.[9] The brilliant hues that Svendsen used to render these effects won critical praise for their modernism, but his color schemes could also seem "garish as well as impossible."[10] Nonetheless, his paintings were so "perilously popular" that the artist was accused of churning them out in large numbers in slavish response to an enthusiastic market.[11]

The Union League Club's *Winter Sunset in Norway* offers much evidence for why Svendsen's snow scenes were so popular with his contemporaries. Here Svendsen renders an essentially static and monochromatic subject in startlingly intense color and meticulous detail, fulfilling one goal of much of late nineteenth-century landscape painting: to express the romance inherent in nature's most undramatic scenes and ordinary moments. Eerily quiet and unpeopled, *Winter Sunset in Norway* is charged further with mystery: traces of recent passage clearly mark the snow's smooth surface, yet are tantalizingly unexplained. Two converging tracks of horse-drawn sleighs curve out of sight into the wood at left; the footprints of a walker that emerge from the lower left corner of the shadowed foreground defy their direction, marching straight off through a "doorway" framed by two tree trunks. A wood fence crosses the way, but in the distance two cottages beckon, their snow-blanketed rooftops just visible beyond the rise of the land. The enigma suggested by the juxtaposition of these elements is intensified by subtle contrasts of light and shadow, particularly the somewhat disquieting effect of the spiky shadows cast by unseen trees beyond the left edge of the picture. The surreal tints of the snow as it catches the sunset glow are achieved by a layering of pinks over a dark-red ground. WG

Oil on canvas; 43 x 32 3/4
(109.22 x 83.19 cm.)
Signed lower right:
SVEND SVENDSEN '97; signed on
reverse: Dilluy. Roma
UL1906.1

Provenance:
ULC, 1906

References:
Loy and Honig. *One Hundred Years*.
Page 190.

McCauley. *Catalogue*, 1907. #14.

Martin. *Art in the ULC*.
Page 47.

239 **Svend Svendsen** *Winter Sunset in Norway,* 1897

GEORGE GARDNER SYMONS
(1861–1930)

In the Mohawk Valley, ca. 1910

George Gardner Symons was born in Chicago to German-Jewish immigrant parents.[1] After attending the Art Institute he studied in Munich, Paris, and London. Symons maintained studios in Chicago (until 1921) and New York, and he painted in Europe, in Laguna Beach, where he became a lifelong part-time member of the area's growing artists' community, and in New England, the setting for the winter landscapes for which he is best known.[2] Symons's work enjoyed considerable repute, particularly after he won the Carnegie Prize at the National Academy of Design in 1909; within two years he was admitted to full membership in the Academy. Symons became one of the most successful landscape painters of his day, and during his lifetime such important institutions as The Art Institute of Chicago, the Metropolitan Museum of Art, and the Corcoran Gallery of Art acquired his works.

The stillness and subtle light effects of the rural landscape under snow attracted many tonalist and impressionist painters at the turn of the century. For a generation of artists concerned with conveying a direct, emotional, even sensual experience of nature in their work, cold winter scenes were particularly attractive vehicles. Like such contemporaries as Walter Elmer Schofield and Edward Redfield, with whom he was often compared,[3] Symons used an antiacademic palette of crisp, invigorating color and bold, muscular brushwork to create winter images that are realist in their unsparing evocation of a bleak season in rural New England.

A convert to plein-air naturalism after his sojourn in the art colony of St. Ives in Cornwall, England, during 1898 and 1899, Symons painted his winter scenes on the spot in the area around his home in Colrain, in the Berkshire Mountains of western Massachusetts. The Union League Club's painting is similar to many of these winter scenes, notably the Art Institute's *Winter Sun* (1910); both probably depict the North River, on which Colrain is situated. An old Indian trail known as the Mohawk Trail (since replaced by a paved highway), traversed the valley cut by the North River; the trail ran just south of Colrain from Greenfield to North Adams.[4] Symons's title refers to the region's history, but his image offers a thoroughly contemporary approach to the landscape. Nondescript houses cluster in the left distance and a trudging figure pulling a sled appears on the crest of the hill that rises from the banks of the stream flowing from the foreground. The composition of layered diagonals juxtaposes static, frozen elements with signs of warmth and movement. Caught in the glare of bright, indirect sunlight, thinning patches of snow retreat from the tawny ground, melting into the rapidly moving stream. The bright blue sky, studded with puffy clouds, echoes the land's promise of the coming spring. WG

Oil on canvas;
49 1/2 x 60 1/4 inches
(125.73 x 154.04 cm.)
Signed lower right: Gardner Symons
UL1910.3

Provenance:
ULC, 1910

Exhibitions:
"American Art in the Union League Club of Chicago, A Centennial Exhibition," traveling exhibition organized by ULC, 1980 (painting shown only in Chicago)

References:
Loy and Honig. *One Hundred Years.* Pages 46–47.

Martin. *Art in the ULC.* Pages 29, 47.

Sparks. *American Art in the ULC.* Page 30.

241 **George Gardner Symons** *In the Mohawk Valley*, ca. 1910

A. FREDERIC TELLANDER
(1878–1977)

Surf at Ogunquit, ca. 1927

Born in the small east-central Illinois town of Paxton, A. Frederic Tellander was primarily a self-taught artist.[1] From 1895 to 1897 he attended Northern Indiana Normal School (later Valparaiso University), where he studied under Samuel B. Wright, a former pupil of Thomas Eakins. Tellander worked as a commercial artist while developing his interest in landscape painting; he also essayed sculpture and was a talented watercolorist. He began exhibiting at The Art Institute of Chicago's annual exhibitions in 1910; his work was especially popular in the 1920s and 1930s, when he received several important prizes. Tellander painted New England landscapes, marines, and midwestern scenes. After two years in Europe in the mid-1920s, he also exhibited French and Italian city views. In the 1940s Tellander's work as an illustrator included advertising images for the Bendix and Studebaker corporations.[2] He was still painting the day before he died, at age ninety-eight.[3]

By the time Tellander visited Ogunquit in the 1920s, this spot on Maine's southern coast not far from Portsmouth, New Hampshire, had long been a popular summer tourist destination. Artists had flocked there since 1898, when painter Charles Woodbury built a summer home at Ogunquit and established an annual seasonal school.[4] In the 1920s, such painters as Gertrude Fiske typically painted its sunny beaches and colorfully dressed bathers under the welcome glare of summer's sun. Tellander, in contrast, chose to picture a scene of romantic, elemental conflict that recalls Winslow Homer's images of the rocky shore at Prout's Neck, not far to the north. With its tipped-up perspective and commanding size, *Surf at Ogunquit* suggests the artist's first-hand experience of nature. At the center of the image white surf cascades over flat rocks. Vigorous strokes of interwoven greens and whites describe the churning water, while the reflective wet surfaces of the blocky rocks that cut across the lower right and jut into the center left edge of the composition are rendered in slashing marks of pink, green, and black. In the distance, the high horizon, separated from the boiling surf of the foreground by a band of rolling wave, affords a glimpse of blue sky and sea rendered in patterned brushwork that suggests the fresh vigor of the setting.

Surf at Ogunquit was one of Tellander's most successful works. Exhibited in the Art Institute's 1927 annual "Chicago and Vicinity" exhibition, it won the visitors' popularity vote; Tellander's fellow artists seconded the opinion of the laity.[5] The painting was awarded both the Municipal Art League's annual purchase prize and the gold medal of the Association of Chicago Painters and Sculptors.[6] That organization, to which Tellander belonged, boasted a membership of conservative artists who had seceded from the more liberal Chicago Society of Artists in 1921. With its decorative impressionist style and emphasis on the timeless power of the sea, *Surf at Ogunquit* bore out Tellander's advocacy of an "openhearted attitude toward Nature" as an antidote to modernism's "'isms' and warped vagaries [which are] being so noisily and insistently foisted upon us today."[7] WG

Oil on canvas; 49 1/2 x 60 inches
(125.73 x 152.4 cm.)
Signed illegibly at lower right:
Frederic Tellander
UL1976.50

Provenance:
MAL, 1927–1951; UL C&AF, 1951–1976; ULC, 1976

Exhibitions:
AIC Chicago and Vicinity Annual, 1927, #235

"Paintings by Chicago Artists," Garfield Park Art Galleries, Chicago, 1936, # 37

References:
Loy and Honig. *One Hundred Years*. Page 194.

Martin. *Art in the ULC*. Page 47.

243 **A. Frederic Tellander** *Surf at Ogunquit*, ca. 1927

LESLIE PRINCE THOMPSON
(1880–1963)

Calves and Child, ca. 1901

Leslie Prince Thompson was part of a circle of Boston artists at the turn of the twentieth century whose leader was the noted American impressionist Edmund Tarbell. Thompson, who was born in Medford, Massachusetts, studied with Tarbell at the School of the Museum of Fine Arts, Boston, from 1901 until 1904. He continued his artistic studies at the Massachusetts Normal Art School and in Europe.[1] When Tarbell resigned his teaching position at the museum school in late 1912, Thompson was appointed his successor, and he taught painting and drawing there until 1930. Thompson belonged to several artists' organizations, including the National Academy of Design, the Guild of Boston Artists, and the St. Botolph Club. His studio was at Fenway Studios—the only American studio building designed from artists' specifications that still exists—from 1909 until 1947, where he worked near Tarbell and the noted impressionists William McGregor Paxton and Joseph DeCamp.[2]

Thompson was an accomplished painter of still lifes, portraits, landscapes, and genre scenes. *Calves and Child* is an early work, dating to his student days with Tarbell at the Museum School. It is unclear how the Union League Club came to purchase it. There is no record of the painting having been in a local exhibition, the usual place that members of the Club's Art Committee found new works for the collection. In 1901, Thompson was just beginning his course of study, and the acquisition of a painting by the obscure young artist is thus a surprising choice for a Chicago organization.

Following the tenets of impressionism, Thompson painted *Calves and Child* in a free manner that stresses the overall view rather than detail. Two cows in the foreground gaze at the viewer somewhat confrontationally, while the child appears oblivious to the intrusion. In the distance, the red roof of the farm is visible through the trees. Although the painting's subject matter is inherently sentimental, Thompson's treatment is surprisingly candid, a snapshot that is in keeping with the impressionist style with which he had recently become familiar. MR

Oil on canvas;
28 3/4 x 23 1/2 inches
(73.03 x 59.69 cm.)
Signed lower left: L. Thompson
UL1901.4

Provenance:
ULC, 1901

References:
McCauley. *Catalogue*, 1907, #28.

Leslie Prince Thompson *Calves and Child*, ca. 1901

EDWARD JOSEPH FINLEY TIMMONS
(1882–1960)

The Stevenson House, Monterey, California, ca. 1940

One of the historic sites of Monterey, California, is the house in which Robert Louis Stevenson lodged for several months in 1879 to be near the woman he eventually married, Fanny Vandegrift Osbourne. Stevenson's book *The Amateur Emigrant*, written in 1879 and 1880, is an account of the journey to California that left the chronically ill author near death and penniless. Stevenson's quarters were in a two-story adobe house believed to have been built in the 1830s. By the first third of the twentieth century, the house was badly deteriorated. Two local residents purchased it in 1937 to save it from destruction and later presented the house as a gift to the State of California.

In the 1940s, shortly after the house became part of Monterey State Historic Park, Edward Joseph Finley Timmons began maintaining a studio in nearby Carmel-by-the-Sea. A conservative artist who was not interested in experimenting with modernist styles in which the emphasis was no longer on creating a reflection of the world, Timmons instead accurately represents the main entrance of the Stevenson house and conveys a sense of spatial recession in this painting.[1] His loose handling of the earth and small trees in the foreground reveal the continuing influence of the impressionist technique with which he had first become acquainted as a student at the School of the Art Institute of Chicago.

According to family lore, Timmons's interest in art was precocious. As a four-year-old child, he had made a watercolor of the family farm in Janesville, Wisconsin, in which the front yard was filled with flowers while the nearby carriage yard was blanketed under snow. In this way, he had told his parents, the picture would be "a whole one."[2] Although his parents hoped that Timmons, who held a state record in high school track, would use his athletic ability to gain a scholarship to the University of Wisconsin, he instead enrolled at the School of the Art Institute of Chicago. In 1906, three years after graduating with honors, Timmons joined the faculty, teaching at the school until he resigned in 1918. He was a member of the New York Art Students League, the Association of Chicago Painters and Sculptors, the Chicago Society of Artists, and the Carmel Art Association. Primarily a portraitist and landscape painter, he concentrated on the latter subject matter in California. Timmons continued to make his primary home in the Chicago area, however, living for the last fifteen years of his life in Evanston. MR

Oil on canvas; 24 1/8 x 30 1/4 inches (61.28 x 76.84 cm.)
Signed lower left:
Edw. J. F. Timmons
Gift of Marjorie Gilbert Timmons
UL1966.1

Provenance:
Marjorie Gilbert Timmons, 1960–1966; ULC, 1966

References:
Loy and Honig. *One Hundred Years.* Pages 192, 194.

247 **Edward Joseph Finley Timmons** *The Stevenson House, Monterey, California,* ca. 1940

CHARLES YARDLEY TURNER
(1850–1918)

John Alden's Letter, ca. 1887

Educated in Quaker schools in his native Baltimore, Charles Yardley Turner began his career as a photographic finisher while attending night classes in art at the Maryland Institute.[1] In 1870 he moved to New York, continuing his work in photography and studying at the National Academy of Design and at the Art Students League, which he helped found in 1875. Turner went to Paris in 1878 for three years of further study with the academic painters Léon Bonnat, Jean-Paul Laurens, and Mihaly von Munkacsy. He returned to the United States to teach at the Art Students League. Exhibiting widely, Turner won acclaim for his oil paintings and watercolors on literary and historical themes and was elected a full member of the National Academy of Design in 1886. At the World's Columbian Exposition of 1893, Turner served as assistant director of decoration, and he executed murals. Thereafter he became a successful mural painter, decorating such major buildings as the Wisconsin State House, the courthouse in Baltimore, and the Appellate Courthouse in New York City. Toward the end of his career Turner also worked in the print medium of etching.

The Centennial Exposition of 1876 unleashed a tidal wave of nostalgic interest in America's colonial past. America's white, Anglo-Saxon elite cherished the heritage of the Puritan forebears as their political and social hegemony met challenges from newer immigrant populations. Under the lingering influence of the colonial revival, Turner and other artists created meticulously detailed images of life in old New England, including the life and history of the Pilgrims. Artists often took their inspiration from literature, notably works by Nathaniel Hawthorne, John Greenleaf Whittier, and Henry Wadsworth Longfellow. Offering pictorial windows through which contemporary viewers could escape into a sentimentalized national past, works like Turner's *John Alden's Letter* blurred the distinction between history and literature by presenting poetic fiction as historical reality. In such images, convincingly rendered (if not always historically accurate) material detail cast a gloss of apparent truthfulness over the artworks' interpretive agendas.

Longfellow's narrative poem *The Courtship of Miles Standish*, first published in 1858, inspired many artistic renderings. In this apocryphal story, Standish, the bluff, middle-aged soldier in charge of the defense of the Plymouth Colony, commissions his friend, the handsome young John Alden, to carry his proposal of marriage to the Puritan maid Priscilla. She boldly replies with the question, "Why don't you speak for yourself, John?" Alden is at first too loyal to his friend to do so, but eventually he and Priscilla are united. Several artists pictured Priscilla at her spinning wheel in the company of the tongue-tied Alden, as in an 1884 painting by Turner entitled *The Courtship of Miles Standish*.[2]

In *John Alden's Letter*, however, Turner tackled the less familiar opening scene of the poem, in which Standish deputizes Alden to convey the proposal of marriage to his intended. It is an essentially static moment that the painter, following Longfellow's description, uses to explore the contrasting appearance and character of the two friends. In the dim but well-furnished interior of a seventeenth-century dwelling, the two figures are arranged to maximize their difference, their heads appropriately framed against contrasting backgrounds.[3] Standish, an upright, stalwart figure in tall boots that hint of his active, outdoor life, turns his bearded face toward the window and the world glimpsed beyond; Alden, the picture of intellectual ability and Cavalier gentility, is seated with his back to the window, bending his handsome, clean-shaven face over the letter he writes on Standish's behalf. Turner's interpretation bears out the nineteenth-century view of Alden and Standish as representatives of complementary facets of the New England Puritan and, by extension, the American character. Their pairing in the poem and in Turner's painting embodies longstanding convictions that in America the Cavalier and the Puritan forces, in conflict in the Mother Country, reconciled.[4] Turner's drab (and historically inaccurate) color scheme conforms to popular notions of Puritan disapproval of material show, even while the painter lavishes attention on the play of light on the lively contours of the solid furniture and the gleaming metalwork seen throughout the room. The painting's virtual monochromaticism plays up the central role of light, which helps to define and illumine the contrast between the two figures and to highlight the details of the physical setting that helped bring the distant past to life for Turner's viewers. wg

Oil on canvas; 30 x 45 inches
(76.2 x 114.3 cm.)
Signed lower left:
Copyright By C-Y-Turner-1887
UL1895R.29

Provenance:
ULC, by 1895

Exhibitions:
"Sixty-Third Annual Exhibition of the National Academy of Design," National Academy of Design, New York, 1888, #328

Palace of Fine Arts, World's Columbian Exposition, Chicago, 1893, #823

"American Art in the Union League Club of Chicago, A Centennial Exhibition," traveling exhibition organized by the ULC, 1980–1981

"Revisiting the White City: American Art from the 1893 World's Fair," National Museum of American Art and National Portrait Gallery, Smithsonian Institution, Washington, D.C., 1993

"Picturing Old New England: Image and Memory," National Museum of American Art, Smithsonian Institution, Washington, D.C., 1999

References:
Corliss. *Catalogue*. 1899. Page 15, #41 (as *Miles Standish and John Alden*).

Hitchcock, Ripley, ed. *The Art of the World: Illustrated in the Paintings, Statuary, and Architecture of the World's Columbian Exposition*. 2 vols. New York: D. Appleton, 1895. Vol. 2, pages 137–38.

Martin. *Art in the ULC*. Page 47.

Picturing Old New England: Image and Memory. Exh. cat. Washington, D.C.: National Museum of American Art, Smithsonian Institution, 1999. Pages 47–49, fig. 38.

Revisiting the White City: American Art at the 1893 World's Fair. Exh. cat. Washington, D.C.: National Museum of American Art and National Portrait Gallery, Smithsonian Institution, 1993. Page 332.

Charles Yardley Turner *John Alden's Letter,* ca. 1887

ROSS TURNER
(1847–1915)

Cologne Cathedral, 1884

Ross Turner's *Cologne Cathedral* holds a special place in the history of the Union League Club's art collection. In 1886, when the watercolor was donated, it was evidently the first acquisition with primarily an aesthetic, rather than historic, claim to value. The donor, Club member J. M. Thacher, had commissioned this view of the great cathedral of Cologne, Germany, which he considered "the finest building in the world to my mind." [1] Thacher's interest in Cologne Cathedral may have been sparked by its recent completion. Construction of the edifice, in the French Gothic style, had been started in 1248 but ceased in the sixteenth century when the style went out of favor. Work resumed in 1842, during the Gothic Revival movement, and the cathedral was finally completed in 1880. It was the largest Gothic church in Northern Europe and the tallest structure built during the Middle Ages. [2]

A somewhat romanticized depiction of the monument, Ross Turner's *Cologne Cathedral* is an example of the work of a recognized authority on watercolor technique. [3] Born in Westport, New York, Turner was raised in Williamsport, in central Pennsylvania. He found work as a draftsman at the United States Patent Office, where he proved his talents in both freehand and mechanical drawing. In 1876 Turner went to Munich and joined the circle of artists led by the influential American painter Frank Duveneck; he also studied in Venice with Whistler. On his return to the United States in 1882 Turner settled in Boston, later moving to Salem, Massachusetts; he also worked in the Bahamas and on the New Hampshire coast, where he was associated with impressionist painter Childe Hassam. [4]

He executed oils as well as watercolors, painted figural and landscape subjects, created illustrations, and made illuminated manuscripts in the medieval tradition. Turner was a popular teacher of watercolor painting in his Boston studio, at the Massachusetts Institute of Technology, and at the Massachusetts Normal School. He wrote an important manual on his favored technique, *On the Use of Watercolors for Beginners*, published in 1886, and he pioneered the movement for the decoration of schoolrooms.

In *Cologne Cathedral* Turner places the structure well within the frame of his composition, but emphasizes its soaring grandeur by juxtaposing the cathedral with the squat houses that huddle in its vicinity as well as the almost empty expanse of the open *platz* spreading before it. A procession of diminutive figures gathers at the cathedral's open doors. Ecclesiastics in gray and white gowns with red stoles, gold canopies, and colorful banners are described with tiny spots of bright color set against the somber grays of the building's stone facade. A woman with two children in the middle ground and a couple slightly further back and off to the right lend a sense of scale by which to assess the cathedral's towering height; these figures also humanize its imposing presence, while directing the eye toward the picture's focus. Approaching his medium conservatively, Turner drew as well as painted with watercolor to carefully preserve the architectural detail of the building's complex surfaces in a manner recalling the English watercolor tradition of the early nineteenth century. At the same time, his somewhat impressionistic rendering of the distant figures may reflect the practice of his teacher Whistler. wg

Watercolor and Chinese
white on paper; 38 x 25 inches
(96.52 x 63.5 cm.)
Signed lower left: Ross Turner 1884
Gift of J. M. Thacher, 1886
UL1886.1

Provenance:
J. M. Thacher, to 1886;
ULC, 1886

Exhibitions:
"American Art in the Union League Club of Chicago, A Centennial Exhibition," traveling exhibition organized by the ULC, 1980–1981

References:
Corliss. *Catalogue*, 1899. Page 18, #53.

Loy and Honig. *One Hundred Years*. Pages 20–21.

McCauley. *Catalogue*, 1907. #108.

Martin. *Art in the ULC*. Page 47.

Sparks. *American Art in the ULC*. Pages 30–31.

Ross Turner *Cologne Cathedral*, 1884

WALTER UFER
(1876–1936)

Near the Waterhole, 1921

Walter Ufer included *Near the Waterhole* in a 1922 exhibition "Recent Paintings by Walter Ufer" at Carson Pirie Scott and Company in Chicago. The canvas, painted in 1921, is one of Ufer's most distinguished. Ufer's philosophy, gleaned from the recommendations of his patron, Carter H. Harrison, dictated that he paint the Native American as he was, involved with everyday activities, and dressed in contemporary costume. Ufer preferred to paint from the model, his favorite being Jim Mirabal. For more than twenty years, Mirabal was Ufer's model, gardener, drinking and gambling partner, and most important, close friend. Ufer places the viewer on the rim of the arroyo. From this vantage point, we are given a bird's-eye view of Jim Mirabal and a woman on horseback and of a complicated system of hoof prints made by a restless animal. From the lower right corner, a second figure, one of Ufer's "water carriers" emerges supporting a large pot (a black *olla* owned by Ufer).

While the painting is a compositional masterpiece, Ufer's ability with the brush is even more noteworthy. Ufer excels in this painting, applying rich, juicy pigment in an exciting series of patterns in the sand and in the rich array of *chamisa* (sage). Stephen Good writes, "The tension between the flat, decorative, patterned effect of the figures and landscape and the bright, animated paint surface reaches a pitch that the illusion of spatial depth is threatened, and the image seems almost to lift itself above the canvas."[1]

A writer for *El Palacio* characterized *Near the Waterhole* as having "the stirring color, the vigorous treatment, the fine execution, the skill in representation that made Ufer always something more than academic."[2] With this painting, created at the height of his career, Ufer rivaled, if not, surpassed, the more recognized wizards of the brush, Robert Henri, Ernest Blumenschein, and Victor Higgins. *Near the Waterhole* was created at the peak of Ufer's career. Unfortunately, he could not maintain the painting's high level of quality. Gambling, excessive drinking, and taking on more responsibilities than he could handle gradually caused his career to go into decline.

Chicago proved to be an important training ground for three artists who would spend their careers in Taos, New Mexico. Walter Ufer was the first to be sent to Taos, sponsored by Chicago mayor Carter H. Harrison and his syndicate in 1914. Ufer was followed by Victor Higgins in the fall of 1914 and by E. Martin Hennings in 1917. Ufer was an artist of curious contradictions. While he was born in Huckeswagen, Germany, in 1876, for political reasons he claimed Louisville, Kentucky, as his birthplace. After his family arrived in America in 1880, Ufer began his lifelong involvement in the arts. From 1893 to 1898, he trained in Germany. In 1899, he moved to Chicago where he studied, taught, and worked as an illustrator for Armor and Company. In 1911 Walter, with his wife Mary, returned to Germany for two additional years of study.

Along with Victor Higgins, Ufer became a member of the Taos Society of Artists in 1917. In the meantime, his brutally frank images of the Taos Indian brought him national attention. He developed a strong patronage system and won several prizes for his New Mexico paintings in juried shows at the Art Institute. Following his success, he, along with Higgins and another Taos colleague, Ernest Blumenschein, dominated juried shows at the National Academy of Design, the Pennsylvania Academy of the Fine Arts, and the Carnegie in Pittsburgh.

His life was cut short on August 2, 1936, when he died from a ruptured appendix. DP

Oil on canvas;
36 1/2 x 40 1/2 inches
(92.71 x 102.24 cm.)
Signed lower left corner: wufer
UL1976.51

Provenance:
L. L. Valentine, possibly for the MAL, 1922; MAL, ?–1951; UL C&AF, 1951–1976; ULC, 1976

Exhibitions:
"Recent Paintings by Walter Ufer," Carson Pirie Scott and Company, Chicago, 1922, #14

"Ufer in Retrospective," Phoenix Art Museum, 1970

"The American West," Continental Bank, Chicago, in cooperation with Mongerson Gallery, 1975

"American Art in the Union League Club of Chicago, A Centennial Exhibition," traveling exhibition organized by the ULC, 1980–1981

"Taos Artists and Their Patrons: 1898-1950," traveling exhibition organized by The Snite Museum of Art, University of Notre Dame, Notre Dame, Ind., 1999

References:
"The Art of Walter Ufer." *El Palacio* 12 (April 15, 1922): 108–109.

Broder, Patricia Janis. *Taos: A Painter's Dream.* Boston: New York Graphic Society, 1980. Page 230.

Good, Stephen L. "Walter Ufer," in Laura M. Bickerstaff, ed., *Pioneer Artists of Taos.* Revised and expanded edition. Denver: Old West Publishing, 1983. Reproduced following page 16.

Good, Stephen L. "Seven Paintings by Walter Ufer." *Artists of the Rockies and the Golden West* 11 (Winter 1984): 47.

Libby, Eleanor. *Ufer in Retrospective.* Exh. cat. Phoenix: Phoenix Art Museum, 1970. Unpaginated (#18).

Loy and Honig. *One Hundred Years.* Page 194.

Porter, Dean A., Suzan Campbell and Teresa Hayes Ebie. *Taos Artists and Their Patrons 1898–1950.* Exh. cat. Notre Dame, Ind.: The Snite Museum of Art, University of Notre Dame, 1999. Page 94.

Martin. *American Art in the ULC.* Pages 30–31.

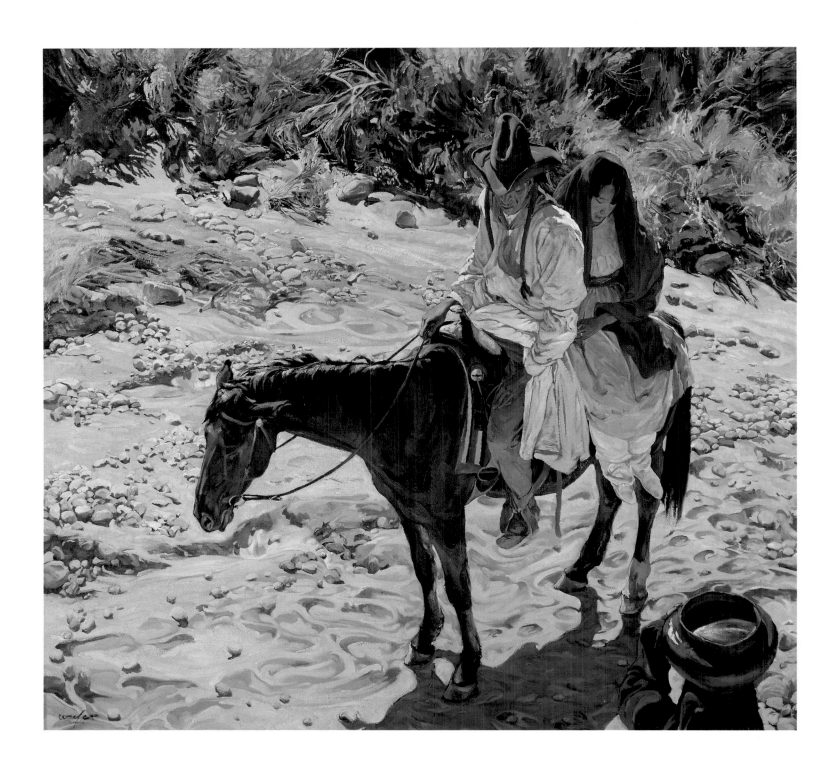

JAMES VALERIO
(b. 1938)

Night Fires, 1984

James Valerio is known for paintings that combine photo-realistic detail with surreal images. A Chicago native, he decided to become an artist after receiving encouragement from Seymour Rosofsky while a student at Wright Junior College.[1] Valerio subsequently attended the School of the Art Institute of Chicago, where he studied with Ray Yoshida and earned both bachelor and master of fine arts degrees. Following a period of independent study abroad, he joined the art faculty at the University of California, Los Angeles, in 1970. Valerio first began his practice of using color transparencies as tools in developing his realist compositions during his time in Los Angeles. His work from this period was inspired by the irrational imagery of the human subconscious. Although his early work was not critically well received, he gained national recognition in 1979 when his painting *Still Life No. 2*, included in "The Big Still Life Show" at Allan Frumkin's New York Gallery, was hailed as an important example of photorealism. Later that year, Valerio joined the faculty at Cornell University. In 1985, he became professor of art theory and practice at Northwestern University, where he continues to teach.

Valerio once observed that his goal is to recreate reality in his work.[2] His technique is painstaking. He begins by writing out his thematic conception of each new work, and he then uses photographic transparencies to decide on specific subject matter and composition. Valerio then makes a preliminary drawing, which he photographs and projects on the wall until he finds the ideal size for the final painting.[3] He stains and primes the canvas with six successively thinner layers of gesso, a type of ground used to prepare the canvas. Because he wishes to retain the texture of the canvas weave, Valerio next sands down the gesso layers. In applying paint to the canvas, the artist prefers to work wet-in-wet, and to this end, he adds oil of clove to his paints, which makes them dry more slowly. Valerio completes only two or three paintings each year.

Night Fires comprises three sections, each one receding further into space. In the foreground is an almost obsessively detailed still life, while behind it, a woman sleeps. The artist's wife, Pat, served as the model for this figure. Disembodied flames are visible in the background; the hypnotic, dangerous quality of fire has been a theme in several of Valerio's paintings. *Night Fires* also reflects the artist's interest in the work of earlier artists, including Dutch Baroque still life painters and, in the dramatic play of light and shadow, the Italian Baroque artist Caravaggio.

Thematically *Night Fires* addresses the issue of the relative transience of material possessions. Valerio, who painted this work while living in Los Angeles, wished to explore the destructive effect that the area's brush fires had on physical property. In discussing the painting at a later date, he recalled,

Sometimes we collect very opulent, beautiful things which cost a lot of money. They are often very luxurious. Yet there are in the world things like fire which can in an instant take everything away I wanted to introduce the fact that one needs to have caution in life. [4] MR

Oil on canvas;
92 x 100 inches
(233.68 cm. x 254 cm.)
Unsigned
UL1994.2

Provenance:
Northern Trust Company,
1987–1994; ULC, 1994

Exhibitions:
"James Valerio: Recent Paintings,"
The University of Iowa Museum
of Art, Iowa City, 1994

"Nocturnes and Nightmares,"
Florida State University
Fine Arts Gallery and Museum,
Tallahassee, 1987

"Art in Chicago 1945–1995,"
Museum of Contemporary Art, Chicago,
1996–1997, #120

References:
Adcock, Craig. *Nocturnes and Nightmares*.
Exh. cat. Tallahassee, Fla.: Florida
State University Fine Arts Gallery and
Museum, 1987. Pages 12, 13, 44–45.

Curran, Pamela White. *James Valerio: Recent Paintings*. Exh. cat. Iowa City, Iowa:
University of Iowa Museum of Art, 1994.
Pages 6–7.

Warren, Lynne, Jeff Abell, Dennis Adrian,
Franz Schulz, and Staci Boris. *Art in Chicago 1945–1995*. Exh. cat. Chicago: Museum of
Contemporary Art, 1996. Page 212.

CLARK GREENWOOD VOORHEES
(1871–1933)

The Tulip Tree, October (The Tulip Tree;
Magnolias, Autumn), ca. 1922

During a bicycle trip to Watch Hill, Rhode Island, in 1893, Clark Greenwood Voorhees discovered the beautiful scenery around Old Lyme, Connecticut; he has the distinction of being the first artist to do so.[1] Within a decade, prominent artists such as Henry Ward Ranger and Childe Hassam had moved there, and the town had become an important art colony. Although Voorhees spent the summers of 1896 and 1898 painting in Old Lyme, each time staying at Florence Griswold's boarding house, the locus of the art colony, he did not become a regular part of the art community until 1901.

Voorhees, born in New York City to an affluent family, graduated from Yale University in 1891 with a degree in chemistry. By the time he had completed a master's degree in chemistry from Columbia University in 1893, he had developed an interest in drawing. In 1894, while working part-time as a laboratory assistant, he enrolled in evening classes at the Art Students League in New York, and he later studied at the Metropolitan School of Fine Arts. In January 1896, Voorhees quit his laboratory position to dedicate himself to full-time artistic study. In addition to the classes in New York, he studied more informally with both Irving Ramsay Wiles and Leonard Ochtman during summers in Long Island and Cos Cob, Connecticut, respectively. As with so many artists of the period, Voorhees completed his formal period of study by attending the Académie Julian in Paris, an art school that was particularly popular with Americans. By 1902, after returning to the United States, he was exhibiting with members of the Old Lyme Art Colony, and in 1903 he purchased an eighteenth-century cottage by the Connecticut River. Well known in the community, Voorhees volunteered as a fireman and served on the board of the town library for many years.[2] He was also a respected amateur ornithologist and naturalist.[3] Voorhees divided his time between Old Lyme; Lenox, Massachusetts; and Bermuda, where he and his family spent winters beginning in 1919. In his last years, he turned to the etching medium as failing health prevented him from painting regularly.

Voorhees's early works were dark in tone and had subtle gradations of color, a preference that he had learned from Henry Ward Ranger , the American Barbizon artist and a leader of the Old Lyme colony.[4] By the early 1920s, under the influence of American impressionist Childe Hassam, another dominant force in Old Lyme, Voorhees began using pastel tones and freer brushwork, as evidenced in *The Tulip Tree, October*. This scene, in which airy trees seem to merge and blend into each other, is one of a very few in which Voorhees achieved the dissolution of form that was another hallmark of impressionism. The tall tree to the left of the center of the composition is the eponymous tree, also known as a yellow poplar, a species that is actually part of the magnolia family. Voorhees painted the trees and grass in a series of parallel brushstrokes, a technique that gives the painting a patterned, decorative quality and a somewhat flattened sense of space, and that creates a feeling of life and movement in the trees. The lyrical mood of *The Tulip Tree, October* is abundantly expressive of Voorhees's great love of nature. MR

Oil on canvas; 28 1/8 x 36 inches
(71.44 x 91.44 cm.)
Signed left of center: Clark G. Voorhees
UL 1976.52

Provenance:
L. L. Valentine, dates unknown;
MAL, ?–1962; UL C&AF,
1962–1976; ULC, 1976

Exhibitions:
"Ninety-Eighth Annual Exhibition,"
National Academy of Design, New York
City, 1923, #134

Painters & Sculptors Gallery Association,
Grand Central Terminal, New York City,
date unknown, #848

"Clark G. Voorhees 1871–1933,"
Florence Griswold Museum, Old Lyme,
Conn. 1981, #16

References:
Loy and Honig. *One Hundred Years*.
Pages 66–67.

MacAdam, Barbara J. *Clark G. Voorhees*
1871–1933. Exh. cat. Old Lyme, Conn.:
Lyme Historical Society, Florence
Griswold Museum, 1981. Page 28.

257 **Clark Greenwood Voorhees** *The Tulip Tree, October (The Tulip Tree; Magnolias, Autumn)*, ca. 1922

FRANK RUSSELL WADSWORTH
(1874–1905)

A River Lavadero, *Madrid*
(*Street in Madrid*), undated

Frank Russell Wadsworth was the son of a prominent Chicago physician.[1] He attended the Art Institute and then studied extensively with William Merritt Chase in New York and abroad. Primarily a landscape painter, Wadsworth exhibited widely beginning in 1896 and won several honors. He had already served on the Art Institute's Jury of Acceptance and its Hanging Committee, a token of his fellow artists' recognition of his precocious talent. Wadsworth's premature death at age thirty-one occurred while he was in Madrid, Spain, as a member of Chase's painting class. The following year the Municipal Art League purchased his *Wharf of Red Boats*, now also in the Club's collection.

The posthumous gift of the artist's mother, *A River* Lavadero, *Madrid* may date to either of Wadsworth's two recorded trips to Spain, in 1896 and in 1905. The Art Institute's 1906 memorial exhibition of the artist's paintings, most of them recently executed Spanish scenes, included a work of this title listed for sale.[2] The Club's painting has long carried the title *Street in Madrid*, although the work clearly depicts a riverside *lavadero*, meaning washhouse or laundry in Spanish.[3] Wadsworth painted several Dutch and Spanish city views that emphasize riverways, but only one title listed among his exhibited works points to the subject depicted here. A possibly related painting, entitled *River Washerwomen, Madrid*, was also shown in the 1906 exhibition.

Wadsworth's portrayal of a commercial laundry takes an unusual view of its mundane subject. The image centers on the brick foundation of a wooden pedestrian bridge that extends beyond the right edge of the picture to the stream's opposite shore. Clumps of spiky greenery nestle against the masonry while the muddy ground, executed in slashing strokes that reveal the influence of Chase, slants precipitously down toward the river below. The laundry's red-roofed building and open shed are seen in the distance, near the high horizon; lines draped with drying white fabric blanket the riverbank while in the right foreground garments hang on wooden framework by the bridge. Almost lost in the crowd of these forms are the figures of two laundresses: one kneels over her washing on the edge of the stream; the other, bearing a basket, crosses the bridge in the upper right corner of the image. Wadsworth's impressionist technique and unorthodox composition impart a sense of spontaneity; the image places the viewer virtually on the spot before its humble subject, while subordinating the representation of physical actuality to formal concerns. WG

Oil on canvas; 30 1/4 x 36 1/4 inches
(76.84 x 92.08 cm.)
Unsigned
Gift of the estate of Sarah F. Wadsworth
UL1940A.4.2

Provenance:
Sarah F. Wadsworth (the artist's mother), to 1926; ULC, 1926

Exhibitions:
"Memorial Exhibition of Works by Frank Russell Wadsworth," AIC, 1906, #297 (as *A River "Lavanders"* [*sic*], *Madrid*)

References:
Loy and Honig. *One Hundred Years*. Page 195.

Martin. *Art in the ULC*. Page 27.

259 **Frank Russell Wadsworth** *A River* Lavadero, *Madrid* (*Street in Madrid*), undated

WILLIAM WENDT
(1865–1946)

*In the Shadow of the Grove
(Sunlight and Shadow)*, 1907

Born in Bentzen, Germany, William Wendt immigrated to the United States at the age of fifteen and worked as a commercial artist in Chicago.[1] He briefly attended classes at the Art Institute but abandoned his studies there as his interest turned to landscape painting, in which he was essentially self-taught.[2] Wendt exhibited actively, winning the Yerkes Prize at the 1893 Chicago Society of Artists exhibition. Between 1896 and 1904, he made several trips to California and England with his friend, painter Gardner Symons.[3] Following his marriage in 1906 to sculptor Julia Bracken, Wendt moved to Los Angeles. The 1906 earthquake and fire that devastated San Francisco and disrupted its art life encouraged the rapid rise of southern California as the setting for impressionist painting. Wendt's move to Los Angeles from Chicago coincided with the region's new popularity. He quickly assumed a leading role in the development of its growing art community and of a dominant impressionist aesthetic informed by the distinctive light and terrain of the "southland." Wendt was a founder of the Painters' Club, renamed the California Art Club in 1909, and he served two terms as the organization's president. In 1912 he settled in Laguna Beach where he was also a founding member of the Laguna Beach Art Association in 1918. Wendt was widely considered the dean of southern California landscape painters; his work, exhibited in New York and Chicago as well as California, received numerous awards.

Wendt typically began and finished even his monumental canvases outdoors and on site. Often empty of people or animals, they express the artist's sense of God's imminence in nature.[4] *In the Shadow of the Grove* represents Wendt's earlier impressionist style, characterized by feathery brushwork with delicate effect and by a varied palette, which he would abandon around 1912 for bolder, blockier forms and a dominance of browns and greens. In this broad, peaceful view of the rolling hills and tall eucalyptus trees so typical of the native landscape of southern California's Pacific coast, the pervading golden light of sunset lends an elegiac note and creates subtle rhythmic patterns of lights and darks over the landscape. For Wendt's public back in Chicago, where the painting was exhibited soon after completion, *In the Shadow of the Grove* offered a vision of an American Arcadia, remote from local urban reality yet increasingly accessible. It bears out a contemporary critical assessment that Wendt's work generally was marked by "dignity and sincerity, a lofty imagination and an individuality, which rank him among the foremost landscape painters in America."[5] WG

Oil on canvas; 40 x 55 1/4 inches
(101.60 x 140.34 cm.)
Signed lower right: William Wendt
UL1907.3

Provenance:
ULC, 1907

Exhibitions:
AIC American Art Annual, 1907, #430

"An Exhibition of Paintings by William Wendt and of Sculptures by Julia Bracken Wendt," AIC, 1909, #28

References:
Loy and Honig. *One Hundred Years.* Page 194, 196.

McCauley. *Catalogue*, 1907, #8.

Walker, John Alan. *Documents on the Life and Art of William Wendt (1865–1946), California's Painter Laureate of the* Paysage moralisé. Big Pine, Calif.: n.p., 1992. Page 157, #317.

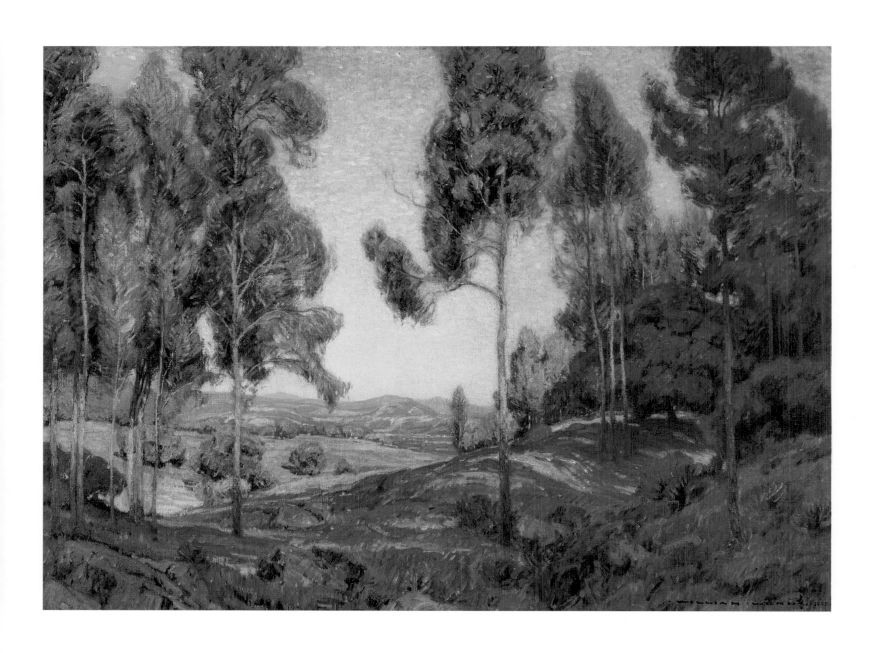

261 **William Wendt** *In the Shadow of the Grove (Sunlight and Shadow)*, 1907

GUY CARLETON WIGGINS
(1883–1962)

Passing Year, 1920

Guy Carleton Wiggins, the most successful of three generations of painters, is best known for his Connecticut landscapes and snowy New York street scenes. Born in Brooklyn, he was the son of John Carleton Wiggins, a prominent painter who had studied with George Inness and who became an active member of the art colony in Old Lyme, Connecticut, after 1905.[1] At the age of eight, the younger Wiggins was already showing signs of following in his father's career, gaining positive notice from New York critics who praised watercolors he made during travels in France and Holland.[2] Despite his evident talent, Wiggins first intended to become an architect, and he briefly enrolled at the Polytechnic Institute in Brooklyn. He then studied painting at the National Academy of Design with William Merritt Chase, the American impressionist, and later with Robert Henri, the urban realist.

Success came early to Wiggins when, at the age of twenty, the Metropolitan Museum of Art acquired one of his paintings for its permanent collection. He was reputed to be the youngest American to be represented in that collection. In 1916, he was elected an associate member of the National Academy of Design and a full academician three years later. In the 1920s, Wiggins began dividing his time between New York and the Connecticut countryside, where he had purchased a farm in Hamburg Cove in Lyme Township in 1920.[3] He remained in Old Lyme until 1937, when he moved to Essex, Connecticut and founded the Guy Wiggins Art School. His continued adherence to impressionism made his work seem outdated after the 1930s, however, and his death, which occurred while vacationing in St. Augustine, Florida, went largely unnoticed.[4]

Although he is probably most identified with his paintings of New York, in fact Wiggins devoted equal attention to rural scenes such as *Passing Year*. He had begun painting the countryside around Old Lyme after his father's move there and devoted even more of his time there after he purchased property. It is probable that *Passing Year* depicts the landscape around his farm. In this work, Wiggins, who always preferred painting autumn and winter scenes, represents the Connecticut countryside at the start of winter. A dusting of snow is visible in the hills, while autumnal colors have the washed-out tones of late fall. The short brushstrokes and heavy impasto reflect the artist's adherence to the impressionist technique he had learned not only from his studies with William Merritt Chase, but also from his acquaintance with impressionists such as Childe Hassam in Old Lyme. Farmhouses are visible in the middle ground of the painting, but it is the natural world, not the civilized one, that dominates, an emphasis typically found in Wiggins's rural landscapes. MR

Oil on canvas; 34 x 40 inches
(86.36 x 101.60 cm.)
Signed lower left: Guy Wiggins
UL1976.55

Provenance:
L. L. Valentine, 1920–?; MAL, ?–1951;
UL C&AF, 1951–1976; ULC, 1976

Exhibitions:
"The Galleries Announce an Exhibition of Recent Paintings by Guy Wiggins, A.N.A.D.," The Galleries at Carson Pirie Scott and Company, Chicago, 1921, #1

AIC American Art Annual, 1921, #207

References:
Loy and Honig. *One Hundred Years*.
Pages 195–96.

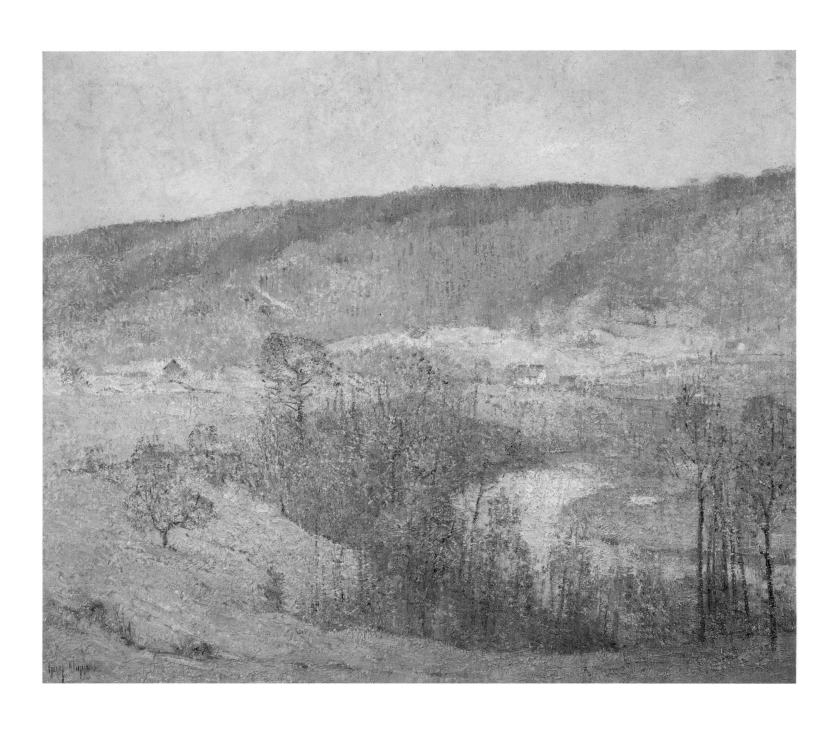

263 **Guy Carleton Wiggins** *Passing Year,* 1920

IRVING RAMSAY WILES
(1861–1948)

The Southwest Wind (The Captain's Daughter),
ca. 1905

Irving Ramsey Wiles was born in Utica, New York, and spent most of his boyhood in New York City.[1] After studying art with his father, landscape painter Lemuel Maynard Wiles, he enrolled at the Art Students League; there his teachers included William Merritt Chase, who became a lifelong friend. In 1882 Wiles went to Europe for two years of study at the Académie Julian and the Académie Colarossi, and in the private studio of the successful portrait painter Carolus-Duran. On his return to New York, he exhibited his oil paintings and watercolors aggressively and also became a successful illustrator for several leading magazines. Wiles won acclaim for his landscape and figure paintings and watercolors, and he was admitted to the National Academy of Design in 1897. But his successful career as a society portraitist was launched with the exhibition of his portrait of actress Julia Marlowe at the National Academy in 1902.

For a decade following his return from France, Wiles joined his father in running the Silver Lake Art School in western New York State. Around 1895, they began conducting summer art classes on the North Fork of eastern Long Island, across the bay from their friend Chase at Shinnecock. Wiles established a summer studio at Peconic, called The Moorings, where he took a respite from the press of portrait commissions to paint landscapes and outdoor figural subjects.[2] He developed a full-blown impressionist style in these works, praised by one critic as "soft and sweet in color full of air and light."[3]

The Southwest Wind appears to have been painted from the artist's summer home, looking south across Peconic Bay toward Shinnecock. Wiles painted several views of small craft on the waters surrounding Long Island, as well as boats and ships at anchor. The artist is said to have made functional ship models for a hobby, perhaps as an aid in painting his marine pictures.[4] This work combines a traditional marine subject with a view of pebbly shore, dock, and beached boats. Introducing an anecdotal note is the figure of a lone woman who wears over her white gown a captain's blue, double-breasted jacket with brass buttons and a red stripe on the sleeve. In reference to the figure, the painting has long borne the title *The Captain's Daughter* in the Club's records. However, examination of the paint surface indicates that Wiles painted in the woman as an afterthought over the image of another boat drawn up on the beach. Loosely executed in the direct, rapid manner typical of Wiles's impressionist technique, *The Southwest Wind* captures the fresh breeze and glaring light of the far Long Island shore. WG

Oil on canvas; 21 1/8 x 27 1/8 inches
(53.66 x 68.90 cm.)
Signed lower right: Irving R. Wiles
UL1905.3

Provenance:
ULC, 1905

Exhibitions:
AIC American Art Annual, 1905 #369

References:
Carroll, Dana. "The Varied Work of Irving R. Wiles." *Arts and Decoration* 1 (Aug. 1911): 403.

Earle. *Biographical Sketches*. Page 340.

Loy and Honig. *One Hundred Years*. Page 196.

McCauley. *Catalogue*, 1907. #5.

Martin. *Art in the ULC*. Pages 41, 48.

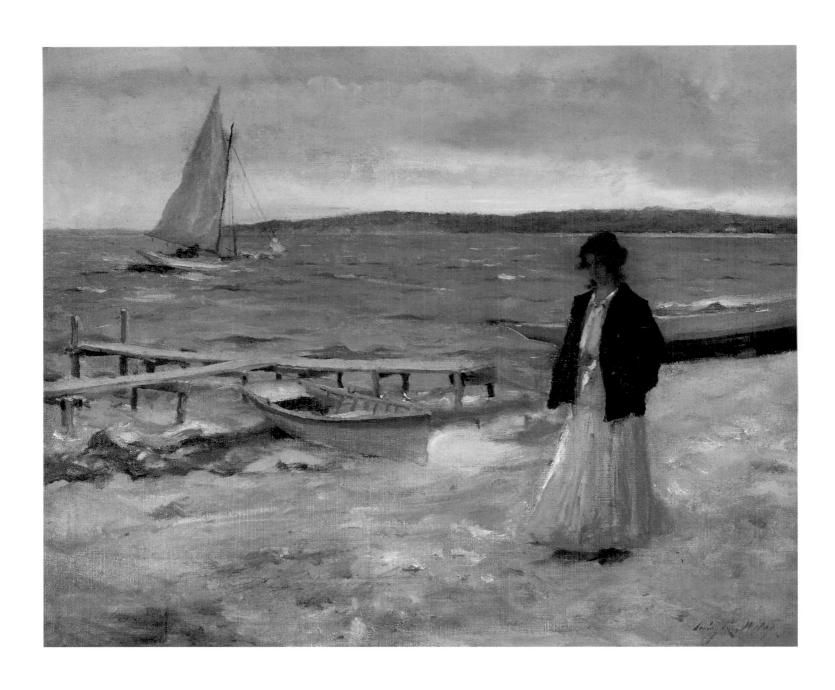

Irving Ramsay Wiles *The Southwest Wind (The Captain's Daughter)*, ca. 1905

RICHARD WILLENBRINK
(b. 1954)

Dwight David Eisenhower, 1990

In 1989, the Union League Club, on the recommendation of its Public Affairs Committee, decided to commemorate the centennial of Dwight David Eisenhower's birth by commissioning an artist to do a portrait of him. A selection committee, composed of members Richard A. Rauch, Robert M. Fitzgerald, and John E. Scully, solicited proposals from five Chicago artists, advising them that Eisenhower could be shown either as president or as supreme commander of Allied Expeditionary Forces. The committee chose Richard Willenbrink, a realist known for monumental figurative work, who wrote that he would depict Eisenhower "in his office with the maps and papers for the Normandy invasion surrounding him I would like to suggest the great weight of this decision upon him. And the awareness that though it is absolutely necessary, many lives will be sacrificed."[1]

Willenbrink, born in Louisville, Kentucky, earned a B. F. A. from the University of Notre Dame in 1976 and an M. F. A. from Northern Illinois University in 1979. After teaching briefly at Sauk Valley College in Dixon, Illinois, he moved to Chicago in late 1979. He began producing large compositions of nudes posed in interiors during the early 1980s. Willenbrink gained important exposure in 1983 when noted Chicago critic and curator Dennis Adrian included his work in the exhibition "Chicago: Some Other Traditions." In the exhibition catalogue, Adrian observed that Willenbrink filled an important void in

Chicago's art community, for no artist had created large-scale figurative work in several decades.[2] Willenbrink began painting still lifes in the mid-1980s. Like his figurative paintings, these works were marked by complex compositions, an intense palette, and painterly brushwork. In 1992, he joined the faculty of the School of the Art Institute of Chicago. In recent years he has lived in Prague, Czechoslovakia.

In the completed portrait of Eisenhower, Willenbrink changed the subject matter to present Eisenhower standing in front of the invasion of Normandy. Since Eisenhower was not physically present at Normandy, the painting is "an allegory of his position as commander and his strength of character."[3] *Dwight David Eisenhower* refers to the work of earlier artists such as Diego Velázquez and Baron Antoine-Jean Gros, who created scenes in the backgrounds of their portraits that alluded to one of the sitter's greatest achievements.

Willenbrink, who works from direct observation, used models as well as a store mannequin dressed in Eisenhower's jacket for *Dwight David Eisenhower*.[4] At the lower left, two soldiers lead the viewer's eye into the painting to their comrades who are invading the beach in the middle ground; the battle rages in the distance. Eisenhower's stance, with one arm placed horizontally across his body, recalls that of Napoleon in portraits by Gros, a visual reference that connects the American hero with great military leaders of the past. MR

Oil on canvas; 66 1/2 x 54 1/8 inches (168.28 x 137.48 cm.)
Signed lower right: Willenbrink '90
UL1991.1

Provenance:
Commissioned by the ULC, 1990

References:
Loy, Dennis. "Richard Willenbrink: Portrait of Dwight D. Eisenhower, 1990." *State of the Union: Official Magazine of the ULC*, 67 (April 1991): 2.

Richter, Marianne. "On the Cover." *State of the Union: Official Magazine of the ULC*, 76 (February 2000): 8.

Richard Willenbrink *Dwight David Eisenhower, 1990*

JAMES WINN
(b. 1949)

Farm Orchard, 1986

James Winn belongs to a group of midwestern artists who have extolled the beauties of prairies and farmlands in their work since the 1970s. Sometimes called "Heartland Painters," they are the artistic descendents of the Luminists, nineteenth-century American landscape painters whose paintings were compositionally similar, featuring a horizontal format and a broad expanse of terrain. Like these earlier artists, Winn, who lives in central Illinois, feels a spiritual connection to the land, valuing the "sense of stillness, of hesitation almost, a feeling of the power and majesty resident in Nature, the mystery of the sublime force which guides the movements of the earth and sky."[1]

It seems appropriate that Winn was born in Hannibal, Missouri, hometown of that great novelist of rural America, Mark Twain. Winn grew up in Metamora, Illinois, home to a community of Mennonites whose spiritual beliefs and ties to the land influenced his own reverential attitude towards nature.[2] After earning B.S. and M.S. degrees from Illinois State University in Normal, Winn returned for an M.F.A. degree, studying with Harold Gregor, the leader of the Heartland Painters. Winn credits his decision to become a landscape painter and the subsequent stylistic direction he chose as having been influenced not only by Gregor, however, but also by his travels in Northern Europe and by the 1980 exhibition at the National Gallery of Art, "American Light," which presented the work of Luminist painters such as John Frederick Kensett and Frederick Church. During his travels, Winn became acquainted with mystical landscape paintings by nineteenth-century Scandinavian and Russian artists, and he experienced the midnight sun in Finland. Drawing inspiration from these varied sources, Winn presents his own vision of the contemporary landscape using a photographically realistic style.

In creating works such as *Farm Orchard*, Winn works both from direct observation of nature and from slides, which he uses to record views that interest him. Using washes of acrylics and watercolors, he begins by painting the sky and then builds up the land mass with a combination of glazes, stains, and opaque colors.[3] Winn prefers to work on paper, wet-in-wet, allowing the pigments to become fully absorbed into the paper to achieve rich, saturated tones. He presents pastoral landscapes in which humans exist peacefully within the natural world, their presence implied rather than shown. In *Farm Orchard*, the Illinois farmhouse is seen at dusk, a time of day Winn finds particularly favorable for reflection and recognition of the divine presence.[4] MR

Acrylic on paper; 19 x 48 inches
(48.26 x 121.92 cm.)
Signed lower right: WINN '86
UL1988.43

Provenance:
ULC, 1987

Exhibitions:
"In a New Light: Three Views from the Heartland," State of Illinois Gallery, Chicago, and Illinois State Museum, Springfield, 1987–1988

"Fifteenth ULC Art Competition & Exhibition," Artemisia Gallery and ULC, 1987, #64

References:
Smith, Kent. *In a New Light: Three Views from the Heartland*. Exh. cat. Springfield, Ill.: Illinois State Museum, 1987, unpaginated [15].

Farm Orchard, 1986

KARL WIRSUM
(b. 1939)

Untitled (Head Study), 1987

Karl Wirsum rose to prominence as a member of the "Hairy Who," a group of young Chicago artists—Art Green, James Falconer, Gladys Nilsson, Jim Nutt, and Suellen Rocca—who exhibited together in the late 1960s. Wirsum, along with the other members of the Hairy Who, became part of the larger Chicago Imagist movement, a term coined by the art historian and critic Franz Schulze. Schulze observed that inspiration for their work typically came from Surrealism and from the imagery of popular culture, and the combination often resulted in "fantastical images" that had a humorous tone.[1]

Wirsum grew up in Chicago, beginning Saturday classes at the School of the Art Institute of Chicago at the age of six. He graduated from the School in 1961 with a B.F.A. Following graduation, Wirsum spent five months in Mexico, an experience that had great impact on his work, as he integrated his formal training with the vivid colors and decorations he had seen on his trip.[2] Upon his return to Chicago, he "made more of a conscious switch to a comic-book style," which has continued to be an integral part of his art.[3] After exhibiting in group exhibitions at the Hyde Park Art Center around 1962, Wirsum was asked by the Center's curator, Don Baum, to participate in the first Hairy Who exhibition, held in 1966.[4] The group exhibited twice more at the Hyde Park Art Center in the 1960s and also exhibited together at the Corcoran Gallery of Art Annex in Washington, D. C.'s Dupont Circle, and at the Gallery of the San Francisco Art Institute. Wirsum joined the faculty of the School of the Art Institute of Chicago in 1974 as a part-time teacher.

Wirsum's paintings, drawings, and three-dimensional works reflect the artist's interest in comic strips and primitive art, as well as an optimistic outlook on life. Of the latter, Wirsum believes that humor is very important and commented once in regard to his work, "There's a lot of sadness in life and we are all subject to it. You can touch on that, but just to stay there, to me, that's not good."[5] Drawing has been a fundamental part of Wirsum's working method in creating paintings and sculpture. Since the 1960s, he has kept sketchbooks, sometimes creating multiple drawings that express the same idea.[6] In addition to preparatory drawings to a painting or three-dimensional work, he also creates drawings that are finished works in themselves.

Wirsum is perhaps best known for complex compositions, but he also creates works in which one image is presented against a plain background.[7] In the Club's untitled drawing, his choice of black paper forms a dramatic contrast with the orange, pink, green, and white Prismacolors. With great economy of line, Wirsum creates a large iconic head, seen from below. Its faint resemblance to both ancient Egyptian images of pharoahs and to the figures carved into Native American totem poles reflects the artist's interest in world cultures and gives this work great visual impact. MR

Prismacolor pencil on black paper;
15 3/4 x 19 inches (40.01 x 48.26 cm.)
Unsigned
Gift of James P. Meyer, 1988
UL1988M.92

Provenance:
James P. Meyer, 1988; ULC, 1988

271　**Karl Wirsum**　　　　　　　　*Untitled (Head Study),* 1987

ALEXANDER HELWIG WYANT
(1836–1892)

Autumn (*Evening–Autumn*), undated

Alexander Helwig Wyant was born in rural eastern Ohio and began his career as a sign painter.[2] A visit to an exhibition in Cincinnati, where he was especially impressed by the work of George Inness, inspired Wyant to become a fine artist. After seeking the advice of Inness, he appears to have received some artistic instruction in both New York and Cincinnati. In 1863 Wyant began exhibiting at the National Academy of Design; two years later he traveled to Europe for further training, returning to New York in 1866. Wyant was active in the American Watercolor Society (of which he was a founding member) and the Society of American Artists; he was elected a full member of the National Academy in 1869. On a government-sponsored expedition to the Far West in 1873, Wyant suffered a paralyzing stroke that forced him to learn to paint with his left hand. He continued to exhibit, however, and he also took on several pupils. Beginning in the mid-1870s, he painted for much of the year in the Adirondack Mountains, moving in 1889 to the Catskills. For several decades after his death Wyant was regarded as one of America's greatest landscape painters.

In the late 1860s, under the influence of the Barbizon school of French painters, English romantic painter John Constable, and George Inness, Wyant began to abandon the tightly executed, detailed, panoramic approach of his early career. His shift toward a freer, more atmospheric style was accelerated partly by the effects of illness, which confined him to smaller canvases. Wyant's tonalist mature work, like that of Inness, presents an intimate view of nature, expressing a mood of serene introspection rather than describing the physical reality of the natural world.

Both the Catskill and the Adirondack mountains were favorite settings for the work of the Hudson River school, which dominated American landscape painting in the middle decades of the nineteenth century. Although Wyant, too, painted in those regions, their unique wilderness character is downplayed in his later landscape paintings, to which he usually assigned correspondingly generic titles. The Club's *Autumn*, which probably dates to the artist's years in the Catskills, is a typically generalized image: a calm, even static view that only hints in the faint distance at the gentle rise of hills beyond a sunlit lake. An empty field and bordering trees are rendered in softly blurred strokes of subdued browns and greens, Wyant's characteristic palette. *Autumn* demonstrates the qualities that won the artist plaudits for the "subtle, serene and illusive [sic] spirit which we can best hint at by the word charm."[3] WG

Oil on canvas; 21 x 31 1/2 inches
(53.34 x 80.01 cm.)
Signed lower left: H W Wyant
UL1895R.18

Provenance:
The artist's estate, to 1894;
ULC, 1895[1]

Exhibitions:
"American Art in the Union League Club
of Chicago, A Centennial Exhibition,"
traveling exhibition organized by the
ULC, 1980–1981

References:
Corliss. *Catalogue*, 1899. Page 16, #44.

Loy and Honig. *One Hundred Years.*
Pages 12–13.

McCauley. *Catalogue*, 1907. #30.

Martin. *Art in the ULC.* Page 48.

273 **Alexander Helwig Wyant** *Autumn (Evening–Autumn)*, undated

RAY YOSHIDA
(b. 1930)

Learned Limbed Ladder, 1981

As both an artist and a teacher, Ray Yoshida has been one of the most significant forces in the Chicago art community since the 1960s. The seventh of eight children, Yoshida was born in Kapàa on the Hawaiian island of Kauài to a father who had emigrated from Hiroshima and to a mother whose father had also emigrated from Hiroshima.[1] Yoshida attended the School of the Art Institute of Chicago, graduating in 1953 with a degree in art education, and he earned an M.F.A. from Syracuse University in 1958. The following year, he was appointed to the faculty of the School of the Art Institute, a position he held until his recent retirement. His teaching inspired and influenced numerous students, including many of the Chicago Imagists. Yoshida's students recall his practice of taking them with him on his frequent forays into flea markets and antique shops where he sought "trash treasures."[2] In so doing, he encouraged them to look at the ways in which both design and technical problems were solved in these populist forms of visual expression, a habit he himself practiced.

Yoshida's work has gone through a number of distinct phases: collages that used images from comic books; "bathrobe pictures," which featured faceless robed figures made of vertical bands; and, in the mid-1990s, a series that focused on images of automobiles. *Learned Limbed Ladder* dates to the early 1980s, a time when the artist created vibrantly colored large-scale images of static figures shown in profile or directly confronting the viewer.[3] Georges Seurat was a source of inspiration for Yoshida's paintings of this period. In works such as *A Sunday on La Grande Jatte*, one of the masterpieces in The Art Institute of Chicago's collection, Yoshida saw the successful solution to a formal problem that intrigued him, namely, "the coexistence of the INERT—figures frozen stiffened as though holding still for a snapshot the FRENETIC surrounding areas."[4] *Learned Limbed Ladder* demonstrates Yoshida's own approach to this problem. Four figures, two men and two women, are placed in a friezelike procession across the canvas. The figures of the women, shown in profile, and the smaller man are immobile, yet their jagged contour lines and the purposefully busy quality of both their bodies and the background make them appear to be full of repressed energy.[5] In contrast to their fixed poses, the second male figure ascends an invisible staircase, while the pair of "limbed" ladders also suggests movement. Yoshida's use of strong outlines and vibrant colors, as well as his simplification of detail, superficially resemble the stylistic characteristics of comic book illustrations. Varied visual sources, the result of Yoshida's remarkably far-flung interests, combine in *Limbed Learned Ladder* to create a stylistically distinctive work that is ultimately most indebted to the artist's personal vision. MR

Acrylic on canvas;
36 x 60 inches (91.44 x 127 cm.)
Unsigned
UL1991.5

Provenance:
Borg-Warner Collection, ?–1991;
ULC, 1991

Exhibitions:
"Ray Yoshida: A Review," N.A.M.E. Gallery, Chicago, 1984, #37

"Ray Yoshida: A Retrospective 1968-1998," traveling exhibition organized by The Contemporary Museum, Honolulu, Hawaii, 1998, #27

References:
Adrian, Dennis. *Ray Yoshida: A Review.* Exh. cat. Chicago:N.A.M.E. Gallery, 1984. Pages 17, 31.

Selections from the Borg-Warner Corporate Collection of Art. Chicago: Borg-Warner Corporation, ca. 1985–1986. Page 28.

Jensen, James. *Ray Yoshida: A Retrospective 1968–1998.* Exh. cat. Honolulu, Hawaii: The Contemporary Museum, 1998. Pages 25, 84.

NOTES

Adam Emory Albright

1 Gardner Teall, "The Sunny Years: Illustrated by Adam Emory Albright's Paintings of Childhood," *The Craftsman* 19 (November 1910): 148.

2 Background information about Albright can be found in the following sources: Adam Emory Albright, *For Art's Sake* (Chicago and Crawfordsville, Ind.: The Lakeside Press and R. R. Donnelly and Sons Company, 1953); Adam Emory Albright, "Outdoor Painting," *Palette and Bench* 1 (August 1909): 238–42; E. O. Laughlin, "Albright, Painter of Child-Life," *The Interior*, Nov. 27 1902: 1530–32; Henry E. Willard, "Adam Emory Albright, Painter of Children," *Brush and Pencil* 12 (April 1903): 1–3.

3 See the Ivan Albright Collection at the Ryerson & Burnham Libraries Archives, AIC, E28086. The photograph was taken ca. 1901.

4 Albright studied with Benjamin Constant in Paris and Carl Marr in Munich.

5 Obituary, "Adam Albright, 95, Artist in Chicago,"*New York Times*, September 15, 1957.

Ivan Le Lorraine Albright

1 Biographical information has been derived from Michael Croydon, *Ivan Albright* (New York: Abbeville Press, 1978); Courtney Graham Donnell, Susan S. Weininger and Robert Cozzolino, *Ivan Albright*, exh. cat. (Chicago: AIC, 1997).

2 Michael Croydon, *Ivan Albright*, 252.

3 Katherine Kuh, "Ivan Albright," in *The Artist's Voice: Talks with Seventeen Artists* (New York: Harper & Row, 1960), 33.

4 Kuh, "Ivan Albright," 25.

Charles Dudley Arnold

1 Information on Arnold is taken from "C. D. Arnold of Pan-American Art Fame Dies," *Buffalo Courier Express*, May 9, 1927, and Peter B. Hales, *Constructing the Fair: Platinum Photographs by C. D. Arnold of the World's Columbian Exposition*, exh. cat. (Chicago: AIC, 1993), 5.

2 For a summary of photography at the fair see Peter B. Hales, *Silver Cities: The Photography of American Urbanization, 1839–1915* (Philadelphia: Temple University Press, 1984), 134–53; James Gilbert, "Fixing the Image: Photography at the World's Columbian Exposition," in Neil Harris, Wim de Wit, James Gilbert, and Robert W. Rydell, *Grand Illusions: Chicago's World's Fair of 1893*, exh. cat. (Chicago: Chicago Historical Society, 1993), 99–132; and Julie K. Brown, *Contesting Images: Photography and the World's Columbian Exposition* (Tucson: University of Arizona Press, 1994).

3 Hales, *Silver Cities*, 135, 141.

John James Audubon

1 For an overview of Audubon's life and career and a bibliography, see Amy Meyers, "Audubon, John James (Laforest)" in *The Dictionary of Art* (London: Macmillan Publishers Limited, 1996), 2: 709–10.

2 Audubon quoted in Lois Elmer Bannon and Taylor Clark, *Handbook of Audubon Prints* (Gretna, La.: Pelican Publishing Company, 1980), 18.

3 Plate LXXVI shows an immature red-shouldered hawk attacking a covey of northern bobwhite; plate LXXI shows a young red-shouldered hawk (erroneously identified by Audubon as a "Winter Hawk") grasping a large bullfrog in a death-grip. Annette Blaugrund and Theodore E. Stebbins, Jr., eds., *John James Audubon: The Watercolors for The Birds of America* (New York: Villard Books, Random House, Inc., 1993), 46–47, 149–51, 309.

4 Bannon and Clark, 93.

5 Audubon, *Ornithological Biography*, excerpted in Alice Ford, ed., *The Bird Biographies of John James Audubon* (New York: The Macmillan Company, 1957), 100.

Martha Susan Baker

1 Obituary notice, *Bulletin of The Art Institute of Chicago* 5 (April 1912): 54. Biographical information has been derived from the above citation, as well as from *A Memorial Exhibition of Works of the Late Martha S. Baker at The Art Institute of Chicago*, exh. cat. (Chicago: AIC, 1912), unpaginated; M. J. G. O., "Studio-Talk," *International Studio* 21 (November 1903-February 1904): 85–86.

2 L. M. McCauley, "Chicago's Municipal Art Gallery," *Fine Arts Journal* 23 (September 1910): 141.

3 *A Memorial Exhibition of Works of The Late Martha S. Baker*," [1-2].

Robert Barnes

1 Leah Stoddard, "Blood, Paint, and Perfume," *Arts Indiana* 17 (March 1995): 24. The article is the author's interview with Barnes. Biographical information on Barnes is derived from Dennis Adrian, *Robert Barnes 1956–1984: A Survey*, exh. cat. (Madison, Wis.: Madison Art Center, 1985) and Michael Allen Rooks, "Allusion and Metaphor in Robert Barnes's *Arthur Craven Still Lives*," (Master's thesis, School of the Art Institute of Chicago, 1995).

2 Rooks, "Allusion and Metaphor," 5.

3 Rooks, "Allusion and Metaphor," 5.

4 Stoddard, "Blood, Paint, and Perfume," 24–25.

5 Adrian, *Robert Barnes*, 8.

6 As quoted in Stoddard, "Blood, Paint, and Perfume," 25.

Frederic Clay Bartlett

1 For information on Bartlett see his *Sortofa Kindofa Journal of My Own* (Chicago: Lakeside Press, 1965) and Erne R. and Florence Frueh,"Frederic Clay Bartlett: Chicago Painter and Patron of the Arts," *Chicago History* 8 (Spring 1979): 16–19.

2 Karl Baedeker (firm), *Southern France Including Corsica*, 4th ed. (Leipzig: K. Baedeker, 1902): 429. Martigues was especially famous as the residence of painter Félix Ziem.

3 The precise setting and direction of the view is unclear. Either the Etang de Berre or the Etang de Coronte, a bay on the sea-side of the isthmus on which the village is situated, may be pictured. Equally ambiguous is the meaning of the sudden shift in the color of the water, where no land seems to divide it into two separate bodies.

4 Marcel Brion, *Provence*, trans. and adapted by S. G. Colverson (London: Nicholas Kaye, 1954): 185, 188.

5 Unidentified article from *Chicago Record Herald*, inscribed Dec. 24, 1905, in AIC Scrapbooks, vol. 21, Ryerson & Burnham Libraries, AIC, microfilm.

6 Contemporary reviewer quoted in Frueh, "Frederic Clay Bartlett," 17.

Don Baum

1 Biographical information is derived from Sue Taylor, *Don Baum: Domus*, exh. cat. (Madison, Wis.: Madison Art Center, 1988), 10–12 and Lynn Warren et al., *Art in Chicago 1945–1995*, exh. cat. (Chicago: Museum of Contemporary Art, 1996), 244.

2 The information about Baum's interest in the concept of shelter and in Montaillou comes from Taylor, *Don Baum*, 10–12. See also Emmanuel Le Roy Ladurie, *Montaillou, village occitan de 1294 à 1324* (Paris: Gallimard, 1975).

George Bellows

1 Forbes Watson, "George Bellows," *The Arts* 7 (January 1925): 4. This essay originally appeared in the *New York World*.

2 Biographical information about Bellows has been drawn from Margaret C. S. Christman, *Portraits by George Bellows*, exh. cat. (Washington, D.C.: Published for the National Portrait Gallery, Smithsonian Institution, by the Smithsonian Institution Press, 1981); Michael Quick, Jane Myers, Marianne Doezema, and Franklin Kelly, *The Paintings of George Bellows*, exh. cat. (Los Angeles: Los Angeles County Museum of Art; Fort Worth: Amon Carter Museum; New York: Harry N. Abrams, Inc., Publishers, 1992).

3 Quick, Myers, Doezema, and Kelly, *The Paintings of George Bellows*, 39.

4 Quick, Myers, Doezema, and Kelly, *The Paintings of George Bellows*, 172.

Louis Betts

1 W. H. de B. Nelson, "A Painter's Painter: Louis Betts," *The International Studio* 64 (May 1918): 78.

2 Background information about Betts can be found in the following sources: James William Pattison, "Louis Betts—Painter," *The Sketch Book* 6 (December 1906): 171–80; Gerdts, *Art Across America* 2: 312; Nelson, "A Painter's Painter," 71, 78.

3 For a discussion of the conservative taste of Chicago and Pattison's support of the Armory Show when it was displayed at The Art Institute of Chicago, see Neil Harris, "The Chicago Setting," in *The Old Guard and the Avant-Garde*, ed. Sue Ann Prince (Chicago and London: The University of Chicago Press, 1990), 3–22. Pattison is mentioned on page 17.

4 Pattison, "Louis Betts—Painter," 178.

5 Lena M. McCauley, "An Appreciation of Louis Betts," *Art: A Monthly Magazine* 1 (April 1913): 90.

Kathleen Blackshear

1 Biographical information is taken from C. J. Bulliet, "Artists of Chicago Past and Present: No. 97 Kathleen Blackshear," *Chicago Daily News*, July 29, 1939 and Norman Rice, Margaret T. Burroughs, and Carole Tomollan, *A Tribute to Kathleen Blackshear*, exh. cat. (Chicago: The Betty Rymer Gallery at the School of the Art Institute of Chicago, 1990).

2 Rice, Burroughs, and Tomollan, *Kathleen Blackshear*, 33.

Harriet Blackstone

1 Harriet Gambert Higgins, "An Afternoon with Some Well-Known Chicago Artists," *Woman's Civic Magazine*, December 1915, 14.

2 Biographical information is taken from Mary S. Dangremond, *A Mystical Vision: The Art of Harriet Blackstone, 1864–1939*, exh. cat. (Bennington, Vt.: The Bennington Museum, 1984); Giselle d'Unger, "Harriet Blackstone: Portrait Painter," *Fine Arts Journal* 26 (February 1912): 97–101.

3 d'Unger, "Harriet Blackstone," 100.

Marie Elsa Blanke

1 C. J. Bulliet, "Artists of Chicago Past and Present: No. 43 Marie Elsa Blanke," *Chicago Daily News*, December 14, 1935.

2 Jane Purse, "Jane Heap: The Early Chicago Years," (unpublished manuscript, special collections, Morris Library, University of Delaware, undated), 1. See also Holly A. Baggett, ed., *Dear Tiny Heart: The Letters of Jane Heap and Florence Reynolds* (New York: New York University Press, 2000), 9–10. *The Little Review* (1914–1929), for which Heap shared editorial duties with Margaret Anderson, published the work of authors and poets such as James Joyce, Ezra Pound, and Gertrude Stein. It was an advocate for feminism, anarchism, and radical art movements such as Dadaism and Surrealism (p. 2).

3 Irene Powers, "Hail Artist at Exhibit in Cordon," *Chicago Tribune*, February 2, 1962.

4 "Report of Art Committee," *Union League Club of Chicago Annual Report* (Chicago: ULC, 1900), 45.

Edwin Howland Blashfield

1 Edwin Blashfield, Letter of January 25, 1926, to Club president William J. Jackson, curatorial file UL 1926.1, ULC.

2 Biographical information about Blashfield has been drawn from Leonard N. Amico, *The Mural Decorations of Edwin Howland Blashfield (1848–1936)*, exh. cat. (Williamstown, Mass.: Sterling and Francine Clark Art Institute, 1978); Edwin H. Blashfield, *Mural Painting in America: The Scammon Lectures* (New York: Charles Scribner's Sons, 1913); Karen Zukowsky, "Edwin Blashfield," in Annette Blaugrund, Albert Boime, D. Dodge Thompson, H. Barbara Weinberg, and Richard Guy Wilson, *Paris 1889: American Artists at the Universal Exposition*, exh.cat. (Philadelphia and New York: Pennsylvania Academy of the Fine Arts and Harry N. Abrams, Inc. Publishers, 1989), 114–15; and Royal Cortissoz, *The Works of Edwin Howland Blashfield* (New York: Charles Scribner's Sons, 1937).

3 Amico, *The Mural Decorations*, 7.

4 Zukowsky, "Edwin Blashfield," 115.

5 "Mural Vividly Portrays the Union League Spirit," *Union League Club Bulletin* 3 (October 1926): 5.

6 William J. Jackson, "'Patria' Symbol of the Union League Spirit," *Union League Club Bulletin* 5 (December 1928): 11. These architectural decorations were painted over a number of years ago; recently discussions have begun regarding the possibility of uncovering them.

7 Percy B. Eckhart, "The Art Committee," *Union League Club of Chicago Annual Report* (Chicago: ULC, 1929), 37.

Albert Bloch

1 "Albert Bloch," *Chicago Illustrated Post*, September 12, 1922.

2 Henry Adams, Margaret C. Conrads, and Annegret Hoberg, *Albert Bloch: The American Blue Rider*, exh. cat. (Munich and New York: Prestel-Verlag, Munich in association with the Nelson Gallery Foundation and Stadtische Galerie im Lenbachhaus, 1997), 71. This is the most complete source of information about Bloch and has been used for the biographical background on the artist.

3 Adams, Conrads, and Hoberg, *Albert Bloch*, 74.

Jessie Arms Botke

1 The most complete source of information on Jessie Arms Botke is Patricia Trenton and Deborah Epstein Solon, *Birds, Boughs, & Blossoms: Jessie Arms Botke (1883–1971)*, exh. cat. (Carmel, Calif.: William A. Klarges Fine Art, 1995). See also Patricia Trenton, ed., *Independent Spirits: Women Painters of the American West, 1890–1945*, exh. cat. (Berkeley, Calif.: Autry Museum of Western Heritage in association with University of California Press, 1995): 52–56, 59–61. I am grateful to Patricia Trenton and to Maureen Murphy for their insights into this painting.

2 Botke quoted in "Jessie Arms Botke: A Painting Career That Has Revolved Around Peacocks," *American Artist* 13 (June 1949): 27.

3 Trenton, ed., *Independent Spirits*, 56.

4 Jessie Arms Botke to Edward Sunny, Santa Paula, California, May 20, 1950, curatorial file UL1949.1, ULC. In this letter Botke described the Mandarin ducks as "look[ing] exactly as if they were toys carved out of wood and painted," and noted that she had quickly adopted them as her "mascot."

Nicholas Richard Brewer

1 On Brewer see his autobiography, *Trails of a Paintbrush* (Boston: The Christopher Publishing House, 1938); "N. R. Brewer, Painted Notables' Portraits," *The New York Times*, February 16, 1949; Rena Neumann Coen, *Painting and Sculpture in Minnesota 1820–1914* (Minneapolis: University of Minnesota Press, 1976), 78; and Charles P. Helsell, *Made in Minnesota I: Art at 3M by Artists Born before 1930* (Saint Paul, Minn.: 3M Corporate Art Program, 1997), 8.

2 "Nicholas Brewer," *Chicago Evening Post*, Oct. 11, 1921.

3 Brewer, *Trails of a Paintbrush*, 216.

4 Brewer, *Trails of a Paintbrush*, 224.

5 Marguerite B. Williams, "Work of American Artist," *Chicago Daily News*, Sept. 3, 1921.

6 Unidentified critic quoted in Brewer, *Trails of a Paintbrush*, 217.

7 Brewer, *Trails of a Paintbrush*, 217–18. Brewer noted that he had maintained a studio in Chicago for five years and had spent two winters there with his wife. He was also a member of the Chicago Society of Artists—ironically, the body that had complained to the Municipal Art League that the organization's purchase prize had been awarded to a nonresident, and therefore ineligible, artist.

Frederick Arthur Bridgman

1 Susan James-Gadzinski, "Frederick Arthur Bridgman (1847–1928)," in Annette Blaugrund, Albert Boime, D. Dodge Thompson, H. Barbara Weinberg, and Richard Guy Wilson, *Paris 1889: American Artists at the Universal Exposition*, exh. cat. (Philadelphia and New York. Pennsylvania Academy of the Fine Arts; Harry N. Abrams, Inc., Publishers, 1989), 122. Information about Bridgman is taken from Holly Edwards, Brian T. Allen, Steven C. Caton, Zeynap Calik, and Oleg Grabar, *Noble Dreams, Wicked Pleasures: Orientalism in America, 1870–1930* (Princeton, N. J.: Princeton University Press in association with the Sterling and Francine Clark Art Institute, 2000); James-Gadzinski, "Frederick Arthur Bridgman," 122–124.

2 Montezuma (pseud.), "My Note Book," *Art Amateur* 12 (January 1885): 28.

Fritzi Brod

1 C. J. Bulliet, "Artists of Chicago, Past and Present: No. 74 Fritzi Brod," *Chicago Daily News*, August 1, 1936.

2 Bulliet, "Artists of Chicago."

3 Peter Hastings Falk, ed., *Annual Exhibition Record of the Art Institute of Chicago, 1888–1950* (Madison, Conn.: Sound View Press, 1990), 152.

4 She was the subject of a 1935 *Wisconsin News Gazette* article entitled "Nude Art Picture Displayed, Vulgarity Charged: One-Man Show Meets with Disapproval at the Art Institute," *Wisconsin News Gazette*, January 21, 1935 in Brod Papers, Archives of American Art, Washington, D.C.

5 Bulliet, "Artists of Chicago."

Roger Brown

1 Sidney Lawrence and John Yau, *Roger Brown*, exh. cat. (New York and Washington, D.C.: George Braziller in association with the Hirschhorn Museum and Sculpture Garden, Smithsonian Institution, 1987), 104. Biographical information about Brown has been largely drawn from this catalogue. Other sources include Ken Johnson, "Other Vision: The Art of Roger Brown," *Arts Magazine* 64 (December 1987): 61–63; Roger Brown, "Rantings and Recollections," in Tony Knipe, *Who Chicago? An Exhibition of Contemporary Imagists*, exh. cat. (Sunderland, England: Ceolfrith Gallery, Sunderland Arts Center, 1980).

2 Lawrence and Yau, *Roger Brown*, 105.

3 Lawrence and Yau, *Roger Brown*, 11.

4 "A Talking Profile of the Artist," interview with Brown by Phyllis Kind, Ray Yoshida, Donald L. Baum, and Dennis Adrian, in Lawrence and Yau, *Roger Brown*, 94.

Charles Francis Browne

1 A brief biography of Browne is given in James William Pattison, "The Art of Charles Francis Browne," *The Sketch Book* 5 (Jan. 1906): 190–207; see also Gerdts, *Art Across America*, 2:305-6.

2 On Browne as an advocate for local subject matter see William H. Gerdts, *American Impressionism* (New York: Abbeville Press, 1984), 144–45.

Claude Buck

1 Information on Buck is taken from Paul J. Karlstrom, *Claude Buck: American Symbolist 1890–1974*, exh. cat. (San Francisco: Glastonbury Gallery, 1983); see also "First One-Man Show by Artist Claude Buck in Santa Cruz Is Opened," *Santa Cruz Sentinel-News*, May 2, 1954 (New York Public Library Artists Files on microfiche).

2 Edward Alden Jewell, "Claude Buck Gives One-Man Art Show," *The New York Times*, Dec. 10, 1940.

3 Marguerite B. Williams, "Portrait of an Artist Who Makes Fiction Come True," *Chicago Daily News*, July 24, 1929.

4 "First One-Man Show;" I. K., "Mr. Claude Buck," *The Christian Science Monitor*, Mar. 12, 1932.

5 I. K., "Mr. Claude Buck." Buck's *Girl Reading* was reproduced on the front cover of Josephine Hancock Logan's 1937 book *Sanity in Art*, the bible of Logan's antimodernist crusade, which Buck actively supported.

6 Fred Koch-Wawra, "A New Force in American Art," *The American Art Student* 10 (Dec. 1926): 69.

7 Williams, "Portrait of an Artist."

Karl Albert Buehr

1 Information on Buehr is taken from Sparks, "Biographical Dictionary," 1: 310–11; Gerdts, *Art Across America*, 2: 316; and the website of the Illinois Historical Art Project, www.illinoisart.org (consulted Dec. 14, 2000). See also Kathleen B. Granger, "My Most Unforgettable Character," *Reader's Digest* 94 (April 1969): 88–92.

2 M. B. W. [Marguerite B. Williams], "Karl Buehr's New Picture," *Chicago Daily News*, Feb. 2, 1924.

3 Mary Kathleen Buehr exhibited in Chicago exhibitions between 1924 and 1942 under her maiden name and under her married name of Kathleen Granger. She died in 1952. See Peter Falk, ed., *Who Was Who in American Art 1546–1975: 400 Years of Artists in America* (Madison, Conn.: Sound View Press, 2000), 2: 1346. Kathleen Buehr's date of birth is given in "Study Guide—Revised 1994—for the Nettie J. McKinnon Art Collection," 23–24, typescript on deposit in the files of the Nettie J. McKinnon Art Collection, Ogden School, La Grange, Ill. I am grateful to Sharon Flaim for access to the McKinnon Art Collection and its files.

4 M. B. W., "Karl Buehr's New Picture."

5 M. B. W., "Karl Buehr's New Picture."

6 The painting's title, given in quotes in the AIC's exhibition catalogue, suggests a literary source, but none has been identified.

Edward Burgess Butler

1 For information on Butler see Percy B. Eckhart, "Edward B. Butler, Citizen and Artist," *Union League Club Bulletin* 5 (Nov 1928): 8–9; Paul Gilbert and Charles Lee Bryson, *Chicago and Its Makers* (Chicago: Felix Mendelsohn Publisher, 1929), 852; and Peter Falk, ed., *Who Was Who in American Art 1546–1975: 400 Years of Artists in America* (Madison, Conn.: Sound View Press, 2000), 1: 526.

2 Gilbert and Bryson, *Chicago and Its Makers*, 852.

3 C. J. Bulliet, "Artists of Chicago Past and Present: No. 5 Frank Charles Peyraud," *Chicago Daily News*, Mar. 23, 1935.

4 Janice Harmer and Miriam Lorimer, Chronology in *Frank C. Peyraud: Dean of Chicago Landscape Artists*, exh. cat. (Peoria, Ill.: Lakeview Museum of Arts and Sciences, 1985), n.p.

5 See "E. B. Butler Dead," *Art Digest* 2 (Mar. 1, 1928): 4.

6 Nicholas R. Brewer, *Trails of a Paintbrush* (Boston: The Christopher Publishing House, 1928), 256. Brewer notes that Butler's studio was near that of Alson Skinner Clark. The setting as it appeared at the time is evident in a photographic view of Clark's home and studio reproduced in Patricia Trenton and William H. Gerdts, eds., *California Light 1900–1930*, exh. cat. (Laguna Beach, Calif.: Laguna Art Museum, 1990), 129, fig. 135.

Alson Skinner Clark

1 Clark's career is detailed in Jean Stern, *Alson S. Clark* (Los Angeles: Petersen Publishing Company, 1983); see also Jean Stern, "Alson Clark: An American at Home and Abroad," in Paticia Trenton and William H. Gerdts, eds., *California Light 1900–1930*, exh. cat. (Laguna Beach, Calif.: Laguna Art Museum, 1990), 113–36.

2 Stern, "Alson Clark," 121.

Ralph Elmer Clarkson

1 For information on Clarkson see James W. Pattison, "Ralph Clarkson," *The Sketch Book* 5 (Dec. 1905): 151–58; C. J. Bulliet, "Artists of Chicago Past and Present: No. 10 Ralph Elmer Clarkson," *Chicago Daily News*, April 27, 1935; and Kenneth Hay, "Ralph Clarkson: An Academic Painter in an Era of Change," *Journal of the Illinois State Historical Society* 3 (Autumn 1983): 177–94.

2 Clarkson is also credited with compiling the first history of art in Chicago, his "Chicago Painters Past and Present" in "Chicago as an Art Center," a special issue of the journal *Art and Archaeology* 12 (Sept.–Oct. 1921): 129–43.

3 The Club's other Lincoln portrait, by John Doctoroff, did not enter the collection until 1959, the sesquicentennial of Lincoln's birth.

4 The photograph is one of a group of five taken at one sitting, traditionally dated to about April 10, 1865, five days before Lincoln's assassination. However, other evidence suggests instead that the sitting took place on February 5, 1865. For a detailed explanation, see James Mellon, comp., *The Face of Lincoln* (New York: The Viking Press, 1979), 184–85, 201.

Walter Marshall Clute

1 L. M. McCauley, "Art and Artists," *Chicago Evening Post*, April 15, 1911.

2 Brief information about Clute may be found in *Catalogue of the Fifth Annual Exhibition of Selected Paintings by American Artists*, exh. cat. (Buffalo, N.Y.: Buffalo Fine Arts Academy and Albright Art Gallery, 1910), 21; see also Sparks, "A Biographical Dictionary," 1: 335, and Gerdts, *Art Across America*, 2: 312.

3 The exact years of Clute's stay in Paris are unknown. Gerdts, *Art Across America*, 2: 312.

4 The other works in the series, both unlocated, seem to have been painted around the same time as *The Golden Age*. *The Child in the House—Another Morning* was exhibited in the fifteenth annual exhibition of the Society of Western Artists in 1911 and is illustrated in the catalogue of the City Art Museum of St. Louis venue. *The Child in the House—The Little Room* was included in Clute's 1911 solo exhibition at the Chicago Academy of Fine Arts.

5 McCauley, "Art and Artists."

6 For an overview of the theme of women reading in American art see H. Barbara Weinberg, Doreen Bolger, and David Park Curry, *American Impressionism and Realism: The Painting of Modern Life, 1885–1915*, exh. cat. (New York: The Metropolitan Museum of Art, 1994), 251–57.

William Cogswell

1 Information on Cogswell is taken from George C. Groce and David H. Wallace, *The New-York Historical Society's Dictionary of Artists in America 1564–1860* (New Haven and London: Yale University Press, 1957), 136, and Sparks, "A Biographical Dictionary," 1: 337. I am grateful to David Meschutt for additional information about Cogswell's portraits of Grant.

2 In addition, Cogswell painted a portrait of Grant and his family, now in the National Museum of American History.

3 *Spirit of the Union League* (Chicago: ULC, 1926), 117–18.

William Conger

1 Victor Cassidy, "William Conger's Summer of Paper," *Artnet.com Magazine* (http://www.artnet.com/magazine/features/cassidy/cassidy3-4-98).

2 Mary Matthews Gedo, "Abstractions as Metaphors: The Evocative Imagery of William Conger, Miyoko Ito, Richard Loving, and Frank Piatek," *Arts Magazine* 57 (October 1982): 112.

3 Cassidy, "Summer of Paper."

4 For his most recent review, see Kristen Brooke Schleifer, "William Conger," *Art News* 99 (December 2000): 163.

5 Mary Matthews Gedo, "William Conger," in *Painting at Northwestern: Conger, Paschke, Valerio*, exh. cat. (Evanston, Ill.: Mary and Leigh Block Gallery, Northwestern University, 1986), 8.

Leonard Crunelle

1 On Crunelle's early career see Isabel M'Dougall, "Leonard Crunelle— From Coal Miner to Sculptor," *Chicago Record Herald*, Feb. 24, 1907, and Christine Bennett, "Leonard Crunelle, A Sculptor of Youth," *Arts and Decoration* 1 (Aug. 1911): 406 .

2 Ira J. Bach and Mary Lackritz Gray, *A Guide to Chicago's Public Sculpture* (Chicago: The University of Chicago Press, 1983), 24.

3 Lorado Taft, *The History of American Sculpture*, 2nd ed. rev. (New York: Macmillan, 1924), 583.

4 Bach and Gray, *A Guide to Chicago's Public Sculpture*, 23.

5 M'Dougall, "Leonard Crunelle—From Coal Miner to Sculptor."

6 An unidentified newspaper article marked *Chicago Post*, May 12, 1908, in AIC Scrapbooks, vol. 24, on microfilm, Ryerson & Burnham Libraries, AIC, notes two copies of the sculpture: one purchased by the MAL, evidently the version now at the Cliff Dwellers Club, and a "replica secured at the same time by the Union League Club." The Art Institute's copy was accessioned in 1909.

7 Jane Bassett and Peggy Fogelman, *Looking at European Sculpture: A Guide to Technical Terms* (Los Angeles: J. Paul Getty Museum, 1997), 34.

Charles W. Dahlgreen

1 Charles Dahlgreen, "Autobiography," undated MS, pp. 197–98, in Charles Dahlgreen Papers, Archives of American Art, Smithsonian Institution, microfilm reel 3954, 12–13.

2 On the Brown County art colony see William H. Gerdts, "The Golden Age of Indiana Landscape Painting" in *Indiana Influence: The Golden Age of Indiana Landscape Painting*, exh. cat. (Fort Wayne, Ind.: Fort Wayne Museum of Art, 1984), 37–49, and Rachel Perry, "Introduction: An American Art Colony" in Lyn Letsinger-Miller, *The Artists of Brown County* (Bloomington, Ind.: Indiana University Press, 1994), 14–21.

3 Charles Dahlgreen, "Autobiography," 197–98.

4 Biographical information on Dahlgreen is found in his autobiography, cited above, and in C. J. Bulliet, "Artists of Chicago Past and Present: No. 25 Charles W. Dahlgreen," *Chicago Daily News*, Aug. 10, 1935. See also Letsinger-Miller, *Artists of Brown County*, 180–81.

5 "To Open Atelier Here," *Oak Leaves*, Apr. 2, 1921, notes that Dahlgreen had moved to Oak Park "less than a year ago."

Charles Harold Davis

1 Holly Pyne Connor, "Charles Harold Davis," in Annette Blaugrund, Albert Boime, D. Dodge Thompson, H. Barbara Weinberg, and Richard Guy Wilson, *Paris 1889: American Artists at the Universal Exposition*, exh. cat. (Philadelphia and New York: Pennsylvania Academy of the Fine Arts and Harry N. Abrams, Inc., Publishers, 1989). 142.

2 Connor, "Charles Harold Davis," 142.

3 Charles H. Davis, "A Study of Clouds," *Palette and Bench* 3 (September 1909): 261–63.

4 Connor, "Charles Harold Davis," 142.

5 Louis Bliss Gillet, "Charles Harold Davis," *The American Magazine of Art* 27 (March 1934): 105.

Peter Dean

1 Lucy Lippard, *Peter Dean: A Retrospective*, exh. cat. (New York: Alternative Museum, 1990), 7. Biographical information has been also been derived from Sam Hunter, "Peter Dean's Mystical Theater," in *Peter Dean: Recent Paintings*, exh. cat. (New York: Galleri Bellman, 1984); Carter Ratcliff, *Peter Dean*, exh. cat. (Grand Forks, N.D.: North Dakota Museum of Art, 1989).

2 Sam Hunter, "Peter Dean's Mystical Theater," 10.

Wallace Leroy DeWolf

1 Ralph Clarkson, "Chicago Painters Past and Present" in *Chicago as an Art Center*, special issue, *Art and Archaeology* 12 (Sept.–Oct. 1921): 143. On DeWolf see also Percy B. Eckhart, "Wallace L. DeWolf: Artist and Patron of Fine Arts," *Union League Club Bulletin* 5 (Sept. 1928): 8–9, and "Wallace L. DeWolf" in Paul Gilbert and Charles Lee Bryson, *Chicago and Its Makers* (Chicago: Felix Mendelsohn, Publisher, 1929), 853.

2 Eckhart, "Wallace L. DeWolf," 8.

3 Evelyn Marie Stuart, "The Call of the Desert," *The Fine Arts Journal* 37 (Sept. 1919): 17–32.

4 Gilbert and Bryson, *Chicago and Its Makers*, 853. DeWolf is said to have been the first American artist to portray the desert in etchings (Stuart, "The Call of the Desert," 25).

Paul Dougherty

1 A date, now illegible, appears near the signature. The painting is assumed to have been completed shortly before it was first exhibited.

2 For information on Dougherty, see Edwin A. Rockwell, "Paul Dougherty—Painter of Marines: An Appreciation," *International Studio* 36 (Nov. 1908): iii–xi; Peter Falk, ed., *Who Was Who in American Art 1546–1975: 400 Years of Artists in America* (Madison, Conn.: Sound View Press, 2000), 1: 947; and William H. Gerdts, et al., *All Things Bright & Beautiful: California Impressionist Paintings from the Irvine Museum*, exh. cat. (Irvine, Calif.: The Irvine Museum, 1998), 87–88, 147, 177.

3 "Studio Talk," *International Studio* 30 (Dec. 1906): 180–82.

4 Sloan quoted in Falk, *Who Was Who*, 1: 947

5 Gerdts, *All Things Bright and Beautiful*, 177.

6 Dougherty's work in Maine is mentioned in William B. Mundie, "Fine Example of Marine Art in Club Collection. Canvas Depicts Motion and Power Standing Still in Upright Plane," *Union League Club Bulletin* 4 (March 1927): 11.

Ruth Duckworth

1 Information about Duckworth's life and contributions as an artist has been derived from the following sources: Michael McTwigan, "Ruth Duckworth," *American Ceramics* 10 (1992): 18–27; Janet Koplos, "Sources of Inspiration: Ruth Duckworth," *Crafts* 160 (September-October 1999): 46–49; Ruth Duckworth and Alice Westphal, *Ruth Duckworth*, exh. cat. (Evanston, Ill: Gallery of American Ceramics, 1977); Harrie A. Vanderstappen, "Ruth Duckworth: Life Becomes Sculpture," *American Craft* 51 (October–November 1991): 34–39; Debora Duez Donato, *Ruth Duckworth and Martyl*, exh. cat. (Chicago: State of Illinois Art Gallery, 1990); Garth Clark, *Ruth Duckworth at 80*, exh. cat. (New York, NY: Garth Clark Gallery, 1999).

2 As stated by Duckworth in Duckworth and Westphal, *Ruth Duckworth*, unpaginated.

3 As stated by the artist to McTwigan, "Ruth Duckworth," *American Ceramics*: 24.

Frank Virgil Dudley

1 Information about Dudley can be found in C. J. Bulliet, "Artists of Chicago Past and Present: No. 58 Frank Virgil Dudley," *Chicago Daily News*, June 15, 1935; *The Rent for Cottage 108*, exh. brochure (Indianapolis, Ind.: Indiana State Museum, 1981), unpaginated; and Judith Vale Newton and Carol Weiss, *A Grand Tradition: The Art and Artists of the Hoosier Salon, 1925–1990* (Indianapolis, Ind.: Hoosier Salon Patrons' Organization, 1993): 365.

2 An adjacent area was designated a National Lakeshore in 1966.

3 *The Rent for Cottage 108*.

4 Bulliet, "Artists of Chicago."

5 Bulliet, "Artists of Chicago."

Charles Warren Eaton

1 Information on Eaton is taken from Charles Teaze Clark and Maureen C. O'Brien, "Introduction," in *Charles Warren Eaton (1857–1937)*, exh. cat. (Montclair, N.J.: Montclair Art Museum, 1980), 3–6.

2 Maureen C. O'Brien, "Charles Warren Eaton at the Turn of the Century," in *Charles Warren Eaton*, 8.

3 Charles Warren Eaton, "Pastels and Their Treatment," *Palette and Bench* 1 (March 1909): 136.

4 The AIC's 1906 annual exhibition of watercolors, pastels, and miniatures in which the ULC's *On Lake Lugano* was shown included another work by Eaton entitled *Lugano* (#97, no medium noted). This may well be the pastel of the same title reproduced in the artist's 1909 article, cited above.

Eve Garrison

1 Eve Garrison letter of January 26, 1961, Chicago, Ill., to C. Dewey Imig, ULC Art Committee chair, curatorial file UL1961.1, ULC

2 Garrison to Imig, January 26, 1961.

3 See "Fourth Union League Art Show," *Men and Events* 37 (March 1961): 4, 9; "Art Committee Selects Bride and Groom by Eve Garrison (1908–): Painting of the Month," *Men and Events* 59 (April 1973): 17.

4 Kaliopee Malagaris, "A Little Lady Lost in Her Art," *Chicago Tribune*, June 28, 1967.

Miklos Gaspar

1 The Union League Boys and Girls Clubs took over the direction of a third club, located in Humboldt Park, "The Barreto" club, in 1970. A fourth Boys and Girls Club opened in September 2002, also in Humboldt Park. The summer camp has greatly expanded over the years and now has over two hundred acres.

2 Information on Gaspar is taken from *An Exhibition of Some of the Paintings of Miklos Gaspar 1885–1945*, exh. flyer (Chicago: The Little Gallery of the Esquire Theatre, 1947), unpaginated.

3 I am grateful to Elyse L. Klein, ULC paintings conservator, for discussing Gaspar's technique with me during a conversation held on November 7, 2001.

Frederic Milton Grant

1 For information on Grant's career see C. J. Bulliet, "Artists of Chicago Past and Present: No. 62 Frederic Milton Grant," *Chicago Daily News*, April 25, 1936, and Sparks, "A Biographical Dictionary," 2: 399.

2 Grant letter of Nov. 4, 1958 to Nita Herczel, Oakland, California, in curatorial file UL1976.18, ULC.

3 Grant described this approach to art-making in his written statement titled, "This is the help in words I give to my students," Oakland, California, Dec. 8, 1958, manuscript, curatorial file UL1976.18, ULC.

James Jeffrey Grant

1 Biographical information about Grant may be found in C. J. Bulliet, "Artists of Chicago Past and Present: No. 46 James Jeffrey Grant," *Chicago Daily News*, Jan. 4, 1936; Publicity Sheet for Exhibitors, The Art Department, The Chicago Public Library, form completed by Grant, in J. J. Grant file, Fine Arts Division, Chicago Public Library Harold Washington Center; and Edith Weigle, "Ever Go to a Library to Browse Thru an Art Show?" *Chicago Tribune*, Aug. 11, 1957.

2 Bulliet states that Grant came to America at the age of twenty-one, which would have been in 1904 or 1905, whereas Martin, *Art in the ULC*, gives the date as 1907.

3 Several newspaper sources state that Grant studied in Munich (or "on the Continent") before coming to Canada, but in his "Publicity Sheet for Exhibitors, The Art Department, The Chicago Public Library," cited above, Grant only mentions training in Munich during 1926 and 1927.

4 Frank Holland, "Conservatives Have Their Day," *Chicago Sun Times*, Aug. 9, 1957.

5 Joan Wagner, *A History of the Art Collection of the ULC* (Chicago: Published by the Art Committee of the ULC, 2000), 36.

Oskar Gross

1 "Biographical Outline on Oskar Gross, Portrait Painter," biographical questionnaire completed by the artist, in Oskar Gross pamphlet file, Ryerson and Burnham Libraries, AIC.

2 "Biographical Outline."

3 C. J. Bulliet, "Artists of Chicago Past and Present: No. 59 Oskar Gross," *Chicago Daily News*, April 14, 1936.

4 Oskar Gross, "The Origin of a Painting," *The Union League Club Bulletin* 20 (May 1943): 18. The rest of the description of Gross's process for making the painting comes from this article.

Oliver Dennett Grover

1 Report of the Art Committee of the ULC, 1928–29, in the archives of the ULC. I am grateful to Joan G. Wagner for this information.

2 Information on Grover is taken from Arthur Nicholas Hoskings, "Oliver Dennett Grover," *The Sketch Book* 5 (Sept. 1905): 1–8; Lena M. McCauley, "Oliver Dennett Grover," *The Chicago Evening Post*, Feb. 22, 1927; and C. J. Bulliet, "Artists of Chicago Past and Present: No. 96 Oliver Dennett Grover," *Chicago Daily News*, July 22, 1939.

3 *Upper St. Mary's* may also have been shown at Grover's solo exhibition at AIC from December 1923 through January 1924. The exact contents of this and the Ackermann Galleries show are unrecorded.

4 Jerry Camarillo Dunn, Jr., *The Rocky Mountain States*, The Smithsonian Guide to Historic America (New York: Stewart, Tabori & Chang, 1989), 368.

5 Thomas G. Aylesworth and Virginia L. Aylesworth, *America's National Parks* (Greenwich, Conn.: Bison Books, 1984), 36.

Lowell Birge Harrison

1 For information on Harrison see Arthur Hoeber, "Birge Harrison, N. A., Landscape Painter," *The International Studio* 44 (July 1911): iii–v; Annette Blaugrund, Albert Boime, D. Dodge Thompson, H. Barbara Weinberg, and Richard Guy Wilson, *Paris 1889: American Artists at the Universal Exposition*, exh. cat. (Philadelphia and New York: Pennsylvania Academy of the Fine Arts; Harry N. Abrams, Inc., Publishers, 1989), 164–65; and *Lasting Impressions: American Painters in France 1865–1915*, exh. cat. (Giverny, France: Musée Américain Giverny, 1992), 230.

2 On Harrison's associations with Woodstock see *Woodstock's Art Heritage: The Permanent Collection of the Woodstock Artists Association* (Woodstock, New York: Overlook Press, 1987), 19–20, 98–99.

3 On tonalism in American art see Wanda M. Corn, *The Color of Mood: American Tonalism 1880–1910*, exh. cat. (San Francisco, Calif.: M. H. De Young Memorial Museum and the California Palace of the Legion of Honor, 1972), which includes a brief biography of Harrison (p. 38).

4 *Woodstock's Art Heritage*, 98–99.

5 Birge Harrison, *Landscape Painting* (New York: C. Scribner's Sons, 1913), quoted in L[eila] M[echlin], "Birge Harrison's Paintings," *Art and Progress* 3 (Nov. 1911): 379; see also Birge Harrison, "Refraction in Landscape Painting," *Palette and Bench* 1 (July–Aug. 1909): 226–27, 247–48.

6 Arthur Hoeber, "Birge Harrison," iv.

7 Unidentified article marked *Chicago Evening Post*, Dec. 21, 1911, in AIC Scrapbooks, vol. 27, p. 89, on microfilm, Ryerson Library, AIC. The following quotes are all taken from this article.

Lucie Hartrath

1 Hartrath's birth date has been a matter of some dispute, with 1868 most commonly given. Her death certificate establishes 1867 as the year of her birth. I am grateful to Joel Dryer, Director of the Illinois Historical Art Project, for this information.

2 Information on Hartrath is taken from Minnie Bacon Stevenson, "A Painter of the Indian Hill Country," *American Magazine of Art* 12 (Aug. 1921): 278–79; C. J. Bulliet, "Artists of Chicago Past and Present: No. 73 Lucie Hartrath," *Chicago Daily News*, July 25, 1936; and Lyn Letsinger-Miller, *The Artists of Brown County* (Bloomington, Ind.: Indiana University Press, 1994), 179–80.

3 On the Brown County artists' colony see William H. Gerdts, "The Golden Age of Indiana Landscape Painting" in *Indiana Influence*, exh. cat. (Fort Wayne, Ind.: Fort Wayne Museum of Art, 1984), 14–58, and Rachel Perry, "Introduction: An American Art Colony" in Letsinger-Miller, *The Artists of Brown County*, 14–21.

4 Stevenson, "A Painter of the Indian Hill Country," 278.

5 Stevenson, "A Painter of the Indian Hill Country," 278.

6 Stevenson, "A Painter of the Indian Hill Country," 278–79.

Charles Webster Hawthorne

1 The most comprehensive discussion of Hawthorne is in Richard Mühlberger, *Charles Webster Hawthorne* (Chesterfield, Mass.: Chameleon Books, 1999), 11. See also Marvin S. Sadik, *The Paintings of Charles Hawthorne*, exh. cat. (Storrs, Conn.: The University of Connecticut Museum of Art, 1968).

2 Mühlberger, *Charles Webster Hawthorne*, 11.

3 Mühlberger, *Charles Webster Hawthorne*, 36.

4 The bottle in the background was likely a studio prop, for it reappeared in other portraits by the artist. See Mühlberger, *Charles Webster Hawthorne*, 18.

5 Mrs. Charles W. Hawthorne, comp. *Hawthorne on Painting: From Students' Notes Collected by Mrs. Charles W. Hawthorne* (New York: Dover Publications, 1960), 71.

George Peter Alexander Healy

1 Healy's important career still awaits scholarly examination. The best sources to date are his own *Reminiscences of a Portrait Painter* (Chicago: A. C. McClurg and Company, 1894) and John Caldwell and Oswaldo Rodriguez Roque, *A Catalogue of Works by Artists Born by 1815*, vol. 1 of *American Paintings in the Metropolitan Museum of Art*, ed. Kathleen Luhrs, (New York: Metropolitan Museum of Art, 1994), 569–70. Useful but often vague or inaccurate are Mary [Healy] Bigot, *Life of George P. A. Healy* (n.p., [1913]), and Marie de Mare, *G. P. A. Healy, American Artist: An Intimate Chronicle of the Nineteenth Century* (New York: David McKay, 1954).

2 De Mare, *G. P. A. Healy*, 225–26.

3 For further discussion of *Webster Replying to Hayne*, see Frederick Voss, "*Webster Replying to Hayne*: George Healy and the Economics of History," *American Art* 15 (Fall 2000): 34–53.

4 Healy, *Reminiscences*, 164.

5 On Webster and Marshfield, see Irving H. Bartlett, *Daniel Webster* (New York: W. W. Norton & Company, Inc., 1978), 122–23, 211–14.

6 Bartlett, *Daniel Webster*, 213.

7 William B. Mundie, "Club Canvas is Fine Likeness of Statesman: Healy, One of America's Greatest Portrait Painters, Lived in Chicago," *Union League Club Bulletin* 4 (July 1927): 12.

Victor Higgins

1 Ernest L. Blumenschein, "Introduction to the Original Edition," in Laura M. Bickerstaff, ed., *Pioneer Artists of Taos*, rev. and exp. ed. (Denver: Old West Publishing Company, 1983), 24.

2 The oil sketch for this painting is in the collection of the Museum of Fine Arts, Museum of New Mexico, Santa Fe.

3 J. Keeley, "Real American Art—At Last!," *Chicago Sunday Herald*, April 15, 1917.

Thomas Hill

1 Important sources of information on Hill's career are Janice T. Dreisbach and William H. Gerdts, *Direct from Nature: The Oil Sketches of Thomas Hill*, exh. cat. (Sacramento, Calif.: Crocker Art Museum, 1997); David Robertson, *West of Eden: A History of the Art and Literature of Yosemite* ([Yosemite National Park, Calif.]: Yosemite Natural History Association; [Berkeley, Calif.]: Wilderness Press, 1984), 27–29; and Natalie Spassky, *Catalogue of Works by Artists Born between 1816 and 1845*, vol. 2 of *American Paintings in the Metropolitan Museum of Art*, ed. Kathleen Luhrs (New York: The Metropolitan Museum of Art, 1985), 311–12.

2 The date of Hill's return to San Francisco is given as 1870 by Spassky, as 1871 by Eden Milton Hughes, *Artists in California 1876-1940* (San Francisco: Hughes Publishing Company, 1989), 256, and as 1872 by Janice T. Dreisbach, "The Oil Sketches of Thomas Hill," *American Art Review* 9 (Aug. 1997): 90.

3 J. Gray Sweeney, "The Artist-Explorers of the American West" (Ph.D. diss., Indiana University, 1975), 258.

4 Dreisbach, "The Oil Sketches of Thomas Hill," 92–93.

5 The valley and surrounding area were set aside as a state park in 1864 and designated a national park in 1890.

6 Spassky, *Catalogue of Works*, 312–13.

7 Hughes, *Artists in California*, 256; Dreisbach and Gerdts, *Direct from Nature*, 11.

8 Hill's repetitive use of subjects and titles makes it extremely difficult to identify his extant paintings with works recorded in nineteenth-century exhibitions.

9 John Muir, ed., *West of the Rocky Mountains* (orig. publ. *Picturesque California and the Region West of the Rockies from Alaska to Mexico*, 1888, reprint ed. Philadelphia: Running Press, 1976), 79.

10 Sweeney, "The Artist-Explorers of the American West," 258.

Othmar Hoffler

1 Biographical information is derived from "Biographic Data," unpublished sheet completed by the artist on March 14, 1933, in Othmar Hoffler pamphlet file, Ryerson and Burnham Libraries, AIC; Sparks, "A Biographical Dictionary," 2: 435. See also "Othmar Hoffler Painter and Illustrator," *The Palette & Chisel* 7 (March 1927): 1–2.

2 Eleanor Jewett, "Paintings by the Staceys," under subtitle, "Undertakes Two New Mediums," *Chicago Tribune*, March 8, 1931.

3 The Art Institute acquired *The Bath* in 1910.

Milton Horn

1 Harold Haydon, Paula Garrett-Ellis, and Milton Horn, *Milton Horn, Sculptor*, exh. cat. (Chicago: Spertus Museum of Judaica, 1989), 10. The biographical information in this essay derives from this catalogue. See also Paula Garrett-Ellis, ed., *Milton Horn, Sculptor: 1906–1995* (San Francisco, Calif: Milton and Estelle Horn Fine Arts Trust, 1996).

2 Haydon, Garrett-Ellis, and Horn, *Milton Horn*, 16.

3 I am grateful to Paula Ellis, executor of the Milton and Estelle Horn Fine Arts Trust, for discussing Horn's thoughts about this work with me.

William Henry Howe

1 For information on Howe see Arthur Hopkin Gibson, comp., *Artists of Early Michigan* (Detroit: Wayne State University Press, 1975), 139; *Old Lyme: The American Barbizon*, exh. cat. (Lyme, Conn.: Lyme Historical Society, 1982), 41–42; and John A. Mahe II and Rosanne McCaffrey, *Encyclopaedia of New Orleans Artists 1718–1918* (New Orleans: The Historic New Orleans Collection, 1987), 191.

2 "In Honor of the Village of Bronxville's 75th Birthday/An Exhibit of the Early Art Colony/Bronxville Public Library/May 1973," manuscript, curatorial file UL1908.4, ULC.

3 On the art colony at Old Lyme see *Old Lyme: The American Barbizon*, cited above, and *En Plein Air: The Art Colonies at East Hampton and Old Lyme 1880–1930*, exh. cat. (Old Lyme, Conn.: Florence Griswold Museum, 1989).

4 Henry Ward Ranger quoted in Annette Stott, *Holland Mania: The Unknown Dutch Period in American Art & Culture* (Woodstock, N.Y.: The Overlook Press, 1998), 53; Annette Stott, "Dutch Utopia: Paintings by Antimodern American Artists of the Nineteenth Century," *Smithsonian Studies in American Art* 3 (Spring 1989): 47, 60, n. 2.

5 Stott, *Holland Mania*, 54.

6 Stott, *Holland Mania*, 54; Peter Bermingham, *American Art in the Barbizon Mood*, exh. cat. (Washington, D.C.: National Collection of Fine Arts, 1975), 74.

7 Stott, "American Painters Who Worked in the Netherlands," (Ph.D. diss., Boston University, 1986), 186–87; see also "William Henry Howe: A Chief of Cattle-Painters," *The Art World* 3 (Oct. 1917): 5–6.

8 Stott, "American Painters Who Worked in the Netherlands," 186.

9 Lois Marie Fink, *American Art at Nineteenth-Century Paris Salons* (Cambridge and New York: Cambridge University Press, 1990), 227.

Richard Howard Hunt

1 Hilton Kramer, *The Age of Avante-Garde: An Art Chronicle of 1956–1972* (New York: Farrar, Straus and Giroux, 1973), 452.

2 The exhibition was organized by the Museum of Modern Art. Hunt describes his early experiences working in metal in "Oral History Interview with Richard Hunt," Dennis Barrie, interviewer, March 3, 1979, Archives of American Art, Smithsonian Institution. The School did not offer classes in metalwork during the time Hunt was a student.

3 Biographical information is derived from the following sources: Richard Hunt, interview by Dennis Barrie; Paul Cummings, "Interview: Richard Hunt Talks with Paul Cummings," *Drawing* 16 (Nov.–Dec. 1994): 78–81; Horace Brockington, *Richard Hunt: Affirmations*, exh. cat. (Detroit and Washington, D.C.: The Museum of African American History and International Arts & Artists, Inc., 1998); Samella S. Lewis, *Two Sculptors, Two Eras: Richmond Barthé, Richard Hunt* exh. cat. (Los Angeles: Landau/Travelling Exhibitions and Samella Lewis, ca. 1992).

4 Lewis, *Two Sculptors*, 14.

Rudolph Frank Ingerle

1 Biographical information on Ingerle is taken from C. J. Bulliet, "Artists of Chicago Past and Present: No. 23 Rudolph Ingerle," *Chicago Daily News*, July 27, 1935, and Edna Sellroe, "Rudolph F. Ingerle—Famous Painter of Landscapes and Character Studies of Mountaineers," *Artistry* [3?] (Dec. 1937): 2–3. For reproductions of Ingerle's paintings see *Rudolph Ingerle (1879–1950): Paintings of the Ozarks, The Great Smoky Mountains and the 1933 Century of Progress Exposition* (Chicago: Aaron Galleries, [2000]).

2 Isabel M'Dougall, "Fine Paintings in Current Art Exhibition," *Chicago Record-Herald*, Feb. 9, 1908. On the Brown County artists' colony see William H. Gerdts, "The Golden Age of Indiana Landscape Painting" in *Indiana Influence*, exh. cat. (Fort Wayne, Ind.: Fort Wayne Museum of Art, 1984), 14–58, and Rachel Perry, "Introduction: An American Art Colony" in Lyn Letsinger-Miller, *The Artists of Brown County* (Bloomington and Indianapolis: Indiana University Press, 1994), 14–21.

3 Ingerle began working in the Smokies as early as 1922. The caption for a photograph of the artist painting in the Smoky Mountain National Park, published in the *Charlotte Observer*, Oct. 30, 1938, states that this was the sixteenth autumn that the artist had been painting in the region.

4 Sellroe, "Rudolph F. Ingerle," 2; C. J. Bulliet, "Art in Chicago," *Art Digest* 25 (Feb. 15, 1951): 15.

5 Bulliet, "Artists of Chicago."

6 Bulliet, "Artists of Chicago."

7 See their works reproduced in Gerdts, *Art Across America* 2:311; Gerdts, *American Impressionism* (New York: Abbeville Press, 1984), 237–38; and Gerdts, *An American Tradition: The Pennsylvania Impressionists* (New York: Beacon Hill Fine Art, 1996), 18–21.

George Inness

1 The standard studies of Inness are LeRoy Ireland, *The Works of George Inness: An Illustrated Catalogue Raisonné* (Austin and London: University of Texas Press, 1965); Nicolai Cikovsky, Jr., *George Inness* (New York: Praeger, 1971); and Nicolai Cikovsky, Jr., and Michael Quick, *The Paintings of George Inness*, exh. cat. (Los Angeles: Los Angeles County Museum of Art, 1985).

2 Inness quoted in Michael Quick, "The Late Style in Context" in Cikovsky and Quick, *The Paintings of George Inness*, 52.

3 H. H. D[ownes], "Inness, George" in *Dictionary of American Biography* (New York: Charles Scribner's Sons, 1928–1996), 9: 488.

4 Charles DeKay, "George Inness," *Century Magazine* 24 (May 1882): 63.

Wilson Henry Irvine

1 On Irvine's life and works see Harold Spencer, *Wilson Henry Irvine and the Poetry of Light*, exh. cat. (Old Lyme, Conn.: Florence Griswold Museum, 1998) and Spencer, "Wilson Henry Irvine," *American Art Review* 10 (1998): 124–33.

2 Harriet Monroe, "Surprises at Art Exhibit," *Chicago Tribune*, Jan. 31, 1911.

3 Artist's questionnaire completed by Irvine in "Illinois Artists: Art Institute Questionnaires 1918 and Illinois Academy of Fine Arts Biographical Data 1929," Ryerson & Burnham Libraries, AIC, vol. 2.

Miyoko Ito

1 Biographical information has been drawn from Dennis Adrian, *Miyoko Ito: A Review*, exh. cat. (Chicago: The Renaissance Society at the University of Chicago, 1980); Miyoko Ito interview by Dennis Barrie, at the Oxbow Summer School of Painting, Saugatuck, Michigan, July 20, 1978, Smithsonian Institution, Archives of American Art, 1978 (available online at http://archivesamericanart.si.edu/oralhist/ito78.htm).

2 Adrian, *Miyoko Ito*, 6.

3 See Mary Mathews Gedo, "Abstraction as Metaphor: The Evocative Imagery of William Conger, Miyoko Ito, Richard Loving, and Frank Piatek," *Arts Magazine* 57 (October 1982): 116–17.

4 Adrian, *Miyoko Ito*, 5. Adrian's essay has also been the source of information about Ito's painting technique.

5 Recently, Thomas McCormick has suggested that Ito left the tacks this way to make it easier to remove the canvas from the stretcher rather than for some symbolic purpose. While McCormick bases his theory on comments that Ito made to her framer, Fred Baker, many art historians and critics believe that Ito had more than one motivation for preferring to leave the tacks only partially hammered down into the stretcher. See Thomas McCormick and Michelle Brandt, *Miyoko Ito: Mistress of the Sea*, exh. cat. (Chicago: Thomas McCormick Gallery, 2000), 30.

Billy Morrow Jackson

1 Information about Jackson has been drawn from Howard E. Wooden, *Billy Morrow Jackson: Interpretations of Time and Light* (Urbana and Chicago, Ill.: University of Illinois Press, 1990); Howard E. Wooden, *Moments in Light: Paintings by Billy Morrow Jackson*, exh. cat. (Wichita, Kans.: Wichita Art Museum, 1980); Billy Morrow Jackson, *A Conversation with Artist Billy Morrow Jackson* (Champaign, Ill.: Krannert Art Museum, 1996.)

2 Wooden, *Billy Morrow Jackson*, 109.

John Christen Johansen

1 Information about Johansen has been gathered from the following sources: Carolyn Kinder Carr, Margot Jackson, and William Robinson, *The Edwin C. Shaw Collection of American Impressionist and Tonalist Painting* (Akron, Ohio: Akron Art Museum, 1986), 78, 132; Arthur Hoeber, "John C. Johansen, A Painter of the Figure, Landscape and of Architecture," *The International Studio* 42 (November 1910): iii–x; Helen Earle, *Biographical Sketches*, 169–70; Gerdts, *Art Across America* 2: 312–13, 358, n. 74.

2 Carr, Jackson, and Robinson, *Shaw Collection*, 78.

3 Arthur Hoeber, "John C. Johansen," vi.

4 *Fiesole, Florence*, 1908, is in the collection of the Art Association of Richmond, and *Spring in Tuscany* is in the collection of the Lafayette Museum of Art.

5 Walter Marshall Clute, "John C. Johansen, Painter," *The Sketch Book* 5 (October 1905): 53.

Eastman Johnson

1 On Eastman Johnson see Patricia Hills, *Eastman Johnson*, exh. cat. (New York: Whitney Museum of American Art, 1972) and Teresa A. Carbone, Patricia Hills, and Jane Weiss, *Eastman Johnson: Painting America*, exh. cat. (Brooklyn, N.Y.: Brooklyn Museum, 1999). See also Natalie Spassky, *A Catalogue of Works by Artists Born between 1816 and 1845*, vol. 2 of *American Paintings in the Metropolitan Museum of Art*, ed. Kathleen Luhrs (New York: Metropolitan Museum of Art, 1985), 220–22.

2 I am grateful to David Meschutt for pointing out this connection.

3 Corliss, *Catalogue* (1899), 9. On Trumbull's portraits of Hamilton see Theodore Sizer, *The Works of Colonel John Trumbull, Artist of the American Revolution* (New Haven, Conn.: Yale University Press, 1950), 28, and Helen A. Cooper, et al, *John Trumbull: The Hand and Spirit of a Painter*, exh. cat. (New Haven, Conn.: Yale University Art Gallery, 1982), 122–23.

Frank Tenney Johnson

1 Big Grove has since changed its name to Oakland. Information has been taken from Harold McCracken, *The Frank Tenney Johnson Book* (Garden City, N.Y.: Doubleday & Company, 1974) and Julien Ryner, "A Classic: Frank Tenney Johnson (1874–1939)," *Southwest Art* 9 (October 1979): 74–77.

2 William H. Gerdts, *Art Across America*, 2: 335; McCracken, *Frank Tenney Johnson*, 27.

3 Fred Hogue, "In Navajo Land," *Los Angeles Times*, March 24, 1928, as quoted in McCracken, *Frank Tenney Johnson*, 168.

4 Obituary, "Frank T. Johnson, A Noted Painter," *The New York Times*, January 2, 1939.

Alfred Juergens

1 Juergens quoted in Peter Brink, "Public May View Remarkable Display of Rare and Exquisite Canvases," *The Oak Parker*, May 27, 1932.

2 Information on Juergens is taken from Oney Fred Sweet, "Beauty of Oak Park Immortalized on Canvas," *Sunday Chicago Tribune*, Oct. 19, 1930, Metropolitan Section, 1; *Centennial Exhibition of the Works of Alfred Juergens 1866–1934*, exh. cat. (Kalamazoo, Mich.: The Art Center, Kalamazoo Institute of Arts, 1966), 2; and the Illinois Historical Art Project website, www.illinoisart.org (consulted Dec. 12, 2000).

3 *Centennial Exhibition*, 2.

4 Juergens quoted in Brink, "Public May View Remarkable Display."

5 Maude I. G. Oliver, "'Most Important Show' Is a Trite Phrase, But Current Art Exhibition Deserves It," *Chicago Record Herald*, Feb. 2, 1913.

6 On the League (now known as the Oak Park Art League) see *The Art League Book* (n.p.: Austin, Oak Park and River Forest Art League, 1940), unpaginated.

7 Sweet, "Beauty of Oak Park Immortalized on Canvas."

8 Sweet, "Beauty of Oak Park Immortalized on Canvas."

William Keith

1 Information on Keith is taken from Eden Milton Hughes, *Artists in California 1876–1940* (San Francisco: Hughes Publishing Company, 1989), 301–302, and Natalie Spassky, *A Catalogue of Works by Artists Born between 1816 and 1845*, vol. 2 of *American Paintings in the Metropolitan Museum of Art*, ed. Kathleen Luhrs (New York: The Metropolitan Museum of Art, 1985), 532–34.

2 See for instance J. Gray Sweeney, "The Artist-Explorers of the American West" (Ph.D. diss., Indiana University, 1975), 259, and David Robertson, *West of Eden: A History of the Art and Literature of Yosemite* (Yosemite National Park, Calif.: Yosemite Natural History Association; Berkeley, Calif.: Wilderness Press, 1984), 29. Spassky, *American Paintings in the Metropolitan Museum of Art*, states in the entry on Thomas Hill that Keith and Williams accompanied him to Yosemite in 1862 (p. 311), but the entry on Keith states that he first went there in 1872 (p. 534).

Charles Pritchard Killgore

1 Charles Killgore, Chicago, Ill., to Earl Martin, Jan. 11, 1966, in curatorial file UL1976.31, ULC. The primary information about Killgore is available in a brochure printed by his family, curatorial file UL1976.31, ULC.

Vera Klement

1 Biographical information has been derived from Dore Ashton and James Yood, *Vera Klement: A Retrospective, 1953–1986*, exh. cat. (Chicago: The Renaissance Society at The University of Chicago, 1987); Gregory G. Knight and Sue Taylor, *Vera Klement: Paintings 1965–1998*, exh. cat. (Chicago: The City of Chicago Department of Cultural Affairs, 1999).

2 Interview with John Himmelfarb, 1985, as quoted in Ashton and Yood, *Vera Klement*, 11.

Daniel Ridgway Knight

1 For information on Knight's career see Jennifer A. Martin Bienenstock, *The Forgotten Episode: Nineteenth Century American Art in Belgian Public Collections*, exh. cat., (Brussels: The American Cultural Center, 1987), 46; Ridgway B. Knight, "Ridgway Knight: A Master of the Pastoral Genre," in *A Pastoral Legacy: Paintings and Drawings by the American Artists Ridgway Knight and Aston Knight*, exh. cat. (Ithaca, N.Y.: Herbert F. Johnson Museum of Art, Cornell University, 1989); and Arnette Blaugrund, Albert Boime, D. Dodge Thompson, H. Barbara Weinberg, and Richard Guy Wilson, *Paris 1889: American Artists at the Universal Exposition*, exh. cat. (Philadelphia and New York: Pennsylvania Academy of the Fine Arts; Harry N. Abrams, Inc., Publishers, 1989), 179.

2 Peter Bermingham, *American Art in the Barbizon Mood*, exh. cat. (Washington, D.C.: Smithsonian Institution, National Collection of Fine Arts, 1975), 34.

3 See Lois Marie Fink, *American Art at Nineteenth-Century Paris Salons* (Cambridge and New York: Cambridge University Press, 1990), 196–213.

4 Knight, "Ridgway Knight."

5 Knight quoted in Fink, *American Art at Nineteenth-Century Paris Salons*, 210.

6 The title *Waiting for the Ferry* more properly applies to a related painting that shows two peasant girls, with a donkey and a dog, looking across a river, evidently awaiting an unseen boat. This painting, dated 1885, is in the Heckscher Museum, Huntington, New York. The ULC's painting, though clearly a finished exhibition piece and executed in Paris, cannot be identified with the titles of Knight's recorded Salon exhibits (see Fink, *American Art at Nineteenth-Century Paris Salons*, 362–63), nor with any of the works he is recorded to have exhibited at American venues.

7 Blaugrund, Boime, Thompson, Weinberg, and Wilson, *Paris 1889*, 179.

Carl Rudolph Krafft

1 Information on Krafft is taken from V. E. Carr, "Carl R. Krafft," *The American Magazine of Art* 17 (Sept. 1926): 475–80; C. J. Bulliet, "Artists of Chicago Past and Present: No. 38 Carl Rudolph Krafft," *Chicago Daily News*, Nov. 9, 1935; and Lal Davies (Gladys Krafft), *An Artist's Life* (New York: Vantage Press, 1982).

2 The League was founded in 1921 but not chartered until 1924. See *The Art League Book* (n.p.: Austin, Oak Park and River Forest Art League, 1940), unpaginated.

3 Bulliet, "Artists of Chicago."

4 Bulliet, "Artists of Chicago."

5 Krafft quoted in Lena M. McCauley, "A Poet Painter of the Ozarks," *Fine Arts Journal* 34 (Oct. 1916): 471.

6 Bulliet, "Artists of Chicago."

7 Otto Hake, "October in the Ozarks," *The Cow Bell* 2 (Dec. 1, 1913): unpaginated. Krafft had evidently pictured a similar subject earlier in his almost identically titled *The Banks of the Gasconade*, which he exhibited at the Art Institute in 1914.

8 Hake, "October in the Ozarks."

9 Eleanor Jewett, "Pleasing Pictures in Exhibition of Chicago Artists," *Chicago Tribune*, Feb. 1, 1920; see also Lena M. McCauley, "Local Artists Display at Art Institute," *Chicago Evening Post*, Feb. 3, 1920, and Evelyn Marie Stuart, "South Shore's Exhibition of Paintings," *South Shore Country Club Magazine* 4 (July 1920): 24.

10 Stuart, "South Shore's Exhibition of Paintings," 24; Davies, *An Artist's Life*, 48.

11 Davies, *An Artist's Life*, 8. However, Bulliet, "Artists of Chicago," states that it was with the winning of a medal for his 1916 painting *Charm of the Ozarks* that Krafft gave up commercial work.

Evelyn Beatrice Longman

1 Information for this essay was gathered from Janis Conner, "American Women Sculptors Break the Mold," *Art and Antiques* 3 (May/June 1980): 81–84 and Charlotte Streifer Rubenstein, *American Women Sculptors: A History of Women Working in Three Dimensions* (Boston, Mass.: G. K. Hall, 1990), 172–76.

Mary Fairchild MacMonnies Low

1 On Low see Mary Smart, "Sunshine and Shade: Mary Fairchild MacMonnies Low," *Woman's Art Journal* 4 (fall 1983/winter 1984): 20–25, and E. Adina Gordon, *Frederick William MacMonnies (1863–1937), Mary Fairchild MacMonnies (1858–1946): Deux artistes américains à Giverny*, exh. cat. (Vernon, France: Musée Municipal A.-G. Poulain-Vernon, 1988); and Derrick Cartwright, "Beyond the Nursery: The Public Careers and Private Spheres of Mary Fairchild MacMonnies Low," in Joyce Henri Robinson and Derrick Cartwright, *An Interlude in Giverny*, exh. cat. (College Station, Penn.: Palmer Museum of Art, Pennsylvania State University, and Giverny, France: Musée d'Art Américain Giverny, 2001): 35–56.

2 Le Moutier, also dubbed the "MacMonastery," attracted a host of American painters who flocked to Giverny at the turn of the century to pay homage to the less welcoming Claude Monet, whose residence stood at the opposite end of the village. Cartwright, "Beyond the Nursery," 45.

3 Smart, "Sunshine and Shade," 24.

4 Will H. Low, "In an Old French Garden," *Scribner's Magazine* 32, (July 1902): 3–19.

5 On the early relationship between Mary MacMonnies and Will Low see Ron White, "Will & Mary, A Bohemian Fatuation: Lifestyle among Artists of the World's Columbian Exposition," curatorial file UL1902C.18, manuscript, ULC.

6 Will Low's painting, reproduced in Low, "In an Old French Garden," 8, is unlocated. See "An Old French Garden," *New York Times*, Feb 28, 1902.

7 Low's *In the Sun, Narcissus*, was deaccessioned from the Club's collection in 1983.

Anna Lou Matthews

1 Information about Matthews is taken from Sparks, *A Biographical Dictionary*, 500–501; Glenn B. Opitz, ed., *Mantle Fielding's Dictionary of American Painters, Sculptors & Engravers*, 2nd ed. (Poughkeepsie, N.Y.: Apollo Book, 1986), 595; Peter Hastings Falk, *Who Was Who in American Art* (Madison, Conn.: Sound View Press, 1985), 401, and the Illinois Historical Art Project website, http://www.illinoisart.org, consulted August 2, 2001.

2 Illinois Historical Art Project.

3 Illinois Historical Art Project.

Julius Moessel

1 On Moessel see C. J. Bulliet, "Artists of Chicago Past and Present: No. 26 Julius Moessel," *Chicago Daily News*, Aug. 17, 1935; Judith Breuer, *Julius Moessel: Dekorations—und Kunstmaler 1871–1957* (Stuttgart: Konrad Theiss Verlag, 1995); and Mark Alvey, "Rediscovering Julius Moessel: Chicago and the Field Museum's Master Muralist," *In the Field* 70 (May/June 1999): 2–5.

2 Jill Leslie McKeever-Furst, "Moessel in America: 1929–1957" in Breuer, *Julius Moessel*, 130–31.

3 McKeever-Furst in Breuer, *Julius Moessel*, 131.

4 Eleanor Jewett, "Paintings by Moessel Give Horror Thrills," *Chicago Tribune*, Oct. 28, 1934.

5 *Spring* is unlocated. It is reproduced in Eleanor Jewett, "Unique Order of Hanging Groups Works of Same Character Together," *Chicago Tribune*, June 24, 1934, a review of the All-Illinois Society of the Fine Arts Century of Progress exhibition held at the Drake Hotel, Chicago.

6 Bulliet, "Artists of Chicago," and biographical questionnaire completed by the artist, in Julius Moessel pamphlet file, Ryerson and Burnham Libraries, AIC.

Claude Monet

1 Paul Hayes Tucker, *Monet at Argenteuil* (New Haven and London: Yale University Press, 1982), 2 and 10.

2 For a discussion of the Barbizon and Impressionist painters' interest in this theme, see Richard Brettel, "The Fields of France," in Richard Brettell, Scott Schaefer, Sylvie Gache-Patin, Françoise Heilbrun, and Andrea P. A. Belloli, eds., *A Day in the Country: Impressionism and the French Landscape* (Los Angeles and New York: Los Angeles County Museum of Art, 1984), 241–72.

3 Entry for *Pommiers en fleurs*, in Brettell et al., *A Day in the Country*, 256.

4 Charles F. Stuckey, *Claude Monet 1840–1926*, exh. cat. (Chicago and New York: The Art Institute of Chicago; Thames and Hudson, 1995), 196; Tucker, *Monet at Argenteuil*, 47.

5 Charles Bigot, "Causerie artistique: l'exposition des 'Intransigeants,'" *La Revue Politique et Littéraire* 41 (April 8, 1876): 350: "*Le Printemps* est une allée de jardin, tout herbeuse, qui s'enfonce entre des pommiers en fleurs et des arbustes qui poussent leur premières feuilles; il y a là beaucoup de francheur, une impression du mois de mai qui réjouit les yeux." Translation by author. David Cateforis, then an intern at the M. H. de Young Memorial Museum, first alerted the Club to this review, in a letter dated October 19, 1987 (curatorial file UL1895.R19, ULC). It is believed that the Club's painting obtained its current title from Bigot's phrase "Pommiers en fleurs."

6 Anonymous, "Union League Art," hand-written register of collection, 1896, curatorial department, ULC, 27. While Durand-Ruel is known to have purchased *Pommiers en fleurs* in 1872, the firm unfortunately has no information about to whom the painting was sold. See letter written by Caroline Durand-Ruel Godfroy to Marianne Richter, March 14, 2000, curatorial file UL1895.R19, ULC.

7 I am grateful to Barbara Mirecki, Monet exhibition coordinator, AIC, for this information, which she conveyed to me in a letter dated September 13, 1995, curatorial file UL1895R.19, ULC.

8 In the review of the Monet exhibition, the *Chicago Evening Post*'s art critic mentioned that "Judge Payne, one is glad to see, has recently acquired the 'Springtime' which was praised in these columns when first brought here from New York": "About Art and Artists," *Chicago Evening Post*, March 22, 1895. A search for the earlier reference to *Springtime* has proven unsuccessful. A review in *The Chicago Evening Journal* states, "The pictures are lent by Durand-Ruel, all except one which is owned by Judge J. Barton Payne": "Landscapes by Monet: This Impressionist's Work at Art Institute," *The Chicago Evening Journal*, March 22, 1895.

9 This story appeared in Club publications on more than one occasion in the twentieth century, but no account by a contemporary has been found.

Daniel Morper

1 Information is taken from Daniel Morper, *Daniel Morper: Class of '66*, exh. cat. (Notre Dame, Ind.: Snite Museum of Art, University of Notre Dame, 1986); Norman Kolpas, "Spirit of the Rail Yards," *Southwest Art* 29 (Dec. 1999): 74–78.

2 Morper, n.p.

3 Dennis Loy, "Daniel Morper," *State of the Union: Official Magazine of the Union League Club* 68 (October 1988): 1.

Raymond Perry Rodgers Neilson

1 Information about Neilson is taken from Percy B. Eckhart, "'The Mirror' Painted by Young American Artist," *Union League Club Bulletin* 5 (July 1928): 7; William D. Pawley, *Americans Valiant and Glorious* (New York: Caleb Printing Co., 1945), 71.

John Thomas Nolf

1 C. J. Bulliet, "Artists of Chicago Past and Present: No. 29 John Thomas Nolf," *Chicago Daily News*, September 7, 1935. Information about Nolf is taken from Bulliet's article, as well as from Glenn B. Opitz, ed., *Mantle Fielding's Dictionary of American Painters, Sculptors & Engravers* (Poughkeepsie, N.Y.: Apollo, 1986), 670; "Rites Tonight for John Nolf, Famed Painter," *Chicago Tribune*, May 30, 1950; and "John Nolf," *The New York Times*, May 30, 1950 (obituary).

2 Bulliet, "Artists of Chicago."

3 Bulliet, "Artists of Chicago."

Elizabeth Nourse

1 Lois Marie Fink and Mary Alice Heekin Burke, *Elizabeth Nourse, 1859–1938: A Salon Career*, exh. cat. (Washington, D.C.: National Museum of American Art, Smithsonian Institution, 1983), 111. Biographical information about the artist has been primarily drawn from this catalogue.

2 C. D. Arnold and H. D. Higinbotham, *Official Views of the World's Columbian Exposition Issued by the Department of Photography* (Chicago: Press Chicago Photo-Gravure Co., 1893), 8: pl. 89. The Arnold photograph of the first gallery offers a clear view of *Good Friday*. Carolyn Kinder Carr, "Prejudice and Pride: Presenting American Art at the 1893 World's Columbian Exposition," in *Revisiting the White City: American Art at the 1893 World's Fair* (Washington, D.C.: Smithsonian Institution, 1993), 95.

3 Fink and Burke, *Elizabeth Nourse*, 39.

4 Fink and Burke, *Elizabeth Nourse*, 40. Fink also states in footnote 85 (p. 82) that the original sketches are in Nourse's sketchbook number 10.

5 Fink and Burke, *Elizabeth Nourse*, 40.

Leonard Ochtman

1 Frederick W. Morton, "Leonard Ochtman, Landscape-Painter," *Brush and Pencil* 9 (Nov. 1901): 65.

2 Susan Larkin, *The Ochtmans of Cos Cob: Leonard Ochtman (1854–1934), Mina Fonda Ochtman (1862–1924), Dorothy Ochtman (1892–1971), Leonard Ochtman, Jr. (1894–1976)*, exh. cat. (Greenwich, Conn.: The Bruce Museum, 1989), 28.

3 Information about Ochtman has been gathered from Larkin, *The Ochtmans* and William H. Gerdts, *Art Across America* 1: 120.

4 The best discussion of his working methods is in Ochtman's article, "A Few Suggestions to Beginners in Landscape Painting," *Palette and Bench* 1 (July 1909): 231–32 and 1 (August 1909): 243–44.

5 Larkin, *The Ochtmans*, 23.

6 Ochtman, "A Few Suggestions," 243.

7 Larkin, *The Ochtmans*, 25.

Pauline Lennards Palmer

1 Palmer's year of birth has been given in various sources as 1865 and as 1867. The Illinois Historical Art Project gives the date as 1865, based on Palmer's birth certificate.

2 *Against the Light* has long been called *From My Studio Window*, almost certainly a confusion of this painting with *From My Study Window, Brittany*, exhibited at the Art Institute's Chicago annual in 1907. The title of the Club's painting is established by a captioned reproduction in a notice of Palmer's solo exhibition at Carson, Pirie, Scott in 1927, in the *Chicago Herald Examiner*, March 27, 1927. In addition, the costume worn by the sitter clearly dates to the 1920s and not 1907.

3 Information on Palmer's career is taken from C. J. Bulliet, "Artists of Chicago Past and Present: No. 51 Pauline Palmer," *Chicago Daily News*, Feb. 1, 1936; Fred W. Soady, "A Brief History of the Artist" in *Pauline Palmer: American Impressionist 1867–1938*, exh. cat. (Peoria, Ill.: Lakeview Museum of Arts and Sciences, 1984), unpaginated; and David Sokol, "Palmer, Pauline Lennards" in *Women Building Chicago 1790–1990: A Biographical Dictionary*, eds. Rima Lunin Schultz and Adele Hast (Bloomington and Indianapolis: Indiana University Press, 2001), 664–65.

4 Esther Sparks, "Pauline Palmer's *From My Studio Window*," *Men and Events* 54 (Dec. 1980): 14.

5 Lena McCauley, "Versatile Exhibition by Pauline Palmer," *Chicago Evening Post Magazine of the Art World*, Mar. 15, 1927.

6 Paul Schulze, "Chicago's 'Painter Lady,'" *Men and Events* 16 (Sept. 1939): 3.

7 Schulze, "Chicago's 'Painter Lady,'" 2.

William Ordway Partridge

1 For information on Partridge see Marjorie Pingel Balge, "William Ordway Partridge (1861–1930): American Art Critic and Sculptor" (Ph.D. diss., University of Delaware, 1982).

2 William Ordway Partridge, *The Works in Sculpture of William Ordway Partridge, M.A.* (New York: John Lane Company, 1914), 54, states that the bust was sculpted from life.

3 On Hale's career see Francis J. Bosha, "Edward Everett Hale," in *American National Biography* (New York and Oxford: Oxford University Press, 1999), 9: 816–17.

4 William C. Langdon, "William Ordway Partridge, Sculptor," *New England Magazine*, n.s. 22 (June 1900): 384.

5 Balge notes at least nine plaster versions. Partridge, in his *Works in Sculpture*, 54, mentions three replicas, but it is not clear whether these are plaster or bronze.

6 Information on Head is found in Paul Gilbert and Charles Lee Bryson, *Chicago: Its Men and Makers* (Chicago: Felix Mendelsohn, Publisher, 1929), 1059. Partridge, *The Works in Sculpture*, 54, states that the Club acquired the sculpture in 1891. However, it does not appear in the Club's annual report until 1895, the earliest documentation of the work in the collection.

7 See Partridge, *The Works in Sculpture*, 54.

Ed Paschke and (art)ⁿ

1 The best information about (art)ⁿ can be found at the group's website, http://www.artn.com. See also Abigail Foerstner, "Spatial Effects: Ed Paschke + (art)ⁿ = the future," *Northshore Magazine* 21 (March 1998), for a discussion of Paschke's PHSColograms. For information about Ed Paschke, see: Neal Benezra, with contributions by Dennis Adrian, Carol Schreiber, and John Yau, *Ed Paschke* (New York and Chicago: Hudson Hills Press and The Art Institute of Chicago, 1990); Michele Vishny, "Ed Paschke," in *Painting at Northwestern: Conger, Paschke, Valerio*, exh. cat. (Evanston, Ill.: Mary and Leigh Block Gallery, Northwestern University, 1986), 30–35.

2 (art)ⁿ website, http://www.artn.com/how.html, consulted August 28, 2001.

3 For a discussion of *PHSCologram 1983*, see Michel Ségard, "Artists Team Up for the Future," *New Art Examiner* 11, (Jan. 1984): 11, 26.

4 Paschke discusses these works in "A Conversation with Ed Paschke," interview by Dennis Adrian, in Benezra et al., *Ed Paschke*, 121–122.

James William Pattison

1 The best source of information on Pattison remains Walter Marshall Clute, "James William Pattison: Author, Critic and Painter," *The Sketch Book* 5 (May 1906): 310–17. See also Gerdts, *Art Across America*, 2:312.

2 Clute, "James William Pattison," 311, states that Pattison "came under the influence" of several landscape artists including Sanford R. Gifford (1823–1880). However, Pattison's obituary in *American Art News* 13 (June 12, 1915): 5, names landscapist R. Swain Gifford (1840–1905) as among his teachers. Both Giffords were successful artists working in New York in 1867–68 when Pattison was studying there, and he might have worked with either. For this information I am grateful to Rebecca B. Bedell.

3 Pattison also lectured for the Central Art Association. In September 1897 he was noted as a lecturer at the Art Institute, probably at the museum ("James William Pattison," *Arts for America* 7 [Sept. 1897]: 29); according to the museum school's circular for the 1897–98 year, he began giving his course of lectures there at the beginning of 1898.

4 Gerdts, *Art Across America*, 2:312.

5 Several are reproduced in Clute, "James William Pattison."

6 Clute, "James William Pattison," 316.

7 An apparently closely related work entitled *Early Morning*, exhibited at the Society of Western Artists annual exhibition of 1911, was described as showing "sheep in a grove. A tender light is diffused over the scene, which is out of the ordinary as a picture in its decorative quality" (L. M. McCauley, "Art and Artists," *Chicago Evening Post*, April 8, 1911).

8 An early reproduction of the painting suggests that the paint colors, especially in the sky, may have darkened over time.

9 McCauley, "Art and Artists."

Frank Charles Peyraud

1 On Peyraud see C. J. Bulliet, "Artists of Chicago Past and Present: No. 5 Frank Charles Peyraud," *Chicago Daily News* Mar. 23, 1935; Janice Harmer and Miriam Lorimer, "Frank C. Peyraud: His Life and Work" in *Frank C. Peyraud: Dean of Chicago Landscape Artists*, exh. cat. (Peoria, Ill.: Lakeview Museum of Arts and Sciences, 1985), unpaginated; and Gerdts, *Art Across America*, 2:300.

2 Kaltenbach quoted in Harmer and Lorimer, "Frank C. Peyraud," unpaginated.

3 Hamlin Garland quoted in Harmer and Lorimer, "Frank C. Peyraud," unpaginated.

4 Peyraud quoted in C. J. Bulliet, "Artists of Chicago."

Bert Geer Phillips

1 Information about Phillips has been drawn from Laura M. Bickerstaff, "Bert Geer Phillips," in *Pioneer Artists of Taos*, rev. ed. (Denver: Old West Publishing Co., 1983), 51–63; Patricia Janis Broder, *Taos: A Painter's Dream* (Boston: New York Graphic Society, 1980), 96–113; Julie Schimmel and Robert R. White, *Bert Geer Phillips and the Taos Colony* (Albuquerque: University of New Mexico Press, 1994). See also Dean A. Porter, Teresa Hayes Ebie, and Suzan Campbell, *Taos Artists and Their Patrons 1898–1950* (Notre Dame, Ind.: The Snite Museum of Art, University of Notre Dame, 1999).

2 Bert Geer Phillips, "The Taos Art Colony," unpublished manuscript, ca. 1936, The Bert Geer Phillips Papers, Henry E. Huntington Library and Art Gallery, reprinted in Schimmel and White, *Bert Geer Phillips*, 308.

3 Porter, Ebie, and Campbell, *Taos Artists*, 38.

William Lamb Picknell

1 David Sellin and Lauren Rabb, *The Art of William Lamb Picknell 1853–1897*, exh. cat. (New York: Taggart and Jorgensen Gallery, 1991), 3, 15. Information about Picknell has been derived from this catalogue as well as from the following sources: William H. Gerdts and David B. Dearinger, *Masterworks of American Impressionism from the Pfeil Collection*, exh. cat. (Alexandria, Va: Art Services International, 1992), 200–202; William H. Gerdts, Carole L. Shelby, and Jochen Wierich, *Lasting Impressions: American Painters in France 1865–1975*, exh. cat.(Chicago: Terra Foundation for the Arts, 1992), 19–20.

2 "By Native Painters: Coming Exhibition of Pictures from American Easels," *Chicago Chronicle*, October 31, 1897.

3 Sellin and Rabb, *William Lamb Picknell*, 9.

Albín Polášek

1 Information on Polášek is taken from Jiří Klucka, *Albín Polášek* Man Carving His Own Destiny: *Life and Work of Albín Polášek* (Czech Republic: Muzejní a vlastive dná spoleěnost ve Frenštát p.R. and Městské muzeum ve Frenštát, p.R.), 1995. The following sources also provided information: Emily Polášek, *Albín Polášek: Man Carving His Own Destiny* (Jacksonville, Fla.: Convention Press, 1970); Ruth Sherwood, *Carving His Own Destiny: The Story of Albín Polášek* (Chicago: Ralph Fletcher Seymour, 1954).

2 Jiří Klucka, *Albín Polášek*, 10.

3 Sherwood, *Carving His Own Destiny*, 332. Sherwood was Polášek's second wife.

4 Blanche C. Messias, "Is Chicago Ready to Forsake Banality for Leadership in Art?" *Chicago Herald and Examiner*, January 7, 1923.

5 Percy B. Eckhart, "Carving His Own Destiny," *Union League Club Bulletin*, 6 (March 1929): 8.

Tunis Ponsen

1 Patrick Coffey, "Chronology: Significant Events in the Life and Career of Tunis Ponsen (1891–1968)," in Patrick Coffey, William H. Gerdts, Susan Weininger, and Kenneth B. Katz, *The Lost Paintings of Tunis Ponsen*, exh. cat. (Muskegon, Mich.: Muskegon Museum of Art, 1994), 36. This catalogue is the primary source of information about the artist.

2 Susan Weininger, "Tunis Ponsen," in *The Lost Paintings of Tunis Ponsen*, 31–32.

3 Weininger notes that Ponsen may also have attended graduate school there: "Tunis Ponsen," 33, n. 4. I am grateful to Professor Weininger for examining the Club's painting and sharing her expertise about Ponsen.

4 Weininger, "Tunis Ponsen," 30.

5 For information about the Century of Progress World's Fair, see *Official Book of the Fair: An Introduction to A Century of Progress International Exposition* (Chicago: The Fair, 1933); John E. Findling, *Chicago's Great World's Fairs* (Manchester and New York: Manchester University Press, 1994); Lenox R. Lohr, *Fair Management, the Story of A Century of Progress Exposition: A Guide for Future Fairs* (Chicago: Cuneo Press, 1952).

6 Coffey, "Chronology," 45.

Edward Henry Potthast

1 Information on Potthast is taken from Arlene Jacobowitz, "Edward Henry Potthast," *The Brooklyn Museum Annual* 9 (1967–68): 113–28; William H. Gerdts, *American Impressionism* (New York: Abbeville Press, 1984), 224; and Susan Sipple Elliott, "Edward Henry Potthast," *American Art Review* 9 (Sept.–Oct. 1997): 96–99.

2 Jacobowitz, *Edward Henry Potthast 1857–1927*, exh. cat. (New York: Chapellier Galleries, [1969?]), unpaginated.

3 Elliott, "Edward Henry Potthast," 98.

4 Potthast rarely dated his works and the year at which he turned to beach scenes is in dispute. Gerdts, *American Impressionism*, 224, suggests it may have been as late as 1910.

5 William H. Gerdts, "Surf and Shore: Nineteenth-century Views of the Beach" in Russell Lynes, William H. Gerdts, and Donald B. Kuspit, *At the Water's Edge: 19th and 20th Century American Beach Scenes*, exh. cat. (Tampa, Fla.: Tampa Museum of Art, 1989), 25–39.

6 J. W. Young, *Edward Henry Potthast*, exh. cat. (Chicago: J. W. Young Gallery, 1920), unpaginated. I am grateful to Prof. William H. Gerdts for furnishing a copy of this catalogue.

Hiram Powers

1 The best source of information about Powers's life and work is Richard P. Wunder, *Hiram Powers: Vermont Sculptor, 1805–1873*, 2 vols. (Newark: University of Delaware Press; London and Toronto: Associated University Press, 1991). For information about Daniel Webster, see Irving H. Bartlett, *Daniel Webster* (New York: W. W. Norton & Company, 1978), and Dumas Malone, ed., *Dictionary of American Biography*, vol. 19 (New York: Charles Scribner's Sons, 1936), 585–92.

2 Letter from Hiram Powers to Robert Montgomery Bird, Washington D.C., February 1, 1835, as quoted in Wunder, *Hiram Powers*, 1: 92, 100 (n. 1). The original letter is in the collection of the University of Pennsylvania Library.

3 According to Wunder, a bust had been made in 1838 shortly after Powers's move to Italy and was purchased in 1844 by the Boston Athenaeum. *Hiram Powers*, 2: 105.

4 For a discussion of American sculptors' emulation of Roman portrait busts, see Stephen Crawford, "Physiognomy in Classical and American Portrait Busts," *American Art Journal* 9 (May 1977): 49–60. Crawford discusses Powers on pages 55–57.

5 Letter from Powers to Hiram Fish, Florence, Italy, November 17, 1859, as quoted in Wunder, *Hiram Powers*, 2: 92.

6 Wunder, *Hiram Powers*, 1: 15–17.

7 Lorado Taft, *The History of American Sculpture* (New York: The MacMillan Company, 1924), 68.

Hovsep Pushman

1 For information on Pushman see "Notable Memorial Gift," *Men and Events* 35 (July 1959): 3–4; "Study Guide—Revised—1981 for the Nettie J. McKinnon Art Collection in the Gallery at Ogden Avenue School, District 102" manuscript prepared by the Friends of the Nettie J. McKinnon Art Collection, Inc., 1981; and "Hovsep Pushman (1877–1966): The Armenian Spirit Glorified in Art" at Crgalleries.com, the website of Cantor-Roughton Galleries, Inc. (consulted Dec. 1, 2000). For a bibliography of mostly early articles on Pushman see Gerdts, *Art Across America*, 2:358, n. 66.

2 See for instance Eleanor Jewett, "Two New Art Shows to Open During Week," *Chicago Tribune*, Mar. 14, 1937.

3 For examples of his early figural work and its critical acclaim, see Evelyn Marie Stuart, "The Dawn of a Colorist," *Fine Arts Journal* 34 (Feb. 1916): 79–84.

4 "Legends of the Far East: Pushman's Symbolical Compositions of the Orient," *Pictures on Exhibit* 2 (Nov. 1938): 20–21.

5 "Legends of the Far East," 21.

6 See for instance *Exhibition of Paintings by Hovsep Pushman*, exh. cat. (Chicago: Anderson Galleries, 1940).

7 Information supplied by Elyse L. Klein, ULC paintings conservator.

Henry Ward Ranger

1 On Ranger see Doreen Bolger Burke, *A Catalogue of Works by Artists Born between 1846 and 1864*, vol. 3 of *American Paintings in the Metropolitan Museum of Art*, ed. Kathleen Luhrs (New York: Metropolitan Museum of Art, 1980), 319–22; Jack Becker et al., *Henry Ward Ranger and the Humanized Landscape*, exh. cat. (Old Lyme, Conn.: Florence Griswold Museum, 1999); and Estelle Riback, *Henry Ward Ranger: Modulator of Harmonious Color* (Fort Bragg, Calif.: Lost Coast Press, 2001).

2 See *Old Lyme: The American Barbizon*, exh. cat. (Old Lyme, Conn.: Florence Griswold Museum, 1982) and *En Plein Air: The Art Colonies at East Hampton and Old Lyme 1880–1930*, exh. cat. (Old Lyme, Conn.: Florence Griswold Museum, 1989). On Ranger's presence in Old Lyme and Noank, see Becker et al., *The Humanized Landscape*, 15–17, 19–21.

3 Ralcy Husted Bell, *Art-Talks with Ranger* (New York and London: G. P. Putnam's Sons, 1914), 15.

4 Burke, *Catalogue of Works*, 321.

5 In *Catalog of Paintings by Eminent American Old Masters and By Some of the Prominent Living American Artists*, exh. cat. (Chicago: Young's Art Galleries, [1918]), #32, a painting entitled *Hawk's Nest Pool*, undoubtedly related to the Club's work, was described thus: "The spot was one of his favorite haunts for painting near Lyme, Connecticut. The gnarled oaks that are characteristic of Lyme are painted under a brilliant autumn sky."

6 Bell, *Art-Talks*, 110. On Ranger's techniques see Lance Mayer and Gay Myers, "'The Colour-Charm of the Tone-Picture': Ranger, Glazes and Tonalist Technique" in Becker et al., *The Humanized Landscape*, 35–41.

Thomas Buchanan Read

1 Information on Read is taken from George C. Groce and David H. Wallace, *The New-York Historical Society's Dictionary of Artists in America 1564–1860* (New Haven and London: Yale University Press, 1957), 527, and Katherine M. Krile, "Read, Thomas Buchanan" in *American National Biography*, eds. John A. Garraty and Mark C. Carnes (New York and Oxford: Oxford University Press, 1999), 18: 230–32.

2 On Sheridan see Richard O'Connor, *Sheridan the Inevitable* (Indianapolis and New York: Bobbs-Merrill Company, Inc., 1953).

3 James M. McPherson, *Battle Cry of Freedom: The Civil War Era* (New York: Ballantine Books, 1989), 780.

4 The manuscript is dated Rome, 1871.

5 Maxwell Whiteman, "Sheridan's Ride: Thomas Buchanan Read and the Union League," in *T. Buchanan Read Artist Poet Sculptor March 12, 1822–May 11, 1872 on the Occasion March 12, 1972 of the Sesquicentennial of His Birth*, comp. George Norman Highley (Glen Loch, Penn.: Printed by Graphic Arts Department of the Church Farm School, 1972), 25–26. I am grateful to Thomas M. Whitehead, Special Collections, Temple University Library, for assistance in obtaining a copy of this publication.

6 Mark Mayo Boatner III, *The Civil War Dictionary*, rev. ed. (New York: David McKay Company, Inc., 1988), 700. The horse, now stuffed, is preserved in the museum on Governor's Island, New York. Read's life-size study of Sheridan's head, also owned by ULC, is said to have been executed as a study for Philadelphia's large-scale version. The date on the canvas is illegible.

7 As of November, 2000, the Smithsonian Institution's Inventory of American Paintings listed what appear to be thirteen distinct versions, ranging in size from 14 by 12 inches to 140 by 106 inches. The 25¼ by 20⅜-inch canvas in the Milwaukee Art Museum, dated Rome, 1865, appears to be the earliest. I am grateful to Margaret Andera, Assistant Curator at the Milwaukee Art Museum, for information on this version.

8 On Sheridan's role in containing the fire and subsequent civil unrest, see O'Connor, *Sheridan the Inevitable*, 312–14.

9 Joan G. Wagner, *A History of the Art Collection of the ULC* (Chicago: Art Committee of the ULC, 2000), 12–13. In 1923 Gutzon Borglum's heroic statue of the mounted Sheridan on his famous ride was erected in Lincoln Park (see Ira J. Bach and Mary Lackritz Gray, *Chicago's Public Sculpture* [Chicago and London: The University of Chicago Press, 1983], 158–59).

10 Sallie A. Brock, "My Souvenirs. Buchanan Read—Rinehart—Powers," *Appleton's Journal* 14 (July 7, 1875): 76–79. I am grateful to Jack Perry Brown, Director, Ryerson & Burnham Libraries, AIC, for obtaining this and other references in *Appleton's Journal*.

Robert Reid

1 On Reid see *Artists by Themselves: Artists' Portraits from the National Academy of Design*, exh. cat. (New York: National Academy of Design, 1983), 130; William H. Gerdts, *American Impressionism* (New York: Abbeville Press, 1984), 181–85; and H. Barbara Weinberg, *The Lure of Paris: Nineteenth-Century American Painters and Their French Teachers* (New York: Abbeville Press, 1991), 246–50.

2 Weinberg, *The Lure of Paris*, 248.

Julius Rolshoven

1 D. Strazdes, "Frank Duveneck," in Theodore Stebbins, Jr., with essays by William H. Gerdts, Erica E. Hirshler, Fred S. Licht, and William L. Vance, *The Lure of Italy: American Artists and the Italian Experience, 1760–1914*, (Boston: Museum of Fine Arts, Boston; New York: Harry N. Abrams, 1992), 356–68.

2 D. Strazdes, "Frank Duveneck," 356. Biographical information about Rolshoven is derived from Virginia Couse Leavitt, "Julius Rolshoven," in Charles C. Eldredge and J. Gray Sweeney et al., *Artists of Michigan from the Nineteenth Century*, exh. cat. (Muskegon: Muskegon Museum of Art, 1987), 148–154; Gerdts, *Art Across America* 2: 244, 355, n. 16; Michael Quick, *American Expatriate Painters of the Late Nineteenth Century*, exh. cat. (Dayton, Oh.: The Dayton Art Institute, 1976), 126–127; Earle, *Biographical Sketches*, 269–71.

3 See article by Aubyn Trevor-Battye, "Julius Rolshoven, Painter," *Artist* 26 (December 1899): 185–96, for a contemporary account of Rolshoven's portrait career in London.

4 Clyde H. Burroughs, "The Passing of Julius Rolshoven," *El Palacio* 30 (Feb. 4, 1931): 77–78.

5 Earle, *Biographical Sketches*, 271.

6 H. C. Payne, "The Exhibition of the Western Society of Artists," *The Sketch Book* 5 (Jan. 1906): 221.

Seymour Rosofsky

1 Biographical information is derived from the following sources: Barbara Tannenbaum, "The Paintings of Seymour Rosofsky" (Ph.D. diss., University of Michigan, 1993); Hayden Herrera, Franz Schulze, and Barbara Tannenbaum, eds., *Seymour Rosofsky* (Chicago: Columbian Press, 1985); Dennis Adrian, *The Art of Seymour Rosofsky*, exh. cat. (Urbana-Champaign, Ill.: Krannert Art Museum, University of Illinois, 1984).

2 The phrase "Monster Roster" was coined by Franz Schulze in "Chicago Letter," *Art News* 57 (Feb. 1959): 49, 56.

3 Artists obtained transcripts of Dubuffet's lecture, "Anticultural Positions," for distribution. See Dennis Adrian, "Private Treasures, Public Spirit." *Art in Chicago 1945–1995*, exh. cat. (Chicago: Museum of Contemporary Art, 1996), 75. In his lecture, Dubuffet advocated the values of savagery and madness. See Richard L. Feigen, ed., *Dubuffet and the Anticulture* (New York: Richard L. Feigen & Co., 1969), facsimile of Dubuffet's manuscript located between pages 8 and 10.

4 Franz Schulze, "Rosofsky: The Struggle of Art and Art History," in *Seymour Rosofsky*, 48, 51.

5 Tannenbaum, "The Paintings of Seymour Rosofksy," 149.

6 Tannenbaum, "The Paintings of Seymour Rosofsky," 70.

7 Hayden Herrera, "Seymour Rosofsky," in *Seymour Rosofsky*, 29–33.

Edgar A. Rupprecht

1 Dennis Loy, "Conservator Discovers a Hidden Treasure," *State of the Union: Official Magazine of the ULC* 62 (Sept. 1987), inside cover.

2 Biographical information has been gathered from Sparks, "Biographical Dictionary," 2: 583. Loy, "Hidden Treasure"; undated, manuscript biography written by Edith Rupprecht Sandborg (artist's sister), ca. 1987, curatorial file UL1976.45A, ULC.

3 Loy, "Hidden Treasure."

John Collier Sabraw

1 John Collier Sabraw, *I Wouldn't Be Scared* (New York: Orchard Books, 1990).

2 John Collier Sabraw discussion with Elyse L. Klein, ULC paintings conservator, May 2000. Notes on the discussion are in curatorial file UL2000.1, ULC.

3 Artist's written statement accompanying the exhibition, "John Sabraw," Thomas McCormick Works of Art, Chicago, February 1999. See also Fred Camper, "Escape from the Image Glut. Show Review," *Chicago Reader*, February 5, 1999.

4 I am grateful to the artist for discussing the painting with me (February 3, 2002).

William Samuel Schwartz

1 Biographical information about Schwartz can be found in Douglas Dreishpoon, *The Paintings, Drawings and Lithographs of William S. Schwartz*, exh. cat. (New York: Hirschl & Adler Galleries, 1984).

2 William Samuel Schwartz, "An Artist's Love Affair with America," *Chicago Tribune Magazine*, April 5, 1970, 65.

Hollis Sigler

1 Dennis Adrian, *Chicago: Some Other Traditions*, exh. cat. (Madison, Wis.: Madison Art Center, 1983), 56.

2 Hollis Sigler interview by Barbara Tannenbaum, June 26, 1986, quoted in Barbara Tannenbaum, *Hollis Sigler: Paintings, Drawings and Prints 1976–1986*, exh. cat. (Akron, Oh.: Akron Art Museum, 1986), 4. See also James Yood, "Hollis Sigler: An Appreciation," in Susan M. Love, M.D. and James Yood, *Hollis Sigler's Breast Cancer Journal* (New York: Hudson Hills Press, 1999), 14.

3 Yood, "Hollis Sigler: An Appreciation," 15. Sigler was 37 at the time of her initial diagnosis.

Jeanette Pasin Sloan

1 Artist's statement in John Arthur, *Jeanette Pasin Sloan*, exh. cat. (New York: Tatistcheff and Company, Inc., 1995): inside front cover.

2 Gerrit Henry, *Jeanette Pasin Sloan* (New York: Hudson Hills Press, 2000), 16; Marty Stewart Huff, *Jeanette Pasin Sloan*, exh. cat. (Milwaukee: University of Wisconsin Art Museum, University of Wisconsin-Milwaukee, 1995), 4.

3 Henry, *Jeanette Pasin Sloan*, 22.

4 Henry, *Jeanette Pasin Sloan*, 11.

Ethel Spears

1 Information on Spears may be found in C. J. Bulliet, "Artists of Chicago Past and Present: No. 82 Ethel Spears," *Chicago Daily News*, May 1, 1937; Louise Dunn Yochim, *Role and Impact: The Chicago Society of Artists* (Chicago: Chicago Society of Artists, 1979), 274; and Patricia Trenton, ed., *Independent Spirits: Women Painters of the American West, 1890–1945* (Berkeley, Calif.: Autry Museum of Western Heritage in association with University of California Press, 1995), 195. Spears's year of birth is generally given as 1903, but in an undated "Publicity Sheet for Exhibitors" she completed for the Chicago Public Library (Chicago Public Library artists' files) she gave her birthdate as October 5, 1902, with which Trenton agrees.

2 Badger's comments as recalled by Barton Faist (telephone interview with Barton Faist, January 18, 2001). I am also grateful to Barton Faist for his expertise in dating *Oak Street Beach*.

Robert Spencer

1 For information on Spencer see Thomas Folk, *The Pennsylvania School of Landscape Painting: An Original American Impressionism*, exh. cat. (Allentown, Pa.: Allentown Art Museum, 1984), 14–15, 67–69; Folk, *The Pennsylvania Impressionists* (Madison, N. J. and Teaneck, N.J.: Fairleigh Dickinson University Press, 1997), ch. 7; and Lauren Robb, *The Pennsylvania Impressionists: Painters of the New Hope School*, exh. cat. (Washington, D.C.: Taggart & Jorgensen Gallery, 1990), 7.

2 See Folk, *The Pennsylvania Impressionists*, 87.

3 Spencer quoted in Folk, *The Pennsylvania School*, 69.

4 Spencer quoted in Frederic Newlin Price, "Spencer—And Romance," *International Studio* 76 (March 1923): 489. See also Folk, *The Pennsylvania Impressionists*, 84–85.

5 Folk, *The Pennsylvania School*, 72, 87.

6 R[ichard] F. S[now], "The American City: A Gathering of Turn-of-the-Century Paintings," *American Heritage* 27 (April 1976): 36.

Henry Fenton Spread

1 For information on Spread see Ralph Clarkson, "Chicago Painters, Past and Present," *Art and Archaeology* 12 (Sept.–Oct., 1921): 133–34; Sparks, "A Biographical Dictionary," 2: 617–18; and Gerdts, *Art Across America*, 2:292.

2 *The Spirit of the ULC 1879–1926* ([Chicago: ULC, 1926]), 40.

3 I am grateful to Joel Dryer for calling my attention to the fact of the portrait's being a commission: see "Art Notes," *Inter Ocean*, Dec. 22, 1889.

4 Suffolk County Courthouse, Boston.

Anna Lee Stacey

1 For information on Anna Stacey see Frances Cheney Bennett, ed., *History of Music and Art in Illinois* (Philadelphia: Historical Publishing Co., 1904), 515–16; questionnaire completed by the artist in "Illinois Artists: Art Institute Questionnaires 1918 and Illinois Academy of Fine Arts Biographical Data 1929," manuscript in Ryerson & Burnham Libraries, AIC, vol. 4; Sparks, "A Biographical Dictionary," 2: 618.

2 Bennett, ed., *History of Music and Art in Illinois*, 516.

John Franklin Stacey

1 Sources of information on Stacey include Frances Cheney Bennett, ed., *History of Music and Art in Illinois* (Philadelphia: Historical Publishing Co., 1904), 511–12; questionnaire completed by the artist in "Illinois Artists: Art Institute Questionnaires 1918 and Illinois Academy of Fine Arts Biographical Data 1929," manuscript in Ryerson & Burnham Libraries, AIC, vol. 4; Sparks, "A Biographical Dictionary," 2: 619.

2 Gerdts, *Art Across America*, 2:299.

3 Eleanor Jewett, "Chicago Loses Two Painters to California," *Chicago Tribune*, September 12, 1937.

4 Gerdts, *Art Across America*, 2: 299.

5 On the Mystic art colony see Gerdts, *Art Across America*, 1:121.

6 Bennett, ed., *History of Music and Art in Illinois*, 511–12.

7 The reflected light on the sides of the distant white frame houses suggests that the river, which runs north-south toward the shoreline, is here viewed from the west.

8 On the image of New England in late nineteenth- and early twentieth-century American art, see William H. Truettner and Roger B. Stein, eds., *Picturing Old New England: Image and Memory*, exh. cat. (Washington, D.C.: National Museum of American Art, Smithsonian Institution, 1999), especially ch. 1: Roger Stein, "After the War: Constructing a Rural Past," 15–41.

Antonin Sterba

1 Unconfirmed information courtesy of the Illinois Historical Art Project.

2 Information on Sterba is taken from a questionnaire completed by the artist in "Illinois Artists: Art Institute Questionnaires 1918 and Illinois Academy of Fine Arts Biographical Data 1929," manuscript in Ryerson & Burnham Libraries, AIC, vol. 4; C. J. Bulliet, "Artists of Chicago Past and Present: No. 32 Antonin Sterba," *Chicago Daily News*, Sept. 28, 1935; obituary, *Chicago Tribune*, April 9, 1963; brief biography in *Antonin Sterba (1875–1963)*, exhibition brochure (Sturgeon Bay, Wis.: The Miller Art Center, 1996), unpaginated. There are two villages in the Czech Republic (the former Czechoslovakia) named Heřmaneč (or Heřmanče in the genitive form), located 16 kilometers apart and about 120 kilometers southeast of Prague in the Czech-Moravian Hills near the border between Moravia and Bohemia. It is not known which village is the artist's birthplace. I am indebted to Jan and Eva Roček for this information.

3 Bulliet, "Artists of Chicago." Ivan Albright would become Sterba's most famous pupil at the Art Institute.

4 Bulliet, "Artists of Chicago," states that Sterba spent 1929 in the Los Angeles vicinity. The brochure of his solo exhibition at Jules Kievits Galleries, of which the copy at the Ryerson Library, Art Institute of Chicago, is hand-dated 12/18/28, notes that the artist is spending his leave of absence in Pasadena.

Svend Rasmussen Svendsen

1 Information on Svendsen is taken from Algot E. Strand, *A History of the Norwegians in Illinois* (Chicago: John Anderson Publishing Company, 1905), 491; unsigned, undated manuscript biography in the curatorial files UL1906.1, ULC; and Gerdts, *Art Across America*, 2:309. See also "Svend Svendsen," *The Arts* 4 (Dec. 1895): 183, and "Svend Svendsen," *Brush and Pencil* 6 (April 1900): 28.

2 Strand, *A History of the Norwegians*, 491. Another source states that Svendsen emigrated from Norway directly to Chicago in 1882 ("Svend Svendsen," *The Arts* 4 [Dec. 1895]: 183).

3 See "Svend Svendsen," *The Arts*, 183.

4 Entry on Svendsen in the Illinois Historical Art project website, www.illinoisart.org (consulted Jan. 11, 2001).

5 Lowell M. Comee, New York City, to Tayler Hay, Manager of ULC, March 24, 1969, curatorial file UL1906.1, ULC. Comee describes how his father supported Svendsen's artistic efforts in the last years of his life.

6 "Poverty Killed Him," *Art Digest* 5 (Nov. 15, 1930): 5.

7 "Art," *Chicago Times Herald*, March 19, 1899.

8 Dennis J. Loy, "On the Cover," *State of the Union: Official Magazine of the ULC* 66 (Jan. 1989): inside front cover.

9 "Svend Svendsen," *Brush and Pencil*, 28.

10 "Art," *Chicago Tribune*, Mar. 19, 1899.

11 "Art and Artists," *Chicago Post*, March 18, 1899.

George Gardner Symons

1 For information on Symons see Thomas Shrewsbury Parkhurst, "Gardner Symons, Painter and Philosopher," *Fine Arts Journal* 34 (Nov. 1916): 557–65; Earle, *Biographical Sketches*, 300–301; Doreen Bolger Burke, *A Catalogue of Works by Artists Born between 1846 and 1864*, vol. 3 of *American Paintings in the Metropolitan Museum of Art*, ed. Kathleen Luhrs (New York: Metropolitan Museum of Art, 1980), 406–7. Symons's date of birth has been a matter of dispute, but his death certificate gives October 27, 1861, as the date. In the mid-1890s the artist anglicized his surname, originally Simons (Nancy Dustin Wall Moure, "A History of the Laguna Beach Art Association to 1955" in *Publications in Southern California Art 4, 5, 6* [Los Angeles: Dustin Publications, 1999]: 7).

2 Moure, "A History of the Laguna Beach Art Association," 7. On Symons's time in California, see Gerdts, *Art Across America*, 3:307.

3 Burke, *American Paintings*, 3:407.

4 Saul B. Cohen, ed., *The Columbia Gazeteer of the World* (New York: Columbia University Press, 1998), 2:2013.

A. Frederic Tellander

1 Little information is available on Tellander. Biographical data given here is taken from Tellander's introduction to the brochure for "An Exhibition of Paintings by Frederic Tellander" held at Chicago Galleries Association, [1926], unpaginated; and manuscript notes titled "Artist's Data fr. Paxton, Ill. Record 11/15/27," both in the Tellander pamphlet file in the Ryerson & Burnham Libraries, AIC; Sparks, "A Biographical Dictionary," 2:632–33; and Peter Falk, ed., *Who Was Who in American Art 1546–1975: 400 Years of Artists in America* (Madison, Conn.: Sound View Press, 2000), 3:3266 (where he is listed as A. Frederic Tellander).

2 Information kindly supplied by Ralph H. Bower, who knew the artist in his last years as a resident of a Goshen, Indiana, nursing home. Ralph H. Bower, e-mail message to Marianne Richter, Curator, Union League Club of Chicago, March 17, 2000, and letter to Wendy Greenhouse, January 17, 2001.

3 Information courtesy of Ralph H. Bower.

4 On the development of Ogunquit as an artists' haunt, see William H. Gerdts, "Surf and Shore: Nineteenth-Century Views of the Beach" in Russell Lynes, William H. Gerdts, and Donald B. Kuspit, *At the Water's Edge: 19th and 20th Century American Beach Scene*, exh. cat. (Tampa, Fla.: Tampa Museum of Art, 1989), 30–31.

5 Lena M. McCauley, "Surf at Ogunquit Wins," *Chicago Evening Post Magazine of the Art World*, March 8, 1927; see also "News of the Artists and Galleries," *Chicago Daily News*, Mar. 9, 1927.

6 *Surf at Ogunquit* was the first marine painting added to the Municipal Art League's collection.

7 Tellander quoted in introduction to the brochure for "An Exhibition of Paintings by Frederic Tellander," held at the Chicago Galleries Association, [1926] (copy in Tellander pamphlet file, Ryerson & Burnham Libraries, AIC).

Leslie Prince Thompson

1 Biographical information about Leslie Thompson has been derived from Sandra P. Lepore, "The Works of Leslie Prince Thompson," exh. brochure (Boston: The St. Botolph Club, 1992) and R. H. Ives Gammell, *The Boston Painters, 1900–1930*, Elizabeth Ives Hunter, ed. (Orleans, Mass.: Parnassus Imprints, 1986), 194–95.

2 The best history of Fenway Studios is found in Nancy Allyn Jarzombeck, *Mary Bradish Titcomb and Her Contemporaries: The Artists of Fenway Studios 1905–1939*, exh. cat. (Boston, Mass.: Vose Galleries, 1998).

Edward Joseph Finley Timmons

1 Irene Alexander, "Noted Artist Joins Colony in Carmel: Edw. J. F. Timmons Portrait Painter Here from Chicago," *Monterey Peninsula Herald*, March 13, 1945. The writer discusses Timmons's preference for the Old Masters.

2 As quoted in Alexander, "Noted Artist." Alexander's article provided biographical information, along with *Who's Who in Chicago*; *The Book of Chicagoans: A Biographical Dictionary of Leading Living Men and Women of the City of Chicago and Environs*. Chicago: A. N. Marquis and Co., 1941; *Chicago Illustrated News*, February 7, 1989; Sparks, "Biographical Dictionary," 2:635. See also "New Paintings in the Club Collection." *Men and Events* 43 (October 1967): 28.

Charles Yardley Turner

1 On Turner see James William Pattison, "The Mural Decorations of C. Y. Turner, at Baltimore, Maryland," *International Studio* 24 (Jan. 1905): lvii–lxi; Peggy and Harold Samuels, *The Illustrated Biographical Encyclopedia of Artists of the American West* (Garden City, N.Y.: Doubleday & Company, Inc., 1976), 493; and William H. Truettner and Roger B. Stein eds., *Picturing Old New England: Image and Memory*, exh. cat. (Washington, D.C.: National Museum of American Art, Smithsonian Institution, 1999), 227. Turner was the subject of a master's thesis: Evdokia Savidou, "The Career of Painter Charles Yardley Turner (1850–1910)" (master's thesis, Queens College of the City University of New York, 1986), cited in Gerdts, *Art Across America*, 1:387, n. 42.

2 The most popular depiction of this subject was John Rogers's "*Why Don't You Speak For Yourself, John?*" (1885), one of the most successful of his numerous mass-produced plaster sculpture groups. See Roger B. Stein, "Gilded Age Pilgrims," in *Picturing Old New England*, 47–48. Turner's painting entitled *The Courtship of Miles Standish* (1884) is unlocated. Along with his *John Alden's Letter* it was exhibited at the World's Columbian Exposition in a group of ten paintings that garnered an award for the artist. It is reproduced in Carolyn Kinder Carr, ed., *Revisiting the White City: American Art at the 1893 World's Fair*, exh. cat. (Washington, D.C.: National Museum of American Art and National Portrait Gallery, Smithsonian Institution, 1993), 332.

3 In his poem Longfellow describes Standish thus: "Short of stature he was, but strongly built and athletic;/Broad in the shoulders, deep-chested, with muscles and sinews of iron;/Brown as a nut was his face, but his russet beard was already/Flaked with patches of snow, as hedges sometimes in November." Alden is "Fair-haired, azure [sic]-eyed, with delicate Saxon complexion."

4 See William R. Taylor, *Cavalier and Yankee: The Old South and American National Character* (Garden City, N.Y.: Doubleday and Co., 1963). See also Stein, "Gilded Age Pilgrims," 51.

Ross Turner

1 J. M. Thacher, Chicago, to Union League Club president John McGregor Adams, 28 June 1886, transcription of letter in the ULC Board Minutes for 1886 (vol. 1, p. 355).

2 Wim Swaan, *The Gothic Cathedral* (London: Elek Books Limited, 1969), 226.

3 Information on Turner is taken from *The Collector* 5 (Feb. 15, 1894): 118, and F. W. C., "Turner, Ross Sterling" in *Dictionary of American Biography* (New York: Charles Scribner's Sons, 1928–1996), 19:70–71.

4 Turner served as a teacher in watercolor painting to Celia Thaxter, best known as a patron of Childe Hassam, and he worked on the Isle of Shoals, Thaxter's private art colony, painting impressionist watercolor images of the flowers in her garden. See William H. Gerdts, "Three Themes," in Warren Adelson, Jay E. Cantor, and William H. Gerdts, *Childe Hassam, Impressionist* (New York: Abbeville Press, 1999), 178; see also 8, 125.

Walter Ufer

1 Stephen L. Good, "Walter Ufer," in *Pioneer Artists of Taos*, Laura Bickerstaff, ed., rev. and expanded ed. (Denver: Old West Publishing, 1983), 152.

2 "The Art of Walter Ufer," *El Palacio* 12 (April 15, 1922): 108–109.

James Valerio

1 John Arthur, *Realists at Work* (New York: Watson-Guptill Publications, 1983), 132. Biographical information has been drawn from the following sources: Craig Adcock, *Nocturnes and Nightmares*, exh. cat. (Tallahassee, Fla.: Florida State University Fine Arts Gallery & Museum, 1987), 12, 44–45; John Arthur, "James Valerio," in *Painting at Northwestern: Conger, Paschke, Valerio*, exh. cat. (Evanston, Ill.: Mary and Leigh Block Gallery, 1986), 50–53; John Arthur, *Realists at Work*, 130–43; Pamela White Curran, *James Valerio: Recent Paintings*, exh. cat. (Iowa City, Iowa: University of Iowa Museum of Art, 1994).

2 Valerio's statement about *Night Fires* appears in Curran, *James Valerio*, 15.

3 Arthur, *Realists at Work*, 137. The size of the projected image determines the size of the canvas.

4 Artist's statement in Curran, *James Valerio*, 7.

Clark Greenwood Voorhees

1 Harold Spencer, Susan G. Larkin, and Jeffrey W. Anderson, *Connecticut and American Impressionism*, exh. cat. (Storrs, Conn.: The William Benton Museum of Art, The University of Connecticut, Storrs, 1980), 176. Henry Ward Ranger is acknowledged as the founder of the Old Lyme art colony. Biographical information for this essay has been drawn from the entry on Voorhees in this book, 175–76, and from Barbara J. MacAdam, *Clark G. Voorhees 1871–1933*, exh. cat. (Old Lyme,Conn.: Lyme Historical Society, Florence Griswold Museum, 1981), 6–16.

2 Voorhees was elected a trustee of the library in 1919 and in 1927 was appointed president; see Spencer, Larkin, and Anderson, *Connecticut and American Impressionism*, 176 and MacAdam, *Clark G. Voorhees*, 15.

3 MacAdam, *Clark G. Voorhees*, 8.

4 MacAdam, *Clark G. Voorhees*, 16.

Frank Russell Wadsworth

1 Wadsworth's short career is little documented. Information is taken from brief obituaries in *American Art News* 4 (Oct. 28, 1905) and *Chicago Chronicle*, Nov. 19, 1905; Peter Falk, ed., *Who Was Who in American Art 1546–1975: 400 Years of Artists in America* (Madison, Conn.: Sound View Press, 2000), 3: 3432; and the website of the Illinois Historical Art Project (www.illinoisart.org), consulted Jan. 23, 2001.

2 "Memorial Exhibition of Works by Frank Russell Wadsworth," AIC, 1906, #297. There the title is given as *A River "Lavanders" Madrid*, almost certainly a corruption of *lavadero*, meaning a laundry or washing place (see note 3 below).

3 Edwin B. Williams, *Spanish and English Dictionary/Diccionario inglés y españñol* (New York: Holt, Rinehart and Winston, 1962), 352.

William Wendt

1 Information on Wendt is taken from Nancy Dustin Wall Moure, *William Wendt 1865–1946*, exh. cat. (Laguna Beach, Calif.: Laguna Beach Museum of Art, 1977); William H. Gerdts, *All Things Bright & Beautiful: California Impressionist Paintings from The Irvine Museum*, exh. cat. (Irvine, Calif.: The Irvine Museum, 1998), 105, 190; and John Alan Walker, *Documents on the Life and Art of William Wendt (1865–1946), California's Painter Laureate of the* Paysage moralisé (Big Pine, Calif.: n.p., 1992). For a bibliography of works on Wendt see Gerdts, *Art Across America*, 3:359, n. 23.

2 Gerdts, *All Things Bright & Beautiful*, 190, states that Wendt attended classes briefly at AIC. Walker, *Documents*, in his chronology of Wendt's life, does not mention any formal training, and Earle, *Biographical Sketches*, 334, states that he was self-taught.

3 In his chronology, Walker, *Documents*, 46–67, disagrees with other sources on a number of key dates in Wendt's biography before 1906.

4 Wendt often gave his works titles that reflect the inspiration of epic poetry or biblical passages. Gerdts, *All Things Bright & Beautiful*, 105.

5 "Chicago Art Echoes," *American Art News* 3 (Mar. 11, 1905): [5].

Guy Carleton Wiggins

1 Biographical information is derived from Harold Spencer, Susan G. Larkin, and Jeffrey W. Anderson, *Connecticut and American Impressionism*, exh. cat. (Storrs, Conn.: The University of Connecticut, 1980), 178–79; Adrienne L. Walt, "Guy Wiggins: American Impressionist," *American Art Review* 4 (Dec. 1977): 100–113; and Campanile Galleries, *Guy C. Wiggins, American Impressionist*, exh. cat. (Chicago: Campanile Galleries, 1970).

2 Spencer, Larkin, and Anderson, *Connecticut and American Impressionism*, 179.

3 Spencer, Larkin, and Anderson, *Connecticut and American Impressionism*, 179.

4 Walt, "Guy Wiggins," 107.

Irving Ramsey Wiles

1 Information on Wiles is taken from Gary A. Reynolds, *Irving R. Wiles*, exh. cat. (New York: National Academy of Design, 1988), which includes a well-referenced biography of the artist as well as a bibliography. See also Doreen Bolger Burke, *A Catalogue of Works by Artists Born between 1846 and 1864*, vol. 3 of *American Paintings in the Metropolitan Museum of Art*, ed. Kathleen Luhrs (New York: Metropolitan Museum of Art, 1980), 412–14, and *Artists by Themselves: Artists' Portraits from the National Academy of Design*, exh. cat. (New York: National Academy of Design, 1983), 80.

2 Dana Carroll, "The Varied Work of Irving R. Wiles," *Arts and Decoration* 1 (Aug. 1911): 402.

3 "The Week in Art," *The New York Times Review of Books and Art*, Jan. 6, 1900, quoted in Reynolds, *Irving R. Wiles*, 22.

4 Carroll, "The Varied Work of Irving R. Wiles," 402.

Richard Willenbrink

1 Richard Willenbrink, undated proposal for *Dwight David Eisenhower*, curatorial file UL1991.1, ULC.

2 Dennis Adrian, *Chicago: Some Other Traditions*, exh. cat. (Madison, Wis.: The Madison Art Center, 1983), 76.

3 Richard Willenbrink, undated description of completed painting, curatorial file UL1991.1, ULC.

4 Dennis Loy, "Richard Willenbrink: Portrait of Dwight D. Eisenhower, 1990," *State of the Union: Official Magazine of the ULC* 67 (April 1991): 2.

James Winn

1 James Winn, "Artist's Statement," in *James Winn*, exh. cat. (Chicago: Frumkin and Struve Gallery, 1985), [1]. In addition to the Frumkin and Struve catalogue, biographical information is drawn from Kent Smith, *In a New Light, Three Views of the Heartland: Paintings and Drawings by George Atkinson, James D. Butler and James Winn*, exh. cat. (Springfield, Ill.: Illinois State Museum, 1987); and Sherry French, *James Winn: Acts of Light*, exh. cat. (New York: Sherry French Gallery, Inc., 1988). For information about the Heartland Painters, see John Arthur, "Competing Prospects: The Contemporary Prairie," in Joni Kinsey, *Plain Pictures: Images of the American Prairie*, exh. cat. (Washington, D.C.: Published for the University of Iowa Museum of Art by the Smithsonian Institution Press, 1996), 159–210.

2 Winn himself is not a Mennonite but a self-described "orthodox Christian in the puritan tradition." See Smith, *In a New Light*, [3].

3 French, *James Winn*, [3].

4 James Winn, "Artist's Statement."

Karl Wirsum

1 Information about Wirsum is taken from Dennis Adrian, *Karl Wirsum*, exh. cat. (Urbana-Champaign, Ill.: Krannert Art Museum, University of Illinois at Urbana-Champaign, 1991) and Roger Brown, *Karl Wirsum: A Retrospective*, exh. cat. (Glen Ellyn, Ill.: Arts Center Gallery, College of DuPage, 1988), which is an interview with Wirsum. See also Franz Shulze, *Fantastic Images: Chicago Art Since 1945* (Chicago: Follet Publishing Company, 1972).

2 Brown, *Karl Wirsum: A Retrospective*, unpaginated [1]

3 Brown, *Karl Wirsum: A Retrospective*, unpaginated, [1].

4 Adrian, *Karl Wirsum*, 17 n. 5.

5 Brown, *Karl Wirsum: A Retrospective*, unpaginated [3].

6 Adrian, *Karl Wirsum*, 13–14.

7 Adrian, *Karl Wirsum*, 7.

Alexander Helwig Wyant

1 Wyant's estate sale, reported in *The Collector* 5 (Feb. 1894): 126–27, included a painting entitled *Autumn* (#9, sold for $110) as well as an *Autumn Landscape* (#125, $370). Several works were purchased by dealers. The date of the ULC's acquisition of this clearly late Wyant painting suggests it may have been purchased from one such dealer.

2 For information on Wyant see Doreen Bolger Burke, *A Catalogue of Works by Artists Born between 1846 and 1864*, vol. 3 of *American Paintings in the Metropolitan Museum of Art* (New York: Metropolitan Museum of Art, 1980), 411–12, and Annette Blaugrund, Albert Boime, D. Dodge Thompson, H. Barbara Weinberg, and Richard Guy Wilson, *Paris 1889: American Artists at the Universal Exposition*, exh. cat. (Philadelphia: Pennsylvania Academy of the Fine Arts; New York: Harry N. Abrams, Inc., Publishers, 1989), 232.

3 Eliot Clark, "The Art of Alexander Wyant," *Art in America* 2 (June 1914): 311.

Ray Yoshida

1 James Jensen, *Ray Yoshida: A Retrospective 1968–1998*, exh. cat. (Honolulu, Hawaii: The Contemporary Museum, 1998), 8.

2 See Roger Brown, "Rantings and Recollections," *Who Chicago?: An Exhibition of Contemporary Imagists*, exh. cat. (Sunderland, Eng.: Ceolfirth Gallery, Sunderland Arts Centre, 1980), 31; Jim Nutt, "Mr. Yoshida," in Jensen, *Ray Yoshida*, 12.

3 James Yood, "Reading Ray Yoshida," in Jensen, *Ray Yoshida*, 14–16.

4 Yood, "Reading Ray Yoshida," 15; Yoshida quoted in Dennis Adrian, *Ray Yoshida: A Review*, exh. cat. (Chicago: N.A.M.E. Gallery, 1984), 12.

5 Yood, "Reading Ray Yoshida," 16.

CHECKLIST

Vito Acconci
(b. 1940)
Wav(er)ing Flag, 1990
color lithograph in six panels;
17 15/16 x 23 7/8 inches
(43.18 x 58.42 cm.) printed at
Landfall Press, Chicago
signed lower right,
sixth panel: *lp/ixAcconci90*,
provenance: ULC, 2001
UL2001.1A–F

David Acuff
(b. 1939)
Basking, 1981
watercolor on paper;
29 x 39 inches (73.66 x 99.06 cm.)
signed lower right:
DAVID/ACUFF
provenance: UL C&AF
1981–1986; ULC, 1986
UL1986c.7

Jean Crawford Adams
(1890–1972)
View of the Board of Trade
oil on canvas; 31 x 23 inches
(78.74 x 58.42 cm.)
unsigned,
provenance: Barton Faist, ?–1988;
ULC, 1988
UL1989.11

Adam Emory Albright
(1862–1957)
*Home from the Harvest
(The Path from the Fields)*, 1914
oil on canvas; 42 x 60 inches
(106.68 x 152.40 cm.)
signed lower right:
ADAM EMORY ALBRIGHT 1914
provenance: Mrs. Alexander Bruce,
?–1977; UL C&AF,
1977–1986; ULC, 1986
UL1986c.8

*Log in the River
(Boy on a Log)*, ca. 1908
Page 24

Ivan Le Lorraine Albright
(1897–1983)
*Knees of Cypress (Reflections
of a Cypress Swamp)*, 1965
Page 26

*Sketchbook for Reflections of a Cypress
Swamp*, 1965
leather-bound book with 25 pages of
notes and sketches in both graphite and
ballpoint pen;
11 x 8 1/2 x 3/4 inches
(27.94 x 21.59 x 1.91 cm.)
signed title page: *Ivan Albright /*

*Swamp— / Georgia—March April
1965 / Some notes about a swamp.*
provenance: Senator William Benton,
by 1970–1973; Charles and Marjorie
Benton, 1973–1989; ULC, 1989
UL1991.6.1

Joseph Allworthy
(1897–1991)
Still Life, 1931
oil on canvas mounted on board;
40 x 29 3/4 inches (101.60 x 75.57 cm.)
signed lower left: *Allworthy 31*;
signed on reverse:
Joseph Allworthy / Jan. 5, 1931
provenance: ULC, 1931
UL1931.1

Anonymous, American
Portrait of Thomas Jefferson,
19th century
oil on canvas; 27 1/2 x 69 inches
(69.85 x 175.26 cm.)
unsigned
provenance: John R. Walsh,
?–1895; ULC, 1895
gift of John R. Walsh
UL1895.23

Anonymous, American
Theodore Roosevelt, 1910
oil on canvas; 30 x 25 inches
(76.2 x 63.5 cm.)
signed lower right: *Copyright, 1910*
provenance: ULC, 1919
UL1919.1

Anonymous, Dutch
Rozenburg Art Nouveau Vase, 1910
ceramic; 23 1/2 x 12 x 12 inches
(59.69 x 30.48 cm.)
marked on base: *Rozenburg/Den Haag*
and *VW415*
provenance: ULC, by 1988
UL1988.34

Anonymous, Dutch
Rozenburg Art Nouveau Vase, 1910
ceramic; 18 x 10 x 10 inches
(45.71 x 25.4 x 25.4 cm.)
marked on base: *Rozenburg/Den Haag*
and *VW440*
provenance: ULC, by 1988
UL1988.35

Anonymous, Japanese
Cloisonné Enamel Vase, 1880
cloisonné and enamel
on porcelain;
48 1/2 x 19 1/2 x 19 1/2 inches
(123.19 x 49.53 x 49.53 cm.)
unsigned
provenance: ULC, 1901
UL1901.11

Anonymous, Japanese
Satsuma Vase, 1880
porcelain; 8 5/8 x 11 1/4 x 8 inches
(21.91 x 28.58 x 20.32 cm.)
unsigned
provenance: ULC, 1901
UL1901.10

Anonymous, Japanese
Vase with Bird, ca. 1900
pottery, lacquer, and gold;
12 x 7 1/4 x 8 1/2 inches
(30.48 x 18.42 x 21.59 cm.)
unsigned
provenance: ULC, 1988
UL1988.6

Anonymous, Japanese
*Vase with Frieze of Bird
Feeding Its Young*, ca. 1910
porcelain; 14 7/8 x 7 x 7 inches
(37.78 x 17.78 x 17.78 cm.)
unsigned
provenance: ULC, 1988
UL1988.7

Anonymous, Japanese
*Vase with Frieze of
Attacking Birds*, ca. 1910
porcelain;
14 1/2 x 7 1/2 x 7 1/2 inches
(36.83 x 19.05 x 19.05 cm.)
unsigned
provenance: ULC, 1988
UL1988.8

Anonymous, Japanese
Elephant Attacked by Tigers,
ca. 1890s
bronze;
28 1/2 x 35 x 16 1/2 inches
(72.39 x 88.9 x 41.91 cm.)
cast mark on belly:
Nihon Genry Usai Seiya Sei(?)
provenance: Grant's Auction Gallery,
ca. 1945; William Bartholomay, Jr.,
ca. 1945–1968; ULC, 1968
gift of Mrs. Ralph E. Clark, Jr.,
in memory of
William Bartholomay, Jr..
UL1968.1

Joseph Allworthy, *Still Life*, 1931

Anonymous, Native American
Yei Rug (Farmington—Shiprock),
ca. 1930
wool; 42 x 70 inches
(106.68 x 177.80 cm.)
unsigned
provenance: Foorman L. Mueller
to 1980;
UL C&AF, 1980–1986; ULC, 1986
UL1986C.6

Anonymous, Native American
Three Concho Belts, 20th century
silver, copper, and turquoise;
41 x 1¾ inches (104.14 x 4.45 cm.);
40 x 1¼ inches
(101.60 x 3.175 cm.);
40⅝ x 1¾ inches
(103.19 x 4.45 cm.)
unsigned
provenance: Foorman L. Mueller to 1980;
UL C&AF, 1980–1986; ULC, 1986,
UL1986C.3, UL1986C.4, UL1986C.5

Anonymous, Persian
Hamadan Serebend Carpet,
20th century
wool; 93 x 68 inches
(236.22 x 172.72 cm.)
unsigned,
provenance: ULC, 1979
gift of Prince Moulay Abdellah
of Morocco
UL1979.48

John Taylor Arms
(1887–1953)
Momento Vivere
etching; 13¼ x 7 inches
(33.65 x 17.78 cm.)
unsigned
provenance: ULC, 1981
UL1981N.10

Charles Dudley Arnold
*Suite of Photographs of the World's
Columbian Exposition*, 1893
Page 28

Jeffrey Asan
(b. 1959)
Still Life on Case, 1986
oil on canvas; 40 x 50 inches
(101.60 x 127 cm.)
signed lower left: *ASAN*
provenance: ULC, 1986
UL1986.6

John James Audubon
(b. Haiti, 1785–1851)
Hawk Owl (Strix Funerea)—
Plate 378 from *Birds of America*, 1837
etching with engraving and
aquatint and added watercolors;
26 x 21¾ inches
(66.04 x 55.25 cm.)
inscribed in plate, lower left:
*Drawn from Nature by J. J. Audubon F.R.S.
F.L.S.*; inscribed in plate,
lower right: *Engraved, Printed,
& Coloured by R. Havell 1837*
provenance: ULC, 1957
UL1957A.13.2

*Red-Shouldered Hawk
(Falco lineatus)*— Plate 56 from
Birds of America, 1829
Page

Sharp Skinned Hawk (Falco Velox)—
Plate 374 from *Birds of America*, 1837
etching with engraving and
aquatint and added watercolors;
19¼ x 15 inches (48.90 x 38.1 cm.)
inscribed in plate, lower left:
*Drawn from Nature by J. J. Audubon
F.R.S. F.L.S.*; inscribed in plate,
lower right: *Engraved,
Printed, & Coloured by R. Havell 1837*
provenance: ULC, 1957
UL1957A.13.5

Stanley Hawk (Astur Stanleii)—
Plate 36 from *Birds of America*, 1837,
etching with engraving and
aquatint and added watercolors;
36 x 24½ inches (91.44 x 62.23 cm.)
inscribed in plate, lower left:
*Drawn from Nature and Published by
John J. Audubon F.R.S.E. F.L.S. M.W.S.*;
inscribed in plate, lower right:
*Engraved, Printed, & Coloured by R.
Havell & Son, London*
provenance: ULC, 1957
UL1957A.13.6

Lili Aver
(dates unknown)
*Brigadier General Nathan William
MacChesney, USAR*, 1943
plaster and pigment;
26 x 66 inches
(66.04 x 167.64 cm.)
signed bottom left:
LILI AVER 1943
provenance: ULC, 1981
UL1981.N.24

Frances S. C. Badger
(1904–?)
*Eighty-four Original Illustrations for
The Spirit of the Union League Club,
1879–1926*, ca. 1926
pen and ink on paper mounted
on board; sizes vary
unsigned
provenance: ULC, 1926
UL1988B.1–UL1988B.84

Martha Susan Baker
(1871–1911)
In an Old Gown, 1904
Page 32

Robert Barnes
(b. 1934)
Bocuse, 1980
Page 34

William Barron
(dates unknown)
Hidden Lake, 1988
oil on canvas; 25½ x 59½ inches
(64.77 x 151.13 cm.)
signed lower right: *W. Barron 88*
provenance: ULC, 1989
UL1989.2

Frederic Clay Bartlett
(1873–1953)
Martigues, France, 1905
Page 36

Don Baum
(b. 1922)
Andromeda, 1992
Page 38

Vera Berdich, *The Stare of Eternity*, 1972

Domus. 1992
Three-dimentional object comprised
of six lithographic panels;
16 ½ x 9 x 13 ½ inches
(41.91 x 22.86 x 34.29 cm.)
signed: 92/100 Don Baum '92
provenance: private collection to
2003, ULC, 2003
gift to the Union League Club in
honor of the artist
UL2003.3

Beatrice L. Becker
(b. 1927)
Still Life
casein; 24 x 36 inches
(60.96 x 91.44 cm.)
signed lower right: *Becker*
provenance: Clarence W. Elmer, 1967;
UL C&AF, 1967–1986; ULC, 1986,
UL1986C.10

Carl J. Becker
(active 1887–1899)
Portrait of Lt. Gen. Philip A. Sheridan, 1887
graphite pencil on paper;
17½ x 13½ inches (44.45 x 34.29 cm.)
signed middle left: *Carl J. Becker/
Washington 1887*.; signed lower right:
Yours Truly/ P.A. Sheridan./Lieut. General.
provenance: ULC, 1907
UL1907C.19

Emelle/Emilie Becker
(dates unknown)
*Floral Arrangement
(Floral Arrangement No. 2)*, 1922
oil on canvas; 35 x 22 inches
(88.9 x 55.88 cm.)
signed lower left: *E. Becker 1922*
provenance: Frederick E. Hack,
?–1952; UL C&AF, 1952–1986; ULC, 1986,
UL1986C.12

Floral Arrangement, 1922
oil on canvas; 35 x 22 inches
(88.9 x 55.88 cm.)
signed lower left: *E. Becker 1922*
provenance: Frederick E. Hack,
?–1952; UL C&AF, 1952–1986; ULC, 1986,
UL1986C.11

Bruno Beghé
(b. Italy, 1892–1972)
Portrait of Charles S. Deneen
oil on canvas;
30¼ x 25⅛ inches
(76.84 x 63.82 cm.)
signed lower left: *Bruno Beghé*
provenance: Mrs. Theodore House,
?–1959; ULC, 1959
gift of Mrs. Theodore House
UL1959.4

George Wesley Bellows
(1882–1925)
Girl with Flowers, 1915
Page 40

Antimo Beneduce
(1900–1977)
La Salute, Venice
watercolor;
30 x 20 inches
(76.2 x 50.8 cm.)
signed lower left: *Antimo Beneduce*
provenance: Paul Gunthorp
Warren, 1963; UL C&AF, 1963–1986;
ULC, 1986
UL1986C.16

Rainey Bennett
(1907–1998)
Quiet Lakeshore, 1952
watercolor and graphite pencil
on paper; 17½ x 22 inches
(44.45 x 55.88 cm.)
signed lower right:
Rainey / Bennett [?]52
provenance: UL C&AF, 1955–1987;
ULC, 1987
UL 1987.1

Vera Berdich
(b. 1915)
The Stare of Eternity, 1972
watercolor and collage
print on paper;
23¼ x 26⅛ inches
(59.06 x 66.36 cm.)
unsigned
provenance: ULC, 1988
UL1988.47

Louis Betts
(1873–1961)
Portrait of Luther Laflin Mills, 1899
oil on canvas; 45 x 30 inches
(114.3 x 76.2 cm.)
signed lower right: *Louis Betts 99*
provenance: Chicago Press Club,
1899–?; Chester M. MacChesney
?–1951; UL C&AF, 1951–1986; ULC, 1986
UL1986C.17

James William Pattison, 1906
Page 42

Joseph Pierre Birren
(1864–1933)
*The Court of the Lions,
Alhambra, Spain*, 1929
oil on canvas mounted
on board; 16 x 20 inches
(40.64 x 50.8 cm.)
signed lower right: *Joseph P. Birren –*
provenance: Summit Gallery,
?–1994; ULC, 1994
UL1994.13

Kathleen Blackshear
(1897–1988)
Zinnias, ca. 1929
Page 44

Harriet Blackstone
(1864–1939)
*Man with a Cane: Portrait of James Edwin
Miller*, ca. 1910–1912
Page 46

Roger F. Blakley
[b. 1942?]
Cetou, ca. 1973
bronze mounted on wood pedestal;
22½ x 16 x 6 inches
(57.15 x 40.64 x 15.24 cm.)
unsigned
provenance: UL C&AF, 1973–1986;
ULC 1986
UL1986C.18

Marie Elsa Blanke
(1879–1961)
A Bit of Beach, ca. 1899
Page 48

Edwin Howland Blashfield
(1848–1936)
Patria, 1926
Page 50

Albert Bloch
(1882–1961)
Dreiergruppe (Group of Three), 1921
Page 52

Jessie Arms Botke
(1883–1971)
Vanity
Page 54

William Bradford
(1823–1892)
*U.S.S. Chicago
(U.S. Cruiser, Chicago)*,
ca. 1885–1895
oil on canvas; 32 x 48 inches
(81.28 x 121.92 cm.)
signed lower right: *WmBradford*
provenance: ULC, 1895
UL1895R.15

Karl Brandner
(1898–1961)
Mill at Fullersburg
oil on canvas;
15½ x 19½ inches
(39.37 x 49.53 cm.)
signed lower left: *K C Brandner*
provenance: Mr. and Mrs.
Ralph S. Johns, 1963;
UL C&AF, 1963–1986; ULC, 1986
UL1986C.19

Nicholas Richard Brewer
(1857–1949)
Motherhood, ca. 1921
Page 56

Paul Huie Brewer
(b. 1934)
Locked Door
casein on cardboard;
29½ x 22 inches
(74.93 x 55.88 cm.)
signed lower right: *Paul Brewer*
provenance: UL C&AF, 1967–1986;
ULC, 1986

Frederick Arthur Bridgman
(1847–1928)
*Hot Bargain in Cairo
(A Hot Bargain, Cairo;
Horse Market, Cairo)*, 1884
Page 58

Fritzi Brod
(1900–1952)
Katia, 1935
Page 60

Richard Norris Brooke
(1847–1920)
Portrait of James Madison, 1895
oil on canvas;
30½ x 25¼ inches
(77.47 x 64.14 cm.)
signed lower left: *RN Brooke*
provenance: ULC, 1895
UL1895.24

Alden Finney Brooks
(1840–1933)
Boys Fishing, before 1893
watercolor on paper;
14¾ x 13½ inches
(37.47 x 34.29 cm.)
signed lower left: *A.F. Brooks –*
provenance: ULC, 1895
UL1895R.17

Edward Brooks
(b. 1961)
Sedgwick El Station #1, 1987
acrylic on canvas; 35½ x 48 inches
(90.17 x 121.92 cm.)
signed lower right: *Brooks '87*
provenance: ULC, 1989
UL1989.4

Alice Dalton Brown
(b. 1939)
Atheneum with Raking Light, 1983
acrylic on canvas;
50 x 66½ inches
(127 x 168.91 cm.)
signed lower right:
Alice Dalton Brown
provenance: ULC, 1983
UL1983.13

Louis Betts, *Portrait of Luther Laflin Mills*, 1899

Roger Brown
(1941–1997)
Cathedrals of Space, 1983
Nine-color lithograph/silkscreen;
42 x 31 inches (106.68 x 78.74 cm.)
printed at Styria Studio, New York
signed lower left: *58/65*;
signed lower middle:
Cathedrals of Space;
signed lower right: *Roger Brown 83*
provenance: Borg-Warner Collection,
?–1992; ULC, 1992
UL1992.2

Chicago Taking a Beating, 1989
Page 62

Charles Francis Browne
(1859–1920)
Chateau Gaillard, 1913
oil on canvas; 19½ x 28 inches
(49.53 x 71.12 cm.)
signed lower left: *C F Browne / 1913*;
signed on reverse
top stretcher in graphite:
*Chateau Gaillard from
the Island. Petit (Au)dely
France Charles Francis Browne 1913*
provenance: MAL, 1907–1951;
UL C&AF, 1951–1976; ULC, 1976
UL1976.6

The Mill Pond, 1904
Page 64

George Elmer Browne
(1871–1946)
*La Guidecca-Venice
(Fishing Boats-Venice)*
oil on canvas; 32 x 39⅝ inches
(81.28 x 100.65 cm.)
signed lower right:
Geo. Elmer Browne
provenance: ULC, 1905
UL1905.4

Jennie Bird Bryan
(d. 1919)
Portrait of Thomas B. Bryan, 1898
oil on canvas;
23½ x 19 inches
(59.59 x 48.26 cm.)
signed upper right: *Bird Bryan/1898*
provenance: ULC, 1898
gift of the artist
UL1898.1

Claude Buck
(1890–1974)
Estride's Mother (My Mother-in-Law), 1932
oil on canvas mounted
on panel; 53½ x 48 inches
(135.89 x 121.92 cm.)
signed mid-lower right:
1932/Claude Buck
provenance: Juel Buck Schiller
(the artist's daughter) to 1975;
UL C&AF, 1975–1986; ULC, 1986
UL1986C.21

Portrait of Juel, 1941
oil on board; 72 x 47 inches
(182.88 x 119.38 cm.)
signed lower left: *Claude Buck*
provenance: Juel Buck Schiller
(the artist's daughter), to 1994;
John Schiller, 1994–1996; ULC, 1996
gift of John Schiller in memory
of his wife, Juel Buck Schiller
UL1996.3.1

Self-Portrait, 1950
Page 66

Untitled (Landscape with Faun)
oil on board; 15½ x 19½ inches
(39.37 x 49.53 cm.)
signed lower right: *Claude / Buck*
provenance: Juel Buck Schiller
(the artist's daughter), to 1994; John
Schiller, 1994–1996; ULC, 1996
gift of John Schiller in memory
of his wife, Juel Buck Schiller
UL1996.3.3

Jeannette Buckley
(d. 1945)
In Old Hyde Park, ca. 1900
oil on wood panel;
11½ x 15½ inches (29.21 x 39.37 cm.)
signed lower left: *J. Buckley*
provenance: ULC, 1900
UL1900.1

Karl Albert Buehr
(1866–1952)
The Fourth Descendant
oil on canvas;
35 x 30 inches (88.9 x 76.2 cm.)
signed lower left: *K.A. Buehr*
provenance: L.L. Valentine; MAL to 1962;
UL C&AF, 1962–1976; ULC, 1976,
ULC1976.7

"If I Were Queen," ca. 1924
Page 68

Byron Burford
(b. 1920)
At Dead Horse Point (Hang Glider), 1985
acrylic resin paint on canvas;
54 x 64 inches (137.16 x 162.56 cm.)
signed lower middle:
Byron Burford, 1985
provenance: L. Herbert Tyler; ULC, 1988,
gift of L. Herbert Tyler
UL1988T.53

Bally with Baby Ruth, 1987
alkyd resin paint on canvas;
54 x 60 inches (137.16 x 152.4 cm.)
signed lower left: *Byron Burford, 1987*
provenance: L. Herbert Tyler; ULC, 1988,
gift of L. Herbert Tyler
UL1988T.52

Edward Burgess Butler
(1853–1928)
Beyond the Desert, 1919
Page 70

In the Berkshires, 1919
oil on canvas;
36 x 46 inches
(91.44 x 116.84 cm.)
signed lower left: *Edward B. Butler–1919.*
provenance: ULC, 1920
UL1920.1

Stream in the Meadow, 1918
oil on canvas board;
36 x 46 inches (91.44 x 116.84 cm.)
signed lower right: *Edward B. Butler 1918*
provenance: MAL, 1919–1951;
UL C&AF, 1951–1976; ULC, 1976,
UL1976.9

Edgar Spier Cameron
(1862–1944)
Nocturne, ca. 1926
oil on canvas; 29 x 24 inches
(73.66 x 60.96 cm.)
signed lower right: *E. Cameron*
provenance: MAL, 1926–1951;
UL C&AF, 1951-1976; ULC 1976
UL1976.10

Portrait of William H. Seward
oil on canvas; 30⅛ x 25 3/16 inches
(76.52 x 63.97 cm.)
signed lower left: *E. Cameron*
provenance: D.F. Cameron,
?–1895; ULC, 1895
gift of D.F. Cameron
UL1895.5

Joseph Caraud
(1821–1905)
Discovered, 1854
oil on canvas; 31½ x 25 inches
(80.01 x 63.5 cm.)
signed lower right: *J. Caraud / 1854.*
provenance: Clinton E. Frank,
?–1963; UL C&AF, 1963–1986; ULC, 1936,
UL1986C.23

Samuel Chamberlin
(1895–1934)
Cathedral de Sens
etching with drypoint on paper;
10½ x 7 inches
(26.67 x 17.78 cm.)
unsigned
provenance: ULC, 1981
UL1981N.6

Francis Chapin
(1899–1965)
Museum Garden, Rome, 1960
watercolor on paper;
28½ x 38½ inches (72.39 x 97.79 cm.)
signed lower right: *Francis Chapin*
provenance: UL C&AF, 1961–1987;
ULC, 1987
UL1987.3

Alson Skinner Clark
(1876–1949)
Saint Gervais, ca. 1909
Page 72

Ralph Elmer Clarkson
(1861–1942)
Portrait of Eugene Cary, ca. 1900
oil on canvas; 30½ x 25½ inches;
(77.47 x 64.77 cm.)
signed upper left:
Ralph Clarkson /after photo
provenance: ULC, by 1907
UL1907C.11

Portrait of Elbridge G. Keith, 1904
oil on canvas; 42 x 32 inches
(106.68 x 81.28 cm.)
signed upper left: *Ralph Clarkson*
provenance: ULC, by 1907
UL1907C.10

Portrait of Lincoln, ca. 1909
Page 74

Twilight Harmony, ca. 1904
oil on canvas; 43 x 64 inches
(109.22 x 162.56 cm.)
signed lower left: *Ralph Clarkson*
provenance: ULC, 1905
UL1905.1

Walter Marshall Clute
(1870–1915)
*The Child in the House—
The Golden Age*, ca. 1910
Page 76

William Cogswell
(1819–1903)
General U.S. Grant, 1879
Page 78

William Conger
(b. 1937)
Eagle City, 1972
Page 80

William Crawford
(1825–1869)
The Highland Chief
oil on canvas; 95 x 59 inches
(241.30 x 149.86 cm.)
remnant of signature
middle lower right
provenance: Balaban and
Katz Theater, ?–1988; ULC, 1988
UL1988.4

Leonard Crunelle
(1872–1942)
Squirrel Boy, ca. 1908
Page 82

T. Scott Dabo
(1868–1934)
River Landscape, Twilight
oil on canvas;
19½ x 23½ inches
(49.53 x 59.69 cm.)
remnant of signature lower left;
provenance: William C. and
Emmeline W. Lamoreaux
to 1970; UL C&AF, 1970–1986; ULC, 1986
UL1986C.26

Charles W. Dahlgreen
(1864–1955)
*Autumn in Bloom (Autumn in Brown
County)*, ca. 1920
Page 84

S. Chester Danforth
(1896–?)
The New Union League Clubhouse,
ca. 1928–29
pencil drawing; 17 x 9 inches
(43.18 x 22.86 cm.)
unsigned
provenance: ULC, 1928
gift of S. Chester Danforth
UL1929.3

Charles Harold Davis
(1856–1933)
The Last Rays, 1887
Page 86

Arthur Dawson
(1859–1922)
Bringing Home the Cows
watercolor on paper; 18 x 25 inches
(45.72 x 63.5 cm.)
signed lower right: *Arthur Dawson*
provenance: ULC, 1901
UL1901.8.2

Highway at Twilight
watercolor; 16¾ x 26 inches
(42.55 x 66.04 cm.)
signed lower right: *Arthur Dawson*
provenance: ULC, 1901
UL1901.8.4

The Old Lock
watercolor; 16¼ x 19¼ inches
(41.28 x 48.90 cm.)
signed lower left: *Arthur Dawson*
provenance: ULC, 1901
UL1901.8.1

Portrait of Daniel Webster
oil on canvas;
34 x 27 inches
(86.36 x 68.58 cm.)
signed center right: *Arthur Dawson /
after / Stemenir*
provenance: ULC, 1907
UL1907C.8

George Elmer Browne, *La Guidecca-Venice (Fishing Boats-Venice)*

Francis Chapin, *Museum Garden, Rome*, 1960

S. Chester Danforth
(1896–?)
The New Union League Clubhouse,
ca. 1928–29
pencil drawing;
17 x 9 inches
(43.18 x 22.86 cm.)
unsigned
provenance: ULC, 1928
gift of S. Chester Danforth
UL1929.3

Charles Harold Davis
(1856–1933)
The Last Rays, 1887
Page 86

Arthur Dawson
(1859–1922)
Bringing Home the Cows
watercolor on paper;
18 x 25 inches
(45.72 x 63.5 cm.)
signed lower right: *Arthur Dawson*
provenance: ULC, 1901
UL1901.8.2

Highway at Twilight
watercolor; 16¾ x 26 inches
(42.55 x 66.04 cm.)
signed lower right: *Arthur Dawson*
provenance: ULC, 1901
UL1901.8.4

The Old Lock
watercolor; 16¼ x 19¼ inches
(41.28 x 48.90 cm.)
signed lower left:
Arthur Dawson
provenance: ULC, 1901
UL1901.8.1

Portrait of Daniel Webster
oil on canvas;
34 x 27 inches
(86.36 x 68.58 cm.)
signed center right: *Arthur Dawson /
after / Stemenir*
provenance: ULC, 1907
UL1907C.8

Peter Dean
(1934–1993)
Three Evening Pines, 1979
Page 88

**Bernadine Deneen and
Anonymous American Women
on behalf of the Women's
Board of the Union League Boys
and Girls Clubs**
*Multi-patch Needlepoint Rug
Depicting the State Birds*, 1976
wool; 60 x 90 inches
(152.40 x 228.60 cm.)
signed: each patch includes the
initials of its maker
provenance: ULC, 1976,
gift of the Women's Board of the
Union League Boys and Girls Clubs
UL1976.58a

Bernadine Deneen
*Needlepoint Bell-Pull
Depicting Nine Birds*, 1976
wool;
69½ x 6½ inches
(176.53 x 69.5 cm.)
unsigned
provenance: ULC, 1976
gift of the Women's
Board of the Union League Boys
and Girls Clubs
UL1976.58b

Wallace Leroy DeWolf
(1854–1930)
California Coast, 1915
Page 90

James E. Disrud
(1952–1994)
Vita Bona, 1989
oil on canvas;
24 x 36 inches
(60.96 x 91.44 cm.)
signed upper left: *Disrv*
provenance: ULC, 1989
UL1989.3

John Doctoroff
(1893–1970)
Portrait of Abraham Lincoln, 1936
oil on canvas;
22 x 18 inches
(55.88 x 45.72 cm.)
signed lower right: *John Doctoroff /*
provenance: Frank C. Rathje,
?–1959; UL C&AF, 1959–1986;
ULC, 1986
UL1986c.29

Portrait of Frank C. Rathje, 1952
oil on canvas; 50 x 40 inches
(127 x 101.60 cm.)
signed lower right:
John Doctoroff /–1952–
provenance: Frank C. Rathje, 1952–1967;
UL C&AF, 1967–1986; ULC, 1986
UL1986c.30

Paul Dougherty
(1877–1947)
The Surf Ring, ca. 1908
Page 92

Dorothy Doughty
(1892–1962)
51 American Birds, 1936–1963
porcelain; various sizes stamped
with marks for Royal Worcester
and Alex Dickins and facsimile
signature, *ddoughty*
provenance: Charles F. and
Edith J. Clyne, ?–1979
gift of Edith J. Clyne in memory of
Charles F. Clyne, 1979
UL1979.1.1a–UL1979.1.26

Edward James Dressler
(1859–1907)
Autumn Landscape, 1899
oil on panel; 4½ x 6⅜ inches
(10.16 x 15.24 cm.)
signed lower left: *E J Dressler 1899*
provenance: ULC, 1907
UL1907C.6

Ernest E. Dreyfuss
(1903–?)
Old Town, 1968
oil on canvas; 36 x 24 inches
(91.44 x 60.96 cm.)
signed lower right: *Dreyfuss*
provenance: Elliot Donnelly, 1969;
UL C&AF, 1969–1986; ULC, 1986
UL1986c.31

John Doctoroff , *Portrait of Abraham Lincoln*, 1936

Ruth Duckworth
(b. 1919)
Untitled, 2002
Page 94

Frank Virgil Dudley
(1868–1957)
The Dunes
oil on canvas; 27 x 30 inches
(68.58 x 76.2 cm.)
signed lower left: *Frank V. Dudley.*
provenance: Jane O. Thompson,
?–1964; ULC C&AF, 1964–1986; ULC, 1986
UL1986c.32

One Winter's Afternoon, ca. 1914
Page 96

Joseph A. Du Pace
(dates unknown)
Du Sable's Journey, 1991
celegraph on paper; 32 x 32 inches
(81.28 x 81.28 cm.)
signed lower left: *97/125*; signed
lower center: *"Du Sable's Journey;"*
signed lower right: *Joseph A. Du Pace 1991 /
Esalla (?) Quiell (?) Mojozo / Houston E.
Comill(?)*
provenance: ULC, 1991
gift of the Chicago Cultural Center
UL1991.7

W. A. Duncan
(dates unknown)
Portrait of Lewis L. Coburn, 1885
pastel on paper mounted to board;
36 x 30⅛ inches (91.44 x 76.52 cm.)
signed lower right: *W.A. Duncan /85*
provenance: ULC, 1895
UL1895R.11

Charles Warren Eaton
(1857–1937)
On Lake Lugano, ca. 1906
Page 98

Frank Virgil Dudley, *The Dunes*

Donald Ellwanger
(b.1910)
A New England Winter, 1981
watercolor on paper:
21¼ x 28¼ inches (53.98 x 71.76 cm.)
signed lower right: *Ellwanger*
provenance: ULC, 1981
UL1981.1

William C. Emerson
(?–1934)
Rhapsody #2
tempera on panel; 22 x 28 inches
(55.88 x 71.12 cm.)
signed lower right: *Emerson*
provenance: Frank A. Hecht,
?–1953; UL C&AF, 1953–1986;ULC, 1986
UL1986c.33

Woodland Scene, 1909
tempera on panel;
22 x 28 inches
(55.88 x 71.12 cm.)
signed lower right: *Emerson 09*
provenance: Frank A. Hecht, ?–1953; UL
C&AF, 1953–1986; ULC, 1986
UL1986c.34

Richard Ruh Epperly
(1891–1973)
*La Lavendera, Grand Canary Island
(The Laundress)*, 1963
oil on canvas: 28 x 24 inches
(71.12 x 60.96 cm.)
signed lower right: *Epperly '63*
provenance: Mr. and Mrs.
Cyril H. Brown, ?–1966; UL C&AF, 1966-
1986; ULC, 1986
UL1986c.35

Peter Fagan
(b. 1949)
Raptor, 1977
bronze, red cedar, Southern yellow pine;
55 x 15 inches (139.7 x 38.1 cm.)
signed verso: *Sparrow-Hawk, Peter Fagan*
provenance: UL C&AF, 1977–1986;
ULC, 1986
UL1986c.36

James Faulkner
(b. 1933)
Frontispiece—Triptych, 1987
collage on paper;
16¾ x 33¾ inches
(42.55 x 85.73 cm.)
unsigned
provenance: ULC, 1988
UL1988.45

Michelle Fire
(b. 1951)
Gate of Ionas, 1984
paper, colored pencil,
balsa wood, foam core
paperboard;
16½ x 20 inches
(41.91 x 50.8 cm.)
unsigned
provenance: ULC, 1984
UL1984.2

Jane Fisher
(b.1961)
Cake and Peaches, 1986
oil on canvas; 45 ½ x 49 ¾ inches
(115.57 x 126.37 cm.)
unsigned
provenance: ULC, 1986
UL 1986.8

Edgar Forkner
(1867–1945)
Flowers at Window
oil on canvas; 28 x 22 inches
(71.12 x 55.88 cm.)
signed lower left: *Edgar Forkner*
provenance: John Jirgil, ?–1966;
UL C&AF, 1966–1986; ULC, 1986
UL1986c.40

Old Boats, Puget Sound
oil on canvas; 20½ x 24 inches
(52.07 x 60.96 cm.)
signed lower right: *Edgar. Forkner*
provenance: Anna Maude Stuart,
?–1978; UL C&AF, 1978–1986;
ULC, 1986,
UL1986c.41

Gerald A. Frank
(1888 to after 1939)
Lady with Tiger
oil on canvas; 40 x 36 inches
(101.60 x 91.44 cm.)
signed lower right: *Gerald A. Frank*
provenance: L.L. Valentine; MAL, ?–1962;
UL C&AF, 1962–1976; ULC, 1976,
UL1976.15

Maternity, ca. 1929
oil on canvas; 36 ⅛ x 36 inches
(91.76 x 91.44 cm.)
Signed lower left: *G A Frank*
provenance: MAL, 1930–1951;
UL C&AF, 1951–1976; ULC, 1976
UL1976.16

Curt Frankenstein
(b. Germany, 1922)
Poste Restante (General Delivery)
oil with acrylic polymer
on masonite; 33 x 47½ inches
(96.52 x 120.65 cm.)
signed mid-center right on letter
in box 320: *Herr / Curt Frankenstein /
Hanover 1 / Poste Restante*
provenance: ULC, 1965
UL1965.1

John Franklin
(dates unknown)
Untitled (Indians on Horseback),
20th century,
oil on panel; 12 x 16 inches
(30.48 x 40.64 cm.)
signed lower right: *John Franklin*
provenance: Foorman Mueller,
?–1980; UL C&AF, 1980–1986;
ULC, 1986,
UL1986c.43

Richard L. Frooman
(b. 1930)
Merry-Go-Round
oil on panel; 19¼ x 23 inches
(48.90 x 58.42 cm.)
signed lower left: *Richard Frooman*
provenance: ULC, 1959
UL1959.1

Eve Garrison
(1908–?)
Bride and Groom, 1959
Page 100

Percival Gaskell
(1868–1934) *Swiss Lake*
etching and drypoint; 7 x 9 inches
(17.78 x 22.86 cm.)
signed lower left in plate:
P. Gaskell ©; signed lower right in pencil:
Percival Gaskell
provenance: ULC, date of acquisition
unknown
UL1998.6

Miklos Gaspar
(1885–1946)
Scenes from Union League Boys Clubs, 1935
Page 102

Louis H. Gerding
(1902–1958)
U.S.S. Constitution (Old Ironsides), 1954,
ship model (wood, string, brass);
28 x 40 x 6 inches (71.12 x 101.60 x 15.24 cm.)
stamped on copper plate on base:
*United States Frigate "Constitution" /
model by/Louis H. Gerding/1954*
provenance: Louis H. Gerding,1954–1962;
UL C&AF, 1962–1986; ULC, 1986,
UL 1986c.44

Gerald A. Frank, *Maternity*, ca. 1929

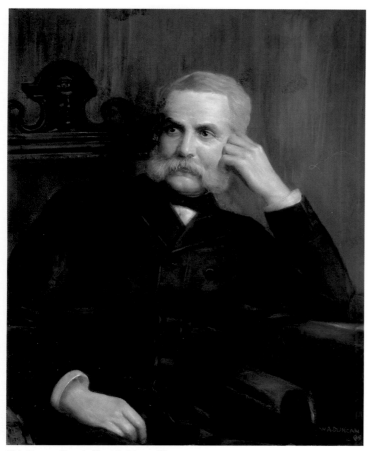

W. A. Duncan, *Portrait of Lewis L. Coburn*, 1885

Byron Gere
(1898–?)
Contemporary Sculptor, 1953
oil on canvas;
27¾ x 35 inches
(70.49 x 88.9 cm.)
signed lower right:
BYRON GERE '53
provenance: ULC, 1955
UL1955.1

S. Ghurty
(dates unknown)
Chartres Cathedral
etching with drypoint;
20½ x 14½ inches
(52.07 x 36.83 cm.)
signed lower right: *S. Ghurty*;
signed lower center: *6 Sep./no 18*
provenance: ULC, 1983
UL1983.7

Robert Alan Gough
(b. 1931)
The Return, 1960
oil on canvas;
40 x 30 inches
(101.60 x 76.2 cm.)
signed lower center:
Robert Alan Gough 1960
provenance: UL C&AF, 1961–1986;
ULC, 1986
UL1986c.45

Steve Graber
(b. 1950)
McKay Township
Graphite on paper;
5 x 7½ inches
(12.7 x 19.05 cm.)
signed lower right: *Graber*
provenance: ULC, ca. 1989
UL1998.5

Katherine Grace
(b. 1913)
Winter in Lincoln Park
oil on panel;
15¼ x 19½ inches
(38.74 x 49.53 cm.)
signed lower right: *K. Grace*
provenance: First National Bank of
Chicago, through Homer J.
Livingston and Harold W. Lewis,
?–1960; UL C&AF,
1960–1986; ULC, 1986,
UL1986c.46

Clement Rollins Grant
(1849–1893)
Woman with Bucket
oil on canvas; 30½ x 20 inches
(77.47 x 50.8 cm.)
signed lower right: *C. R. Grant*
provenance: John L. Enright,
?–1951; ULC, 1951
gift of John L. Enright
UL1951.1

Frederic Milton Grant
(1886–1959)
County Fair, 1916
oil on canvas; 30 x 30 inches
(76.2 x 76.2 cm.)
signed lower right: *Frederic M. Grant / 16*
provenance: ULC, 1917
UL1917.4.1

The Sketch Class, 1914
Page 104

Sunday Morning, 1910
oil on canvas; 22½ x 22 inches
(57.15 x 55.88 cm.)
signed lower left: *Frederic M. Grant '10*
provenance: ULC, 1917
UL1917.4.2

J. Jeffrey Grant
(1883–1960)
The Fascinating Village, 1956
Page 106

Main Street, ca. 1936
oil on canvas; 30 x 35 inches
(76.20 x 88.90 cm.)
signed lower right: *J. Jeffrey Grant*
provenance: MAL, 1936–1951;
UL C&AF, 1951–1976; ULC, 1976
UL1976.19

Mending the Nets, 1959
oil on canvas; 24 x 30 inches
(60.96 x 76.2 cm.)
signed lower right: *J. Jeffrey Grant*
provenance: Henry E. Cutler,
?–1959; UL C&AF, 1959–1986; ULC, 1986
gift of Henry E. Cutler in memory
of Hattie M. Cutler
UL1986c.49

Harold Gregor
(b. 1929)
Illinois Landscape #104, 1988
Oil and acrylic on canvas;
45 x 20 inches (114.30 x 50.80 cm)
signed lower right: H GREGOR;
signed upper left top,
reverse: HAROLD GREGOR
provenance: Arthur Andersen LLP,
1988–2002; ULC, 2002
UL2002.1

Mary Griep
(b. 1951)
Pinnacle Peak Road #2
acrylic on paper; 30 x 44 inches
(76.20 x 111.76 cm.)
signed lower right: *Mary Griep*
provenance: ULC, 1990
UL1990.3

Edward Thomas Grigware
(1889–1960)
Paradise Valley, ca. 1931
oil on canvas; 30 x 36 inches
(76.2 x 91.44 cm.)
signed lower right: *Edward T. Grigware*
provenance: MAL, 1931–1951;
UL C&AF, 1951–1976; ULC, 1976
UL1976.20

Paul Grolleron
(1848–1901)
Battle Scene, 1882
oil on canvas;
29 x 23½ inches
(73.66 x 59.69 cm.)
signed lower right: *P. Grolleron*
provenance: Madame E.,
Paris, 1919–?; ULC, 1957
UL1957A.7

Oskar Gross
(b. Austria 1871–1963)
Mother Earth, 1937
Page 108

Oliver Dennett Grover
(1861–1927)
Her Grandmother's Gown, 1898
oil on canvas;
30½ x 15 inches
(77.47 x 38.10 cm.)
signed lower left:
Grover 1898
provenance: ULC, 1899
UL1899.2

The Riva, Venice, 1908
oil on canvas;
30 x 24¼ inches
(76.2 x 61.56 cm.)
signed lower left:
Oliver Dennett Grover 1908
provenance: MAL, 1910–1951;
UL C&AF, 1951–1976;
ULC, 1976
UL1976.22

*Upper St. Mary's, Glacier
National Park*, 1923
Page 110

H. Gugler
(dates unknown)
Portrait of President Lincoln,
19th century steel engraving;
28 x 20 inches
(71.12 x 50.8 cm.)
unsigned
provenance: Earle W. Grover,
?–1955; ULC, 1955
gift of Earle W. Grover
UL1955.3

Jane Fisher, *Cake and Peaches*, 1986

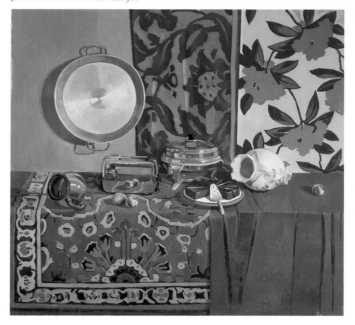

Axel Herman Haig
(1835–1921)
Canterbury: The Pilgrims' Aisle
etching; 18½ x 13¼ inches
(46.99 x 33.66 cm.)
signed lower right: *Axel H. Haig*; signed
lower center: *Canterbury:
The Pilgrims' Aisle*
provenance: Frank Flagg Taylor,
?–1957, ULC 1957
UL1957.3

Patti Hansen
(b. 1939)
Casis Series: New York Casis, 1983
oil on linen; 36 x 36 inches
(91.44 x 91.44 cm.)
unsigned,
provenance: ULC, 1983
UL1983.14

Lowell Birge Harrison
(1854–1929)
Sunlight and Mist, Quebec, ca. 1910
Page 112

Lucie Hartrath
(1867–1962)
*The Oaks (The Red Oak;
Autumn Pageant)*, ca. 1922
Page 114

Charles Webster Hawthorne
(1872–1930)
The Shad Fisherman,
ca. 1915–1916
Page 116

George Peter Alexander Healy
(1813–1894)
Portrait of Stephen A. Douglas
oil on canvas;
30 x 25 inches
(76.20 x 63.50 cm.)
unsigned
provenance: Thomas B. Bryan,
?–1895; ULC, 1895
gift of Thomas B. Bryan
UL1895R.4

Portrait of John C. Fremont
oil on canvas;
30 x 25½ inches
(76.20 x 64.14 cm.)
unsigned
provenance: Thomas B. Bryan,
?–1888; ULC, 1888
gift of Thomas B. Bryan
UL1895R.4

*Daniel Webster at
Marshfield*, 1848
Page 118

Marcia Henderson
(b. 1957)
Untitled (Cityscape), 1984
watercolor and pastel
on paper; 50 x 38 inches
(127 x 96.52 cm.)
unsigned
provenance: ULC, 1986
UL1986.1

Victor Higgins
(1884–1949)
*Jacinto and the Suspicious Cat
(Juanito and the Suspicious Cat)*, 1916
Page 120

Moorland Gorse and Bracken,
ca. 1911–12
oil on canvas;
42⅛ x 47 inches
(107 x 119.38 cm.)
signed lower right: *Victor Higgins –*
provenance: MAL, 1915–1951;
UL C&AF, 1951–1976; ULC, 1976
UL1976.24

Thomas Hill
(1829–1908)
Crescent Lake (Yosemite Valley), 1892
Page 122

Robert Hinckley
(1853–1941)
Chief Justice Melville Weston Fuller
oil on board;
46¾ x 55 inches
(118.75 x 139.70 cm.)
signed lower right: *Robert Hinckley*
provenance: Erskin M. Phelps; ULC, 1910
gift of the estate of Erskin
M. Phelps through John E. Wilder
UL1910.1

Edgar Hinkley
(b. 1946)
Bathers, 1984
watercolor on paper;
38 x 27¼ inches
(96.52 x 69.22 cm.)
signed lower left: *Ed Hinckley /" 1984*
provenance: ULC, 1985
UL1985.8

Othmar Hoffler
(1893–1954)
Babette, ca. 1933
Page 124

Milton Horn
(1906–1995)
Maquette of Franklin Delano Roosevelt,
ca. 1950s–1995
Page 126

Untitled (Vase of Flowers), 1940
oil on board; 20 x 15¾ inches
(50.8 x 40.01 cm.)
signed lower left: *Milton Horn '40*
provenance: Milton and Estelle Horn
Fine Arts Trust, 1995–1998;
ULC, 1998
gift of the Milton and Estelle
Horn Fine Arts Trust
UL1998.3.2

William Henry Howe
(1844–1929)
*Evening at Laren, the Meadows—
Cattle*, 1890
Page 128

Saybrook Point, Connecticut River, 1908
oil on canvas;
23½ x 29½ inches
(59.59 x 74.93 cm.)
signed lower left: *William H.
Howe N.H. 1908;*
signed on reverse top stretcher:
*Saybrook Point,
Cattle on the Beach. By mouth of the
Connecticut River William H. Howe*
provenance: L.L. Valentine;
MAL, ?–1962; UL C&AF, 1962–1976;
ULC, 1976,
UL1976.26

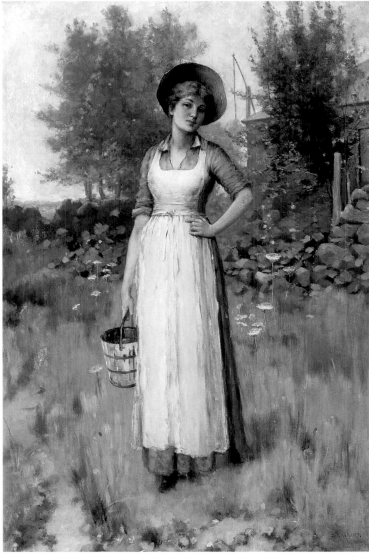

Clement Rollins Grant, *Woman with Bucket*

Thorvald Arnst Hoyer
(1872–1949)
Untitled (Landscape), 1921
oil on canvas; 17⅛ x 21⅛ inches
(43.50 x 53.66 cm.)
signed lower right: *1921 T.A. Hoyer*
provenance: Olga Pegelow (the artist's
daughter), 1949–1995; ULC, 1995
gift of Olga Pegelow
UL1995.2

Richard Howard Hunt
(b. 1935)
Maquette of Eagle Columns, 1991
bronze; 13½ x 4¾ x 4 inches
(34.29 x 12.07 x 10.16 cm.)
signed bottom left side: *R Hunt 5/10*
provenance: ULC, 1991
UL1991.8

Sidearm, 1991
Page 130

Portrait of the Artist as a Young Man, 1998
bronze and brass; 22 x 15 x 11¾ inches
(55.88 x 38.1 x 29.85 cm.)
signed on back: *R. Hunt 98*
provenance: ULC, 1994
gift of the artist
UL1998.1

Rudolph Frank Ingerle
(1879–1950)
The Lifting Veil, 1922
Page 132

George Inness
(1825–1894)
*Picnic in the Woods, Montclair,
New Jersey (The Picnic Party;
Beech Woods; The Beeches)*, 1894
Page 134

Wilson Henry Irvine
(1869–1936)
Branching Tracery, ca. 1916
oil on canvas;
23½ x 27 inches
(59.69 x 68.58 cm.)
signed lower right: *IRVINE*
provenance: ULC, 1917
UL1917.7

The Old Homestead, ca. 1916
oil on canvas;
35½ x 46½ inches
(90.17 x 118.11 cm.)
signed lower left: *IRVINE*
provenance: ULC, 1916
UL1917.3

The Road, 1910
Page 136

Simpson's Meadow, ca. 1913
oil on canvas; 34¼ x 40½ inches
(87 x 102.87 cm.)
signed lower left: *IRVINE*
provenance: James A. Brannum, ?–1964;
UL C&AF, 1964–1986; ULC, 1986,
UL1986C.52

Winter Landscape, 1914
watercolor on paper; 16¼ x 19¾ inches
(41.28 x 50.17 cm.)
signed lower right: *Irvine 14*
provenance: Mrs. Alice Wakefield,
?–1964; UL C&AF, 1964–1986; ULC, 1986
UL1986c.53

Miyoko Ito
(1918–1983)
Untitled, ca. 1973
Page 138

Alla Jablokov
(b. 1929)
In the Ravine
watercolor on paper; 22 x 30 inches
(55.88 x 76.2 cm.)
signed lower right: *Alla Jablokov*
provenance: ULC, 1978
UL1978.2

Billy Morrow Jackson
(b. 1926)
Before My Time, ca. 1965
Page 140

Zygmund Jankowski
(b. 1925)
Rocky Neck Harbor, 1968
watercolor on paper; 14¼ x 22 inches
(36.20 x 55.88 cm.)
signed lower right: *Jankowski*
provenance: H. Barry McCormick, 1969;
UL C&AF, 1969-86; ULC, 1986
UL1986c.54

Jens Johannessen
(b. 1934)
Brang
colored lithograph;
28½ x 21 inches (72.39 x 53.34 cm.)
unsigned
provenance: Edward Weiss,
?–1988; ULC, 1988
UL1988.w.55

John Christen Johansen
(1876–1964)
Hills of Fiesole, Springtime, 1908
Page 142

Eastman Johnson
(1824–1906)
Alexander Hamilton, 1890
Page 144

Frank Tenney Johnson
(1874–1939)
Night in the Canyon, ca. 1929–1937
Page 146

James Jordan
(b. 1938)
Country
mixed media on canvas;
24 x 28¼ inches (60.97 x 71.76 cm.)
unsigned
provenance: UL C&AF, 1965–86;
ULC, 1986,
UL1986c.56

Alfred Juergens
(1866–1934)
Afternoon in May, ca. 1913
Page 148

Field of Flowers
(Flowers of the Northwoods)
oil on canvas; 42 x 54 inches
(106.68 x 137.16 cm.)
signed lower left: *Alfred Juergens*
provenance: Women's City Club of
Chicago, ?–1966; UL C&AF, 1966–1986;
ULC, 1986
UL1986c.58

Lilac Time
oil on canvas; 24 x 32 inches
(60.96 x 81.28 cm.)
signed lower right: *Alfred Juerg*
provenance: ULC, 1940
UL1940A.2

Oliver Dennett Grover, *The Riva, Venice*, 1908

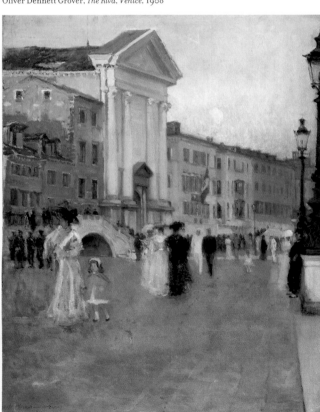

Max Kahn
(b. 1904)
The Fountain
oil on canvas; 26 x 34½ inches
(66.04 x 87.63 cm.)
signed lower right: *Max Kahn*
provenance: Edward M. Martin,
?–1955; UL C&AF, 1955–1986; ULC, 1986
UL1986c.59

Robert Kaiser
(b. 1928)
Under the Bridge, 1974
watercolor on paper;
14½ x 10½ inches (36.83 x 26.67 cm.)
signed lower right:
Robert E. Kaiser AWS '74
provenance: UL C&AF, 1965–86;
ULC, 1986
UL1986c.60

William Keith
(1839–1911)
High Sierras
Page 150

R. C. Kennert
(dates unknown)
Union League Club Entrance Doorway,
ca. 1929
pen and ink drawing on paper;
9 x 7 inches (22.86 x 17.78 cm.)
signed lower right: *R. C. Kennert*
provenance: William Bryce Mundie,
ca. 1929; ULC, 1929
gift of William Bryce Mundie
UL1929.2

After John Gerrard Keulemans
(1842–1912)
*Carmine Throated Bee Eater – Merops
Numicoides*
hand-colored lithograph;
15 x 11¼ inches (38.1 x 28.58 cm.)
unsigned
provenance: ULC, 1957
UL1957A.17.2

Green Throated Bee Eater—Merops Nubicus
hand-colored lithograph;
15 x 11¼ inches (38.1 x 28.58 cm)
unsigned
provenance: ULC, 1957
UL1957A.17.1

Charles P. Killgore
(1889–1979)
Mexican Market, 1935
Page 152

Vera Klement
(b. 1929)
Woman at the Window, 1965
Page 154

Daniel Ridgway Knight
(1840–1924)
Waiting for the Ferry, 1883
Page 156

Robert Koch
(dates unknown)
The Red Swing, 1981
watercolor on paper;
21½ x 29¾ inches
(54.61 x 75.57 cm.)
signed lower right: *Koch*
provenance: ULC, 1981
UL1981.3

Carl Rudolph Krafft
(1884–1938)
Banks of the Gasconade, 1920
Page 158

The Charms of the Ozarks, ca. 1916
oil on canvas; 45 x 50 inches
(114.30 x 127 cm.)
signed lower right: *CARL R. KRAFFT*
provenance: MAL, 1916–1951;
UL C&AF, 1951–1976; ULC, 1976
UL1976.32

Harriet B. Krawiec
(1894–1934)
Pigeons
oil on canvas; 40 x 30 inches
(101.60 x 76.20 cm.)
signed lower left: *Harriet Krawiec*.
provenance: William M. Hales,
?–1961; UL C&AF, 1961–1986; ULC, 1986,
UL1986c.65

White Statue, ca. 1937
oil on canvas; 40 x 30 inches
(101.60 x 76.20 cm)
signed lower left: *Harriet Krawiec*
provenance: MAL, 1937–1951;
UL C&AF, 1951–1976; ULC, 1976
UL1976.34

Edmund D. Laars
(dates unknown)
Summer Idyll in the Highlands, 1875
oil on fabric mounted on board;
68 x 40½ inches (172.72 x 102.87 cm.)
signed lower left: *Edmund D. Laars 1875*
provenance: Mr. and Mrs. Earl J. Gossett,
?–1963; UL C&AF, 1963-1986; ULC, 1986
UL1986c.66

Willem Lamoriniere
(dates unknown)
Autumn Leaves, 1893
oil on canvas; 37½ x 45½ inches
(95.25 x 115.57 cm.)
signed lower right: *Willem Lamoriniere / 1893*
provenance: ULC, 1895
UL1895.21

Gustave LeHeutre
(1861–1934)
Chartres Cathedral
etching; 16½ x 11¼ inches
(41.91x 28.58 cm.)
unsigned
provenance: Frank Flagg Taylor
to 1959; ULC, 1959
gift of Frank Flagg Taylor
UL1959.7

Martin Levine
(b. 1945)
Union League Club of Chicago, 1983
hand-colored etching;
20½ x 16½ inches (52.07 x 41.91 cm.)
signed lower right: *Martin Levine 1983*
provenance: ULC, 1983
UL1982.4

Ossip L. Linde
(1871–1940)
Reflections
oil on canvas; 29 x 36 inches
(73.66 x 91.44 cm.)
signed lower right: *Ossip L. Linde*.
provenance: L.L. Valentine; MAL, ?–1962;
UL C&AF, 1962–1976; ULC, 1976,
UL1976.35

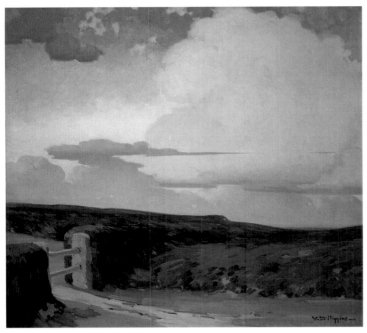

Victor Higgins, *Moorland Gorse and Bracken*, ca. 1911–12

Evelyn Beatrice Longman
(1874–1954)
Victory, ca. 1905
Page 160

Robert Lostutter
(b. 1939)
Superb Sunbird, 1991
18-color lithograph;
19¼ x 25 inches
(48.90 x 63.5 cm.)
signed lower right: *22/50*
SUPERB SUNBIRD LOSTUTTER 1991
provenance: ULC, 1991
UL1991.3

Robert Elmer Lougheed
(1910–1982)
Passing the Old Homestead
oil on board; 12 x 16 inches
(30.48 x 40.64 cm.)
signed lower right:
*ROBERT LOUGHEED / ESPANOLA,
NEW MEXICO*
provenance: Foorman L. Mueller,
1968/70–1980; UL C&AF, 1980–1986;
ULC, 1986
UL1986c.69

Mary Fairchild MacMonnies Low
(1858–1946)
*Blossoming Time in
Normandy*, 1901
Page 162

Dennis Jaeger Loy
(1939–1994)
It's a Lazy Afternoon, 1993
oil on canvas; 30 x 48 inches
(76.2 x 121.92 cm.)
signed lower right: *Loy '93*
provenance: ULC, 1993
gift of Dennis Loy
UL1993.1

Winter Sunrise, Barlow Lake, 1982
oil on linen;
33 x 73½ inches
(83.82 x 186.69 cm.)
signed lower left: *Loy '82*
provenance: ULC, 1983
UL1983.15

Stephen Luecking
(b. 1948)
Untitled (Abstract Composition), 1976
collage with pencil and acrylic on paper;
22 x 30 inches (55.88 x 76.20 cm.)
signed lower left: *'76/AUG*;
signed lower right: *S. Luecking*
provenance: Mr. and Mrs. Douglas
Kenyon, ?–1985; ULC, 1985
gift of Mr. and Mrs.
Douglas Kenyon
UL1986.4

John Mahtesian
(1915–2002)
*Chef Gerard, Vauvenargues,
Provence*, 1994
silver gelatin print;
14 x 11 inches (35.56 x 27.94 cm.)
unsigned
provenance: ULC, 1999
gift of the artist
UL1999.1

*Chef Gerard, Vauvenargues,
Provence*, 1994
silver gelatin print;
13 x 10¾ inches (33.02 x 27.31 cm.)
unsigned
provenance: John Mahtesian,
1994–2002; ULC, 2002
gift of the artist's estate
UL2002.2.1

Performer—Paris, 1995
silver gelatin print;
13¾ x 8¾ inches (34.93 x 22.23 cm.)
unsigned
provenance: John Mahtesian,
1995–2002; ULC, 2002
gift of the artist's estate
UL2002.2.2

Antonio Marrani
(1788–1861)
*In a Church (Apsidal Area of Santa Maria
Novella, Florence)*
watercolor; 25½ x 31½ inches
(64.77 x 80.01 cm.)
signed left of center: *A. Marrani*
provenance: ULC, 1957
UL1957A.9

Kerry James Marshall
(b. 1955)
Brownie, 1995
Color lithograph on paper;
19¾ x 15 inches (50.17 x 38.10 cm.)
signed lower right: *KJ Marshall '95*;
inscribed lower center: *Brownie*;
inscribed lower left corner: *AP7*
provenance: Kerry James Marshall,
1995–2003; ULC, 2003
gift of the artist
UL2003.2

Suzanne Schweig Martyl
(b. 1918)
Spain, ca. 1955, oil on canvas;
28½ x 34 inches (72.39 x 86.36 cm.)
signed lower left: *Martyl*;
signed upper left: *Martyl*
provenance: ULC, 1955
UL1955.2

Anna Lou Matthews
(1882–1962)
Our Daily Bread, ca. 1932
Page 164

After Anton Mauve
(Dutch, 1838–1888)
Sheep with Shepherd
oil on canvas mounted on masonite;
20 x 25 inches (50.80 x 63.50 cm.)
signed lower left: *A. Mauve*
provenance: Mrs. Emmaling W.
Lamoreaux, ?–1970;
UL C&AF, 1970–1986; ULC, 1986
UL1986.72

Clara Taggart McChesney
(1861–1928)
The Discovery, 1905
watercolor on board;
32¼ x 26 inches (81.92 x 66.04 cm.)
signed lower right:
C. McChesney / 1905
provenance: ULC, 1905
UL1905.3

Mark McMahon
(b. 1950)
The Printing Press, ca. 1981
watercolor and acrylic on paper;
30 x 22 inches (76.2 x 55.88 cm.)
signed lower right: *Mark McMahon /
© 1998 / World Colon(?) Corp / Salem,
Illinois*
provenance: ULC, 1981
UL1981.2

Union League Club of Chicago, 1989
watercolor on paper; 40? x 26 inches
(102.87 x 66.04 cm.)
signed lower right: *Mark McMahon /
© 1989 / Union League Club of Chicago*
provenance: ULC, 1989
UL1989.7

Everett Carr McNear
(1904–1985)
Farm Near Ravello, 1956
oil on canvas; 32½ x 19 inches
(82.55 x 48.26 cm.)
signed lower left: *EVERETT MCNEAR – 56*
provenance: Joseph Allen Matter,
?–1957; ULC C&AF, 1957–1986; ULC, 1986
UL1986c.73

Jan Miller
(1939–1986)
Kitsch-in Series: Oranges
acrylic on canvas; 36 x 36 inches
(91.44 x 91.44 cm.)
inscribed on reverse:
Kitsch-In Series—Oranges
provenance: ULC, 1974
UL1974.3

Stanley Mitruk
(b. 1922)
Quince and Ironstone, 1956
oil on canvas; 23¼ x 40½ inches
(59.06 x 102.87 cm.)
signed upper right: *Mitruk–1956*
provenance: ULC, 1957
UL1957.2

Richard Howard Hunt, *Portrait of the Artist as a Young Man*, 1998

Robert Lostutter, *Superb Sunbird*, 1991

Julius Moessel
(1871–1960)
Springtime, ca. 1934
Page 166

Claude Monet
(French, 1840–1926)
Pommiers en fleurs
(*Apple Trees in Blossom; Le Printemps;
Springtime*), 1872
Page 168

Alfred Gwynne Morang
(1901–1958)
Untitled (Seascape)
oil on canvas; 23½ x 29¾
(59.69 x 75.57 cm.)
signed lower right: *A.G. Morang.*
provenance: ULC, 1997
UL1997.2

Herman More
(1887–1968)
Green Covered Dunes
(*Cloudy Day in the Dunes*)
oil on board;
30 x 36⅛ inches
(76.2 x 91.76 cm.)
signed lower right: *Hermon More*
provenance: ULC, 1917
UL1917.5

Daniel Morper
(b. 1944)
Zeus, 1983
Page 172

John Mulvany
(1844–1906)
Portrait of Albert L. Coe, 1889
oil on canvas;
36¼ x 29⅜ inches
(92.08 x 74.61 cm.)
signed middle left:
Jno/Mulvany/ 1889
provenance: ULC, 1895
UL1895R.12

Herman Dudley Murphy
(1867–1945)
Venice (A Doorway), 1908
watercolor on paper;
5¼ x 4¾ inches
(13.34 x 12.07 cm.)
signed lower left: *HDM*
provenance: ULC, 1908
UL1908.2.2

Winter Scene (Snow)
watercolor on paper;
10¼ x 6¾ inches
(26.04 x 17.15 cm.)
signed lower left: *HDM*
provenance: ULC, 1908
UL1908.2.1

Virginia A. Myers
(b. 1927)
A Time of Malfeasance:
series of twenty-one prints, 1974
engraving and drypoint on paper; sizes vary
unsigned
provenance: L. Herbert Tyler,
?–1988; ULC, 1988
gift of L. Herbert Tyler
UL1988T.16.1–21

To Iowa and Mollybrooks
engraving; 18¾ x 29¾ inches
(47.63 x 75.57 cm.)
signed lower right: *Virginia A. Myers*
provenance: L. Herbert Tyler,
?–1988; ULC, 1988
gift of L. Herbert Tyler
UL1988T.50.1

Limestone Quarry
engraving; 9¾ x 13 inches
(24.77 x 33.02 cm.)
signed lower right: *Virginia A. Myers*
provenance: L. Herbert Tyler,
?–1988; ULC, 1988
gift of L. Herbert Tyler
UL1988T.50.2

The Ghost Elm II
etching, gold leaf, intaglio;
14¾ x 22½ inches
(37.47 x 57.15 cm.)
signed lower right:
Virginia A. Myers
provenance: L. Herbert Tyler,
?–1988; ULC, 1988
gift of L. Herbert Tyler
UL1988T.50.3

The Engraver
engraving; 33½ x 19 inches
(85.09 x 48.26 cm.)
signed lower right: *Virginia A. Myers*
provenance: L. Herbert Tyler,
?–1988; ULC, 1988
gift of L. Herbert Tyler
UL1988T.50.4

Johnson County, Iowa
engraving; 6½ x 13 inches
(16.51 x 33.02 cm.)
signed lower right: *Virginia A. Myers*
provenance: L. Herbert Tyler,
?–1988; ULC, 1988
gift of L. Herbert Tyler
UL1988T.50.5

Frosty Morning
engraving; 17½ x 7 inches
(44.45 x 17.78 cm.)
signed lower right:
Virginia A. Myers
provenance: L. Herbert Tyler,
?–1988; ULC, 1988
gift of L. Herbert Tyler
UL1988T.50.6

Rainy Day
engraving; 8½ x 5 inches
(21.59 x 12.7 cm.)
signed lower right:
Virginia A. Myers
provenance: L. Herbert Tyler,
?–1988; ULC, 1988
gift of L. Herbert Tyler
UL1988T.50.7

The Ghost Elm
engraving; 8¼ x 22¼ inches
(20.96 x 56.52 cm.)
signed lower right:
Virginia A. Myers
provenance: L. Herbert Tyler,
?–1988; ULC, 1988
gift of L. Herbert Tyler
UL1988T.50.8

Charles Frederick Herbert Naegele
(1857–1944)
The Captive, ca. 1898
oil on canvas; 37 x 74 inches
(93.98 x 187.96 cm.)
signed lower right: *Charles Frederick
Naegele / Copyright applied for C.F.N.*
provenance: George Ives Haight,
?–1941; ULC, 1942
gift of George Ives Haight
UL1942.1

Raymond Perry Rodgers Neilson
(1881–1964)
The Mirror, 1921
Page 174

Didier Nolet
(b. 1953)
Burgundy Landscape, 1983
charcoal on paper; 28 x 39? inches
signed lower right: *Nolet 83*
provenance: Borg-Warner Corporation,
1983–1992; ULC, 1992
gift of the Borg-Warner Corporation
UL1992.1

John Thomas Nolf
(1872–1950)
Boys Plowing, ca. 1928
Page 176

John W. Norton
(1876–1934)
Untitled (European cityscape)
pencil and crayon on paper;
7⅛ x 9⅛ inches (18.10 x 23.18 cm.)
unsigned
provenance: Margaret F. Norton,
?–1935; ULC, 1935
gift of Margaret F. Norton
UL1997.1

Elizabeth Nourse
(1859–1938)
Good Friday (Vendredi Saint), 1891
Page 178

Arvid Fredrik Nyholm
(1866–1927)
Portrait of William Bryce Mundie
oil on canvas;
23½ x 20 inches (59.69 x 50.8 cm.)
signed upper left: *A. Nyholm*
provenance: Elizabeth Mundie,
?–1959; ULC, 1959
gift of Miss Elizabeth Mundie, 1959
UL1960.1

Dennis Jaeger Loy, *Winter Sunrise, Barlow Lake*, 1982

Kerry James Marshall, *Brownie*, 1995

Soei Obiya
(Japanese, b. 1923)
Vase, 1983
porcelain; 13½ x 7 x 6½ inches
(34.29 x 17.78 x 16.51 cm.)
unsigned
provenance: ULC, 1992
gift of Soei Obiya
UL1992.3

Leonard Ochtman
(1854–1934)
Field of Grain, 1894
oil on canvas; 24 x 36 inches
(60.96 x 91.44 cm.)
signed lower left: *LEONARD
OCHTMAN / 1894*
provenance: ULC, 1895
UL1895.26

Frosty Morning, 1894
Page 180

Pauline Palmer
(1867–1938)
Cottage at Provincetown
oil on canvas; 20 x 24 inches
(50.8 x 60.96 cm.)
signed lower left: *Pauline Palmer*
provenance: Mrs. Luther M. Swygert,
?–1978; ULC, 1978
gift of Mrs. Luther M. Swygert
UL1978.5

*Against the Light (Silhouetted against the
Light; From My Studio Window)*, ca. 1927
Page 182

In the Open, 1920
oil on canvas; 40 x 39½ inches
(101.60 x 100.33 cm.)
signed lower left: *Pauline Palmer / 1920*.
provenance: L.L. Valentine; MAL, ?–1962;
UL C&AF, 1962–1976; ULC, 1976
UL1976.39

William Ordway Partridge
(1861–1930)
Edward Everett Hale, 1891
Page 184

Ed Paschke
(b. 1939)
Hat Study, 1989
mixed media on paper;
30 x 22⅜ inches (76.2 x 56.83 cm.)
signed lower center: "*Hat Study*";
signed lower right: *E. Paschke '89*
provenance: ULC, 1990
UL1991.2

**Ed Paschke and (art)ⁿ
(Stephan Meyers, Ellen Sandor
and Janine Fron)**
Primondo, 1997
Page 186

James William Pattison
(1844–1915)
Tranquility, ca. 1906
Page 188

Nancy Eiseman Paul
Two Tomatoes, 1996
graphite on paper;
7 x 10¼ inches
(17.78 x 26.04 cm.)
unsigned
provenance: ULC, 1997
gift of the artist
UL1997.8

Rudolf Pen
(1918–1989)
Mexico
watercolor on paper;
27½ x 40 inches
(69.22 x 101.60 cm.)
signed lower center: *Pen*
provenance: ULC, 1967
UL1967.5

Henry E. C. Peterson
(b. 1841)
Portrait of J. McGregor Adams
oil on canvas;
29 x 24 inches
(73.66 x 60.96 cm.)
unsigned
provenance: ULC, 1895
UL1895R.9

Frank Charles Peyraud
(1858–1948)
The Sunlit Valley (Sunset), 1899
Page 190

After Alfred H. Phillips
Woodrow Wilson, ca. 1918
etching; 16 x 12 inches
(40.64 x 30.48 cm.)
signed lower right:
Alfred H. Wilson; inscribed in plate,
lower left: *Woodrow Wilson*;
inscribed in plate, top left:
© *Charles Barmore Paterson, N.J.*
provenance: George D. Cook,
?–1918; ULC, 1918
gift of George D. Cook
UL1918.1

Bert Geer Phillips
(1868–1958)
*The Chief (Captain of the
Firelight Dance)*, ca. 1935
Page 192

William Lamb Picknell
(1854–1897)
*In France (Sunday Morning,
Moret)*, 1894
Page 194

Maryrose Pilcher
(b. 1944)
Legion #1, 1975
aluminum; 13 x 46 inches
(33.02 x 116.84 cm.)
unsigned
provenance: ULC, 1975
UL1975.2

Clara Taggart McChesney, *The Discovery*, 1905

Paul Frank Pinzarrone
(b. 1951)
Untitled, 1974
acrylic lacquers on plexiglas;
24 x 28⅞ inches (60.96 x 73.34 cm.)
signed on reverse: *paul f. pinzarrone*
provenance: ULC, 1974
UL1974.2

Albín Polášek
(1879–1965)
Man Carving His Own Destiny, 1926
Page 196

Jack Pollari
(dates unknown)
Fog Bound, 1960s
watercolor on paper; 15 x 21¼ inches
(38.1 x 53.98 cm.)
signed lower center: *Jack Pollari*
provenance: Norman S. Schmitz, 1969;
UL C&AF, 1969–1986; ULC, 1986
UL1986c.81

Tunis Ponsen
(1891–1968)
*Untitled (Century of Progress,
World's Fair)*, ca. 1933–34
Page 198

Edward Henry Potthast
(1857–1927)
In the Surf, ca. 1914
Page 200

Hiram Powers
(1805–1873)
Daniel Webster, 1854
Page 202

Hovsep Pushman
(1877–1966)
Autumn Winds (Oriental Still Life)
oil on panel; 25¼ x 14½ inches
(64.14 x 36.83 cm.)
signed lower right: *Pushman*
provenance: Mary Sharp Foucht,
?–1975; UL C&AF, 1975–1986; ULC, 1986,
UL1986c.85

Herman More, *Green Covered Dunes (Cloudy Day in the Dunes)*

The Golden Grace
Page 204

Oriental Still Life with Seated Buddha
oil on panel; 22³/₄ x 24¹/₂ inches
(57.79 x 62.23 cm.)
signed lower right: *Pushman*
provenance: Mary Sharp Foucht, ?–1975;
UL C&AF, 1975–1986; ULC, 1986,
UL1986C.86

Prelude to Paradise
oil on panel; 22 x 16³/₄ inches
(55.88 x 42.55 cm.)
signed lower right: *Pushman*;
inscribed on frame: *Adoramus te Domine /
Jesu Christ et benedicimus / tibio v per santo /
crucem tpastuam redemisti mundum*
provenance: Mary Sharp Foucht, ?–1975;
UL C&AF, 1975–1986; ULC, 1986
UL1986C.84

Henry Ward Ranger
(1858–1916)
*The Pool at Hawk's Nest
(Hawk's Nest Pool)*, 1901
Page 206

Roberto Rascovich
(1857–1904)
A Venetian Canal at Night
casein with oil wash
on paper board;
22 x 36 inches
(55.88 x 91.44 cm.)
signed lower left:
Roberto Rascovich, Venezia.
provenance: ULC, 1895
UL1895R.2

Thomas Buchanan Read
(1822–1872)
*Portrait Sketch for
"Sheridan's Ride"*
oil on canvas; 11¹/₂ x 9¹/₂ inches
(29.21 x 24.13 cm.)
signed lower left:
T. Buchanan Read 18__(illegible)
provenance: ULC, 1895
UL1895R.8

Sheridan's Ride, 1871
Page 208

Sheridan's Ride
(Manuscript), 1871
ink on paper; 22¹/₂ x 18¹/₈ inches
(57.15 x 46.99 cm.)
signed lower right: *T. Buchanan Read/by
the author/Rome 1871.*
provenance: ULC, 1910
UL1910A.2

Robert Reid
(1862–1929)
Blessing the Boats, ca. 1887–1889
Page 210

Arthur Grover Rider
(1886–1975)
Peasants at the Seashore
oil on canvas; 12 x 15 inches
(30.48 x 38.10 cm.)
signed lower right: *A G Rider*
provenance: E. Haupt,
?–1981; ULC, 1982,
gift of E. Haupt
UL1982.1

Julius Rolshoven
(1858–1930)
*The Cloister, Church of St. Francis
of Assisi (The Cloister)*, ca. 1905
Page 212

After George Romney
(1734–1802)
Portrait of Edmund Randolph
oil on canvas;
29¹/₂ x 23¹/₂ inches
(74.93 x 59.69 cm.)
unsigned
provenance: ULC, 1940
UL1940A.3

**Rookwood Pottery
(Albert Robert Valentien)**
(1862–1925)
Vase with Poppies, 1900
pottery with standard ware glaze;
14¹/₂ x 4¹/₂ inches at top
(36.83 x 11.43 cm.)
signed on base: *A.R.V.* and
impressed with firm's mark,
with 14 flames, and *857*
provenance: ULC, 1988
UL1988.2

Peter David Roos
(b. 1955)
Self-Portrait with Walking Hat, 1983
oil on canvas;
25¹/₂ x 24 inches
(64.77 x 60.96 cm.)
signed right edge: *PR*
provenance: ULC, 1985
UL1985.2

Seymour Rosofsky
(1924–1981)
Bather's Monument, ca. 1967
Page 214

After Peter Paul Rubens
(Flemish, 1577–1640)
*Artemisia Drinking the Ashes of her
Husband, Mausolous*
oil on panel; 38 x 49¹/₂ inches
(96.52 x 125.73 cm.)
signed lower left:
P.P. RUBENS / F.B. (signature appears
to be later addition)
provenance: Sidney Corning Eastman,
?–1928; ULC, 1928
gift of Sidney Corning Eastman
UL1928.2

Edgar A. Rupprecht
(1889–1954)
The Summer Visitor, ca. 1924
Page 216

Untitled (Woman Writing at Desk), ca. 1924
Page 216

John Collier Sabraw
(b. 1968)
Closet Formalism, 1998
Page 218

Ed Paschke, *Hat Study*, 1989

Salvatore Salla
(Persian American b. 1903)
Portrait of Frank Flagg Taylor
oil on canvas board;
24 x 20¹/₄ inches
(60.96 x 51.44 cm.)
signed lower right: *S. Salla*
provenance: ULC, 1957
UL1957A.11

William Herman Schmedtgen
(1862–1936)
After the Fight at Caney, 1898
watercolor on paper;
17¹/₂ x 12 inches
(44.45 x 30.48 cm.)
signed lower left: *Wm. Schmedtgen*
provenance: ULC, 1900
UL1901.9.5

Cavalry Outpost, 1898
watercolor on paper;
23¹/₂ x 18¹/₂ inches
(59.69 x 46.99 cm.)
signed lower left:
W. Schmedtgen
provenance: ULC, 1900
UL1901.9.1

Cuban Resting, 1898
watercolor on paper;
12 x 8 inches (30.48 x 20.32 cm.)
signed lower left: *W. Schmedtgen*
provenance: ULC, 1900
UL1901.9.6
Cubans Scouting, 1898
watercolor on paper; 12 x 19¹/₄ inches
(30.48 x 48.90 cm.)
signed lower left: *W. Schmedtgen*
provenance: ULC, 1900
UL1901.9.4

The Maria Teresa after Battle, 1898
watercolor on paper;
10¼ x 16 inches (26.04 x 40.64 c.m)
signed lower left: *W. Schmedtgen, Cuba*
provenance: ULC, 1900
UL1901.9.2

On the Skirmish Line, 1898
watercolor on paper; 9 x 6 inches
(22.86 x 15.24 cm.)
signed lower right: *Schmedtgen*
provenance: ULC, 1900
UL1901.9.7

Otto J. Schneider

(1875–1934)
Michigan Avenue, 1916
etching with drypoint; 9 x 8¾ inches
(22.86 x 22.23 cm.)
signed lower right: *Schneider, 1916*
provenance: ULC, 1957
UL1957A.14

Carolyn Schock

(b. 1939)
Bouquet #1
watercolor on paper; 30 x 22 inches
(76.2 x 55.88 cm.)
unsigned
provenance: ULC, 1985
UL1997.5.3

Cut Flower Arrangement
watercolor on paper;
30 x 22 inches (76.2 x 55.88 cm.)
unsigned
provenance: ULC, 1985
UL1997.5.4

Flowering Nautilus
watercolor on paper;
22 x 30 inches (55.88 x 76.2 cm.)
unsigned
provenance: ULC, 1985
UL1997.5.2

Flowers for Georgia
oil and acrylic on canvas;
34½ x 34½ inches (87.63 x 37.63 cm.)
signed lower right: *C.Schock*; signed
on reverse: *"Flowers for Georgia"*
Carolyn Schock; on stretcher bar:
Flowers for Georgia Carolyn Schock
provenance: ULC, 1985
UL1985.6

Strawberry Cantata
watercolor on paper; 22 x 30 inches
(55.88 x 76.2 cm.)
unsigned
provenance: ULC, 1985
UL1997.5.1

George F. Schultz

(1869–1945)
Coast of Maine
oil on canvas; 20 x 24 inches
(50.8 x 60.96 cm.)
signed lower left: *Geo. F. Schultz*
provenance: ULC, 1917
UL1917.8

Lake Michigan Shoreline
watercolor on paper;
15 x 20 inches (38.1 x 50.8 cm.)
signed lower left: *Geo. F. Schultz*
provenance: UL C&AF, ?–1986; ULC, 1986,
UL1986C.90

The Road Home
watercolor on paper;
15¼ x 20 inches (38.74 x 50.8 cm.)
signed lower right: *Geo. F. Schultz*
provenance: UL C&AFF, ?–1986;
ULC, 1937,
UL1986C.119

John Schulze

(1915–1999)
Midwest Reflections
(Suite of ten photographs)
black-and-white photographs;
sizes vary
unsigned
provenance: ULC, 1988
gift of L. Herbert Tyler
UL1988T.81.1–10

Suite of Nine Photographs
color photographs; sizes vary
unsigned
provenance: ULC, 1988
gift of L. Herbert Tyler
UL1988T.60.1–9

Carl E. Schwartz

(b. 1935)
Garden Path, 1973
acrylic on canvas;
35½ x 44½ inches
(90.17 x 113.03 c.m.)
signed lower right: *C. E. Schwartz*
provenance: ULC, 1974
UL1974.1

The Great Society, 1967
oil on canvas; 48 x 38 inches
(121.92 x 96.52 cm.)
signed lower right: *Schwartz*
provenance: ULC, 1967
UL1967.2

William Samuel Schwartz

(1896–1977)
*Earn Your Bread by the Sweat
of Your Brow*, 1935
Page 220

Irving Shapiro

(1827–1994)
A Different View, 1987
watercolor on paper; 30 x 38½ inches
(76.2 x 97.79 cm.)
signed lower right: *I. SHAPIRO AWS / '87*
provenance: ULC, 1988
UL1988.48

David Sharpe

(b. 1944)
Untitled (Abstraction), 1972
oil on canvas; 48 x 48 inches
(121.92 x 121.92 cm.)
signed lower right: *Sharpe '72*
provenance: Mr. and Mrs. Douglas
Kenyon to 1985; ULC, 1985
gift of Mr. and Mrs. Douglas Kenyon ~
UL1986.3

Kathryn Westerhold Shay

(dates unknown)
George Ives Haight, 1954
bronze; 19 x 48 inches
(48.26 x 121.92 cm)
signed at base: *Kathryn Shay May 1954*
provenance: William Huebner,
?–1964; UL C&AF, 1964–1986; ULC, 1986,
UL1986C.91

Rudolf Pen, *Mexico*

Hollis Sigler

(1943–2001)
White Bathing Suit, ca. 1973–1975
Page 222

Belle Silveira

(1877–?)
Woman Seated
graphite on paper; 13¾ x 8¾
inches (34.93 x 22.23 cm.)
signed lower center: *Belle Silveira*
provenance: ULC, 1900
UL1900.4

Steve Skinner

(b. 1953)
Cortland and Ashland, 1991
watercolor on paper; 21¼ x 59⅞ inches
(53.98 x 152.08 cm.)
signed lower right: *Steve Skinner /
4/91*; on reverse: *CORTLAND and ASHLAND /
chicago,4/9/91/ STEVE SKINNER*
provenance: ULC, 1993
UL1993.2

Jeanette Pasin Sloan

(b. 1946)
Valle de Colore, 1994
Page 224

Frithjof Smith-Hald

(Norwegian, 1846–1903)
Return of the Boats
oil on canvas; 21½ x 37 inches
(54.61 x 93.98 cm.)
signed lower left: *Smith-Hald*
provenance: ULC, 1895
UL1895.31

Ethel Spears

(b. 1902–1974)
Oak Street Beach
Page 226

John Adams Spelman

(1880–1941)
The Gray Smokies, 1925
oil on canvas; 22 x 26 inches
(55.88 x 66.04 cm.)
signed lower right: *J. A. Spelman*
provenance: Summit Gallery, 1994; ULC, 1994
UL1994.12

Robert Spencer

(1879–1931)
The Rag Pickers (Red Shale Road), ca. 1921
Page 228

Hollis Sigler

Henry Fenton Spread

(1844–1890)
Rufus Choate, 1890
Page 230

Anna Lee Stacey

(1871–1943)
Acacia
oil on canvas; 36 x 34 inches
(91.44 x 86.36 cm.)
signed lower left: *Anna Lee Stacey*
provenance: MAL, 1907–1951;
UL C&AF, 1951–1976; ULC, 1976
UL1976.48

Trophies of the Field, 1902
Page 232

John Franklin Stacey

(1859–1941)
*The Valley of the Mystic
(Across the Valley
of the Mystic)*, ca. 1902
Page 234

Country Lane (also known as
Wooded Landscape), 1928
oil on canvas; 34 x 36 inches
(86.36 x 91.44 cm.)
signed lower left: *JOHN STACEY 1928*
provenance: Mr. and Mrs. George T.
Buckingham, ?–1964;
UL C&AF, 1964-1986; ULC, 1986
UL1986C.95

Kenneth Steil

(dates unknown)
Ely Cathedral
etching with drypoint;
14¾ x 7¾ inches (37.47 x 19.69 cm.)
signed lower right: *Kenneth Steil*
provenance: Frank Flagg Taylor,
?–1959; ULC, 1959
gift of Frank Flagg Taylor
UL1959.8

Heinrich Steinike

(1825–1909)
Bavarian Mountain Scene, ca. 1875
oil on canvas; 35 x 49 inches
(88.90 x 124.46 cm.)
signed lower left:
Heine. Steinike
provenance: Mr. and Mrs.
Samuel W. Witwer to 1963; UL C&AF,
1963–1986; ULC, 1986
UL1986C.98

After Peter Paul Rubens, *Artemisia Drinking the Ashes of her Husband, Mausolous*

Antonin Sterba
(1875–1963)
Chris Marie (Girl in a Golden Shawl), ca. 1927
Page 236

Pericutin, Mexico
oil on canvas; 27 x 32 inches
(68.58 x 81.28 cm.)
signed lower left: *Antonin Sterba*
provenance: UL C&AF,
1961–1986; ULC, 1986
UL1986C.99

Max Stern
(1872–1943)
Siesta, 1901
oil on canvas; 20½ x 54½ inches
(52.07 x 138.43 cm.)
signed lower right: *Max Stern*
provenance: Anna Maude Stuart,
?–1978; UL C&AF, 1978–1986;
ULC, 1986
UL1986C.100

Helen B. Stevens
(b. 1878–unknown)
University of Chicago
etching; 9½ x 6¼ inches
(23.13 x 15.875 cm.)
provenance: ULC, 1957
UL1957A.29

After Gilbert Stuart
(1755–1828)
George Washington at Dorchester Heights
oil on canvas; 108 x 72 inches
(274.32 x 182.88 cm.)
unsigned
provenance: ULC, 1887
UL1895R.10

Portrait of General Washington,
before 1840
oil on canvas; 25 x 20 inches
(63.5 x 50.8 cm.)
unsigned
provenance: British cotton merchant,
Rome, 1840; Zebina Eastman,
England, 1868; by descent
through the Eastman family to Judge
Sidney Corning Eastman; ULC, 1928
gift of Judge Sidney Corning Eastman
UL1928.3

Fred C. Stueckemann
(b. 1909)
Nigerian Horseman
oil on canvas; 28 x 22 inches
(71.12 x 55.88 cm.)
signed upper right:
STUECKEMANN—
provenance: UL C&AF, 1963–1986;
ULC, 1986,
UL1986C.101

Irina Sukhanova-Olsen
(b. 1935)
Prince and the Firebird, 1987
oil on canvasboard;
24 x 20 inches (60.96 x 50.8 cm.)
unsigned
provenance: ULC, 1987
gift of the artist
UL1987.2

Svend Svendsen
(1864–1930)
Winter Sunset
oil on canvas; 24 x 32 inches
(60.96 x 81.28 cm.)
signed lower right:
SVEND SVENDSEN—
provenance: Judge and Mrs.
Edward Robson, ?–1989; ULC, 1989
gift of Mrs. Edward A. Robson
in memory of her husband,
Judge Edward Robson
UL1989.8

Winter Sunset in Norway, 1897
Page 238

George Gardner Symons
(1861–1930)
In the Mohawk Valley, ca. 1910
Page 240

Jules Tavernier
(1844–1889)
A Festival, 1870
oil on canvas mounted on
masonite; 18¼ x 21½ inches
(46.36 x 53.34 cm.)
signed lower left: *Jules Tavernier 1870*
provenance: William O. Cole,
?–1907; ULC, 1907
gift of William O. Cole
UL1907C.9

Frederic Tellander
(1878–1977)
Ancient Houses along the Seine—Paris, 1958
watercolor on paper; 19 x 23½ inches
(48.26 x 59.69 cm.)
signed lower left: *Frederic Tellander '58*
provenance: UL C&AF, 1959–1986;
ULC, 1986
UL1986C.102

Surf at Ogunquit, ca. 1927
Page 242

Leslie Prince Thompson
(1880–1963)
Calves and Child, ca. 1901
Page 244

Edward Joseph Finley Timmons
(1882–1960)
Marjorie (Mrs. Timmons), ca. 1929
oil on canvas; 24 x 18 inches
(60.96 x 45.72 cm.)
signed lower left: *Edward J. F. Timmons*
provenance: Marjorie Gilbert
Timmons, 1929–1966; UL C&AF,
1966–1986; ULC, 1986
UL1986C.103

*The Stevenson House Monterey,
California (The Robert Louis Stevenson
House in Monterey, California)*, 1940
Page 246

Charles Yardley Turner
(1850–1918)
John Alden's Letter, ca. 1887
Page 248

Ross Sterling Turner
(1847–1915)
Cologne Cathedral, 1884
Page 250

Walter Ufer
(1876–1936)
Land of Mañana, 1917
oil on canvas; 36 x 40 inches
(91.44 x 101.60 cm.)
signed lower left: *wufer*
provenance: ULC, 1917
UL1917.1

Near the Waterhole, 1921
Page 252

Franz Richard Unterberger
(Belgian, 1838–1902)
Riva degli Schiavoni—Venice
oil on canvas; 33½ x 53½ inches
(85.09 x 135.89 cm.)
remnant of signature lower left:
F. R. Unterberger
provenance: ULC, 1895
UL1895.25

Tom Uttech
(b. 1942)
Midwinter Night's Dream, 1984
oil on canvas; 46 x 50 inches
(116.84 x 127 cm.)
signed lower right: *T. UTTECH 12-21-84 ©*
provenance: ULC, 1985
UL1985.6

James Valerio
(b. 1938)
Night Fires, 1984
Page 254

Leonard Wells Volk
(1828–1895)
Abraham Lincoln, after 1864
plaster with bronze-toned paint;
32 x 23 x 14½ inches
(81.28 x 58.42 36.83 cm.)
provenance: ULC, 1907
UL1907C.24

Clark Greenwood Voorhees
(1871–1933)
*The Tulip Tree, October
(Magnolias, Autumn)*, ca. 1922
Page 256

Frank Russell Wadsworth
(1874–1905)
Interior
oil on canvas; 30½ x 24 inches
(77.47 x 60.96 cm.)
unsigned
provenance: Sarah F. Wadsworth (the
artist's mother), to 1926; ULC, 1926
gift of the estate of Sarah F. Wadsworth
UL1940A.4.1

Walter Ufer, *Land of Mañana*, 1917

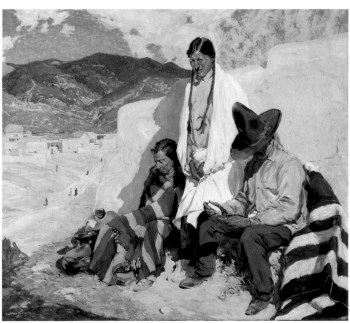

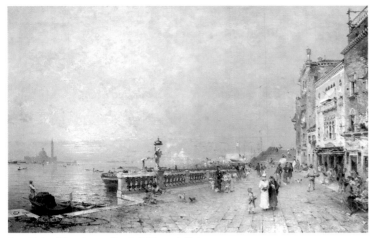
Franz Richard Unterberger, *Riva degli Schiavoni—Venice*

A River Lavadero, *Madrid*
(Street in Madrid)
Page 258

Wharf of Red Boats, Haarlem, 1903
oil on canvas; 30¼ x 36 inches
(76.84 x 91.44 cm.)
signed lower left: *Frank Wadsworth /
Haarlem '03*
provenance: MAL, 1926–1951;
UL C&AF, 1951–1976; ULC, 1976
UL1976.54

Wedgwood Company
(English)
George Washington, 1875
black basaltware bust; 18 x 11¼ x 8¾
inches (45.72 x 28.58 x 22.23 cm.)
marked on back: *WEDGWOOD*
provenance: ULC, 1907
UL1907C.25

Reynolds Henry Weidenaar
(1915–1985)
Glory to God, Fourth Presbyterian Church
etching with drypoint; 13 x 8 inches
(33.02 x 20.32 cm.)
signed lower right; *Reynolds Henry
Weidenaar*
provenance: Frank Flagg Taylor,
?–1959; ULC, 1959
gift of Frank Flagg Taylor
UL1959.9

Gary Weisman
(b. 1952)
Archer, 1994
bronze; 20½ x 5½ x 4½ inches
(52.07 x 13.97 x 11.43 cm.)
signed bottom: *Weisman* and *4pl*
provenance: ULC, 1995
gift of the artist in memory of
Dennis Loy
UL1995.1

Classical Torso, 1992
bronze; 17¾ x 8½ x 6 inches
(45.09 x 21.59 x 15.24 cm.)
signed on bottom: *WEISMAN*
provenance: Betty Weisman,
?–1992; ULC, 1992
gift of Betty Weisman in memory of
her husband, Nathan Weisman
UL1992.5

Untitled (Bronze Horse)
bronze; 25 x 30 x 9 inches
(63.5 x 76.20 x 22.86 cm.)
stamped right rear leg: *Cie /
WEISMAN/ Perdue*
provenance: ULC, 1988
UL1988.51

William Wendt
(1865–1946)
*In the Shadow of the Grove (Sunlight
and Shadow)*, 1907
Page 260

Baroness Violet Beatrice Wenner
(1880–1970)
Portrait of Herbert Hoover
oil on canvas; 40 x 30 inches
(101.60 x 76.20 cm.)
signed lower right: *Violet B. Wenner*
provenance: UL C&AF
(gift of the artist), 1966–1986; ULC, 1986
UL1986C.105

Carl Newland Werntz
(1874–1944)
Three Girls on the Beach, 1914
oil on canvas; 30¼ x 20 inches
(76.84 x 50.8 cm.)
signed lower left: *C.N. Werntz / 14*
provenance: Mrs. Carl Werntz,
?–1957; ULC, 1957
gift of Mrs. Carl Werntz
UL1957A.12

Florie Wescoat
(b. 1953)
Amish Hat and Martin Luther Stamp, 1984
oil on linen; 28 x 22 inches (71.12 x 55.88 cm.)
unsigned
provenance: ULC, 1984
UL1984.4

Levon West
(1900–1968)
Robert Tennyson Stanton, 1924
etching and drypoint;
5 x 6 inches (12.7 x 15.24 cm.)
signed in plate, upper left:
Levon West, New York
provenance: George W. Webster
to 1932; ULC, 1932
gift of George W. Webster
UL1932.1

Sled Dogs
drypoint; 8 x 13¾ inches
(20.32 x 34.93 cm.)
signed lower right: *41.
LEVON WEST IMP.*
provenance: ULC, 1981
UL1931N.21

Glenn Wexler
(b. 1963)
Neptune, 1995
silkscreen; 7⅛ x 5¼ inches
(18.10 x 13.34 cm.)
signed lower right: *Wex 95;*
inscribed lower left: *5/7*
provenance: ULC, 1998
gift of the artist
UL1998.7

Margaret Wharton
(b. 1943)
Book Painting, 1993
Books, concrete, mixed media;
48 x 48 inches (121.92 x 121.92 cm.)
signed reverse: *"Book Painting"
1993/Margaret Wharton*
provenance: ULC, 2003
UL2003.4

Guy Carleton Wiggins
(1883–1962)
Passing Year, 1920
Page 262

John Carleton Wiggins
(1846–1932)
March Hillside, Lyme, Connecticut
oil on panel;
11 x 15 inches (27.94 x 38.10 cm.)
signed lower left:
Carleton Wiggins
provenance: ULC, 1908
UL1908.1

Irving Ramsay Wiles
(1861–1948)
*The Southwest Wind
(The Captain's Daughter)*, ca. 1905
Page 264

Tom Uttech, *Midwinter Night's Dream*, 1984

Richard Willenbrink
(b. 1954)
Dwight David Eisenhower, 1990
Page 266

Untitled (Still Life with Flowers), 1987
oil on canvas; 45 x 35 inches
(114.30 x 88.90 cm.)
signed lower right: *RW '87*
provenance: ULC, 1988
UL1988.46

Florence White Williams
(1895–1953)
Cape New Age, Maine, 1925
oil on canvas; 18 x 18 inches
(45.72 x 45.72 cm.)
signed lower right: *FLORENCE WHITE
WILLIAMS*
provenance: ULC, 1994
UL1994.11

C. S. Wiltschek
(dates unknown)
William John Jackson, 1926
oil on panel; 36 x 28 inches
(91.44 x 71.12 cm.)
signed lower right: *C. S. Wiltschek*
provenance: William John Jackson; ULC, 1969
gift of Robert A. Jackson
and Mrs. Frank G. Nicholson
UL1969.4

James Winn
(b. 1949)
Farm Orchard, 1986
Page 268

Sugar Creek, 1981
acrylic on paper;
8½ x 17 inches (21.59 x 43.18 cm.)
signed lower right: *WINN '81*
provenance: ULC, 1981
UL1981.4

Karl Wirsum
(b. 1939)
Untitled (Head Study), 1987
Page 270

Gary Weisman, *Untitled (Bronze Horse)*

Charles P. Wood, Jr.
(dates unknown)
Oaxaca Window, ca. 1961
oil and casein on panel;
38½ x 47½ inches (97.79 x 120.65 cm.)
signed lower right: *C.W.*
provenance: UL C&AF, 1961–1986; ULC, 1986
UL1986C.107

Grant Wood
(1892–1942)
In the Spring, 1938
Lithograph;
8 15/16 x 11⅞ inches
(22.70 x 30.16 cm.)
signed lower right:
Grant Wood
provenance: ULC, 1988
UL1988.44

Henry Charles Woollett
(active 1851–1872)
Untitled (Barnyard Scene),
before 1872
oil on canvas laid on panel;
20 x 36 inches
(50.8 x 91.44 cm.)
signed lower right:
H.C. Woollett
provenance: ULC, 1988
UL1988.21

Alexander Helwig Wyant
(1836–1892)
Autumn (Evening–Autumn)
Page 272

Mai Yang
(Vietnamese, dates unknown)
*Hmong Story Cloth
(Village Life)*, 1987
pandau embroidery and applique on cotton;
53¼ x 36 inches (135.26 x 91.44 cm.)
unsigned
provenance: Anthony Mourek,
?–1988; ULC, 1988
gift of Anthony Mourek, 1988
UL1989M.5

Alex F. Yaworski
(1907–1997)
Bridge at Du Buque
watercolor on paper; 15 x 23 inches
(38.1 x 58.42 cm.)
signed lower left: *Yaworski A.W.S.*
provenance: George M. Proctor;
UL C&AF, ?–1986; ULC, 1986
UL1986C.109

Ray Yoshida
(b. 1930)
Learned Limbed Ladder, 1981
Page 274

Tino Youvella
(b. 1940)
Morning Kachina, 1960
kachina doll, mixed media; 29 inches
(73.66 cm.)
unsigned
provenance: Foorman Mueller,
?–1982; UL C&AF, 1982–86; ULC, 1986
UL1986C.112

White Buffalo Kachina, 1965
kachina doll, mixed media;
22 inches (55.88 cm.)
unsigned
provenance: Foorman Mueller,
?–1982; UL C&AF, 1982–1986; ULC, 1986
UL1986C.111

Joseph A. Zavadil
(1912–1976)
Chicago Twins, 1960s
watercolor on paper; 17½ x 23¾ inches
(44.45 x 60.33 cm.)
unsigned
provenance: UL C&AF, ?–1986; ULC, 1986
UL1986C.112.

**Felix François Georges
Philbert Ziem**
(French, 1821–1911)
*Venise le Palais des Doges
(Grand Canal, Venice)*, ca. 1899
oil on canvas; 27 x 47½ inches
(68.58 x 120.65 cm.)
signed lower left: *Ziem*
provenance: M. Knoedler & Co.,
New York, 1899; Dr. Leslie Ward,
1899-1911; sold at auction
at the American Art Association,
New York, 1911; Estate of Anna Maude
Stuart, 1978; UL C&AF, 1978–1986;
ULC, 1986
UL1986C.114

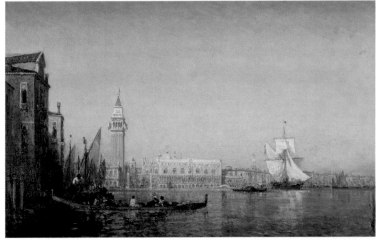

Felix François Georges Philbert Ziem, *Venise le Palais des Doges (Grand Canal, Venice)*, ca. 1899

COLLECTION BY YEAR
OF ACQUISITION

1886
Ross Sterling Turner, *Cologne Cathedral*, 1884

1887
After Gilbert Stuart, *George Washington at Dorcester Heights*

1888
George Peter Alexander Healy, *Portrait of John C. Fremont*

George Peter Alexander Healy, *Portrait of Stephen A. Douglas*

1890
Frederick Arthur Bridgman, *Hot Bargain in Cairo*, 1884

1895
Anonymous, *Portrait of Thomas Jefferson*, 19th century

William Bradford, *U.S.S. Chicago*, 1885–95

Richard Norris Brooke, *Portrait of James Madison*, 1895

Alden Finney Brooks, *Boys Fishing*, before 1893

Edgar Spier Cameron, *Portrait of William H. Seward*

Charles Harold Davis, *The Last Rays*, 1887

W. A. Duncan, *Portrait of Lewis L. Coburn*, 1885

Eastman Johnson, *Alexander Hamilton*, 1890

Willem Lamorinière, *Autumn Leaves*, 1893

Claude Monet, *Pommiers en fleurs*, 1872

John Mulvany, *Portrait of Albert L. Coe*, 1889

Leonard Ochtman, *Field of Grain*, 1894

William Ordway Partridge, *Edward Everett Hale*, 1891

Henry E. C. Peterson, *Portrait of J. McGregor Adams*

Roberto Rascovich, *A Venetian Canal at Night*

Thomas Buchanan Read, *Portrait Sketch for "Sheridan's Ride"*

Frithjof Smith-Hald, *Return of the Boats*

Henry Fenton Spread, *Rufus Choate*, 1890

Charles Yardley Turner, *John Alden's Letter*, 1887

Franz Richard Unterberger, *Riva degli Schiavoni—Venice*

Alexander Helwig Wyant, *Autumn*, 1896

Thomas Buchanan Read, *Sheridan's Ride*, 1871

1897
William Lamb Picknell, *In France*, 1894

1898
Jennie Bird Bryan, *Portrait of Thomas B. Bryan*, 1898

William Cogswell, *General U. S. Grant*, 1879

1899
Oliver Dennett Grover, *Her Grandmother's Gown*, 1858

George Inness, *Picnic in the Woods, Montclair, New Jersey*, 1894

Hiram Powers, *Daniel Webster*, 1854

1900
Marie Elsa Blanke, *A Bit of Beach*, ca. 1899

Jeannette Buckley, *In Old Hyde Park*, ca. 1900

William Herman Schmedtgen, *After the Fight at Caney*, 1898

William Herman Schmedtgen, *Cavalry Outpost*, 1898

William Herman Schmedtgen, *Cuban Resting*, 1898

William Herman Schmedtgen, *Cubans Scouting*, 1898

William Herman Schmedtgen, *The Maria Teresa after Battle*, 1898

William Herman Schmedtgen, *On the Skirmish Line*, 1898

Belle Silveira, *Woman Seated*

1901
Anonymous/Japanese, *Satsuma Vase*, 1880

Anonymous/Japanese, *Cloisonné Enamel Vase*, 1880

Arthur Dawson, *Bringing Home the Cows*

Arthur Dawson, *Highway at Twilight*

Arthur Dawson, *The Old Lock*

Elizabeth Nourse, *Good Friday*, 1891

Leonard Ochtman, *Frosty Morning*, 1894

Frank Charles Peyraud, *The Sunlit Valley*, 1899

Henry Ward Ranger, *The Pool at Hawk's Nest*, 1901

Robert Reid, *Blessing the Boats*, ca. 1887–1889

Leslie Prince Thompson, *Calves and Child*, 1901

1902
Mary Fairchild MacMonnies Low, *Blossoming Time in Normandy*, 1901

Anna Lee Stacey, *Trophies of the Field*, 1902

John Franklin Stacey, *The Valley of the Mystic*, ca. 1902

1903
George Peter Alexander Healy, *Daniel Webster at Marshfield*, 1848

1905
Frederick Clay Bartlett, *Martigues, France*, 1905

George Elmer Browne, *La Guidecca—Venice*

Ralph Elmer Clarkson, *Twilight Harmony*, ca. 1904

Evelyn Beatrice Longman, *Victory*, 1905

Clara Taggart McChesney, *The Discovery*, ca. 1905

Julius Rolshoven, *The Cloister, Church of St. Francis at Assisi*, ca. 1905

Irving Ramsay Wiles, *The Southwest Wind*, ca. 1905

1906
Charles Francis Browne, *The Mill Pond*, 1904

Charles Warren Eaton, *On Lake Lugano*, ca. 1906

Svend Svendsen, *Winter Sunset in Norway*, 1897

1907
Carl J. Becker, *Portrait of Lieutenant General Philip A. Sheridan*, 1887

Ralph Elmer Clarkson, *Portrait of Elbridge G. Keith*, 1904

Ralph Elmer Clarkson, *Portrait of Eugene Cary*, ca. 1900

Arthur Dawson, *Portrait of Daniel Webster*

Edward James Dressler, *Autumn Landscape*, 1899

Jules Tavernier, *A Festival*, 1870

Leonard Wells Volk, *Abraham Lincoln*, after 1864

Wedgwood Company, *George Washington* (bust), 1875

William Wendt, *In the Shadow of the Grove*, 1907

1908
Leonard Crunelle, *Squirrel Boy*, ca. 1908

William Henry Howe, *Evening at Laren, the Meadows—Cattle*, 1890

Herman Dudley Murphy, *Venice (A Doorway)*, 1908

Herman Dudley Murphy, *Winter Scene (Snow)*

John Carleton Wiggins, *March Hillside, Lyme, Connecticut*

1909
Ralph Elmer Clarkson, *Portrait of Lincoln*, ca. 1909

Paul Dougherty, *The Surf Ring*, ca. 1908

John Christen Johansen, *Hills of Fiesole, Springtime*, 1908

1910
Alson Skinner Clark, *Saint Gervais*, ca. 1909

Lovell Birge Harrison, *Sunshine and Mist, Quebec*, ca. 1910

Robert Hinckley, *Chief Justice Melville Weston Fuller*

Thomas Buchanan Read, *Sheridan's Ride* (manuscript), 1871

George Gardner Symons, *In the Mohawk Valley*, ca. 1910

1915
Wallace Leroy DeWolf, *California Coast*, 1915

1916
Wilson Henry Irvine, *The Old Homestead*, ca. 1916

1917
Frederic Milton Grant, *County Fair*, 1916

Frederic Milton Grant, *Sunday Morning*, 1910

Victor Higgins, *Jacinto and the Suspicious Cat*, 1916

Wilson Henry Irvine, *Branching Tracery*, ca. 1916

Herman More, *Green Covered Dunes*

George F. Schultz, *Coast of Maine*

Walter Ufer, *The Land of Mañana*, 1917

1918
After Alfred H. Phillips, *Woodrow Wilson*, ca. 1918

1919
Anonymous, *Theodore Roosevelt*, 1910

1920
Edward Burgess Butler, *In the Berkshires*, 1919

1921
Robert Spencer, *The Rag Pickers*, ca. 1921

1922
Raymond Perry Rodgers Neilson, *The Mirror*, 1921

1926
Frances S. C. Badger, *Eighty-four Original Illustrations for The Spirit of the Union League Club, 1879–1926*, ca. 1926

Edwin Howland Blashfield, *Patria*, 1926

Charles Webster Hawthorne, *The Shad Fisherman*, 1915–1916

Frank Russell Wadsworth, *Interior*

Frank Russell Wadsworth, *A River Lavadero, Madrid*

1928
Albin Polášek, *Man Carving His Own Destiny*, 1926

After Peter Paul Rubens, *Artemisia Drinking the Ashes of Her Husband Mausolous*

After Gilbert Stuart, *Portrait of General Washington*, before 1840

1929
S. Chester Danforth, *The New Union League Clubhouse*, ca. 1928–1929

Oliver Dennett Grover, *Upper St. Mary's, Glacier National Park*, 1923

R. C. Kennert, *Union League Club Entrance Doorway*, ca. 1929

1931
Joseph Allworthy, *Still Life*, 1931

1932
Levon West, *Robert Tennyson Stanton*, 1924

1935
Miklos Gaspar, *Scenes from Union League Boys Clubs*, 1935

John W. Norton, *Untitled (European Cityscape)*

1936
Bert Geer Phillips, *The Chief*, ca. 1935

1940
Alfred Juergens, *Lilac Time*

After George Romney, *Portrait of Edmund Randolph*

1942
Charles Frederick Herbert Naegele, *The Captive*, ca. 1898

1945
Thomas Hill, *Crescent Lake (Yosemite Valley)*, 1892

1948
Charles Dudley Arnold, *Suite of Photographs of the World's Columbian Exposition*, 1893

1949
Jessie Arms Botke, *Vanity*

1951
Clement Rollins Grant, *Woman with Bucket*

1955
Byron Gere, *Contemporary Sculptor*, 1953

H. Gugler, *Portrait of President Lincoln*

Susanne Schweig Martyl, *Spain*, ca. 1955

1957
John James Audubon, *Hawk Owl (Strix Funerea)*, 1837

John James Audubon, *Red-Shouldered Hawk (Falco lineatus)*, 1829

John James Audubon, *Sharp Skinned Hawk (Falco Velox)*, 1837

John James Audubon, *Stanley Hawk (Astur Stanleii)*, 1837

J. Jeffrey Grant, *The Fascinating Village*, 1956

Paul Grolleron, *Battle Scene*, 1882

Axel Herman Haig, *Canterbury; the Pilgrim's Aisle*

After John Gerard Keulemans, *Carmine Throated Bee Eater—Merops Numicoides*

After John Gerard Keulemans, *Green Throated Bee Eater—Merops Nubicus*

Antonio Marrani, *In a Church (Apsidal Area of Santa Maria Novella, Florence)*

Stanley Mitruk, *Quince and Ironstone*, 1956

Salvatore Salla, *Portrait of Frank Flagg Taylor*

Helen Stevens, *University of Chicago*

Carl Newland Werntz, *Three Girls on the Beach*, 1914

1959
Bruno Beghé, *Portrait of Charles S. Deneen*

Richard L. Frooman, *Merry-Go-Round*

Luigi Kasimir, Series of fifteen color etchings

Gustave LeHeutre, *Chartres Cathedral*

Kenneth Steil, *Ely Cathedral*

Reynolds Henry Weidenaar, *Glory to God, Fourth Presbyterian Church (Chicago)*

1960
Arvid Fredrik Nyholm, *Portrait of William Bryce Mundie*

1961
Eve Garrison, *Bride and Groom*, 1959

1965
Curt Frankenstein, *Poste Restante (General Delivery)*

Billy Morrow Jackson, *Before My Time*, ca. 1965

1966
Edward Joseph Finley Timmons, *The Stevenson House, Monterey, California*, 1940

1967
Rudolf Pen, *Mexico*

Carl E. Schwartz, *The Great Society*, 1967

1968
Anonymous/Japanese, *Elephant Attacked by Tigers*, ca. 1890s

1969
C. S. Wiltschek, *William John Jackson*, 1926

1974
Jan Miller, *Kitsch-in Series: Oranges*

Paul Pinzarrone, *Untitled*, 1974

Carl E. Schwartz, *Garden Path*, 1973

1975
Maryrose Pilcher, *Legion #1*, 1975

1976
Adam Emory Albright, *Log in the River*, ca. 1908

Martha Susan Baker, *In an Old Gown*, 1904

George Wesley Bellows, *Girl with Flowers*, 1915

Louis Betts, *James William Pattison*, 1906

Nicholas Richard Brewer, *Motherhood*, ca. 1921

Charles Francis Browne, *Chateau Gaillard*, 1913

Karl Albert Buehr, *The Fourth Descendant*

Karl Albert Buehr, *"If I Were Queen,"* ca. 1924

Edward Burgess Butler, *Stream in the Meadow*, 1918

Edgar Spier Cameron, *Nocturne*, ca. 1926

Walter Marshall Clute, *The Child in the House—The Golden Age*, ca. 1910

Charles W. Dahlgreen, *Autumn in Bloom*, ca. 1920

Bernadine Deneen and anonymous American women on behalf of the Union League Boys and Girls Clubs, *Multi-patch Needlepoint Rug*, 1976

Bernadine Deneen, *Needlepoint Bell-Pull Depicting Nine Birds*, 1976

Frank Virgil Dudley, *One Winter's Afternoon*, ca. 1914

Gerald A. Frank, *Lady with Tiger*

Gerald A. Frank, *Maternity*, ca. 1929

Frederic Milton Grant, *The Sketch Class*, 1914

J. Jeffrey Grant, *Main Street*, ca. 1936

Edward Thomas Grigware, *Paradise Valley*, ca. 1931

Oskar Gross, *Mother Earth*, 1937

Oliver Dennett Grover, *The Riva, Venice*, 1908

Lucie Hartrath, *The Oaks*, ca. 1922

Victor Higgins, *Moorland Gorse and Bracken*, ca. 1911–12

Othmar Hoffler, *Babette*, ca. 1933

William Henry Howe, *Saybrook Point, Connecticut River*, 1908

Rudolph Frank Ingerle, *The Lifting Veil*, 1922

Wilson Henry Irvine, *The Road*, 1910

Alfred Juergens, *Afternoon in May*, ca. 1913

Charles P. Killgore, *Mexican Market*, 1935

Carl Rudolph Krafft, *Banks of the Gasconade*, 1920

Carl Rudolph Krafft, *The Charms of the Ozarks*, ca. 1916

Harriet B. Krawiec, *White Statue*, ca. 1937

Ossip Linde, *Reflections*

Anna Lou Matthews, *Our Daily Bread*, ca. 1932

Julius Moessel, *Springtime*, ca. 1934

John Thomas Nolf, *Boys Plowing*, ca. 1928

Pauline Palmer, *Against the Light (From My Studio Window)*, ca. 1927

Pauline Palmer, *In the Open*, 1920

James W. Pattison, *Tranquility*, ca. 1906

Edward Henry Potthast, *In the Surf*, ca. 1914

Edgar A. Rupprecht, *The Summer Visitor*, ca. 1924

Edgar A. Rupprecht, *Untitled (Woman Writing at Desk)*, ca. 1924

Anna Lee Stacey, *Acacia*

A. Frederic Tellander, *Surf at Ogunquit*, ca. 1927

Walter Ufer, *Near the Waterhole*, 1921

Clark Greenwood Voorhees, *The Tulip Tree, October*

Frank Russell Wadsworth, *Wharf of Red Boats, Haarlem*, 1903

Guy Carleton Wiggins, *Passing Year*, 1920

1978
Edgar Forkner, *Old Boats, Puget Sound*

Alla Jablokov, *In the Ravine*

Pauline Palmer, *Cottage at Provincetown*

1979
Anonymous/Persian, *Hamadan Serebend Carpet*, 20th century

Dorothy Doughty, *Fifty-one American Birds*, 1936–1963

1981
John Taylor Arms, *Momento Vivere*

Lili Aver, *Brigadier General Nathan William MacChesney, USAR*, 1943

Harriet Blackstone, *Man with a Cane: Portrait of James Edwin Miller*, ca. 1910–1912

Donald Ellwanger, *A New England Winter*, 1981

Robert Koch, *The Red Swing*, 1981

Mark McMahon, *The Printing Press*, ca. 1981

James R. Winn, *Sugar Creek*, 1981

1982
Arthur Grover Rider, *Peasants at the Seashore*

1983
Alice Dalton Brown, *Atheneum with Raking Light*, 1983

Peter Dean, *Three Evening Pines*, 1979

S. Ghurty, *Chartres Cathedral*

Patti Hansen, *Casis Series: New York Casis*, 1983

Martin Levine, *Union League Club of Chicago*, 1983

Dennis Jaeger Loy, *Winter Sunrise, Barlow Lake*, 1982

1984
Michelle Fire, *Gate of Ionas*, 1984

Daniel Morper, *Zeus*, 1983

Florie Wescoat, *Amish Hat and Martin Luther Stamp*, 1984

1985
Robert Barnes, *Bocuse*, 1980

Edgar Hinkley, *Bathers*, 1984

Stephen Luecking, *Untitled (Abstract Composition)*, 1976

Peter Roos, *Self-Portrait with Walking Hat*, 1983

Carolyn Schock, *Bouquet #1*

Carolyn Schock, *Cut Flower Arrangement*

Carolyn Schock, *Flowering Nautilus*

Carolyn Schock, *Flowers for Georgia*

Carolyn Schock, *Strawberry Cantata*

David Sharpe, *Untitled (Abstraction)*, 1972

Tom Uttech, *Mid-Winter Night's Dream*, 1984

1986
David Acuff, *Basking*, 1981

Adam Emory Albright, *Home from the Harvest (The Path from the Fields)*, 1914

Anonymous/Native American, *Three Concho Belts*, 20th century

Anonymous/Native American, *Yei Rug (Farmington—Shiprock)*, ca. 1930

Jeffrey Asan, *Still Life on Case*, 1986

Beatrice L. Becker, *Still Life*

Emelie Becker, *Floral Arrangement*, 1922

Emelle Becker, *Floral Arrangement (Floral Arrangement No. 2)*, 1922

Antimo Beneduce, *La Salute, Venice*

Louis P. Betts, *Portrait of Luther Laflin Mills*, 1899

Roger F. Blakley, *Cetou*, ca. 1973

Karl Brandner, *Mill at Fullersburg*

Paul Haie Brewer, *Locked Door*

Claude Buck, *Estride's Mother*, 1932

Edward Burgess Butler, *Beyond the Desert*, 1919

Joseph Caraud, *Discovered*, 1854

William Conger, *Eagle City*, 1972

T. Scott Dabo, *River Landscape, Twilight*

John Doctoroff, *Portrait of Abraham Lincoln*, 1936

John Doctoroff, *Portrait of Frank C. Rathje*, 1952

Ernest E. Dreyfuss, *Old Town*, 1968

Frank Virgil Dudley, *The Dunes*

William C. Emerson, *Rhapsody #2*

William C. Emerson, *Woodland Scene*, 1909

Richard Ruh Epperly, *La Lavendera, Grand Canary Island*, 1963

Peter Fagan, *Raptor*, 1986

Jane Fisher, *Cake and Peaches*, 1986

Edgar Forkner, *Flowers at Window*

John Franklin, *Untitled (Indians on Horseback)*

Louis H. Gerding, *U.S.S. Constitution (Old Ironsides)*, 1954

Robert Alan Gough, *The Return*, 1960

Katherine Grace, *Winter in Lincoln Park*

Frederic Milton Grant, *Still Life*

Marcia Henderson, *Untitled (Cityscape)*, 1984

Wilson Henry Irvine, *Simpson's Meadow (Daybreak)*, ca. 1913

Wilson Henry Irvine, *Winter Landscape*, 1914

Zygmund Jankowski, *Rocky Neck Harbor*, 1968

Frank Tenney Johnson, *Night in the Canyon*, ca. 1929–1937

James M. Jordan, *Country*

Alfred Juergens, *Field of Flowers*

Max Kahn, *The Fountain*

Robert E. Kaiser, *Under the Bridge*,

William Keith, *High Sierras*

Daniel Ridgway Knight, *Waiting for the Ferry*, 1883

Harriet B. Krawiec, *Pigeons*

Edmund D. Laars, *Summer Idyll in the Highlands*, 1875

Robert Elmer Lougheed, *Passing the Old Homestead*

After Anton Mauve, *Sheep with Shepherd*

Everett Carr McNear, *Farm Near Ravello*, 1956

Jack Pollari, *Fog Bound*, 1960s

Hovsep Pushman, *Autumn Winds (Oriental Still Life)*

Hovsep Pushman, *The Golden Grace*

Hovsep Pushman, *Oriental Still Life with Seated Buddha*

Hovsep Pushman, *Prelude to Paradise*

George F. Schultz, *Lake Michigan Shoreline*

George F. Schultz, *The Road Home*

Kathryn Westerhold Shay, *George Ives Haight*, 1954

John Franklin Stacey, *Country Lane*, 1928

Heinrich Steinike, *Bavarian Mountain Scene*, ca. 1875

Antonin Sterba, *Pericutin, Mexico*

Max Stern, *Siesta*, 1901

Fred C. Stueckemann, *Nigerian Horseman*

A. Frederic Tellander, *Ancient Houses along the Seine—Paris*, 1958

Edward Joseph Finley Timmons, *Marjorie*, ca. 1929

Baroness Violet Beatrice Wenner, *Portrait of Herbert Hoover*

J. Jeffrey Grant, *Mending the Nets*, 1959

Charles P. Wood, Jr., *Oaxaca Window*, ca. 1961

Alex F. Yaworski, *Bridge at Du Burque*

Tino Youvella, *Morning Kachina*, 1960

Tino Youvella, *White Buffalo Kachina*, 1965

Joseph A. Zavadil, *Chicago Twins*, 1960s

Felix François Georges Philbert Ziem, *Venise le Palais des Doges*, ca. 1899

1987
Rainey Bennett, *Quiet Lake Shore*, 1952

Francis Chapin, *Museum Garden, Rome*, 1960

Irina Sukhanova-Oksengendler, *Prince and the Firebird*, 1987

James Winn, *Farm Orchard*, 1986

Mai Yang, *Hmong Story Cloth (Village Life)*, 1986

1988
Jean Crawford Adams, *View of the Board of Trade*

Vera Berdich, *The Stare of Eternity*, 1972

Kathleen Blackshear, *Zinnias*, ca. 1929

Byron Burford, *At Dead Horse Point (Hang Glider)*, 1985

Byron Burford, *Bally with Baby Ruth*, 1987

William Crawford, *The Highland Chief*

James Faulkner, *Frontispiece—Triptych*, 1987

Jens Johannessen, *Brarg*

Virginia A. Myers, *The Engraver*

Virginia A. Myers, *Frosty Morning*

Virginia A. Myers, *The Ghost Elm*

Virginia A. Myers, *The Ghost Elm II*

Virginia A. Myers, *Johnson County, Iowa*

Virginia A. Myers, *Limestone Quarry*

Virginia A. Myers, *Rainy Day*

Virginia A. Myers, *A Time of Malfeasance* series

Virginia A. Myers, *To Iowa and Mollybrooks*

Rookwood Pottery (Albert Robert Valentien), *Vase with Poppies*, 1900

John Schulze, *Midwest Reflections (Suite of ten photographs)*

John Schulze, *Suite of Nine Photographs*

Irving Shapiro, *A Different View*, 1987

Hollis Sigler, *White Bathing Suit*, 1973–75

Ethel Spears, *Oak Street Beach*

Gary Weisman, *Untitled (Bronze Horse)*

Richard Willenbrink, *Untitled (Still Life with Flowers)*, 1987

Karl Wirsum, *Untitled (Head Study)*, 1987

Grant Wood, *In the Spring*, 1938

1989
Ivan Le Lorraine Albright, *Knees of Cypress*, 1965

William Barron, *Hidden Lake*, 1988

Fritzi Brod, *Katia*, 1935

Edward Brooks, *Sedgwick El Station #1*, 1987

James E. Disrud, *Vita Bona*, 1989

Steve Graber, *McKay Township*

Marak McMahon. *Union League Club of Chicago*, 1989

Svend Svendsen, *Winter Sunset*

1990
Mary Griep, *Pinnicle Peak Road #2*

Ed Paschke, *Hat Study*, 1989

Richard Willenbrink, *Dwight David Eisenhower*, 1990

1991
Joseph A. Du Pace, *Du Sable's Journey*, 1991

Richard Howard Hunt. *Maquette of Eagle Columns*, 1991

Robert Lostutter, *Superb Sunbird*, 1991

Seymour Rosofsky, *Bather's Monument*, ca. 1967

Ray Yoshida, *Learned Limbed Ladder*, 1981

1992
Roger Brown, *Cathedrals of Space*, 1983

Didier Nolet, *Burgundy Landscape*, 1983

Soei Obiya, *Vase*, 1983

Gary Weisman, *Classical Torso*, 1992

1993
Dennis Jaeger Loy, *It's a Lazy Afternoon*, 1993

Steve Skinner, *Cortland and Ashland*, 1991

1994
Joseph Pierre Birren, *The Court of the Lions, Alhambra, Spain*, 1929

Richard Howard Hunt, *Sidearm*, 1991

John Adams Spelman, *The Gray Smokies*, 1925

James Valerio. *Night Fires*, 1984

Florence White Williams, *Cape New Age, Maine*, 1925

1995
Thorvald Arnst Hoyer, *Untitled*, 1921

Gary Weisman, *Archer*, 1994

1996
Claude Buck, *Portrait of Juel*, 1941

Claude Buck, *Self-Portrait*, 1950

Claude Buck, *Untitled (Landscape with Faun)*

William Samuel Schwartz, *Earn Your Bread by the Sweat of Your Brow*, 1935

Jeanette Pasin Sloan, *Valle de Colore*, 1994

1997
Roger Brown, *Chicago Taking a Beating*, 1989

Nancy Eiseman Paul, *Two Tomatoes*, 1996

Antonin Sterba, *Chris Marie*, ca. 1927

1998
Albert Bloch, *Dreiergruppe (Group of Three)*, 1921

Milton Horn, *Maquette of Franklin Delano Roosevelt*, ca. 1950s–1995

Milton Horn, *Untitled (Vase of Flowers)*, 1940

Richard Howard Hunt. *Portrait of the Artist as a Young Man*, 1998

Ed Paschke and (Art)ⁿ (Ellen Sandor, Stephan Meyers, Janine Fron), *Primondo*, 1997

Glenn Wexler, *Neptune*, 1995

1999
Don Baum, *Andromeda*, 1992

Miyoko Ito, *Untitled*, ca. 1973

Vera Klement, *Woman at the Window*, 1965

John Mahtesian, *Chef Gerard, Vauvenargues, Provence*, 1994

2000
Tunis Ponsen, *Untitled (Century of Progress, World's Fair)*, ca. 1933–34

John Collier Sabraw, *Closet Formalism*, 1998

2001
Vito Acconci, *Wav(er)ing Flag*, 1990

2002
Harold Gregor, *Illinois Landscape #104*, 1988

John Mahtesian, *Chef Gerard, Vauvenargues, Provence*, 1994

John Mahtesian, *Performer—Paris*, 1995

2003
Don Baum, *Domus*, 1992

Ruth Duckworth, *Untitled*, 2002

Kerry James Marshall, *Brownie*, 1995

Margaret Wharton, *Book Painting*, 1993